ONE HUNDRED YEARS OF PHOTOGRAPHIC HISTORY

ONE HUNDRED YEARS OF

PHOTOGRAPHIC
HISTORY

Essays in honor of Beaumont Newhall

EDITED BY VAN DEREN COKE

UNIVERSITY OF NEW MEXICO PRESS, ALBUQUERQUE

One Hundred Years of Photographic History was published with the assistance of a grant from the International Museum of Photography at George Eastman House, Rochester, New York.

TABLE OF CONTENTS

LIST OF ILLUSTRATIONS

INTRODUCTION:
Beaumont Newhall

Van Deren Coke

Beaumont Newhall is justly regarded as the preeminent photographic historian of our time and has been one of the most influential personalities in modern photography. He has earned our gratitude for his pioneering research in the field and for his willingness to share generously his personal knowledge of the masters of photography he knew so well, such as Stieglitz, Steichen, Weston, Adams, Coburn, and Cartier-Bresson. His rich files, assembled over a period of almost a half-century, have been invaluable sources of information for his students and colleagues.

As a writer, he has set high standards for us all to follow. Not only has he published much new material in his books and articles, but he has done so with persuasive coherence, so that beginning students as well as advanced scholars can readily appreciate the fruits of his research.

In the early 1930s Newhall published a few short pieces on various aspects of the history of photography. It was, however, his 1937 catalogue of the innovative exhibition *Photography 1839–1937*, organized at the Museum of Modern Art, that marked him as an art historian with special insight who had elected to take as his field the history of photography. Newhall had gone to the Museum of Modern Art as that institution's librarian in 1933. His interest in another field, photography, was known to the museum's brilliant young director, Alfred Barr. Photography was one of the five fields selected for emphasis when the Museum of Modern Art was chartered. As a consequence, Barr was interested in having a major exhibition on the subject. He asked Newhall if he would like to direct such an exhibition. Receiving an enthusiastic affirmative answer, Barr then inquired as to the scope Newhall had in mind. The reply was typical of Newhall's energy and vision. He said he would like to show the entire history of photography as an art and means of communication. Barr gave him full support, and Newhall set to work planning the exhibition, despite the fact that Alfred Stieglitz said such a comprehensive exhibition was impossible to do in a thorough fashion.

Soon after Newhall received the go-ahead on the exhibition, he married Nancy Parker, painter and writer, in Swampscott, Massachusetts. They planned to go at once to Europe to begin research on the exhibition and catalogue, but before they could start Newhall was struck down with an attack of appendicitis. While recovering in Swampscott, he had Nancy go each day to the Widener Library at Harvard and check out the histories of photography written up to that time and other publications related to the

history of the medium. He read George Potonniée's *Histoire de la découverte de la photographie,* J. M. Eder's *Geschichte der Photographie,* Gisèle Freund's *La Photographie en France au dix-neuvième siècle: Essai de sociologie et d'ésthétique,* Gaston Tissandier's *A History and Handbook of Photography,* Marcus Root's *The Camera and the Pencil,* and John Werge's *The Evolution of Photography.*

When Newhall was able to travel, he and Nancy went to France. He found the magnificent collection of books and prints held by the Société Française housed in an ancient building that had recently been condemned. There was no electricity and therefore the collection was not open for study at night. In the evenings Newhall expanded his knowledge of contemporary French photography. He met Brassaï, Kertész, Nora Dumas, Doisneau, and others. He also met André Lejard, the editor of *Photographie,* the international photography annual published by Arts et Métiers Graphiques.

Lejard arranged for Newhall to meet the prominent French collectors of photography. Major among these was Victor Barthelemy, who made his living working for the city directory of Paris. It was his job to go from door to door and inquire of each resident his name, his profession or trade, the number of children in the household, and their ages and names. He would close his interview with a family, then ask if they had any old photographs they would be willing to sell. In this way he developed a large and very important collection of nineteenth-century French photography. Barthelemy shared the treasures he had collected with Newhall. He then introduced the young American researcher to Albert Gilles, the dean of French collectors. Gilles's collection, now in the Bibliothèque Nationale, had been made over a period of many years. He was an old man, bedridden and hardly able to speak, but his mind was still sharp and his interest in photography still very much alive. During Newhall's visits, Gilles would have his daughter go through the collection and get out things he thought should be seen. The third collector with whom Newhall talked was Georges Sirot, who had a great talent for collecting photographs of events and people and was eager to share his knowledge and show his pictures.

Newhall next went to London, where he spent four weeks researching in the Royal Photographic Society library and collection. With the help of J. Dudley Johnston, the society's secretary, he went through the collection of the work of a host of Victorian photographers and made a study of nineteenth-century photographic journals and books in the library.

After six weeks in Paris and London, Newhall returned to New York to organize his pioneering exhibition and write the catalogue. He decided to write a history of photography from the standpoint of art history. Two authors had inspired him to do this. Freund's intellectual approach to the meaning of photography from a social standpoint gave him one clue as to how best to make relevant the information he had assembled. Heinrich Schwarz's introduction to his very significant monograph on David Octavius Hill provided Newhall with a basis for the study of photography as a means of artistic expression on a par with the study of the history of etchings, engravings, woodcuts, and lithographs.

It is interesting to note that Robert Taft was not known to Newhall at all. Taft's famous history of American photography, written while he was teaching chemistry at the University of Kansas, was submitted to Macmillan for possible publication just as Newhall completed his work. Edward Epstean, to whom Macmillan had sent Taft's manuscript for a reading, knew of Newhall's work and asked him to comment on the manuscript. The discoveries parallel to his own that had been made by Taft amazed Newhall—so much so that he had the publisher write to Taft stating that Newhall had not seen Taft's manuscript until after his own was ready for publication, to prevent any misunderstanding about the sources of information being included in the Museum of Modern Art publication. Newhall had a long correspondence with Taft afterward but never met him in person.

As Schwarz had inspired Newhall, Newhall inspired the work of Helmut Gernsheim. Gernsheim had written a letter to Newhall at the Museum of Modern Art during World War II, which was forwarded to Egypt where Newhall was serving in the Army Air Force as a photo interpreter. In it Gernsheim said he agreed with a statement Newhall had written: that it was not the camera but the man behind it that counted when it came to making good photographs. Newhall wrote Gernsheim from Egypt to say that if he got to England he would look him up. In January 1945, Newhall was sent to London on an intelligence mission, where he met Gernsheim and his wife Alison. They offered him some Anthony stereos they had found in London. Newhall said he could not take them with him and didn't know when he would be returning to New York, then suggested that they be the start of Gernsheim's collection.

After World War II, Newhall returned briefly to the Museum of Modern Art. In 1947 he joined the staff of George Eastman House in Rochester, New York, as

curator of the museum then being organized under the directorship of Oscar N. Solbert. In 1958 General Solbert died and Newhall was named director of George Eastman House. In 1971 he retired from this position and was appointed visiting professor of art at the University of New Mexico, a post he continues to fill. He has been a Fellow of the John Simon Guggenheim Memorial Foundation, 1947; an Honorary Fellow of the Royal Photographic Society of Great Britain; a Fellow of the Photographic Society of America; and a Corresponding Member, Deutsche Gesellschaft für Photographie. In 1954 he received the Brehn Memorial Medal, Delta Lambda Epsilon Fraternity, Rochester Institute of Technology, and in 1968 the Progress Medal from the Photographic Society of America. In 1970 he received the Culture Prize, German Photographic Society, Cologne, and in 1971 he was awarded an honorary Phi Beta Kappa membership by the Executive Board, Iota of New York Chapter, University of Rochester. When he retired as director of George Eastman House on July 1, 1971, a bibliography was published listing the books, articles, and reviews he has written: six hundred and thirty-two entries dating from 1925 to 1971. He has continued his active career as a publishing scholar while teaching full-time. Currently he is completing the fifth revision of his famous *History of Photography.*

Throughout his career Newhall has freely given of his vast knowledge of the history of photography and has helped scores of people expand the knowledge of the history of the medium. The extraordinary amount of information he carries in his head and his extensive files provide him and his students with the data from which new conclusions are being drawn about photography's relationship to the history of science as well as the arts. Newhall now is encouraging scholars and his students to make detailed studies of a multitude of problems, such as the investigation of the role of different kinds of cameras and innovative lens designs on the history of photography and the effect of new films. He is also urging his students to gather biographical information about a host of photographers whose work is now coming to light, and he feels there is a great need for close studies of the developments that evolved during brief periods of time such as he undertook when organizing in 1970–71 the exhibition Photo Eye of the 20s.

The present volume of never-before-published essays is the kind of research Newhall feels should be undertaken. It is therefore most appropriate that this book be dedicated to him.

Van Deren Coke

ÉMILE ZOLA, PHOTOGRAPHER

JEAN ADHÉMAR

ÉMILE ZOLA, PHOTOGRAPHER

Jean Adhémar
*Chief Curator, Cabinet des Estampes,
Bibliothèque Nationale, Paris*

As Beaumont Newhall is well aware (for we have often discussed it), it is vitally important to study Zola the photographer, for even though everyone agrees on the poetic quality of his work, everyone, by the same token, is surprised at his choice of subjects.

These photographs—comprising at least 350–400 negatives—all of which have not yet been printed, were kept by Émile Zola's son, Dr. Jacques Zola, in a small cabinet. Scarcely a fourth of them portrayed Zola's family and Zola himself. It is interesting to note that there was no photograph of his famous Médan group. About 286 were shots of the World's Fair of 1900; about 30 were taken in Monceau Park.

Denise Leblond used to say that her father "approached photography with the same passion that he brought to everything." He was a practicing photographer at least as early as 1887, and it is certain that his photograph of Jeanne Roserot dates from 1893. It is generally agreed that, at that time, he photographed not only Jeanne but also the house at Médan (a three-hour exposure by moonlight). There is no photograph dated between 1893 and 1900. Then, on November 4, 1900, Zola created "Gerbe de chrysanthèmes et de roses," dedicated to his wife, who was in Rome at the time. Later on there was a portrait of Mme Zola dated 1901; a portrait of Jeanne Roserot must also date from that year, because it shows her holding a book published in 1901. The body of material kept by Jacques Zola does not come from either one of these two periods. The series on the World's Fair of 1900 is dated by the subject itself; the one on Monceau Park, winter scenes for the most part, resembles the series on the World's Fair in style.

What does this cycle mean, then? Its numerical importance (286+31=317) proves that it cannot have been an arbitrary exercise. Could it be a group of working notes? One might well think so, for scarcely any written notes exist for the novel *Justice*, on which Zola was working in 1900. We have only some introductory pages for it, and the absence of notes is quite surprising.

Dr. Jacques Zola, to whom we had spoken about this, had been struck by his father's insistence upon taking him to the 1900 World's Fair and by the remarks his father made to him (Jacques Zola was nine years old at the time) about the Seine—its beauty, its wide course. To his daughter (born in 1889), Zola announced (p. 251 of *E. Z. raconté par sa fille*) that his novel *Justice* would be "imbued with kindness, tenderness, an admirable efflorescence, a poignant and shattering cry," opening the "century of tomorrow," a century when France would be "Messiah, Redemptress, Queen," in contrast to the

"old world of Catholicism and Monarchy." Now, how could one better contrast today's France with the France of the past than by contrasting the World's Fair, that explosion of modern power, with an eighteenth-century park, surrounded by cosy, upper-middle-class, slightly sleepy houses?

What does one see in Zola's photographs? Ninety-three views of the Seine showing the pavilions of the exposition, thirty-nine views taken from the Eiffel Tower at different angles, twenty-six pictures of the Eiffel Tower, sixteen exterior views of various pavilions, twelve Far Eastern pavilions, thirty-six pictures of visitors (photographed half-length or full-length—they are not posing; it is not their facial expressions that interest Zola, but their clothing, their carriage, their conversation). Zola did not photograph the interiors of the pavilions. He was not interested in their construction (any more than in the strike, broken up by twenty-five infantry battalions and six cavalry regiments, which preceded the opening).

In order to understand the meaning of his work, let us look at several books on the exposition: first, that of the journalist André Hallays. Hallays is sarcastic toward this ineffectual "lesson of things," this "gigantic bazaar" where one can make discoveries. He explains that "what the public will mainly see of the fair is the outside," and this is because inside there are no guides, notices, or signs. Finally he speaks of photographs and photography. "Let it [photography] be," he writes, "the secretary and note keeper of anyone who needs, in his profession, an absolute material elegance." Surface impressions —the note-keeping type of photography—this is what is interesting.

What do we find in *La Vie Artistique*, by Zola's young friend Gustav Geffroy? "There is nothing as good as a clear image of life, and only an exposition can provide it. There is, behind these light structures, all that you might suppose, fear, hope, or dream. There is a world of work . . . , products of man's knowledge, taste, and ingenuity." Elsewhere: "Everything takes its meaning only from the crowd . . . , these spectators who are themselves a spectacle. . . . It is the fair crowd that one must study and paint. I like to believe that some artist, in love with living spectacles, will preserve for us a little of this great human flow. . . ."

For Charles Quinel in *Une promenade à l'exposition* it is "the poetry of action and activity, the poetry of contemporary endeavor . . . , the Eiffel Tower, although mocked by aestheticians and critics, remaining one of the sensational attractions of the capital." And he adds an invitation addressed to Zola or his students: "A naturalist novelist will easily be able to come here to find the subject of some novel according to the formula of *Le Ventre de Paris*, for example."[1]

From these three examples we can see that the visitors saw only the exterior of the pavilions, that the crowd itself constituted a spectacle, that the fair showed the poetry of action, and that an artist could find inspiration there, either to paint a naturalistic work or to take notes with a camera. Zola—whom the authors in question may have met there—is truly their man. His photographic comments attain the goal expected of him so well that our hypothesis of "photo notes" seems reasonable.

In contrast to the triumph of the World's Fair is another cycle of Zola's photographs showing the elegance of Monceau Park with its bridge, ten views of the Naumachie, snow-covered lawns, and five pictures of the monument to the memory of Guy de Maupassant. Again we have the theme of water, but no longer abundant water, flowing between the new pavilions of the exposition; this is the dead water of a lake and an artificial river surrounded by false ruins.

The monument to Maupassant by Verlet shows a 1900 woman lying under the bust of the novelist. It was Maupassant whom Zola had known at Flaubert's house since 1872, Maupassant who had written to him as early as 1873 to congratulate him for *La faute de l'abbé Mouret*, who had written a book on him in 1883, and of whom Zola said in 1893, "He was a great writer, and I was very fond of him." We can understand, then, why Zola chose to photograph the statue of Maupassant in preference to the many others that cover the lawns of Monceau Park.

Is it not obvious then, thanks to this photographic supplement, thanks to the visual notes that replace the pages of extracts and thoughts accumulated for his earlier novels, what Zola's novel *Justice* would have been? The central theme would have been water, the water of the Seine, to which Zola constantly took his children; it would have contrasted with the stagnant water of the lake; one would have seen, through this symbol, a new France, contrasting, as Zola has told us, with France at the time "of Catholicism and Monarchy." The monumental gate to the exposition, dominated by the colossal figure of La Parisienne, would have been the counterpart of one of the "golden flies" of which Zola speaks in his novels. One would probably not have seen the ruins of the Tuileries, a subject treated by his friend Daudet, even though Zola photographed Jeanne and her daughter in the garden. One dares go no farther,

but these certainties bespeak the interest of Zola's photographs, and it is appropriate to recall that in 1864 the great novelist compared his work as a realist to that of the photographers, offering, like him, "a reproduction that is exact, frank, and naive."[2]

Now that the dates and motivations of Zola's photographs are known, it is up to the aestheticians of photography to define for us their beauty and charm, to tell us how, above many others, thanks to his *Détective Kodak 9/12*, to his *chambre Nadar 18/24*, to the enlargement accessories in his laboratory (described in his auction), and to the light of day, the great naturalist claims, unwillingly, an eminent place among the great photographers of his time.

NOTES

1. We have chosen these three texts as the most significant, after having read many others: *L'Exposition commentée*, by writers and artists, 1899–1900 (Fol. V.4213); *Le Cosmopolite*, newspaper of the Fair (in 6 lang., Gr., Fol. V.830); *1900, Revue mensuelle illustrée* by G. Dupuich (25 November 1898 to 25 December 1899, 4th V.5203); *A travers l'exposition de 1900* by G. de Wailly (17 sections, 8th V.28191); *Les petits mystères de l'exposition*, vaudeville folly by A. Pajol and E. Joullot, 40 p. (4th Yth. 7068); *L'Eglise et l'exposition*, sermon read at Notre Dame de Paris, 29 April 1900, by R. P. Coubé, S.J.

2. Cf. B. Dort's harsh judgment in *France-Observateur*, 3 August 1968: "Zola does not explain, he shows. . . . Unequaled in assembling details, piling them up on top each other, making organic wholes out of them, he is powerless to go beyond the plane of appearances." The author goes back to the ideas of Lukacs (*Problème des Réalismes*, Berlin, Aufbau-Verlag, 1955).

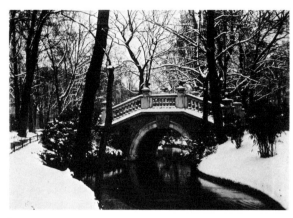

1.

2.

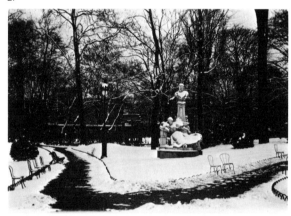

Photographs accompanying this chapter from original negatives of Zola, given to the author by his son, Dr. Zola, for publication.

3.

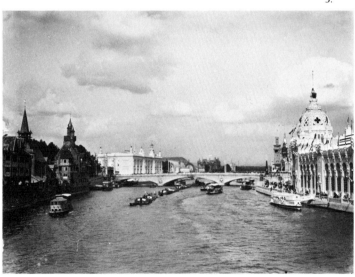

1. Émile Zola. *Monceau Park in Snow, the Bridge*. c 1900. Bibliothèque Nationale, Paris.

2. Émile Zola. *Monceau Park, Bust of Maupassant*. Bibliothèque Nationale, Paris.

3. Émile Zola. *The Seine and the Pavilions, Exposition Universelle, 1900*. Bibliothèque Nationale, Paris.

4. Émile Zola. *Reconstruction of the Temple of Ankhor, Exposition Universelle, 1900*. Bibliothèque Nationale, Paris.

5. Émile Zola. *Exposition Universelle, 1900*. Bibliothèque Nationale, Paris.

6. Émile Zola. *The Seine and the Pavilions, Exposition Universelle, 1900*. Bibliothèque Nationale, Paris.

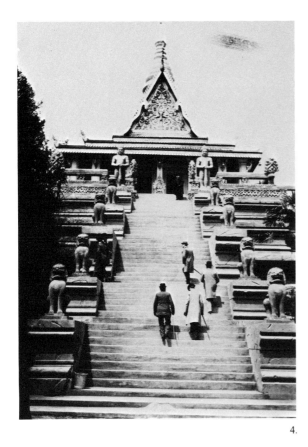

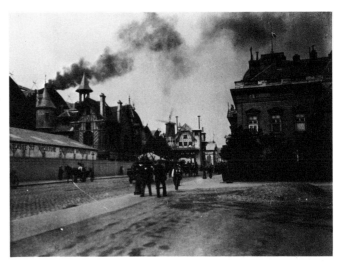

5.

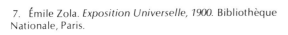

4.

7. Émile Zola. *Exposition Universelle, 1900.* Bibliothèque Nationale, Paris.

8. Émile Zola. *Japanese Bridge, Exposition Universelle, 1900.* Bibliothèque Nationale, Paris.

7.

6.

8.

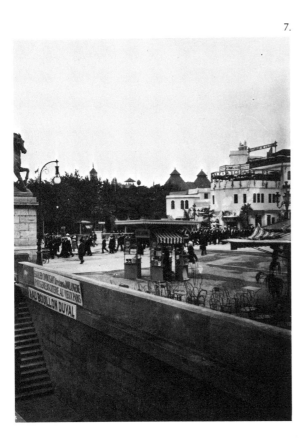

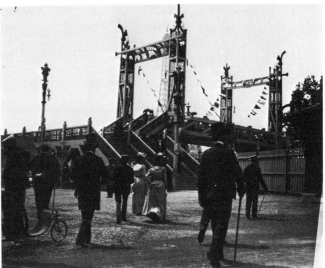

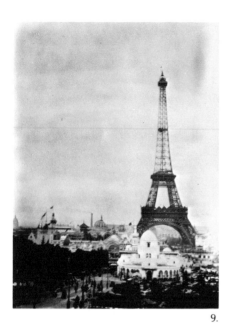
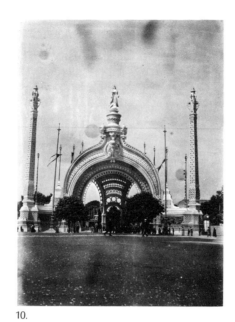

9. 10. 11.

12.

13.

9. Émile Zola. *The Eiffel Tower, Exposition Universelle, 1900.* Bibliothèque Nationale, Paris.

10. Émile Zola. *Entrance, Exposition Universelle, Statue of the Parisienne.* Bibliothèque Nationale, Paris.

11. Émile Zola. *Reconstruction of Old Paris, Exposition Universelle, 1900.* Bibliothèque Nationale, Paris.

12. Émile Zola. *One of the Gates, Exposition Universelle, 1900.* Bibliothèque Nationale, Paris.

13. Émile Zola. *The Trocadero, Exposition Universelle, 1900.* Bibliothèque Nationale, Paris.

THREE PHOTOGRAPHERS AND THEIR BOOKS

THOMAS BARROW

THREE PHOTOGRAPHERS AND THEIR BOOKS

Thomas Barrow

*Associate Director, University Art Museum
and Associate Professor of Art,
University of New Mexico*

When you drop a stone into a well, there is no telling how far it will echo. So it is with photographs. When you allow one to be circulated, it escapes your control. The knowledge of the world offered by photography can lead either to excellent or to disastrous results: it all depends on whether the small episode which it presents has not been wrenched from its spatial, temporal and human context.[1]

When you do nothing more than take snapshots of people, there's a lot about life you just can't see.[2]

We are one of many appearances of the thing called Life; we are not its perfect image, for it has no image except Life, and life is multitudinous and emergent in the stream of time.[3]

It should be evident to the photographer and those interested in photography that after 133 years of picture-making by photography there is a rich visual heritage for the maker and viewer to draw upon. Yet, in spite of the innumerable photographs made in the last fifty years, scholarly or at the very least enlightened comment on them has not kept pace. There have been, in recent years, very few significant additions to the corpus of photographic literature. John Szarkowski's text on Walker Evans stands out as the most humane as well as informative.[4] In fact, it would seem that Evans's work has generated more brilliant, sensitive comment than that of any other twentieth-century photographer. (I refer only to comment about pictures; Stieglitz's personality has certainly provoked the greatest number of words.)

Does this suggest a corollary between the paucity of literature that defines an art form and a lack of general knowledge about that form? Two of the three photographers and their books I want to discuss here would seem to indicate that this is the case. This lack of awareness is less noticeable in other literary forms: contemporary popular fiction in particular makes extensive reference to photography.[5] Since editors try to keep informed of the vicissitudes of popular literature, they could scarcely help realizing that photography is transmitting to the novelists and poets some unique information about our time, although they seem frequently unaware that it has

Henri Cartier-Bresson, *Man and Machine*, New York, Viking Press, 1971; Elliott Erwitt, *Photographs and Anti-Photographs*, Greenwich, Conn., New York Graphic Society, 1972; Duane Michals, *The Journey of the Spirit after Death*, New York, Winter House, 1972.

already told us a great deal about other times. Probably McLuhan's catch phrase for photography, "Brothel without Walls,"[6] made the psychology of the photograph completely accessible with superficial half-truths and a dollop of historical fact. Unfortunately these half-truths seem to have helped create the climate for the books in the Viking catalog, including *The Creation* (somewhat secularized and abridged by Ernst Haas), *Man and Machine,* and others on "important" themes that really make for books of notable unimportance.

Some of the preceding might be overlooked as part of the book business's perennial problem of trying to "be ahead," but when it involves a photographer who has already contributed as much as Henri Cartier-Bresson to the history of photography it cannot be disregarded. It should be noted that the genesis of *Man and Machine* was a commission from IBM, and I have no knowledge as to how much authority Cartier-Bresson had in selecting the images that would ultimately become a part of this book. From the dismal selection that drags along from page to page (the most distressing group of Henri Cartier-Bresson's photographs since his quickly forgotten *Life* magazine essay on Cuba),[7] I would assume he had no purchase whatsoever.

Before discussing the photographs in *Man and Machine,* I want to spend a few moments with the book itself. It is of the usual "ignore the image in the name of book design" guttered nonentity. A fine example is on pp. 84–85 where it has been made to appear that the men at the Paris Air Show are looking at a man inside a Saturn V rocket engine. No text accompanies the images, but to play it a little safe, quotations from a panel of past and present greats have been used with results that vary from almost apt to a kind of ludicrous ironic overkill, i.e., Shakespeare's "Thinking Makes It So" on a page with ragged children from the Iran-Pakistan frontier and a scientist from Thomas J. Watson Research Center in the traditional cliché pose frowning at a blackboard scrawled with cabalistic science stuff.

I think what is so disappointing is that Cartier-Bresson has made most of these pictures before and, almost without exception, much better. *The Decisive Moment*[8] was a beginning of such significance that no photographer might be expected to duplicate it in a lifetime, and yet *The Europeans* was almost as impressive, particularly in the areas *Man and Machine* attempts to illustrate (Fig. 14). I have felt for some time that he aspires to a kind of anonymity in his work not unlike the stereo image (Fig. 15). However, this anonymous quality soon becomes a per-

sonal style and is derived from a more self-conscious intellectual foundation than the snapshot it is often compared with. His style often reveals an almost baroque sense of space coupled with a very real understanding of this century's concept of time. Cartier-Bresson's best photographs have a characteristic density of scene and event that instantly attracts the viewer and informs him of the striking intellect of the man who made these pictures. In *The People of Moscow* and *D'une Chine à l'autre*[9] there are many picture ideas that anticipate present university student thesis projects by twenty years. In the Moscow book, plate 2 is a wonderful handling of the picture-within-a-picture idea and plate 20 a magnificent environmental portrait on Komsomol Square. The man-and-machine idea is again recorded with exquisite subtlety throughout the book, in particular, plates 101–3, the industrialization of agriculture exhibition at the Russian pavilion. Finally, there is the Shanghai picture reproduced here (Fig. 16) from the China book, with its symbols allowing for a mixture of interpretations, political, industrial, and agrarian.

Almost none of this is apparent in *Man and Machine,* although for a faint glimmer of what I refer to you might look at plate 35 of a properly pin-striped Etonian working at a milling machine, the complex linear planes of plate 45 at the Kennedy Space Center, and the frightening incongruities of plate 74 (Fig. 17).

But the ultimate result is of little reward after the consecutive pinpoints of human truth that one can confront in the earlier books I have mentioned. I wonder if the reason for Cartier-Bresson's lapse lies in a quote by J. Robert Oppenheimer on plate 61 of *Man and Machine:*

> There are children playing in the street who could solve some of my top problems in physics, because they have modes of sensory perception that I lost long ago.

Elliott Erwitt's book *Photographs and Anti-Photographs* has many of the same failings as *Man and Machine,* compounded by Sam Holmes's somewhat embarrassing biographical essay. In this essay we are informed of Erwitt's just-right appearance: ". . . his curly hair is still black, long but not mod. He has an oval face which now reminds me of a Modigliani painting." In fact Holmes's brief text is quite revealing in a way that no one would have intended. It certainly makes more clear the "in" part of the title "Anti-Photographs" with a tremendous novelistic glamorizing of the photographer's life and subsequent confusion of photographs and their

maker with heros or anti-heroes: "Photographers' wives learn resignation. They learn to be models, fashion stylists, prop girls, secretaries, travel agents, hostesses and porters. They learn to be spoken to sharply at shooting sessions at which several thousand dollars ride on a single advertising photograph." It is obvious that David Hemmings played *Blow-up* all wrong. The idea of anti-photograph is an intriguing one and if anything had been done to expand upon this idea we might have understood more about the vague area of almost banal imagery that both fascinates and repels us. Instead, one is left with the distinct impression this "anti" business was after the fact, maybe to trade on the popular literary form of some years ago, the "anti-novel."

There is also the tasteless juxtaposition of images and text that is so common in magazines, but which we excuse there because of the economics involved. In a book without these excuses there seems to be no reason for a "semi-secret weapon" (horn) used to "liven up" portrait subjects to be reproduced directly above a poignant, sensitive image of Jacqueline Kennedy at the president's funeral, opposite a page with Erwitt's ads including drinks frozen in a block of ice "for which he was paid $5,000."

I have spent this much time with inanities because they seem unfair to Erwitt's pictures themselves. The pictures are very much in the tradition of Doisneau—witty quickies, flash observations that are not quite so profound at second glance but leave one with a sense of being a harmless voyeur on the human comedy. But does this sort of thing need the one-print-to-a-page $15 art book production? In fact, this one-to-a-page layout has allowed the designer to make some of the following relationships: the well-known shrub-hidden cannon *Fort Dix, New Jersey, 1951* opposite a boy behind a projectile-shattered car window; *Colorado, 1955,* a legless man on wheels faces across the page to a plucked chicken; Bogart with gun pointed across to a group of policemen. If one can manage not to be put off by this sort of incompetence there are some single images of sensitivity, often dominated by dogs: *New York, 1946* (Fig. 18); a dog suspended in midair in *Ballycotton, Ireland;* a dog in the foreground of an atmospheric, spectral, futuristic view of Brasilia.

Overall it is not a satisfying book and Erwitt's own words as quoted by Holmes indicate the underlying cause. Holmes had been discussing Erwitt's inherent restlessness and why journalistic jobs suited him and quotes Erwitt, "Even if it's dull, you know that after a little while, you'll be doing something else and can forget about the dull one." This feeling permeates these pictures made for himself while on jobs; the impermanence and haste necessary for completion of the advertising or journalistic job do not allow for more than the most cursory look at life's complexities. The feeling, intellect, and reflection necessary for observations of this type are not congruent with quick-draw Leicas or pictures made in a minute. These photographic aphorisms have not transcended their literary counterparts in the *Reader's Digest.*

Finally, we come to what is, for me, the most exasperating book of this group: Duane Michals's *The Journey of the Spirit after Death.*[10] As far as book design is concerned it is the least pretentious of the three, although this is certainly more than made up for by the enormous breadth of the subject.

Historically the photograph has not fared well when used as illustration for various literary ideas.[11] The photographs that accompany *The Garden of Adonis,*[12] various nude children as Pan and Cupid, are weak, rather quaint support for the vapid rhymes of William Sharp, Leigh Hunt, and this typical example by James Rhoades:

List to the lilt of the children's song!
Never a thought or fear of wrong!
 Little tongues utter it
 Little hearts flutter it,
Flutter and utter it all day long.

Even a magnificent photographer like Julia Margaret Cameron can suffer the same fate. Her photographs for Alfred Lord Tennyson's *Idylls of the King* were received indifferently during their time and now appear even less forceful than the poem.

Michals's theme, man's confrontation of death, has been dealt with powerfully, succinctly, and with such vivid imagery by writers like Isaak Babel, Jorge Luis Borges, and Joaquin Aderius that it seems an incredible challenge to evolve this idea with a sequence of twenty-seven pictures. Yet similar themes that explore poetic universality and eternal verities are incredibly moving in Eikoh Hosoe's *Kamaitachi.*[13] Part of Hosoe's success in recording the spirit of the legendary sickle weasel is the expressiveness of the dancer Tatsumi Hijikata. Hijikata is playing a dramatic role and it is objectively defined by the camera, but one realizes that this is so effective precisely because it is being done photographically. The changes of emotional scale and metaphysical place are achieved as easily and with as much credibility because of the virtually timeless presence Hijikata and Hosoe have achieved by careful choice of scene, costumes, and facial expressions. On a less emotional but equally intellectual level are John Miles's photo-

graphs in *Night Flight*.[14] This work does make use of a greater number of images than the Michals book and they are printed in a continuous band or loop, but this may offer a clue to the problem of Michals's elusive spirit. *The Journey of the Spirit after Death* is linear in the most traditional book manner with a beginning, middle, and end and yet the idea expressed is that the death-rebirth may not be linear but rather a cyclical event out of time. Certainly the galactic stellar plate (obtained from the Hale Observatories) with the exultant caption "I am" implies an infinite continuity.

Michals's "other" work for *Mademoiselle* and *Vogue* is often remarkable for its clarity of purpose and inventiveness in what are often small, almost static situations. There is an equal number of more boring photo essays in these periodicals: "They Do It" (Fig. 19),[15] "If this case is so important why did they send a woman?"[16] and "Decorating with Fabrics."[17] These are characteristic titles for photo essays that consist of, respectively, society women and the type of needlepoint they find rewarding and relaxing, portraits of women's liberation members, and various interiors and table settings that suggest creative, unusual ways to use fabric. In view of these assignments it is easy to understand his need to work with themes of ambiguity and import, but somehow this book and Michals's sequences in general do not seem to provide sufficient visual information to add to our knowledge or emotions with regard to voyeurism, "The Human Condition," or Paradise. They are literary and yet not quite literate; they are unquestionably photographic but derive little benefit from this fact.

The current popularity of Michals's sequential storytelling may be symptomatic of what appears to be an increasing tendency to confuse photography with a religion, mystic power, or a profound message-bearer that transcends all other forms in our time. The ultimate manifestation is Photography as Magus or an even more primal yearning than this, as fundamental as the closing words of Michals's book, "Oh, to be the Light."

Despite the preceding negative comments on three disappointing books it should not be thought that photographic books are a useless or atrophied method of exhibition. In fact, they remain the most convenient way for a photographer to explore a variety of sequential ideas as well as the most permanent method of preserving a retrospective collection of his work. However, one might hope for the demise of universal themes told only by the camera, a presumptuous approach at best, a total

debacle at its nadir. It is not "unpure" for photography to be accompanied by literate writing, and in these times of waning commercial outlet a beautifully printed frontispiece or fiction that has been intelligently punctuated with photographic imagery might offer an intelligent extension of the literature-photography combination. Photographers will have to accept the odious (to them) facts that the word has been with us for a very long time and that very few pure picture essays offer proof that they have replaced the oral or written tradition. More important than the photographer's acceptance of certain interrelationships will be a new breed of editors who will be able to see the photograph as more than a literal supplement to a lengthy caption.

NOTES
1. Henri Cartier-Bresson, *The Europeans*, New York, Simon and Schuster, 1955.
2. Roger Sale, "I am a Novel," *New York Review of Books*, June 29, 1972.
3. Loren Eiseley, *The Immense Journey*, New York, Vintage Books, 1962, p. 59.
4. John Szarkowski, *Walker Evans*, New York, Museum of Modern Art, 1971.
5. There have been numerous novels and short stories in recent years that have made photography a major factor in the plot or have cast a photographer as protagonist; four of particular interest follow: Peter Everett, *Negatives*, New York, Simon and Schuster, 1965; John Symonds, *The Hurt Runner*, New York, John Day, 1969; William Trevor, *Mrs. Eckdorf in O'Neill's Hotel*, London, The Bodley Head, 1969; Vassilis Vassilikos, *The Photographs*, London, Secker and Warburg, 1971.
6. Marshall McLuhan, *Understanding Media: The Extensions of Man*, New York, McGraw-Hill, 1964.
7. Henri Cartier-Bresson, "This is Castro's Cuba Seen Face to Face," *Life*, March 15, 1963, pp. 28–43.
8. Henri Cartier-Bresson, *The Decisive Moment*, New York, Simon and Schuster in collaboration with Editions Verve of Paris, 1952.
9. Henri Cartier-Bresson, *The People of Moscow*, New York, Simon and Schuster, 1955; Henri Cartier-Bresson and Jean-Paul Sartre, *D'une Chine à l'autre*, France, 1954.
10. An extended review of this book by Alex J. Sweetman, "Duane Michals' Disappointing 'Journey,'" appeared in *Afterimage*, October, 1972.
11. With the two rather remarkable exceptions being the illustrations by Alvin Langdon Coburn for H. G. Wells, *The Door in the Wall and Other Stories*, London, Grant Richards Ltd., 1915, and Peter Milton's etchings derived from photographs, *The Jolly Corner*, Baltimore, Aquarius Press, 1971.
12. Oliver Hill, *The Garden of Adonis*, London, Philip Allan & Co., 1923, p. 28.
13. Eikoh Hoseo, *Kamaitachi*, Tokyo, Gendaishichosha, 1969.
14. Michael Pinney, *Night Flight*, England, Bettiscombe Press, 1969.

15. "They Do It," *Vogue,* January 15, 1972, pp. 58–65.

16. "If this case is so important why did they send a woman?" *Mademoiselle,* February, 1972, p. 141.

17. "Decorating with Fabrics," *Mademoiselle,* March, 1972, pp. 182–83.

14. Henri Cartier-Bresson. *The Europeans.* Reproduced from Henri Cartier-Bresson, *The Europeans,* copyright Éditions Verve of Paris and Simon and Schuster, 1955.

14.

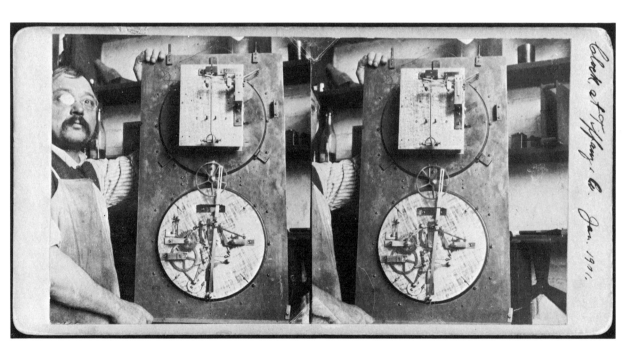

15.

15. Photographer unknown. *Clock at Tiffany & Co., Jan. 1901.* Stereo. International Museum of Photography at George Eastman House, Rochester, N.Y.

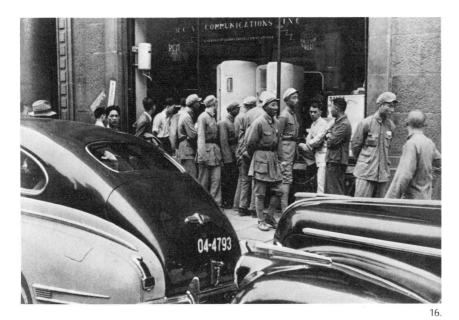

16.

16. Henri Cartier-Bresson. *China*. Reproduced from Henri
Cartier-Bresson and Jean-Paul Sartre, *D'une Chine à l'autre,*
Paris, 1954.

17.

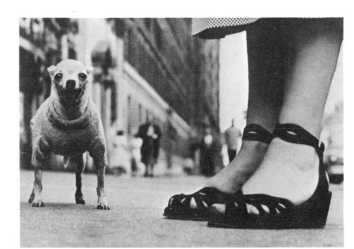

18.

17. Henri Cartier-Bresson. *Artificial Kidney Machine and
Patient, London*. Reproduced from Henri Cartier-Bresson,
Man and Machine, New York, Viking Press, 1971.

18. Elliott Erwitt. *New York, 1946*. Reproduced from Elliott
Erwitt, *Photographs and Anti-Photographs*, Greenwich,
Conn., New York Graphic Society, 1972. Courtesy Magnum
Photos, Inc., New York.

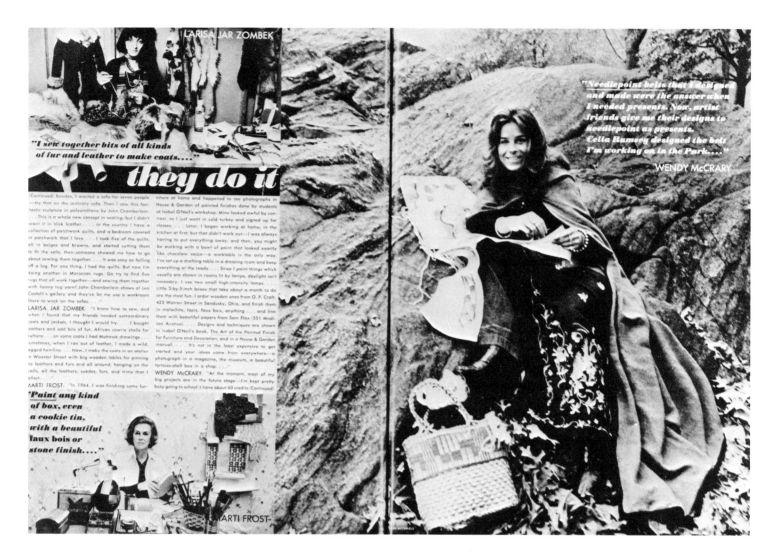

19. Duane Michals. *They Do It.* Reproduced from *Vogue*,
January 15, 1972.

NOTES ON THE EARLY USE OF COMBINATION PRINTING

JAMES BORCOMAN

NOTES ON THE EARLY USE
OF COMBINATION PRINTING

James Borcoman
Curator of Photography
National Gallery of Canada

Many a heated debate during photography's early years denied the possibility that the medium could ever be considered the equal of the fine arts. Among the arguments advanced was the opinion that the photographer lacked control over the components of his picture. "There is no poetry in the pencil of the Sun. The photographer cannot separate what is beautiful from what is common. . . . The painter and the sculptor have at their command all the resources of analysis and combination,—selecting what is beautiful, suppressing what is offensive."[1] Thus began Sir David Brewster in his remarks to the Photographic Society of Scotland in 1856. H. P. Robinson in *Pictorial Effect in Photography* gave further emphasis to this deficiency when he wrote that "Photographers . . . have not the facilities which other artists possess, of making material alterations in landscapes . . . neither have they so much power of improvement in figure subjects."[2] Much later Robinson was still convinced "that a method that will not admit of the modifications of the artist cannot be an art."[3]

In the midst of just such beliefs as this, O. G. Rejlander produced his combination print, *The Two Ways of Life,* for the Manchester Art Treasures Exhibition held in 1857. Although Rejlander was careful to avoid any claim later that his intentions had been to produce a work of art, nevertheless photographers had been encouraged to submit to the Manchester exhibition photographs of a quality that would allow them to be displayed along with paintings and sculpture.[4] Robinson showed no such modesty when he wrote his chapter on combination printing in *Pictorial Effect.* Combination printing was the means by which "great works in photography" could be accomplished.[5]

Robinson is at least partially responsible for the myth that Rejlander was the originator of combination printing. In 1890 he was unequivocal about it,[6] although thirty years earlier he was somewhat more accurate in saying that Rejlander was "the gentleman who first brought it into successful practice."[7] That Rejlander was the source was an opinion held by others as well. An editorial in *The Liverpool & Manchester Photographic Journal,* 15 June 1858, confirms this view. "The seed so liberally sown by Mr. Rejlander has sprung up, and is already bearing fruit."[8] This last reference is to Robinson's combination prints, including *Fading Away,* shown in the London Photographic Society's annual exhibition, which opened in May of that year.

Robinson went so far as to say in 1860 that he knew of no one apart from himself who had attempted to

imitate Rejlander's technique.[9] This seems strange when one considers that the use of a second negative to add clouds to landscapes was widely practiced. Gustave Le Gray's seascapes with dramatic skies of rich, rolling clouds, which he produced from the mid 1850s on, were well known and admired in England. At least one of these, *Grand Vague—Cette*, c. 1857, was a combination print.[10] The reviewer of the Photographic Society's annual exhibition for 1857 spoke of the great conquest that had been made since the last exhibition—"the sky effects, roll and ripple, cloud-mountain, vapour drift, ruffling mist, sun haze."[11] Apart from the use of the stereo, which permitted instantaneous photography, such cloud effects could only have been achieved at this time through combination printing. By 1861, the use of the cloud negative had become common enough so that at least one writer deplored its indiscriminate use.[12]

The revival of interest in the technique of combination printing in our time prompts the question of its origins. Rejlander's statement to the Photographic Society in April 1858 that *The Two Ways of Life* was "the first of the kind I had attempted" is misleading.[13] A review of the society's exhibition held in January 1857 describes a photograph by Rejlander which sounds suspiciously like a combination print: *"An Actor's Day-Dream* is as good as a new novel. . . . It represents an actor, a well-dressed man in a tightly-buttoned close-fitting frock coat, with one hand in the breast of it, leaning in a half doze against the portico pillar of a London theatre; the hand is raised, giving the gesture of the moment's thought. To the left of him you see his dream: there he is again, coming in as Hamlet with one leg bare, listening, with his hand to his ear, to the applause that fills the house—the noise that is his food, and of which he dreams all day and night."[14]

Furthermore, in 1855 Rejlander exhibited a photograph of three figures described in the catalogue as "a group printed from three negatives."[15] It is an interesting coincidence that Berwick and Annan published in the September issue of the *Journal of the Photographic Society* for that same year their method of combination printing to produce a landscape into which the figure of a woman has been inserted.

Since periodical literature exclusively concerned with photography did not make its appearance in England until March 1853, the opportunity for English photographers to publish information of this nature was scanty. If, however, we turn to the Continent, we find ample record in the pages of *La Lumière*, published weekly in Paris beginning in February 1851,

of a lively exchange of technical information as well as lofty pronouncements on art and photography. As early as the third number of *La Lumière* there was a reference to the first tentative steps toward the kind of manipulation that would make combination printing possible. The issue of 23 February 1851 described Hippolyte Bayard's technique for adding graduated tones to the background of studio portraits, for making aureoles around heads, and for graduating the tones of skies and adding clouds.[16] These are techniques which Bayard claimed to have been using for several years and had already demonstrated to other photographers.

Reference was also made to an unnamed German photographer who was using a similar technique. The method consisted of cutting the figure from the background of the paper print, thus obtaining two masks, one to cover the figure and the other the background of the negative. Both masks were blackened. The background mask was attached to the negative at its edges and a print was exposed in which the figures showed but the background, having been protected from the light, remained white. The figure mask was then positioned, being held in place by a sheet of glass, and the background mask removed. An opaque screen was then moved slowly back and forth over the background area, allowing the sun to burn in the top of the picture more than the lower portion, creating in this way a background with graduated tones. This is, of course, simply a description of burning and dodging. All that was required for it to become combination printing was the use of an additional negative. This technique was also used for architecture. The National Gallery of Canada has in its collection a print dating from the early 1850s which had been cut up as a mask for use with a waxed paper negative by the French photographer E. Nicolas. The lower foreground and the window details of the church's facade were burned in by means of this mask.

One month later, the same correspondent to *La Lumière* described a technique for photographing individuals separately but printing them all in the same portrait.[17] It was a method of combination printing which allowed for the printing of one person next to another, even to the resting of a hand on his companion's shoulder. This, again, was not unknown to other photographers, because group portraits made from more than one negative were being shown along the boulevards of Paris.

Bayard's method for adding clouds described in the February 1851 issue of *La Lumière* employed a paper mask cut to the shape of a cloud. It was placed

over the exposed sky area and shifted from time to time to prevent the printing of a sharp outline. The following year, Ernest Lacan announced a new improvement perfected by Bayard for users of glass negatives. Up to this time, the author pointed out, only daguerreotypes were capable of reproducing clouds. Paper negatives and albumen-on-glass required such lengthy exposures for the ground in landscapes that the sky was hopelessly overexposed. Collodion-on-glass, although closer to the daguerreotype in sensitivity, still posed the same problem. "To overcome these difficulties, Bayard thought up the idea of making negatives simply of skies."[18] After a print was exposed and the original negative removed, the ground in the photograph was protected from the further action of light by a paper mask, then a cloud negative was placed over the sky area and allowed to print.

Lacan explained, long before Robinson's *Pictorial Effect*, that by means of Bayard's technique the photographer, like the painter, might match his skies to the mood of his picture: "Should he have reproduced a savage landscape with sombre pines throwing great shadows on a rocky terrain and showing a bizarre and jagged horizon, or some grandiose ruin standing solitary, in the midst of a wild and rough vegetation, by the side of a deep ravine, he will choose from among his negatives a fantastic sky where huge clouds scud and bank into strange shapes."

Of special importance for Lacan was the fact that this freedom to compose his own skies permitted such control over the picture that the same negative could be made to produce entirely different effects, depending upon "the intelligence and sensibility of the artists. . . . Thanks to Bayard's happy idea, it is less than ever possible to reproach photography with being nothing more than a mechanical reproduction of nature. Through this new improvement it enters the domaine of art."

Skies, however, were not the only concern. "Water our art altogether misses, turning it to either congealed mud or to mere chaos and nonentity."[19] One ingenious painter-turned-photographer, André Giroux, showed prints at the 1855 Paris Exposition Universelle in which the technique of combination printing was used to circumvent this difficulty. Negatives were printed upside down to create reflections in the water, "giving to water the transparency it has in nature."[20]

In the light of such activity, perhaps Rejlander's curious first reason given for making *The Two Ways of Life* becomes somewhat less obscure: "It was to be competitive with what might be expected from abroad."[21] Possibly it was known in certain circles that European photographers had already achieved a measure of that control which Sir David Brewster, speaking before his Scottish audience, had denied as a possibility.

NOTES

1. *Journal of the Photographic Society*, vol. 3, no. 42, 21 May 1856, p. 48.

2. H. P. Robinson, *Pictorial Effect in Photography*, 1st ed., London, Piper and Carter, 1869, p. 11.

3. H. P. Robinson, "Paradoxes of Art, Science and Photography," in *Photographers on Photography*, ed. Nathan Lyons, Englewood Cliffs, N.J., Prentice-Hall, 1966, p. 83, reprinted from *Wilson's Photographic Magazine*, vol. 29, pp. 242–45.

4. O. G. Rejlander, "On Photographic Composition; with a Description of 'Two Ways of Life,'" *Journal of the Photographic Society*, vol. 4, no. 65, 21 April 1858, p. 191.

5. H. P. Robinson, *Pictorial Effect in Photography*, p. 192.

6. H. P. Robinson, "Oscar Gustav Rejlander," *The Photographic News*, vol. 34, 3 January 1890, p. 9.

7. H. P. Robinson, "On Printing Photographic Pictures from Several Negatives," *The Photographic and Fine Art Journal*, vol. 1, no. 4, 3rd series, April 1860, p. 114.

8. *The Liverpool & Manchester Photographic Journal*, vol. 2, no. 12, new series, 15 June 1858, p. 147.

9. Robinson, "On Printing Photographic Pictures," *loc. cit.*

10. A comparison of two different states of this print, one in the collection of the National Gallery of Canada and the other in the George Eastman House, shows a cloud in the latter overlapping the horizon line by one-eighth of an inch.

11. *Journal of the Photographic Society*, vol. 3, no. 50, 21 January 1857, p. 193.

12. C. Jabez Hughes, "Art-photography: Its Scope and Characteristics," *The Photographic News*, vol. 5, 4 January 1861.

13. Rejlander, "On Photographic Composition," p. 192.

14. *Journal of the Photographic Society*, vol. 3, no. 50, 21 January 1857, p. 194.

15. A. H. Wall, "Rejlander's Photographic Art Studies —Their Teachings and Suggestions," *The Photographic News*, vol. 30, 27 August 1886, p. 549.

16. De Montfort, "Communication intéressante," *La Lumière*, vol. 1, no. 3, 23 February 1851, p. 9.

17. De Montfort, "Procédé pour grouper plusieurs portraits obtenus isolément afin d'en former un seul tableau héliographique," *La Lumière*, vol. 1, no. 7, 23 March 1851, p. 27.

18. Ernest Lacan, "Épreuves photographiques avec ciels," *La Lumière*, vol. 2, no. 33, 7 August 1852, p. 130.

19. *Journal of the Photographic Society*, vol. 3, no. 50, 21 January 1857, p. 193.

20. Ernest Lacan, "Exposition universelle: photographie," *La Lumière*, vol. 5, no. 41, 6 October 1855, p. 155.

21. Rejlander, "On Photographic Composition," p. 192.

NOTES ON AESTHETIC RELATIONSHIPS BETWEEN SEVENTEENTH-CENTURY DUTCH PAINTING AND NINETEENTH-CENTURY PHOTOGRAPHY

CARL CHIARENZA

NOTES ON AESTHETIC RELATIONSHIPS BETWEEN SEVENTEENTH-CENTURY DUTCH PAINTING AND NINETEENTH-CENTURY PHOTOGRAPHY

Carl Chiarenza
Associate Professor of Art History
Boston University

"The age's central organ was the human eye, its central instrument the lens, its central pursuit the anatomy of the universe."[1] These words, so descriptive of seventeenth-century Holland, apply equally to the age of photography as it developed internationally during the nineteenth century. The eye of the seventeenth-century painter and the eye of the nineteenth-century photographer seemed to respond to the same visual stimuli, and in a like manner. They were nourished by much the same source of inspiration, it would seem. In general, the portrait, landscape, genre scene, still life, interior and exterior architectural view were, for both, the most inspiring and challenging themes[2] and, generally, the intimate scale superseded the monumental.

In 1932 Karel Capek wrote that "Dutch masters painted small pictures for their small houses. No cathedral altars, for Calvinism stripped the Dutch churches; no palace frescoes. . . . Painting . . . found its way into the kitchen, the tavern, the world of clodhoppers, shopkeepers and charitable societies." Capek concluded, as others had earlier, that the Reformation produced a Dutch art which was secular and bourgeois.[3] Capek was a satirist and Seymour Slive, among others, has cautioned against a too-encompassing acceptance of the theory, perhaps first expressed by Hegel, that there is a systematic relationship between the art and social, economic, and religious conditions in the Netherlands,[4] yet there is certainly enough evidence to suggest meaningful thinking about the relationship, albeit unsystematic.

Although perhaps a long way from untangling the web of elements which contributed to it, seventeenth-century Netherlandish art certainly justifies the statement made by Alfred Michiels, c. 1868, that "If this race perished tomorrow, we should rediscover it in its totality in the products of its brush."[5] Michiels may exaggerate when he says that seventeenth-century Dutch painting reveals the "totality" of the culture, but certainly no other culture equaled its visual documentation—no other culture, that is, prior to the age of photography.

The idea of art as a representation of nature is as old as art itself, but it has been variously interpreted. Theorists of many periods instructed artists to follow "nature." The artists and theorists of the Renaissance in Italy, particularly, propagated this notion. In fact, numerous publications attest to the fact that the use of the camera obscura as an aid to artists dates from this period. Leonardo himself left an illustrated record of his interest in the device. It is not necessary, here, to pursue what is a well-known controversy in

art history and theory. Suffice it to say that rarely has "following nature" been the sole focus of art or theory. Whether for aesthetic, formal, or philosophical reasons, or practical limitations of media, consequential art generally goes beyond a recording of surface details. Of course, Dutch art also goes beyond simple documentation. "It is as if this reality were being discovered, taken possession of, and settled down in for the first time."[6] The same effect may be attributed to serious photography.

We can, I think, isolate the essential characteristic of vision shared by the seventeenth-century Dutch painter and the nineteenth-century photographer. It is best described as that quality of still life that pervades Dutch art, to which the French term *nature morte* could never be applied. It is a moment of time captured and held still—even as it shimmers with life and living atmosphere—to be studied, to be shared immediately. At its best, it offers the viewer a direct and deeply personal honesty, a frankness which is available to any who are willing to share the experience of understanding.

The small scale of so many Dutch paintings contributes not a little to this vision. It is a vision to be found as well in a fine photograph. The subject matter is not as important as the fact that the picture communicates the "quality of a portion of life stilled momentarily."

Implicit in all of this, of course, is the fact that the artist—photographer or painter—had to possess a consummate knowledge of his medium. Without it, the image could not have been created, however true his eye. While this is commonplace in art, it must be stated explicitly in this discussion because photography has suffered traditionally from an understandable misconception of its uses in art. The mechanical device it employs has always got in the way of the application to it, as a medium, of the rigorous standards of the older arts. It has been, almost from the beginning, a completely accessible means of expression, and an extremely popular one, with the result that one sees hundreds of ordinary photographs for every important one and concludes, therefore, that the potential of the medium is limited. Only now are rigorous principles of criticism being applied to photography. Only now, therefore, is it beginning to come of age.

The same may be said, but to a far lesser extent, of seventeenth-century Dutch painting; while the "so-called 'Little Masters' often rose to a high rank of originality and quality unequalled in any other country,"[7] there were those who did not, but who nevertheless pursued the art. Among them, perhaps,

were the Dutch travelers who carried their sketchbooks on their journeys and communicated their discoveries to their fellow countrymen with their pictures, rather than verbally as their English colleagues did.[8] Had the camera been available to the Dutch traveler, there is no telling which century would have produced more pictures of every variety.

Holland was, after all, a world center of scientific investigation, pioneering most significantly in the making and using of lenses. The Dutch constructed the first practicable telescopes for astronomical exploration. Antonie van Leeuwenhoeck, who discovered bacteria, was devoted to constructing microscopes for which he ground his own lenses. In addition to being the first to use the microscope successfully, he made daring observations of the *human* lens. Leeuwenhoeck has been linked with Vermeer;[9] they were born at almost the same hour and lived their lives out in Delft. Vermeer died first and Leeuwenhoeck was the executor of the Vermeer estate. He was court appointed; there is no evidence to indicate that they were friends.[10] Yet a recent check of the Delft archives reveals that Leeuwenhoeck was not called on to act as executor of any other estate in the period 1874–77.[11] Some scholars would like to believe that Leeuwenhoeck might have supplied Vermeer with a lens for a camera obscura.

Perhaps the new observation of previously unknown microscopic and telescopic worlds was not as spectacular for the unscientifically minded of the seventeenth century as was the emergence in the nineteenth century of a silvered "mirror of nature" that was both permanent and portable. Nevertheless, the new science of the seventeenth century was related to the development of photography, not simply because it contributed to the growing store of information about optics, but because it played a part—how considerable no one knows—in the development of the peculiar vision common to the painting of its time and the photography that was to come. Men developed a new way of seeing as they had developed a new kind of lens with a different field, and a permanent edge or frame to enclose the image and isolate it: the living moment, stilled, concentrated.

The telescope and the microscope possess optical characteristics which affect the image. Even more is this true of the camera obscura, which had already long been in use by artists and longer by scientists. After the middle of the seventeenth century most books concerned with optics discussed it, often with illustrations. Just as the "modern" camera is, it was based on the principle of the inverted image, thrown

on the wall of a dark chamber by light traveling from each point of the objects outside the chamber but within the angle of view of the aperture or lens in the opposite chamber wall. There are countless variations but even today all cameras use this basic principle.

The artist found a variety of uses for the camera obscura. It allowed him to trace a fully formed image. It automatically transformed three-dimensional space into "accurate" perspective on a two-dimensional surface, which the artist could trace, copy, or simply study, without recourse to mathematical calculation. The image thus created was framed and isolated from distracting material. The subject was reduced in size; it was not only flat, but it was small enough to study in detail with great precision. The image, projected by light, was *luminous* (if onto a viewing screen or ground glass, the image was literally transparent—as in stained glass), which was highly advantageous for the study of chiaroscuro, color and atmospheric effects, ranges or scales of value, *sfumato* modeling, and so on. In portraiture, for instance, the artist could literally examine the individual pores of his model's face without being in close proximity to her or, for that matter, without her being aware of it. The artist who used a portable camera obscura could compose his frame simply by moving the camera (a fraction of an inch at the camera position often making a completely different image). If the lens had a diaphragm, and these were available c. 1568, or a focusing device, the artist could adjust the sharpness of his image, blurring areas, especially highlights and reflections, to achieve, for example, the Vermeer-like halation or to suggest a kind of atmospheric perspective. If he desired, and if he had the appropriate lens (or if his lens forced it upon him), he could distort natural forms, in the complete range from slight distortion to full annihilation of the original subject.

Given the fact that Holland was producing the finest lenses to be found in the seventeenth century and was devoted to the rendering of physical reality, it is not unlikely that some of the Dutch artists used the camera obscura. There is, however, no known documentary evidence to show that they did; a fact which has puzzled many scholars, in view of the preoccupation of the Dutch with perspective for architectural painting, peep shows, landscapes and panoramas, and even genre interiors.[12]

The relevant fact, however, is that the Dutch *saw* photograhically. They were able to manipulate the unwieldy dimension of time, to lift out the moment, flowing from its past into its future, and set it down again intact, alive.

As early as 1781, Sir Joshua Reynolds, the most prominent figure in British painting, remarked on the camera-obscura quality of the work of Jan van der Heyden.[13] The distinctly photographic vision of seventeenth-century Dutch painting was not, however, universally appealing, nor was its subject matter. In fact, seventeenth-century Dutch painting was largely ignored by the critics until gradually it began to gain favor in the nineteenth century; the evidence provided by photography was certainly one of the factors contributing to this change.

In 1829, the first volume of John Smith's nine-volume *Catalogue Raisonné of the Works of the Most Eminent Dutch, Flemish, and French Painters* appeared. Shortly after 1842, Gautier, Baudelaire, Thoré, Champfleury, and others expressed their approval of everyday subject matter, and soon thereafter Dutch art became the leader among the revival movements. Thoré, the first French connoisseur of Dutch painting, coined the slogan, "l'art pour l'homme," in defiance of "l'art pour l'art," the catch phrase of the more traditional critics.

There were, however, political implications: Thoré was a socialist democrat.[14] Nevertheless, Thoré's articles in the *Gazette des Beaux-Arts* from 1858 to 1866 served as a catalyst for the revival of seventeenth-century Dutch painting. The work of Vermeer, especially, enjoyed great popularity during the period immediately preceding Impressionism.[15] Maxime du Camp, a Realist and photographer, called Vermeer's *View of Delft*, c. 1662, The Hague, Mauritshuis, "un Canaletto exagéré."[16]

McCoubrey, commenting on the nineteenth-century revival of Chardin, says that until 1852 still-life painting was largely suppressed. By 1863, however, "still life painters were multiplying like rodents," though traditional critics continued to belittle their works as mere photographic realism.[17]

Eugène Fromentin was obviously familiar with the camera obscura; he describes Ruisdael's eye as having "the properties of the camera obscura; it reduces, diminishes the light and preserves things in the exact proportion of their forms and colors."[18] Holland, he says, "taught us how to see, feel, and to paint."[19] And later he makes an important connection for this discussion: "Photographic studies of the effects of light have changed the greater proportion of ways of seeing, feeling, and painting."[20] Thus he suggests that both Dutch art and photography have changed contemporary art and vision in similar ways.[21]

Describing the art of the nineteenth century, Fritz Novotny wrote, "Never before had there been such a degree of naturalism in painting, not even in Holland in the seventeenth century."[22] Man breaks with the church and looks to landscape, light, atmosphere, and man himself. The seed was planted, he says, during the Renaissance; and it came to fruition in the nineteenth century. He suggests that the century began with its eye on an invisible idea, but grew progressively more concerned with the visible until it reached an "apotheosis of the optical image of nature . . . the end of painting."[23] Constantijn Huygens made a similar remark when he saw the camera obscura image in 1622,[24] as did Delaroche when he looked at the daguerreotype in 1839.[25] In Gartner's work, Novotny sees "the extreme of an almost photographic naturalism,"[26] and he finds "camera-obscura effects" in the work of Spitzweg, saying it "is a type of unreality which invites comparisons with real nature, especially in the landscape."[27] Finally he compares Leibl and Menzel with Vermeer, seeing in all of them a "quality suggesting photographic optics."[28] It is curious that he, like most art historians, doesn't find it necessary to discuss photographers or photographs of the nineteenth century.

Other writers, however, did compare the work of nineteenth-century photographers to seventeenth-century Dutch painting. Indeed to many it was the highest form of praise. "Samuel F. B. Morse, on seeing Daguerre's daguerreotypes in 1839 called them 'Rembrandt perfected,' and persuaded the National Academy of Design to elect Daguerre an honorary member."[29] In 1843, Sir David Brewster wrote D. O. Hill to the effect that Robert Adamson, who would become Hill's photographic partner, made portraits having all the strength and beauty of Rembrandt drawings.[30]

Lady Elizabeth Eastlake, wife of the director of London's National Gallery, observed, in 1857, of Hill and Adamson portraits made ten years earlier: "If we look around a photographic exhibition, we are met by results which are indeed honourable to the perseverance, knowledge, and in some cases to the taste of man. The small, broadly-treated Rembrandt-like studies . . . which first cast the glamour of photography upon us are replaced by portraits of the most elaborate detail, and of every size. . . ."[31]

The approach of the nineteenth-century photographer and that of the seventeenth-century Dutch painter were similar. The nineteenth-century genre photograph was often posed in the studio, or it was a combination print; that is to say, it was made up of several negatives which the photographer later integrated into a single picture. The result was not documentary. Nor were most seventeenth-century Dutch paintings, which were often made up of several sketches which the artist in his studio incorporated into a single picture.

Many photographers toward the end of the century labeled their compositions "à la Rembrandt."[32] Rembrandt is constantly referred to throughout the nineteenth century in material dealing with the entire range of photographic portraiture, including everything from photo gallery signs, advertisements, and studios and their accessories, to costumes worn by sitters and photographers. Photographic equipment was named for him. There were Rembrandt headrests and Rembrandt cameras. In fact, the Rembrandt mystique continues today. Commercial portrait studios continue to advertise Rembrandt lighting, which means, variously, a north-lit studio with curtains drawn over the glass and pulled just enough to let a splinter of light through, or its opposite—a studio overloaded with mirrors and blue bottles, the former to direct the sun, the latter to filter it. In the magazines of the last decade or two of the century one finds titles alluding to the great master in a variety of ways that even Madison Avenue today would find difficult to rival. This is undoubtedly due to the various ways of seeing Rembrandt in relation to the new medium. For instance, it includes Rembrandt as "realist," as "master of chiaroscuro effects," and certainly as the "grand old master."

Well over two hundred photographs have come to my attention which can be related to seventeenth-century Dutch painting, in all categories of subject matter, not including the hundreds of "Rembrandt portraits" or the various direct imitations of known Dutch works. The following comparison of seventeenth-century Dutch paintings of interiors with nineteenth-century photographs of interiors represents a very limited selection from this number which, I think, demonstrates the visual kinship between them.[33]

It seems appropriate to begin this discussion of interiors with a door opening into an interior. *The Open Door* (Fig. 20), by W. H. Fox Talbot, is plate 6 of his book, *The Pencil of Nature* (London, 1844). The book was an illustrated announcement and description of the photographic process he invented. All of the photographs have instructive captions. The one appearing with *The Open Door* is particularly relevant to this discussion and I quote it in full:

> The chief object of the present work is to place on record some of the early beginnings of

a new art, before the period, which we trust is approaching, of its being brought to maturity by the aid of British talent.

This is one of the trifling efforts of its infancy, which some partial friends have been kind enough to commend. We have sufficient authority in the Dutch school of art, for taking as subjects of representation scenes of daily and familiar occurrence. A painter's eye will often be arrested where ordinary people see nothing remarkable. A casual gleam of sunshine, or a shadow thrown across his path, a time-withered oak, or a moss-covered stone may awaken a train of thoughts and feelings, and picturesque imaginings.[34]

The caption tells us not only that Talbot related photography to Dutch painting, but also something about Talbot's conception of Dutch painting: that he sees something in it beyond mere documentation of surface facts, and by extension sees this potential in the new medium.

The picture is by far the most interesting one in the book and it is the only one we can relate directly to seventeenth-century Dutch art (and we would have done so without Talbot's caption). The brush broom is similar to those found in the works of de Hooch, Vermeer, Dou, A. van Ostade, and others. A window in the wall opposite the partially open door, which may have been more visible in the 1840s, suggests the Dutch love of the implied continuation of space. In other words, familiar Dutch motifs appear in this photograph. It was made almost immediately after the medium was invented. There is, in the slightly asymmetrical composition and the playing of the bright exterior against the deeply shadowed interior, only partially visible through the half-open door, a quality of mystery and what might be described as a tending toward that "stilling" of life so characteristic of the Dutch. This quality is certainly enhanced by the precarious position of the broom. It is the only strong diagonal force in the picture, yet it appears to have been caught in the act of falling. At the same time, it is the focal point of the whole. It is in sharper focus than any other part of the picture and stands poised between the bright sunlight and the deep shadow within. It is countered by the lantern hanging on the wall to the right, which is also in clear focus and casts a strong shadow. The picture is framed by the sunlit walls. The vines at the edges which lead the eye beyond the frame suggest a continuation of the scene in both directions; the effect is the same at the top where the edge of the frame cuts across the

open door, and again at the bottom where the frame crops the step up to the door. The mysterious, instantaneous, extended stillness of the whole, the unusual choice of objects and their arrangement, the strongly contrasting chiaroscuro which captures the "density" of the atmosphere itself, and the intimate view of a fragment of an obviously larger whole; all these tend to a symbolic reading of a picture which remains at the same time a simple depiction of an everyday scene. This problem is often encountered when one studies photographs—even those unaccompanied by romantically suggestive captions—for one is always caught between an awareness of the physical reality of the subject before the camera and the desire to find additional meaning in an image which possesses elements of mystery, however slight. Of all the elements here, perhaps the sense of the atmosphere flowing in and around the objects is what most lends itself to interpretive reading.

A comparison of *The Open Door* with a seventeenth-century Dutch painting tells us a great deal about photographic vision. Although it may be less than fair to Talbot, who was, after all, "an English scientist, mathematician, botanist, linguist, archaeologist, and country gentleman,"[35] let us compare his picture with Pieter de Hooch's *A Maid with a Child in a Court*, 1658, London, National Gallery (Fig. 21). A discussion of color must be excluded, since, in limiting our discussion to nineteenth-century photography, we must accept the fact that color does not exist as an element of form for this medium. In so doing, we recognize this as a distinction between the two and as a qualified limitation for the newer medium. Light, value gradation, and atmosphere can nevertheless be compared.

The most obvious difference between Fig. 20 and Fig. 21 (the latter, a black-and-white reproduction) is that the painting has people in it and the photograph does not. Though there are a few seventeenth-century Dutch paintings of genre scenes in which there are no people, such as the *Dutch Interior* (Fig. 22), attributed to Hendrick van der Burch (Berlin-Dahlem, Staatliche Museum),[36] it is more typical of nineteenth-century photography and painting.

An international revival of genre painting began in France about 1810, according to Lorenz Eitner, who feels it stemmed from the Dutch tradition "in the teeth of academic disapproval."[37] A strong Dutch influence is supported by the huge selection of Dutch and Flemish pictures displayed at the Louvre at that time and by the precautions taken to protect them from the great number of copyists.[38] Dutch models were not simply imitated but transformed

into images containing symbols couched in casual reality—"a product of a time and society that loved poetic suggestion."[39] All of the above pertains as well to photography.

The dilemma of interpretation—literal or symbolic —is a central characteristic of the relationship between seventeenth-century Dutch painting and nineteenth-century art in all media. The notion that the Dutch painted only realistic renderings was so prevalent that paintings intended to be symbolic were often misinterpreted.[40] The difficulty of interpretation is reflected in the swing from "realism" to "symbolism" and back again, according to the times. The current tendency is to caution against reading pictures beyond the limits provided by *all* the evidence, for the Dutch painter was most interested in the "unprecedented pleasure in perceiving and painting the harmony of colors, the sparkling play of light, the mystery of shadow, and intangible space."[41]

There is little evidence to suggest that Dutch painters worked outdoors.[42] This is too often relied upon as a defense, as if it were necessary to point out that Dutch artists *did* have a creative imagination, that they *did not* simply "sit out there under a tree and copy what they saw." It is, in fact, the *way* they saw what was out there that makes their vision special. They observed closely and well, and with prodigious acuity. Their vision was tutored and enlarged by what may be described as an essentially photographic way of looking. It is simply going beyond "looking" to "seeing," which implies study, understanding, and the significance of what is out there in its relation to life, and relating objects symbolically to God. Perhaps this is why the Flemish painters, who came close, could not go farther. Research into seventeenth-century workshop practice establishes a direct relationship between art and nature.[43] Artist handbooks were secondary in importance; so was the aesthetic beautification of nature and the idealization of the Renaissance. The masters "were forever impressing on their pupils a deep love of nature as she is. The precept 'Look at nature and imitate her,' takes precedence of all others throughout the flourishing period of Dutch painting."[44]

All of this is apparent in de Hooch's *A Maid with a Child in a Court* (Fig. 21). When compared with the Talbot, one must conclude that the de Hooch is the better "photograph." De Hooch has not overlooked any realistic aspect of the scene (even if this particular scene never actually existed); nor has he idealized it in the common sense of that term. Put another way, he gives us the feeling that this is a snapshot of an actual time and place. The value gradations of its

atmosphere, seen in color, lend it the quality of an image formed by light passing through a lens; seen in black and white, the picture resembles a photographic print.

This quality is best illustrated by the passage on the left where the small space seems to come alive with the vitality of the light. With all its transparency it is subtly controlled by the tonal scale which the artist uses also to construct space. The play of space in this work is defined by light and planes with an exquisite sophistication, yet miraculously it maintains its casual or "photographic" quality. Every element in the picture is supremely calculated to fit.

The Talbot photograph fails in its use of light. All subtlety is washed away by the harshness of the contrasts between black and white; there are almost no transitional values, there is no sense of flow. The shadows are dead, lacking the transparency of optical vision. It lacks the variety of detail that de Hooch produced, examining each section of the whole and then the whole itself.

De Hooch gives us a sense of the variety of surface textures. He rendered them carefully, but not so carefully as to ignore the effect of atmosphere. In other words he did not paint what he would have seen had he been standing where the angle of his vision would have embraced everything that is in the painting. If he had been standing there (and had not moved about) he would not have been able to see the detail he painted. He would have seen a more generalized image. On the other hand, he did not paint each detail as if he had walked up to it and examined it inch by inch with a magnifying glass. Rather he painted the scene in such a way that it looks to us as it might look were it reduced in size to a point where we could see it all and still see the essential details throughout.

None of the above is meant to suggest that de Hooch used any device to aid him in the painting of this or any other picture. For the moment, this is not the problem. What is significant is that, however he achieved it, his image suggests photographic vision.

In the rendering of surface texture, Talbot's photograph fails utterly. Yet the facility to reproduce surface textures was praised as one of the outstanding qualities of the new medium. That he suppressed the textures intentionally, which he could have done, is unlikely.

Both pictures are fragments of a larger whole. The viewer imagines extensions of the scenes in all directions. The photograph shows little variety and a lack of definition and value in the areas on either side of the door. It is also unlikely that this was inten-

tional. In fact, had the contrast between the splayed outline of the thorny vine on the left and the smoother, more undulating one on the right been treated more photographically, the effect would certainly have enhanced the "picturesque imaginings." Moreover, these vines in combination with the washed-out wall sections on either side of the dense interior split the composition in two. The diagonal of the broom, though balanced well against the lantern, is not enough to hold the viewer, once he is satisfied that there is nothing meaningful in the darkness. The sticks, caught in the base of the vines at the right, testify to Talbot's careless eye, as does the ragged bottom edge which could have been eliminated by the simple expedient of moving the camera a fraction of an inch. The trained eye works within the limitations of the medium; it does not increase them by inattention to detail. Clearly, Talbot is not an accomplished artist. He looks but does not see.

De Hooch manages to make all the edges work toward the suggestion of a fragment of time, caught casually as if by a camera. At the same time the picture is well conceived and full of life. He uses a few devices to achieve this effect. The shutter at the left, for instance, suggests a window outside the frame, but our eyes do not linger for long because the shutter acts as a kind of balance for the open door in the passageway. Both of them frame the figure of the woman, whose back draws us to her. The branch at the upper left also suggests something outside, then brings us back by directing us around and down the arch to the woman and child. The one element that fails for lack of subtlety, although it serves as a balancing line, is the object which appears in both pictures: the broom.

The use of space is the informing feature of both of these images, though clearly toward different ends. The de Hooch succeeds; the Talbot fails. The spatial areas in the painting are believable, yet they have been planned to accompany and support each other with such remarkable skill that the whole image, the "still life," with all that the term means, breathes and moves nevertheless.[45] There is such a quality of transcendent peace that one feels the captured moment can go on forever.

Talbot's use of space is ambiguous. What he intended is not clear. If he wished to confine the viewer's attention to the darkened doorway and the room beyond, which, as stated, seems likely, he has failed again. The viewer's attention is distracted not only by the irregular line at the bottom, but by the injudicious cropping at the top center for which the eye seeks to compensate. As a result, the dramatic effect of the broom and the darkened doorway is considerably lessened. The density of shadow of the interior and the door is not relieved by the soft light coming through the windows—it fails to involve us.

It is true that the painter can adjust and arrange anything he chooses to represent to suit the needs of his picture. It is also true that the photographer cannot. He must work within the limits of what the camera sees. He can manipulate his image only to the extent that the camera and the photographic process will allow it, including the use of various methods of making composite photographs. Paintings have the further advantage of an added manipulable element: surface quality of pigment. Photographs do not have, generally, the range of surface manipulation. This is not to detract from the very real aesthetic value of surface in photographs but to point out the distinct difference and the limitations.

Be that as it may, Talbot failed to avail himself even of the photographic controls that *were* at his disposal. *The Open Door* is not a successful work of art; it was chosen for comparison with the de Hooch because of the caption, its title, the presence of the broom, its early date, its creator, and a quality which suggested a conscious attempt to create a work in the Dutch manner without direct imitation.

The choice of the de Hooch was based on a decision to avoid the more obviously "photographic" Dutch paintings, including works by artists strongly suspected of having used the camera obscura or some similar device, e.g., Vermeer, Gerrit Berckheyde, and Jan van der Heyden. The choice was further determined by a desire to analyze a painting that was characteristic of the period. If one were so inclined, for instance, one might read symbolism in the de Hooch as well as in the Talbot. Finally, neither picture conveys the sentimentality that is typical of the poorer examples of seventeenth-century Dutch painting and nineteenth-century photography. In all fairness, one must recognize that Talbot was working under severe handicaps which photographers later in the century were spared. True, he had the finest materials and equipment available, but they were nevertheless unpredictable and unstable. The work of the best practitioners fell far short of the beautifully luminescent image on the ground glass of the camera. (It is still not completely within our grasp.) Granted all this, however, the fact is Talbot was not an accomplished artist.

Elements which contributed to the "photographic" vision of the seventeenth-century Dutch painter, among them the use of space, time, light, atmosphere, chiaroscuro, and optics, have been discussed

previously. All of these are observable in still-life painting per se, as developed in Holland where its very significant appellation was coined.

A discussion of so-called interior views follows, introduced with a quotation from Etienne Gilson, who perceives with striking clarity the sources and nature of Dutch still-life painting:

> The kind of plenary satisfaction we experience while looking at a still life is due to the perfect adequacy that obtains . . . between the substance of the work of art and the reality that it represents. Such pictures are solid and inanimate objects enjoying a continuous mode of physical existence . . . that belongs to inanimate solids situated in space. . . .
>
> The notion of "still life" does not apply only to pictures representing dead animals or inanimate household objects. It is surely not by chance that the seventeenth-century Dutch painters, who were the first to handle still life as a distinct genre and brought it to its point of perfection, were also the first to find fitting subjects in many other man-made objects, or things, whose only common quality is precisely in their stillness. . . . [W]hen the still-life style extended itself from household objects to houses themselves; then to churches, which are the house of God; then to cities, which are made up of houses and of churches, it became obvious that the aim and scope of a still life was something far beyond the mere imitation of inanimate objects.
>
> There is magic in the art of the great Dutch painters. The same intense feeling of reality and of enduring stability suggested by their fruit bowls and their loaves of bread remains perceptible in the interiors painted by Pieter de Hooch before, yielding to a temptation fatal to so many painters of still lifes, he began to turn out mere genre pictures. Generally speaking, the best Dutch interiors [Fig. 23] invite the spectator to partake of a life that is not his own, but with which he communicates without disturbing it in the least. Their quiet housewives do not mind us; they are not even aware of our presence; as to themselves, even if they pretend to be doing something, all that they really have to do is to be. Many Dutch pictures of church interiors proceed from the same spirit. The small personages that people the churches painted by H. van der Vliet do not prevent them from remaining so many still lifes. This is still truer of

the churches painted with a unique blending of finish and sensibility by Pieter Saenredam [Figs. 25, 27, and 28]. But there is a short distance, if any, from an interior by Jan Vermeer [Fig. 23] to his justly celebrated *Street in Delft,* whose life is no less still than that of his own interior scenes. Even his equally famous *View of Delft* shares in the same qualities of quiet presence and actionless existentiality that characterize his little street. A similar extension is observable in the works of Saenredam when he passes from the inside of his churches to their external appearance. There is something of the stillness of Vermeer's *View of Delft* in the portrait of a Utrecht public place by Saenredam.[46]

Emanuel de Witte (1616/18–1692), a painter of various subjects before he began to concentrate on architectural themes around 1650, painted the *Interior of the Portuguese Synagogue in Amsterdam* (Fig. 24, Amsterdam, Rijksmuseum) around 1680. De Witte's interiors are not, generally, accurate renderings, often indeed they are purely imaginary, yet this painting renders one of his favorite interiors accurately. The structure still exists and contains all its furnishings. It can therefore be looked at as a "portrait" of the interior of an actual building. This concept of portraiture is quite different from the still-life ideas discussed earlier. It is, in fact, precisely because this painting represents an accurate rendering of an actual building, yet fails to convey the sense of still life or the sense of photographic vision, that it is included here. That de Witte is known for the persuasive reality with which he convinces the viewer that he is looking at an actual church, even when he is looking at a product of de Witte's imagination, is even more to the point.[47] The painting, though not in good state, is a convincing representation of a grand interior space with patches of light thrown into the space falling here and there on the structure and people, and casting believable shadows. The fact that he was also a genre painter is apparent from the depiction of the crowd. He includes a variety of types and ages, and arranges them with no little amount of wit. Two figures dominate the center of the foreground which they share with two dogs. The viewer becomes involved with the various personalities. Perhaps he notices that the chandeliers are decorative and overflowing in a way that suggests comparison to these two figures, while the columns are strong and sturdy, supporting massive entablatures that thrust themselves heroically into the distance creating a strong

sense of the deep perspective space. Again there are figures standing with their backs solidly parallel to the plane, their clothes hanging upon solid frames in perfect symmetry. The point is that there is absolutely no sense of still life, no sense of mystery, no sense of an atmosphere pervading the space. It is a clear sunny area with active people in an active environment. It is a genre scene. It is accurate without being pedantic; it does not provide detailed information. It is not photographic either. There is no indication of a stilled moment. It is noisy and we are very much aware of the paint, the brush, and the surface. (For a contemporary photographic version of the de Witte, see William Klein's Moscow picture of 1959, reproduced in Nathan Lyons, *Photography in the Twentieth Century*, Horizon Press, 1967, p. 90.)

Comparing a Pieter Saenredam (1597–1665) interior, *Cathedral of St. John at 's-Hertogenbosch*, 1646 (Fig. 25, Washington, D.C., National Gallery of Art, Samuel H. Kress Collection), with a photograph by George Washington Wilson of a similar church interior (Fig. 26), one finds a completely different set of circumstances operating. Admittedly neither reproduction is of good quality. We cannot go far given the limitations of this kind of comparison, but a few observations are in order as a transitional step. We know that Saenredam made a careful drawing of this interior on July 1, 1632, which was then used to make the construction drawing from which the painting was made in 1646 (it is 50⅝ by 34¼ inches).[48] A precise knowledge of his working method (recorded for us by the artist) perhaps obviates the need to speculate on the use of a camera obscura, though one wonders how he achieved such a vision.

A brief note about Saenredam is necessary. He apparently studied perspective, and probably made architectural drawings with the painter and architect Jacob van Campen. His amazing patience and love of detail earlier found an outlet in drawing small portraits, plants, and flowers; and from 1628 on he painted only architectural themes, with the same infinitely precise observation of detail, yet he managed to create a unified whole by combining illusionistic perspective with a subtle, almost monochromatic coloration to achieve a truly "poetical vision."[49]

His father was a Mannerist engraver and draughtsman, who died while Pieter was young. He and his mother moved to Haarlem, where he spent the rest of his life. From 1612 to 1622 he studied with Frans Pietersz. de Grebber; he also worked with another architect-painter, Pieter Post. About fifty paintings are known and all except a few are based on direct observation. He was neat and precise; he had a keen interest in the past and was scrupulous to a fault, noting every change made of a drawing on the drawing itself, so that viewers would know it was not a faithful drawing![50] He was a recluse, perhaps because he was a hunchback.

One point to be made in this comparison is a simple one: the two images have a *superficial* similarity. In fact, this similarity would be quite striking if the photograph were of the same building as the painting. The poor quality of reproduction is actually useful in this case. It must also be pointed out with some emphasis that the photograph was taken by one of the most prolific commercial photographers of "views" in the nineteenth century. The photographer, therefore, probably had no reason to even consider creating a work of art. His purpose was to record as best he could what was before him. In one sense, though in *only* one sense, Saenredam *seems* to have this purpose in mind also. This is suggested by the days he spent checking every detail, measuring, studying, drawing very painstakingly, slowly, and—as one ponders his method and even the careful creation of his inscriptions—one might say, even painfully.

There is another similarity and perhaps the best way to illustrate it is to recall an earlier painter of the north: Jan van Eyck. The character of van Eyck's work is somehow related to both of these pictures. Perhaps it is only in the sharpness of detail that seems to be in every corner of every part of the whole—a lens-like sharpness. Or it may be the smooth, unobtrusive surface which makes one forget, momentarily at least, about pigment and brush. Or it may be the transparency of light and color that seems to be common to all three (a color slide in place of the photograph might be more useful), which suggests at the same time an almost tangible atmosphere. All of these things are there, to be sure, but they are not the same, not identical. If, for instance, we introduce, more directly, the subject of color for the purpose of this discussion only, to examine Saenredam's use of it, we may come to some partial conclusions. Van Eyck's color was brilliantly saturated and local; it caused light and color to fuse locally, generally, so that each object, one might say each particle, was autonomous in his vision. This is somewhat true for all the elements of form in van Eyck: even his perspective seems to have been the result of strictly local vision. Color in Saenredam, on the other hand, is extremely subtle and unobtrusive. In fact, however, for all its subtlety, it exerts great influence on the viewer and actually informs his vision. His use of

light is equally compelling; if one is observant, as Saenredam so totally is, one notices that light does not flood the space, does not destroy window frames as it does in the photograph, but exists with a tangible stillness that, with a certain transparency, unifies the entire image formally and emotionally.

More important than the fact that he never looks at an interior head-on or symmetrically; more important than the fact that he sometimes modified the accuracy of his drawings when making the paintings (after inscribed apologies for corrections on drawings); more important than all of this is the special quality of still life which transforms the picture into a pulsating whole filled with an other-worldly calm. The figures used for scale and often painted by others[51] do not detract from this, as Gilson has indicated. What is more, they seem to contribute less to scale than to the meaning suggested previously: a mysterious, perhaps mystical existence.[52]

Interior of St. Lawrence's Church at Alkmaar (Fig. 27) and *Interior of St. Odulphus' Church at Assendelft* (Fig. 28) convey this and more: the almost fragile color and light and the fragmentary framing dominate the environment even more than in *Cathedral of St. John at 's-Hertogenbosch* (Fig. 25). One senses that Saenredam's interiors are *personal* symbols of a heavenly place. The usual symbolism of a cathedral interior is heightened by his unique way of seeing, while sharing the style of his time. Obviously knowledgeable about architecture, he has surpassed the architects of the buildings he paints in creating a sanctuary of peace. The viewer finds here what Gilson called the "plenary satisfaction we experience," the "continuous mode of physical existence . . . that belongs to inanimate solids situated in space," the "magic . . . of the great Dutch painters," and the "quiet presence and actionless existentiality."

It is uncanny how the unreality of these two paintings (Figs. 27 and 28) depends directly on a precise rendering of reality. This paradox is resolved in the realization that no art reproduces reality; all precise renderings are renderings of particular aspects only. Saenredam's careful observation, his concentration, his "precise" rendering of forms, his order and neatness, all point to a man living apart, in a rarefied atmosphere of the mind that is identical to the one depicted. A moment in life is selected, purified, and perpetuated in a kind of state of grace. It is a "moment preserved." He chooses a fragment of the whole and specific aspects of it ("colored light" and spatial relationships), which he renders precisely at the expense of other fragments and the whole. It is the way he selects the fragment and what he

emphasizes in the isolated moment that indicate a relationship with the photographic vision developed in the nineteenth century. It is as if he moved about with his eye on the ground glass of a camera and stopped when it framed what corresponded to the idea in his mind.

The work of Frederick H. Evans (1853–1943) best illustrates this relationship. Evans is one of several photographers whose work reveals the change taking place in photographic style at the end of the century. Most of the technical problems of the medium had been solved, allowing for greater control, making it possible for the photographer to produce a closer approximation of what he saw on the ground glass, or, if he preferred, making it possible to change what he saw to some extent. Evans, and others, explored the medium's own potential, without looking for "authority in the Dutch school." In this way they discovered what photography was and what it could do. The relationship between his work and that of seventeenth-century Holland is more basic than that seen in direct imitation or emulation. Photography began to rid itself of its inferiority complex. It grew up and faced itself. It took seventy-five years to reach this point, during which time many accidents, experiments, and "miracles" slowly paved the way. Within this development, Dutch art plays more than one role.

In the work of Evans, as in Saenredam's, there is a sanctification of the lifeless object, a quality we have seen associated with the concept of the Dutch still life. In *Kelmscott Manor: Attics* (Fig. 29), Evans uses light to convey the mysterious way in which atmosphere infiltrates space, as well as to convey relationships between spaces, and to give life to space itself. Here is that sense of quietude, that haunting stillness suspended between loneliness and infinity. The picture depicts an architectural space. Evans made architectural views, portraits, and landscapes. Almost all of his architectural views (he preferred interiors) are of churches, yet no photograph by Evans is directly related to a Saenredam painting. There is no evidence to suggest he was even aware of the Dutch painters of architecture.

Evans uses shadow, which Saenredam avoided; he also incorporates a far greater range of values than Saenredam. Over two hundred years separate their lives, yet the relationship holds. They were surprisingly alike and seem to have been informed by the same spirit, one that found its greatest expression within architectural structures where space was given higher meaning by isolating specific fragments in time, using light as atmosphere. The qualities of still

life noted by Gilson are present in the works of both men. Inanimate objects of the earthly world are transformed into images which become symbols with mystical connotations. The inherent symbolism of the church, indicated earlier, cannot be applied to *Kelmscott Manor: Attics*: it is an ordinary place. Not even the Dutch transformed such a mundane subject in this way. The overall silvery grey color of Evans's photographs is, together with the extremely subtle gradations in range of tones, largely responsible for restraining the representational aspect. This relates to the almost monochromatic (and also silvery) "colored light" in Saenredam's paintings. The triangular structure of the attic (also emphasized by the light), on the other hand, does suggest the "idea" of a fragment of a church interior seen, as Saenredam would have, slightly off-center.

The same holds true for *A Sea of Steps* (Fig. 30) made at Wells Cathedral in 1903. Evans revealed his reverence for architectural space and form in words as well as pictures. About this picture he said:

> I succeeded in getting a negative that has contented me more than I thought possible. . . . The beautiful curve of the steps on the right is for all the world like the surge of a great wave that will presently break and subside into smaller ones like those at the top of the picture. It is one of the most imaginative lines it has been my good fortune to try and depict, this superb mounting of the steps.[53]

In this passage he suggests the "stilled moment" when he says the "wave . . . will presently break." As in Saenredam's work (Fig. 27), no matter how fragmentary the view, no matter how asymmetrical the composition, the balanced containment and forceful edges (framing) make the whole immobile.

Evans was a bookseller who began photographing in 1883 as a pastime. In 1898 he decided to devote his life to photographing the things he loved.[54] By 1900, Steichen considered Evans's photographs "the most beautiful rendering of architecture we have ever known."[55] It is easy to understand this when one compares Evans's photographs with the typical architectural photography of the period seen in art history books and slides. His concern for the pure use of photography, without handwork or manipulation so common at the time for those who still attempted to simulate drawing and painting, is expressed in almost a hundred articles. We need not read them to know this, for his photographs reveal the passionate love of precise detail that was central to his nature. His technique was impeccable.

He often spent weeks in the cathedral he was going to photograph, studying the effect of light at various times of the day, always taking careful notes on light, time, and camera positions for later use in deciding the appropriate solution. He wished he could live near each cathedral for a year to be able to work until achieving perfection. He worked very slowly forming the image on the ground glass, studying the light and form from edge to edge. To achieve maximum clarity he used a small aperture and long exposures. He caused havoc at Ely Cathedral when he had all the chairs and gas fixtures removed to be able to get at the purity of the fabric (one of the limitations painting does not suffer).[56]

Expressing his feeling for cathedrals, he said, "And there are no more abiding memories of peace, deep joy, and satisfaction, of a calm realization of an order of beauty . . . than those given by prolonged stay in a cathedral vicinity. The sense of withdrawal, an apartness from the rush of life surging up to the very doors of the wonderful building, is so refreshing and re-creating to the spirit as surely to be worth any efforts of attaining."[57] Photography was the perfect means of recording his feelings, for as he says, it "is one of the finest methods for rendering atmosphere and light and shade in all the subtleties of nature's gradations."[58]

He advises others to "try for a record of emotion rather than a piece of topography. Wait until the building makes you feel intensely . . . then try to analyze what gives you that feeling . . . and then see what your camera can do towards reproducing that effect, that subject."[59]

In 1905, when his prints were exhibited at Stieglitz's gallery, they were highly criticized in the press in a way not far different from seventeenth- and eighteenth-century criticism of Dutch painting.[60] George Bernard Shaw, however, appreciated the man who he said had "the gift of seeing: his picture-making is done on the screen [ground glass]."[61] Years later he said Evans had "dedicated himself to an art which is disparaged by those who believe that when a lens is in a box, it is mechanical, but not when it is in a man's head."[62]

One aspect of a correspondence between Dutch painting and photography has been indicated; that more needs to be done in this area is apparent from work such as *Zuni Pueblo: Interior* (Fig. 31). Looking at this photograph by Adam Clark Vroman (1856–1916), made in 1897, and then glancing at the Vermeer (Fig. 23) will add another dimension to the ponderings over whether Vermeer used a camera obscura. The spatial recession, the light, the order,

and the sense of stillness in both works are certainly related. That the Vroman is, in comparison, a primitive image cannot be argued, yet it is a combination of light, architectural space, time, and a supremely balanced asymmetrical composition that unites the work of Vermeer, Saenredam, Evans, and Vroman. Very little is known about Vroman. He was a railroad man for seventeen years doing odd jobs, and during this time he collected books. He then became a bookseller and took up photography to document the land and people of the American Southwest. Unlike Evans, he continued to be primarily interested in his bookstore. This photograph is somewhat unique in his work. One fact in his biography is intriguing: he was a descendant of a Dutch family that came to America in 1664.[63]

Light was the all-important ingredient, and through the use of brilliant yet subtle techniques, each man captured it in the very act of hollowing out space.[64]

The mystery, the magic of the photograph is locked within this phenomenon. From Saenredam to Evans is one step. The pace quickens from Evans to Stieglitz and the theory of Equivalence which is still rooted in Saenredam. From there the path is clear.[65]

NOTES

1. Victoria and Albert Museum (catalogue), *The Orange and the Rose: Holland and Britain in the Age of Observation, 1600–1750*, 1964, p. 11.

2. See A. Bentssen and H. Omberg, "Structural Changes in Dutch 17th Century Landscape, Still-Life, Genre, and Architectural Painting," *Figura*, I, 1951, for variations in style and meaning within these groups. Rembrandt is an exception but only in that he delved deeper into the surface of man in his attempt to explore and understand man in a perhaps more penetrating manner—by seeing the telling relationship between the surface and the inner man. By stretching the point, one might say that Rembrandt was the most scientific explorer of them all, and perhaps is still the best model for the photographer who tries to understand life through man and nature.

3. Seymour Slive, "Notes on the Relationship of Protestantism to Seventeenth Century Dutch Painting," *Art Quarterly*, vol. 19, 1956, p. 3.

4. Ibid., p. 5.

5. Quoted by Castagnary in 1868; see Linda Nochlin, *Realism and Tradition in Art 1848–1900*, Englewood Cliffs, N.J., Prentice-Hall, Inc., 1966, p. 67; also pp. 11, 50, for nineteenth-century appreciation of *l'art pour l'homme*; and J. Rosenberg, S. Slive, and E. H. TerKuile, *Dutch Art and Architecture 1600–1800*, Baltimore, Md., Penguin, 1964, pp. 3–10, especially 3–4, 9–10.

6. Arnold Hauser, *The Social History of Art*, vol. 2, New York, Vintage Books, pp. 212–13.

7. Rosenberg, Slive, and TerKuile, *Dutch Art and Architecture*, p. 4.

8. *The Orange and the Rose*, p. 10.

9. Ibid., pp. 12–13; also A. Barnouw and B. Landheer, *The Contribution of Holland to the Sciences*, 1943, pp. 270–71, 302–3, 338.

10. Rosenberg, Slive, and TerKuile, *Dutch Art and Architecture*, pp. 117–18.

11. I am indebted to Arthur Wheelock for sharing the rewards of his research before publication.

12. For experiments with the camera obscura in an attempt to show Vermeer's use, see: Charles Seymour, Jr., "Dark Chamber and Light-Filled Room: Vermeer and the Camera Obscura," *The Art Bulletin*, vol. 46, September 1964, pp. 323–32; and Daniel A. Fink II, "An Attempt to Determine a Basis of Johannes Vermeer's Method of Painting by a Comparison of the Images Formed by the Simple Lenses of Seventeenth Century Optical Devices with the Images in Most of Vermeer's Paintings," Ph.D. diss., Ohio University, 1968.

13. J. Reynolds, *The Works of Sir Joshua Reynolds*, London, 1801; vol. 2, "A Journey to Flanders and Holland," p. 360.

14. S. Meltzoff, "The Rediscovery of Vermeer," *Marsyas*, vol. 2, 1942, pp. 151–55.

15. Ibid., p. 145.

16. H. Schwarz, "Vermeer and the Camera Obscura," *Pantheon*, 1966, p. 178. (This article is a follow-up on Charles Seymour's *Art Bulletin* piece cited in n. 12.)

17. John W. McCoubrey, "The Revival of Chardin in French Still-Life Painting, 1850–1870," *The Art Bulletin*, vol. 46, no. 1, March 1964, pp. 39–41.

18. Eugène Fromentin, *The Old Masters of Belgium and Holland*, New York, Schocken, 1963, pp. 190–91.

19. Ibid., pp. 206–7

20. Ibid., p. 214.

21. Ibid. Fromentin, of course, had mixed feelings about "mechanical reproduction," but it is clear that he was farsighted; his praise for Ruisdael's eye was monumental. His mixed emotions are typical of those of many artists and critics of the period. Baudelaire, too, often seemed contradictory in dealing with the new vision and the camera.

22. Fritz Novotny, *Painting and Sculpture in Europe 1780–1880*, Baltimore, Md., Penguin, p. 1

23. Ibid., pp. 2–6.

24. Schwarz, "Vermeer and the Camera Obscura," p. 177.

25. Van Deren Coke, *The Painter and the Photograph*, Albuquerque, University of New Mexico Press, 1964, p. 7.

26. Novotny, *Painting and Sculpture in Europe*, p. 119.

27. Ibid., p. 126.

28. Ibid., pp. 156–57.

29. Beaumont Newhall, foreword to R. Doty, *Photo-Secession*, Rochester, N.Y., 1960, p. 3.

30. M. F. Braive, *The Era of the Photograph*, London, 1966, p. 102.

31. Lady Elizabeth Eastlake, wife of Sir Charles Eastlake, Director of London's National Gallery, President of the Royal Academy and the first president of the Royal Photographic Society—written in 1857 in the American Edition of *The London Quarterly Review*, 1857, pp. 241–55 (a review of seven books on photography); reproduced in B. Newhall, *On Photography*, Watkins Glen, N.Y., Century House, 1956, pp. 96–103.

32. Braive, *The Era of the Photograph*, p. 290.

20. William Henry Fox Talbot. *The Open Door.* c 1843. Calotype. Reproduced from *Pencil of Nature,* London, 1844. International Museum of Photography at George Eastman House, Rochester, N.Y.

21. Pieter de Hooch. *A Maid with a Child in a Court.* 1658. Reproduced by courtesy of the Trustees, The National Gallery, London.

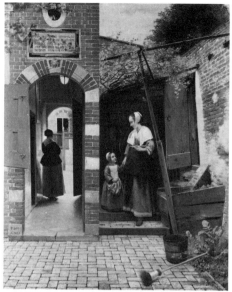

21.

22. Hendrick van der Burch (?). *Dutch Interior.* Staatliche Museen Preussischer Kulturbesitz Gemäldegalerie Berlin (West).

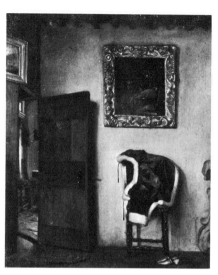

20.

22.

33. Even more than with other media, any discussion of nineteenth-century photographs suffers one handicap: much of the work has not been preserved. Traditionally photographs have not been highly valued. Not only does this attitude frustrate scholarship, it denigrates a medium of enormous potential which creative people have used with sensitivity since its inception.

34. William Henry Fox Talbot, *Pencil of Nature,* London, 1844, unpaged. The caption appears opposite Plate VI.

35. B. Newhall, "William Henry Fox Talbot," *Image,* vol. 8, no. 2, June 1959, p. 60.

36. This work has been attributed to Vermeer and de Hooch. It appears, from the extreme right section, as if it may be a fragment of a larger work, but there is no way to be certain. I have been unable, thus far, to discover·any illuminating evidence regarding this work.

37. Lorenz Eitner, "The Open Window and the Storm-tossed Boat: An Essay on the Iconography of Romanticism," *The Art Bulletin,* vol. 37, no. 4, December 1955, p. 283.

38. Ibid., p. 284.

39. Ibid., p. 285.

40. Seymour Slive, "Realism and Symbolism in Seventeenth Century Dutch Painting," *Daedalus,* Summer 1962, passim.

41. Ibid., p. 500.

42. W. Martin, "The Life of a Dutch Artist in the Seventeenth Century,"· Part 5, "Further Resources of the Dutch Painter," *Burlington Magazine,* vol. 10, 1906–7, pp. 363–70. More evidence to suggest they did work outdoors is now coming to light. I am indebted to John Wisdom and James Burke for sharing unpublished research.

43. Ibid., Part 1, "Instruction in Drawing," vol. 7, 1905,

pp. 125–28; Part 2, "Instruction in Painting," vol. 7, pp. 416–27; Part 3, "The Painter's Studio," vol. 8, 1905–6, pp. 13–24; Part 4, "How a Dutch Picture was Painted," vol. 10, 1906–7, pp. 144–54; Part 5, "Further Resources of the Dutch Painter," vol. 10, pp. 363–70.

44. Ibid., Part 1, pp. 125–28.

45. Though de Hooch is the most famous of the Dutch artists who used the spatial device of the view beyond an open portal, the first known dated Dutch painting of this type was made by Nicholaes Maes in 1655; see Neil MacLaren, *The Dutch School,* The National Gallery, London, 1960, p. 6. An earlier example can be found in the *Turin Hours,* executed in the fifteenth century.

46. Etienne Gilson, *Painting and Reality,* New York, Meridian Books, 1959, pp. 48–49.

47. Rosenberg, Slive, and TerKuile, *Dutch Art and Architecture,* p. 192.

48. Thomas P. Baird, *Dutch Painting in the National Gallery of Art,* Washington, D.C., 1960, p. 24.

49. *The Orange and the Rose,* p. 42; Rosenberg, Slive, and TerKuile, *Dutch Art and Architecture,* p. 189.

50. Rosenberg, Slive, and TerKuile, *Dutch Art and Architecture,* pp. 189–90. For more recent interpretations of Saenredam's working methods and purposes, see B. A. R. Carter, "The Use of Perspective in Saenredam," *Burlington Magazine,* vol. 109, October 1967, pp. 594–95, and Friedrich Wilhelm Heckmanns, *Pieter Janszoon Saenredam, das Problem seiner Raumform,* Aurel Bongers Recklinghausen. I am indebted to Arthur Wheelock for these references.

51. MacLaren, *The Dutch School,* pp. 379–80. The fact that so many architectural and landscape painters in seventeenth-century Holland did not paint their own

23. Jan Vermeer. *Lady at the Virginals with a Gentleman Listening.* c 1668–70. Buckingham Palace, Her Majesty Queen Elizabeth II, copyright reserved.

24. Emanuel de Witte. *Interior of the Portuguese Synagogue in Amsterdam.* c 1680. Rijksmuseum, Amsterdam.

25. Pieter Jansz. Saenredam. *Cathedral of St. John at 's-Hertogenbosch.* 1646. National Gallery of Art, Washington, D.C., Samuel H. Kress Collection.

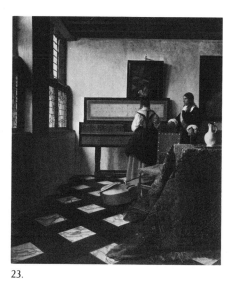

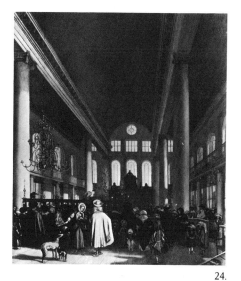

23.

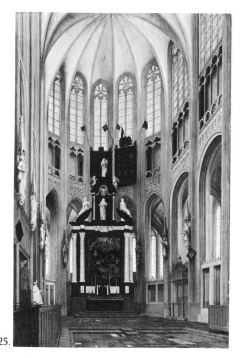

24.

25.

26.

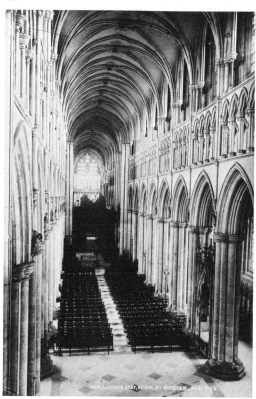

figures lends weight to the thesis that a camera obscura may have been used, for their subject matter remains immobile and thus perfectly suitable to its use, while figures cannot be counted on to remain still—witness the problems of early photographic portraiture.

52. Rosenberg, Slive, and TerKuile, *Dutch Art and Architecture,* p. 188.

53. B. Newhall, *The History of Photography,* New York, 1964, p. 110.

54. B. Newhall, *Frederick H. Evans,* Rochester, N.Y., 1964, p. 10.

55. Ibid., pp. 19–20.

56. Ibid., pp. 10–11.

57. Ibid., p. 20.

58. Ibid., p. 12.

59. Ibid., p. 10.

60. Ibid., p. 29.

61. Ibid., p. 20.

62. Ibid., p. 28.

63. Ruth I. Mahood (ed.), *Photographer of the Southwest, Adam Clark Vroman,* Los Angeles, 1961, pp. 9–20.

64. Hans Koningsberger et al., *The World of Vermeer, 1632–1675,* New York, 1967, p. 69.

65. Special thanks to the interest and criticism given by Seymour Slive, at whose instigation this paper was written.

26. George Washington Wilson. *Nave, Looking East, Beverley Minster.* c 1888. Albumen. International Museum of Photography at George Eastman House, Rochester, N.Y.

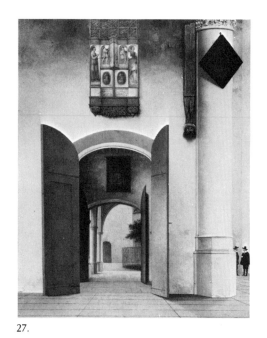

27.

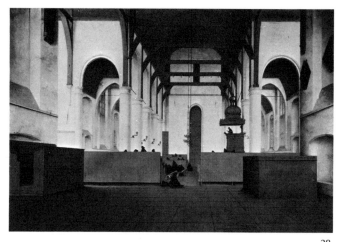

28.

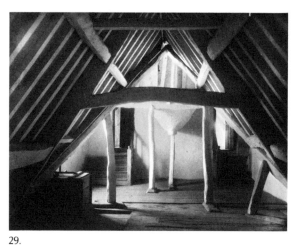

29.

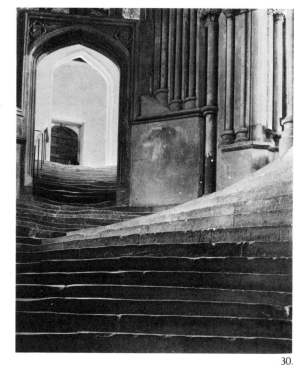

30.

31.

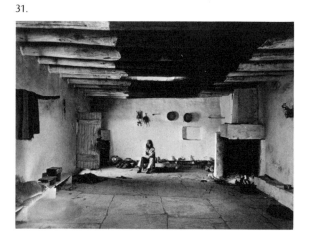

27. Pieter Jansz. Saenredam. *Interior of St. Lawrence's Church at Alkmaar.* 1661. Museum Boymans-van Beuningen, Rotterdam.

28. Pieter Jansz. Saenredam. *Interior of St. Odulphus' Church at Assendelft.* 1649. Rijkmuseum, Amsterdam.

29. Frederick H. Evans. *Kelmscott Manor: Attics.* c 1897. Platinotype. International Museum of Photography at George Eastman House, Rochester, N.Y.

30. Frederick H. Evans. *A Sea of Steps, Wells Cathedral.* 1903. Platinum print. International Museum of Photography at George Eastman House, Rochester, N.Y.

31. Adam Clark Vroman. *Zuni Pueblo:* Interior. 1897. History Division, Natural History Museum of Los Angeles County.

THE CUBIST PHOTOGRAPHS OF PAUL STRAND AND MORTON SCHAMBERG

VAN DEREN COKE

THE CUBIST PHOTOGRAPHS OF
PAUL STRAND AND MORTON SCHAMBERG

Van Deren Coke
*Director, University Art Museum
and Professor of Art
University of New Mexico*

In the final issue of *Camera Work,* published in June 1917, eleven photographs by Paul Strand were reproduced with comments by Alfred Stieglitz. He said Strand's pictures were pure and direct; that they did not rely upon tricks of process and were the direct expression of "today." This was a "today" in an America already populated by over five million automobiles. Despite this fact, few creative photographers had made pictures of automobiles, one of the most popular manifestations of the machine age. Those who had, did so in romantic terms, emphasizing the cloud of exhaust gases the early automobiles emitted or contrasting them with horses (Fig. 32).

Strand was apparently the first to see the expressive possibilities of taking a close-up photograph of a portion of a car to serve as a symbol of a new era, an era that was beginning to be shaped by the automobile. In late 1917, after the pictures reproduced in *Camera Work* had been selected, he made a key photograph, *Wheel Organization* (Fig. 33), which was composed of only a rear wheel and related parts of a Lozier. Up until this picture was made, wheels, cogs, and other parts of machinery were apparently not thought of as having aesthetic qualities. It is true that articles were written about and photographs published of the Corliss Engine, first shown at the Philadelphia Centennial Exposition in 1876 (Fig. 34). This engine, with its giant thirty-foot flywheel and clean unadorned pistons, was admired as a major American invention and as the most powerful machine ever built up to that time. It was also seen as an object of beauty, apart from its functional qualities.

No photographs, however, seem to have been made of details of this engine, taken with artistic intent in mind. Neither were detail photographs made of the very large dynamos developed a few years later which Henry Adams felt would eventually replace the Virgin as objects of veneration, so much did they evoke a feeling of awe.

Paul Strand, like most Americans, felt great respect for machines and what they meant as symbols of man's release from the limitations of sheer muscle. While his earliest photographs were of people, he soon began to photograph objects or parts of objects that had interesting shapes; the shapes as well as the possible meanings of these forms intrigued him. The paintings of Duchamp and Picabia, which he saw at Alfred Stieglitz's Photo-Secession gallery in New York, stimulated him, as did discussions at the gallery that centered on the idea that a mechanical object or a picture of such an object would become a comment on the ambiguity of man's position in a world being rapidly changed by machines.

What most stirred Strand's imagination was the precision of form and clarity of overall treatment found in Duchamp's work and, to an even greater extent, in Picabia's pictures that alluded to machinery. Picabia's *Machine Turns Fast,* 1916–17 (Fig. 35), and *Girl Born without Mother,* 1917, are examples of the innovative paintings then being created which incorporated gears or machine forms. Strand knew of such pictures as well as Picabia's 1917 cover for *391,* which was similar in content. Of course Strand also knew Picabia's *Here is Stieglitz. . . .* (Fig. 36), drawn in 1915, which represented the photographer as a folding camera. Stimulated by such examples and by his reaction to the machine-oriented world around him, Strand made a number of photographs in 1916 and 1917 which emphasized geometric shapes. These were thought of by Strand and others as being related to the abstractions being produced by painters. He was trying to apply the principles of form that grew out of Cubism to photography in order to better understand them. Once he understood what the aesthetic principles of this new vision were, he put this knowledge into effect in his work. Milton Brown, in *American Painting from the Armory Show to the Depression,* noted: "Under the impact of Cubism, Strand had turned in 1917 from his brilliant realistic portraits to the study of abstract manifestations in nature. Attempting to emulate the Cubists, but unable as a photographer to rearrange the world arbitrarily, he sought in it at least the appearance of abstraction. He found that through the use of new angles of vision he could discover new, exciting and often abstract forms in the most common objects or scenes. By his selection of points of view, he revealed abstract patterns of mass, light, and shade in the city's buildings and streets."[1]

Strand made a number of photographs as the result of finding, as Brown said, "abstract forms in the most common objects." *Circular Forms* (originally titled "Abstraction" by Strand) was reproduced by Professor Brown to illustrate the preceding statement. However, Strand's photograph of a wheel and a portion of the rear end of an automobile, *Wheel Organization,* is the best example of this aspect of the photographer's work. It links photography, Cubism, and in a sense American Dada, since it was inspired by Picabia's pictures of similar objects without being intended in any way as a Dada statement. Most people thought of the automobile as a noisy, rushing vehicle, but Strand photographed it in such a way that it became a tranquil, motionless object of formal unity made up of a harmonious "organization" of geometric shapes. By carefully

isolating a part of the car, Strand's pioneering photograph emphasized the essential nature of the mechanism. He set apart the basic forms and gave emphasis to the structural aspect of the wheel and the spokes as they radiated out from the hub to the rim and tire. By using a viewpoint that placed the spokes against a neutral background lighter in tone than the geometric shapes, he drew attention to the repetition of these forms so that they implied motion. Strand saw in the arching forms of the springs and the clear-cut shape of the wheel a rational beauty that was aesthetically stimulating as an arrangement of parts. As a symbol the car's mechanism was also made to stand for the motive power of the automobile and the automobile to stand for the machine age.

In 1918, Strand exhibited *Wheel Organization* in the thirteenth annual Wanamaker Photographic Exhibition in Philadelphia, the most avant-garde juried exhibition in the country. As one commentator wrote, "We may not agree with their awards, but we've got to admit they make us think. And after all, for several years, pictorial photography has been in a lamentable condition. . . ."[2] The print of *Wheel Organization* reproduced here is the print shown in Philadelphia. It was made from a 14-by-17-inch glass plate that had been enlarged, then printed by contact on Satista paper, a product of the Platinotype Company. A combination of platinum and silver, this soft brown paper was made during World War I as a substitute printing paper when the usual ingredients of platinum emulsions were not available.

Strand's position in the world of creative photography at the time he submitted this picture for the Wanamaker Exhibition is indicated by the following quote from *The Camera* magazine:

> On the day the entries closed, a certain young gentleman walked into Wanamaker's Kodak Department with a package of prints. Finding one of the young ladies in the department unoccupied, he inquired whether any prints had been received from Mr. Sheeler, Mr. Schamberg or Mr. Strand, and was told that it was even so. Since the same gentleman had won several small prizes in previous years, someone asked him about this time what he expected to pull down.
>
> "Sheeler, Strand and Schamberg will win all the big money," he replied, "so I may break in on the little prizes." (They did and he did.)
> "What makes you think that?"
> "Because they are *the* Trinity of Photogra-

phy—Mr. Stieglitz says so. Last year I bet even that the only print Strand entered would bring first prize, because it was the frontispiece in *Camera Work* . . . it did."[3]

As predicted, Charles Sheeler won the first prize for one of his Bucks County, Pennsylvania, photographs of a detail of a house interior. He also won the fourth award for his now famous *Bucks County Barn*. The critic W. G. Fitz, commenting in *The Camera* on the prize-winning prints, felt that the Sheeler print which won the top award was merely a technical exercise.

Strand's *Wheel Organization* won second prize. Fitz was more enthusiastic about this choice:

> I have a lot to say for this print. From one viewpoint it is the biggest and strongest print in the show. It almost fulfills our recipe for a great picture. In the first place, the execution is good. It is a striking arrangement, with good values, and is a mighty good technical print, well mounted. In the second place, Mr. Strand has felt that this segment of wheel expressed not only the power of the thing itself, but also the cohesive strength of business, the spirit of the industry which produces it.[4]

Further remarks by this critic shed light on the truly innovative aspects of Strand's pictures compared to the work of other prominent photographers. Fitz said of the work of a California photographer who worked then in a soft-focus fashion, "Mr. Edward Henry Weston, who makes decorative prints not concerned with expressing profound thought, has not improved, to say the least."[5] Strand's work overshadowed Edward Weston's in 1918 but was mentioned in the same sentence in the comments in *The Camera* magazine with that of Morton Schamberg, a painter and photographer who was a close friend of Strand.

Schamberg, a protégé of Stieglitz like Strand, seems not only to have absorbed from Picabia and Duchamp an interest in machines as motifs for expression of aspects of modern life but also to have intuitively understood how to apply the fractured quality of Cubist form to photography. A prime example, for many years in Charles Sheeler's collection, is Schamberg's 1917 photograph taken from the roof of a high-rise building down into a cluster of box-like commercial structures on an unpopulated city street (Fig. 37). He used light in a very effective fashion to emphasize the linear elements in the scene as they zigzagged across the seemingly tilted-up forms of heavily framed windows and parapet-topped roofs. The compressed sense of space he evoked was exaggerated by the dark shadows that obscured the blocky character of the buildings. Triangles, polygons, and other angular shapes—some solid, others seemingly transparent—interact very much as the forms do in an analytical Cubist painting. The serrated outlines of the roofs of the machinery sheds on the tops of the buildings and the odd-shaped roof of the window that juts out from the wall of one building break up the static masses of the masonry structures. As Schamberg had been trained in architecture we can understand his fascination with the problem of representing the geometric aspect of buildings. After his study of architecture at the University of Pennsylvania, he was trained as a painter at the Philadelphia Academy of Fine Arts. This facet of his life is also reflected in the photograph reproduced, for in it we can see Schamberg's sensitivity to the shaping effect of light and the importance of deep shadows to convey a feeling of mass and the illusion of the third dimension. An exhibitor at the Armory Show in 1913, he was well aware of the ground being broken by the Cubists and in the last two years of his life—he died of influenza in 1918 at the age of thirty-seven—divided his time between painting and photographing machines in a Cubist fashion. He, like Strand, was partly influenced by Picabia, but made photographs of buildings from a different standpoint. Schamberg's refer back to his experience with solid and plane geometry when he worked at the drawing board as a student of architecture and dealt with forms that intersected and spaces that were partially made transparent by windows.

As mentioned previously, Schamberg died in 1918. Strand continued to explore the expressive possibilities of close-ups of machines and in 1922 took some photographs of the mechanism of his Akeley movie camera, as well as of a milling machine and a lathe. These were in many ways similar to his friend Schamberg's early paintings of parts of machines, but were presented in a more romantic fashion (Figs. 38–39). Strand has expressed the idea that machines not only play an important role in our lives but are to be admired also for their sheer beauty. Time and again he has photographed the power and marvelous precision which the very functional forms, surfaces, and lines of the machine reflect.

Both Strand and Schamberg compressed into single exposures a Cubist sense of interlocking shapes to provide us with a better understanding of the subtle relationships of the parts of machines, as well as the relationships of the many elements that must be combined in modern buildings which in their complexity are similar to machines.

38

NOTES

1. Milton Brown, *American Painting from the Armory Show to the Depression*, Princeton, N.J., 1955, p. 126.
2. W. G. Fitz, "A Few Thoughts on the Wanamaker Exhibition," *The Camera*, vol. 22, no. 4, April 1918, p. 201.
3. Ibid., p. 202.
4. Ibid., p. 205.
5. Ibid., p. 207.

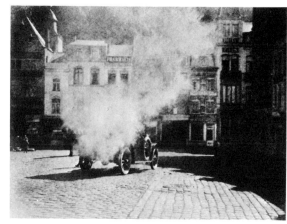

32.

32. Henry W. Dick. *The Eclipse of the Horse.* 1908. Collection Eleanor and Van Deren Coke, Albuquerque, N.M.

33. Paul Strand. *Wheel Organization.* 1917. Collection Eleanor and Van Deren Coke, Albuquerque, N.M.

33.

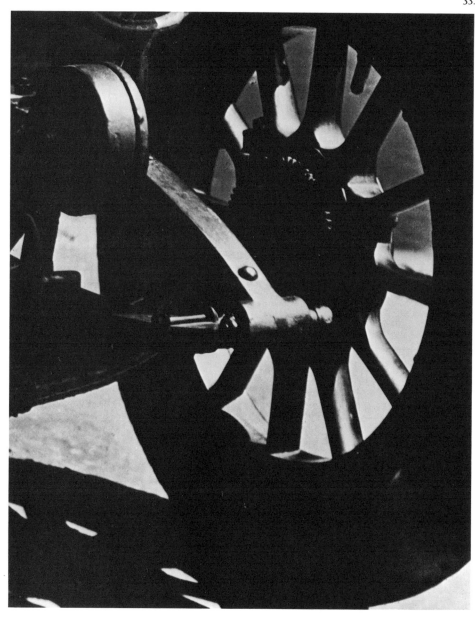

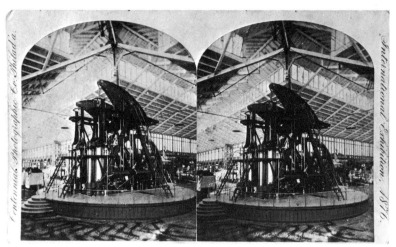

34.

34. Photographer unknown. *Corliss Engine*. c 1876. Collection William C. Darrah, Gettysburg, Pa.

35. Francis Picabia. *Machine Turns Fast*. 1916–17. The Estate of Fred Shore.

36. Francis Picabia. *Here Is Stieglitz.* . . . 1915. Collection Eleanor and Van Deren Coke, Albuquerque, N.M.

37. Opposite page. Morton Schamberg. *Roof Tops*. 1917. Collection Eleanor and Van Deren Coke, Albuquerque, N.M.

35. 36.

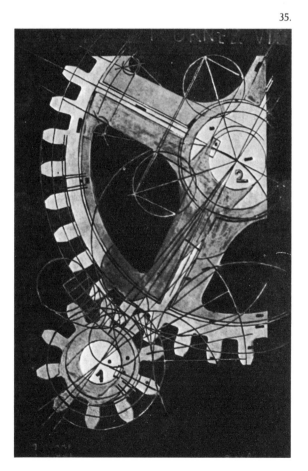

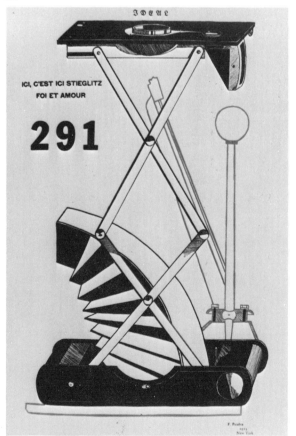

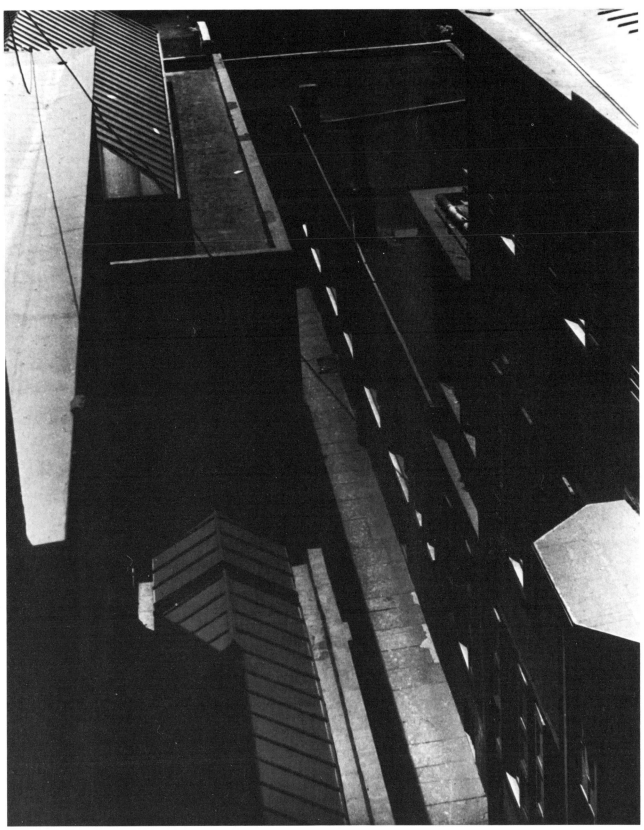

37.

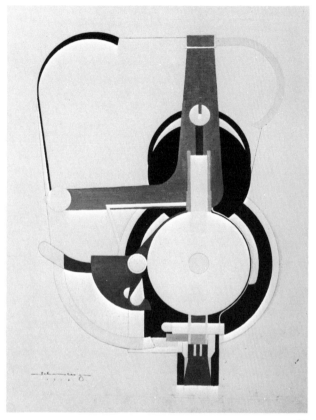 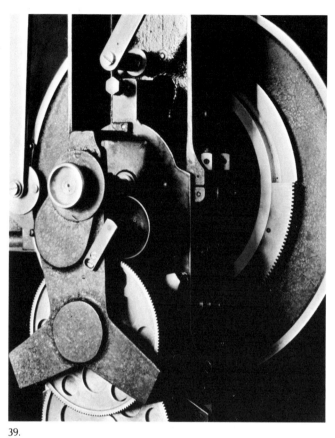

38. 39.

38. Morton Schamberg. *Machine*. 1916.
Yale University Art Gallery.
Gift of Collection Société Anonyme.

39. Paul Strand. *Double Akeley*. 1922.
Collection Paul Strand, Orgeval, France.

STEREOGRAPHS: A NEGLECTED SOURCE OF HISTORY OF PHOTOGRAPHY

WILLIAM C. DARRAH

STEREOGRAPHS: A NEGLECTED SOURCE OF HISTORY OF PHOTOGRAPHY

William C. Darrah
Professor, Gettysburg College

Historians of photography, while commenting upon the popularity of stereographs in the nineteenth century, have nevertheless slighted them. To be sure there are many well-known photographers whose stereo work is fully appreciated. John Soule (Boston), John P. Heywood (Boston), Charles Bierstadt (New Bedford and Niagara Falls), John Carbutt (Chicago), and William H. Jackson (Denver) have received deserved recognition. The images of the pioneers, Langenheim Brothers (Philadelphia), Edward Anthony (New York), William Notman (Montreal), and Alfred A. Hart (Sacramento) are eagerly sought by collectors.

The demand for these classics obscures a rich, almost untapped source of photographic history—the output of literally thousands of local stereophotographers who not only recorded the day-to-day life of a half-century but also experimented in countless ways and contributed substantially to the art and technique of photography.

In 1859 Oliver Wendell Holmes proposed the term "stereograph" for the stereoscopic image, in keeping with the concept that photography was the art of making sun pictures. He wrote enthusiastically of their educational and avocational possibilities and urged the development of private collections and public libraries of them. Holmes did not initiate the stereo fad, for it was already full blown in England and France, but his essays did stimulate great interest in the United States. His invention of the familiar hand stereoscope further increased the popularity of card views. Holmes's term "stereograph" was quickly adopted by the vast majority of photographers, who printed it on their cards, in trade lists, and in professional publications. For forty years, 1900–1940, the great producers of views, Underwood and Underwood and the Keystone View Company, proudly advertised their magnificent "stereographic libraries." For almost a century the designation "stereograph" or simply "stereo view" was universally used. The recent substitution of "stereogram" thus is inconsistent with long-established practice.

The sheer numbers of stereophotographers and the diversity and volume of their production are worthy of serious attention. In 1946 I began to index all stereophotographers known to me through actual examination of their views. As of June 1972 the index includes 5,875 North American and 1,450 foreign names documented by approximate dates of operation, addresses of studios, and notes on types of views and workmanship.

It is probable that this total represents less than half of those who operated in the United States

between 1858 and 1900. Approximately 400 additional names, gathered from advertisements and newspaper references, are not included because actual views have not been examined.

Of the nearly 6,000 American stereophotographers, nearly 100 produced prints from 10,000 or more negatives; nearly 400 produced more than 1,000 titles; more than 2,000 produced more than 500. For the other photographers (more than 3,000 of them) no reliable numerical data have been thus far obtained.

One example will show how quickly numbers pyramid. H. S. Fifield from 1868 to 1883 operated a summer studio at Lincoln, New Hampshire, near the Flume. With a single background, the poised boulder in the flume, he photographed tourists who wished to have a memento of their visit. Fifield averaged a thousand negatives annually, each year numbering consecutively from "No. 1." It is virtually impossible today to reconstruct long runs of these stereographs because each title, being essentially personal, was issued in small quantity.

Stereographs were produced commercially to provide income for the photographers. Thus prints were usually issued in considerable numbers, as long as a demand for the title continued. Sometimes the number ran into the thousands. I have personally handled more than fifty copies of about seventy different Kilburn Brothers views published between 1868 and 1875—before they began mass production. Even a small issue by a village photographer might exceed a hundred copies. The possibility of locating a specific title or of reconstructing a series of titles is therefore quite substantial.

The total number of different stereographs produced commercially in the United States may never be known. Certainly there were more than three million, perhaps more than five million. Yet the volume and diversity is of less significance than the patterns of operation which have in consequence provided us with an almost inexhaustible reservoir of information. Two aspects seem to be indicative of potential importance to historians and collectors: geographic distribution and modes of operation.

The geographic distribution of local stereophotographers during the period 1858 to 1900 is impressive: four states (New York, Pennsylvania, Massachusetts, and New Hampshire) had more than 500 each; ten had more than 200; eight had more than 100; and ten had more than 50. In short almost every city, town, and village of modest size had one or more stereophotographers. A notable exception must be mentioned. The southern states, impoverished after the Civil War, supported relatively few photographers,

particularly in the smaller towns. Consequently, southern views are among the most difficult to locate.

Every local historical society has at least a few photographs among its collections, but seldom has a concerted search for stereographs been undertaken.

There were five main types of local operators:

1. The photographer who specialized in the production of stereo views and confined his practice to local subjects. In many cases he continued operations for a decade or more, generally accumulating a trade list ranging from several hundred to many thousands of negatives.

2. The resort photographer (and there were hundreds of them at Saratoga, White Mountains, Catskills, Niagara, etc.) who virtually limited his work to tourist trade. Many produced negatives numbered in the thousands.

3. The studio photographer who, as a sideline, produced stereographic portraits, poses, interiors of churches and public buildings, commonly issuing a small series of local town views. Most of these are relatively scarce and seldom recognized.

4. The opportunist who produced a few stereo views when some unusual event—flood, fire, tornado, parade, etc.—created a transitory market for souvenirs. In some instances, the negatives or rights to them were sold to large-volume publishers.

5. The roving photographer, who in addition to the production of local views, traveled sometimes quite widely to photograph scenes and events that might interest his clientele. Such issues would be relatively small and the cards consequently scarce.

Nearly every photographer developed his individual style of mounting and labeling, his own degree of skill and artistry, and his own methods of merchandising. Perhaps of more immediate importance is the common relationship between the character of the subjects and the locality in which the photographer operated. A few examples may suggest the nature of these interrelationships.

W. N. Hobbs (c. 1860–75) issued more than three thousand stereographs of the vicinity of Exeter, New Hampshire. Although a majority were intended for the summer resort trade, the cards were produced with great care. A rustic simplicity characterizes his composition.

M. A. Kleckner (c. 1860–80) operated studios in Bethlehem, Allentown, and Mauch Chunk, Pennsyl-

vania. His views exhibit unusual diversity of subjects, composition, and purpose. A remarkable series of some two hundred cards shows the Moravian community of Bethlehem, including domestic arts and crafts. Another small series, with brilliant prints, depicts the mills and mines around Catasaugua, Allentown, and Friedensville. The Mauch Chunk views are typical tourist resort scenes.

J. Freeman (c. 1865–80) operated in Nantucket, Massachusetts. His photographs, of which there are more than twelve hundred covering the town, the island, the ocean, fishing, and whaling, are superb.

J. H. Hamilton (c. 1875–82), Sioux City, Iowa, issued several hundred fine views of the town and vicinity. Hamilton, unlike most of his contemporaries, included people in his photographs.

Theodore Lilienthal (c. 1860–75) thoroughly covered New Orleans and the river front. His many photographs of Mississippi River steamboats are among the most beautiful ever produced.

The list could be extended into an encyclopedia —John Mather (Titusville, Pennsylvania) for his views of the oil region in the infant days of the industry; J. J. Reilly, who operated first at Niagara Falls and later at Stockton, California; J. F. Kennedy of Hotsprings, Arkansas; A. C. McIntyre (Alexander Bay, New York) for his countless views of the Thousand Islands.

Two examples of local photograhers who traveled to augment their trade lists show some surprises. Thomas T. Sweeney (Cleveland, Ohio) issued many fine city views but is better known for a comprehensive series of the Chicago Fire. W. E. Bowman (Ottawa, Illinois) was primarily a portrait photographer but his work includes not only hundreds of fine stereographs of Ottawa and vicinity, but also some beautiful views of Niagara Falls (c. 1865) and Washington, D.C.

While most photographers exploited landscapes and street scenes, there were many who experimented in a variety of directions.

Charles H. Shute (Edgartown, Massachusetts) issued many conventional views of Martha's Vineyard but achieved a remarkably realistic series, "A Whaling Voyage," with model ships and figures, by "table top" photography.

Carl Meinerth (Newburyport, Massachusetts), a versatile musician-jeweler-photographer, made many intriguing still lifes, silhouettes, vignettes, and indoor poses—but not studio—in stereographs.

From the time of their introduction in 1851 until 1865, stereoscopic views were purchased for cultured entertainment. The price of individual cards, 25 and 35 cents for domestic and 35 to 75 cents for fine European, restricted the pleasure to the well-to-do. Gradually, by the mid 1870s the price of views decreased as cards were produced in greater volume and inexpensive format. At the same time, a flood of trivial cheap views was turned out for the amusement of children and the uneducated. Until 1885 local photographers seldom engaged in the cheap trade. They continued to produce fine views, but in drastically diminished volume.

Were one to desire photographic documentation for a given year or date, a specific event, a particular locality or structure, a trade or occupation, a railroad route or a factory, a thorough search *should* be rewarded with reasonable success.

The rising prices of desirable views is reversing a trend of many years. From 1940 to 1970 fine stereographs were moving toward libraries and institutions. Now, however, the private collector able and willing to outbid the competition is "skimming the cream." Collectors have always been the great accumulators and concentrators but too often the rarities of historical interest disappear and become unavailable for research or reproduction.

Perhaps the greatest immediate need is the concentration of information about stereographic collections and stereoscopic photographers. Where are the institutional collections and what are their resources? Who holds the comprehensive and specialized private collections? Are these available for examination or reference? Could there be compilations or check lists of photographers with or without annotation?

The stereograph will prove to be of increasing usefulness to the historian, not only of photography but more widely of technology and of local and social history. Where else can one search among *millions* of photographs of the period 1850–1920?

REMARKS TOWARD AN IDEAL MUSEUM OF PHOTOGRAPHY

ALAN FERN

REMARKS TOWARD AN IDEAL MUSEUM OF PHOTOGRAPHY

Alan Fern
*Chief, Prints and Photographs Division
Library of Congress*

In October 1970 I was invited to speak about the organization of the ideal photo museum in Stockholm, to provide food for thought to the organizers of a new institution there. The occasion provided one of those rare opportunities for utopia-creating so lacking in the everyday life of the museum administrator, and I enjoyed to the fullest having a chance to enunciate plans without worrying about how they could possibly be put into effect. Out of this exercise in impracticality came a few ideas that I feel deserve consideration by anyone involved in the establishment or management of a photographic collection. Some of my thoughts will be all too obvious and too basic to interest experienced curators, and some of my proposals may be questionable, but I hope that those who are facing these problems for the first time may find something of value in what I have to say.

There is no doubt in my mind about the ideal museum of photography. First of all, it is in my own city. It has everything in its collections, and all objects of importance to my current work are on view when I visit. It is comfortable to work in. The galleries and study rooms are brilliantly lit, but not with any light that would cause the objects to deteriorate. Facsimiles of all its collections are available, preferably free of charge, and preferably made up in advance so I do not have to wait to receive them. It is open evenings, weekends, and any other time I can get away from my office. Its staff is never busy when I come—they attend conferences, go out of town, install exhibitions in the galleries, but never when I need to see them. Its halls are never disagreeably crowded with tourists, schoolchildren, or other addicts of photography.

Surely you all agree with my description, and perhaps you even have a few points of your own to add, but if you think about your consent to these characteristics you will also have to agree that such a museum is a logical impossibility. My city is not your city. No one place will do for everyone, so several centers are necessary.

It follows from this, and from the nature of photography, that no one museum can have everything. True, multiple prints of most photographs are made, so Paris and New York and Tokyo can have identical Cartier-Bressons, but what is to be done about the unique negative, or the daguerreotype or ambrotype that exists only in a single copy? And what about the few careful prints made by the photographer, in contrast to the prints for publication made by his lab?

Think of the wall space needed if every photograph in a large collection (say, the couple of million

images in the Library of Congress or the Bibliothèque Nationale) were to be on view. If they are not all on view, how can anyone predict what I will want to see the next time I visit the museum? And who will pay for the production of the facsimiles we want to take away—without charge?

If the staff is always there, who will go out and find new acquisitions? Who will plan programs and solve problems without internal conferences? When will anyone get a vacation? And if the museum is so fine, how can it be kept uncrowded? Who shall decide who is to be excluded? A private collector can be arbitrary (and I know of a few cases where, being arbitrary, he made serious mistakes against his own self-interest as a collector!), but a public museum, supported by a government or a charitable foundation, has an obligation to thousands of people. It cannot deny them access, and it should not.

No. My definition will not do, even though it suggests some obligations that the museum must try to fulfill. It is too self-centered, too focused on the individual visitor. The public is one of the most basic considerations to be taken into account by museums, and one most often poorly defined.

The definition of the museum's *public* is, of course, interrelated with the nature of its *collections*, its *staff*, and its *programs*, and my remarks will be organized around these four topics to suggest the directions I think the ideal museum might take in these areas.

When we talk about the public, or the museum's audience, we have to define the limits of this group for any one activity. Everyone in the city will not go to the ballet on the same evening, or to the art gallery, or to the movies. All our public facilities function on the assumptions that some people will want to do one of these things at a given time, that some people will select another time for the same activity, and that many people will never choose to do some of these things at all. Even if the audience is potentially limited, the rich culturul life of the city demands that these resources be available. The head of the Smithsonian Institution, S. Dillon Ripley, wrote not long ago: "I would contend that museums are the greatest available laboratory for studying the problem of how to create interest, and that this problem is central to our quest for survival as people."[1]

Thus, capturing the interest of the general public is one of the missions of the museum. Bringing them into contact with the treasures of the museum, and guiding that interest, will create a sophisticated group within this general public.

From this group and from others already deeply involved, the museum will find it also has a serious —and smaller—public, a group demanding answers to individual questions, presenting intelligent suggestions, and needing individual guidance. Entirely different facilities are needed for these people, in contrast to the general public.

From this smaller group will come the future leaders of the museum profession itself, and in this group will be found the creators of the photographs collected by the museum as well as the most sophisticated collectors, interpreters, and connoisseurs of photography. A museum ignores its specialized public at its own peril, and only if it is very misguided. So there are at least two publics, and their needs and interests are different. But basically, they have in common that they come to the museum because of its collections.

A wise museum official has pointed out that "A museum may collect anything but it cannot collect everything,"[2] sage advice often forgotten when the acquisitive juices begin to flow. Obviously, a museum cannot have what is already in another public museum, and since—equally obviously—no existing museum of photography can be called "ideal," our Ideal Museum of Photography will have to be new and it will have to do without several essential objects. Nicéphore Niépce's first successful photograph is in the Gernsheim Collection in Texas. Atget's negatives and many original prints are in New York. Brady's negatives are in Washington, Fox Talbot's are in England, and many others could be mentioned.

There is still more than enough to go around, and enough to swamp a new institution. Fortunately, leaving negatives aside, the characteristic multiplication of the photograph makes collecting still possible, as it is not with such unique objects as paintings, if one enters at a later stage than other museums.

It could be argued that only the recorded image is of significance in a photograph, so these worries about unique negatives and daguerreotypes are rubbish. From this standpoint, a superb museum of photography could be compiled from copy photographs and modern prints from early negatives, all without the troublesome problems introduced by handling and conserving precious originals.

I accept this argument only for one portion of the collection; for the rest, the original is essential. First of all, the photographer himself thinks in terms of achieving a specific effect with specific materials. His composition, exposure, scale, focus, all derive not only from an aesthetic stance he assumes but from

the very material he uses. To render this material in another material is like reproducing a bronze statue in soap, or translating Shakespeare into Chinese: the idea may be there, but the unity and ultimate quality of the original are lost.

Moreover, no single technique can capture all the information present in every other technique. Modern films very imperfectly render the image, color, sharpness, and scale of a daguerreotype, for example, and cannot do justice at all to a platinum print. Copies destroy the tactile and sensual experience that can be transmitted only in the original.

If we do not expose our publics to these actual objects, we can never interest them truly in early photography (or even in recent work) apart from transmitting to them the simple antiquarian pleasure of knowing other times and other places. This is a laudable romantic aim, but it has little to do with bringing people to an understanding of what photography is actually all about.

So I feel it is essential for the Ideal Museum of Photography to adumbrate the great historical examples, when it cannot get originals, by copies of the images, but to strive mightily to collect superb originals whenever it can and to distinguish them in its cataloging and labels.

The collection ought to have an individual character, too. We do not have an "agreed history" (or aesthetic) of photography, and we do not need to function purely in terms of masterpieces someone else has discovered. Local or national interest may be one of the most logical sources of this individual character. I have been astonished that until very recently such countries as England, Germany, Japan, and Sweden, with a notable role in the development of photography, have not had substantial national museums concentrating on their photography. France and the United States, more organized in this respect, still have not created institutions with the precise individual flavor I am advocating. I hope someone will, soon.

These are just examples of the questions that the new Ideal Museum will have to answer as it creates its collections. It will also have to consider whether the motion picture belongs in its collections, and whether it is prepared to face the problems created by the showing and demonstration of the equipment and the technical processes involved in the art of photography. Probably it should be involved in these two areas; space does not permit a fuller consideration of these matters, though, since we must pass on to other matters.

Once the character and scope of the collection

have been defined, acquisitions for the Ideal Museum must be made; later, surplus things must be weeded and placed where they will be more useful or more relevant, and the collections must be arranged, classified, and cataloged and portions of them displayed. This does not happen automatically, of course, and it sometimes does not happen even when a large and enthusiastic staff is on board. Leadership and definite goals toward which to aim are essential. But without a staff nothing whatever will be done with even the most distinguished holdings.

In staffing our Ideal Museum of Photography, I wish I could direct you to an academy busily at work training and accrediting such people as are required. Unfortunately, none exists. This is not limited to photography; the greater number of art historians would rather teach in universities than work in museums, and it is very difficult to find a scientist or engineer who would regard a post in a museum of science or technology as a likely fulfillment of his career. Many end up there, and do brilliant work and are amply fulfilled, but they did not train for this and too rarely encourage younger colleagues to prepare for it, either.

Three kinds of staff are needed: administrators, curators, and technicians. Unfortunately, these exist —when they exist at all—in a hierarchical order, with administrators at the top and technicians at the bottom. This not only is a false series of standards, but ultimately defeats the purposes of the museum.

Every museum needs just as much competence in its conservation lab as in its budget-planning committee. There will be no museum without funds, but there will be no need for the funds if all the collections disappear through deterioration. There is no point in being finicky about conservation techniques if exhibition and photocopying personnel damage the objects in handling them. There is no point in a director arguing for buildings and funds without curators to identify and interpret the objects to go into the buildings. And so on.

Many superb conservators are miserable administrators, and many curators are primarily interested in their subjects so they will be unwilling, or poor, administrators. Yet we make it almost impossible for most museum personnel to reach a high status without becoming administrators to a greater or lesser degree.

Our Ideal Museum ought to make an attempt to rectify this situation, and to present a satisfying career line to all kinds of staff without insisting on this misleading hierarchical scale. Since it will have to

find its staff in unlikely places, having a system in which jobs of all kinds can lead to high status and pay ought to make it easier to persuade people who had thought of their careers in other terms to join the museum's staff.

It is not easy to be more specific about the precise qualifications to be sought in a staff until the program of the museum is adequately defined, and this is difficult until the nature of the collection has been established.

Assuming that our Ideal Museum draws part of its individuality from a national or local area, the staff members have to be intimately familiar with the past history and current "scene." They will have to know the languages, customs, economics, and all things related to the artifacts they collect. This may seem an obvious point, but we are often so concerned to have experts in the general history of our arts that we frequently slight more specific local expertise.

I have already said that I believe the Ideal Museum must serve at least two publics, and for this a variety of distinct programs of work will be necessary.

For the general public there must be continuous exhibitions, directed toward explaining the processes and indicating the visual history of photography. These should be carefully constructed for accuracy, simplicity, visual attractiveness, and diversity. The visitor should be able to move from a general comprehension of the photosensitive action of the substances used in photography to a fairly sophisticated realization of what has made photography a memorable recording and artistic medium. Traditional exhibition techniques must be augmented with closed-circuit television displays, subtle optical demonstrations, even working darkroom or Polaroid equipment, to make this as lively and meaningful as possible.

Through these exhibitions, and the written material—wall labels and leaflets—accompanying them, the professional staff will communicate directly with the general public, but with a minimum of personal contact. Through lectures, film programs, and television, the staff will be able to broaden this background and come into more direct contact with the public.

Then there should be changing exhibitions, carefully chosen from the collections of the museum or from the collections of sister institutions, to inform the visitors about some aspects of photography in depth. The exhibition programs of the George Eastman House or the Museum of Modern Art have been so admirable over the years that the administration of our Ideal Museum need only study them to

see what can be done in this area. Traveling exhibitions—assembled and circulated with a due regard for the hazards of shipping and the provision of adequate security in a nonmuseum environment—will serve to further broaden the general public of the Ideal Museum, and should definitely be part of its program.

The more specialized researchers—photographers, photo historians, and writers—will not be adequately served by these activities. For them, the museum's plans will be less glamorous and less easy to execute.

A well-ordered study center will be a necessity, with adequate areas for the convenient and safe study of the objects held in the reserve collections of the museum. Extensive catalogs, cross-indexed by subject, photographer, place, date, technique, and any other points of access needed, are essential, and a convenience would be the provision of a small photo image of the object cataloged on each index card, to permit the researcher to select only the objects he really wishes to study.

For both researchers and staff, a library is essential, and not one restricted to books on photography alone. Basic reference works in many areas will be needed, and whenever books use photographs from the museum's collections copies of the books should be retained, appropriately marked. This is not only for the production of statistics about the use of the collections at budget time—although that function should not be scorned—but also so that when the inevitable requests for copies of the picture on page so-and-so of such-and-such a book come in, these requests can be satisfied quickly and accurately.

Another facility that must be provided—or actually will provide itself if the museum is much used—is a collection of copy negatives for reproduction of originals in the collections. These will have to be keyed to the corresponding objects, to save expense and wear and tear on the objects when succeeding copies are needed.

These are just a few of the aspects of the program for its publics our Ideal Museum must provide when it defines the physical plant it will need. Questions of artificial lighting, building arrangement, and special technical facilities will have to be settled with the architects, who will need to concern themselves with specific climatic and site conditions as well as these functional matters.

In all I have said about programs, I have left out one important "public": photographers. How does the Ideal Museum of Photography serve them?

This is a question that cannot be answered without knowledge of the city in which the Ideal Museum of

Photography is located. If there are galleries where contemporary photography is intelligently shown and offered for sale, the Ideal Museum need do no more than publicize the activities of these galleries and select the finest things shown for purchase for the permanent collections. (Please note, I said purchase. If possible, the museum should be a client of the living artist, not a beggar from him. I have no objection to soliciting gifts from those who do not earn their living from the practice of an art, but most working artists and photographers are not so well off that they should be required to subsidize museums.)

If, on the other hand, there are no places nearby where contemporary photographs can be seen and bought, then the Ideal Museum must become involved. This portion of the program ought to be kept strictly separate from the other activities of the Museum, for it is not desirable to submit young, perhaps experimental, and certainly developing photographers to the same rigorous standards as are applied to permanent additions to the collections from other sources. Perhaps the quirks and oddities of curatorial direction can most perfectly be avoided by putting the gallery activity into the hands of various responsible photographers' groups, either on a cooperative basis, or on a rotational schedule throughout the year. This will be no less idiosyncratic, but at least the oddities will be those of the photographers themselves and not imposed—or superimposed—on them.

Much more could be suggested for the program of the Ideal Museum, but time permits mention of only one other: publication. From the start, our Ideal Museum must put its exhibitions into permanent form through catalogues of a scholarly yet lively nature, and it should endeavor to publish as much about its collections as possible so the museum can communicate beyond its walls and its locality, and so its staff can share its knowledge with future generations. A worthwhile program of publications would include imaginative and superbly produced facsimiles of the finest objects from the collections, or of those that are the most fun; an example that I have liked is the series of little "flip books" of early films produced for *Expo* by the Canadian *Cinémathèque*.

It is not going to be easy to organize the Ideal Museum of Photography, but I sincerely hope that someone, somewhere, will find a sponsor sufficiently intelligent, enlightened, and wealthy to do it. The director of the Ideal Museum will have to steer between the Scylla of technical involvement and the Charybdis of pure aesthetics. The job involves capturing the century-and-a-half history of a whole

world of photography while recognizing local developments. It involves finding or creating committed, experienced, and intelligent staff, who can communicate insights to both the specialist and the schoolchild—and who want to.

Above all, the museum must strike a fine balance between recognition of contemporary practice and study of the past. It is bad to be a captive of a portion of the complex competitive world of today, but it is fatal to try to exist without it. After all, the Ideal Museum of Photography celebrates an art superbly practiced today. By the same token, exclusive dedication to the past makes a curator incapable of seeing the meaning of today's work.

The Ideal Museum must be a needed part of the community—not an artificially exciting place—not a fashionable showcase—not dry as dust—not aristocratic—but a naturally accepted cultural and educational resource.

Above all, the museum must not be afraid to have opinions, to represent something. I feel that the Ideal Museum of Photography should say to the world that it represents enduring human concepts in its particular field, and it should say so eloquently.

Does it exist? Can it exist? Will it exist?

NOTES

1. S. Dillon Ripley, *The Sacred Grove,* New York, Simon and Schuster, 1969, p. 101.

2. Douglas Allan, in UNESCO, *The Organization of Museums,* Paris, UNESCO, 1960, p. 15.

ON APPRECIATION

ROBERT F. FORTH

ON APPRECIATION

Robert F. Forth
Vice-President for Academic Affairs
California College of Arts and Crafts

Many of us owe a debt of gratitude to historians concerned with photography as their primary referent. Their work has offered those of us who use photography in other ways a kind of "capital" that runs into large numbers—all they have been able to accumulate and call our attention to as the "past." This capital permits us to purchase certain kinds of motivating power we cannot always find in ourselves alone, to continue to invest our energy as if we were returning interest gained into an enterprise we believed to be sound and useful to man.

This learnedly valued way of transacting the arts and crafts of photography is not always easy to pursue, particularly in recent times, governed as we increasingly are by a contradictory "existential philosophy of cloture," expressed in the rhetoric of the laws of probability and diminishing-return economics. We are told that we must make decisions (exposures) from existing choices if we wish to make anything essential and meaningful out of life (existence), yet we are also told that the more choices and decisions we make, the more our next choice or decision will become predictable and redundant. We are told this by some behavioral scientists, population scholars, ecologists, economists, government officials, businessmen—and even astronomers and cosmologists—as well as by that most primitive "expert," our own changing, aging body language. In the face of such rational authority, it becomes difficult to keep faith in the open-ended alternative theory of creative behavior that proposes there are surprises and random wonders our imaginations have yet to touch on, that learning is like pursuing the mathematician's *surd,* which suggests that all things cannot be expressed in rational terms, that there are some things (such as $\sqrt{3}$ or *pi*) which are rationally *approachable* but not rationally *soluble,* that the irrational is also a possibility, given a large enough universe of the imagination.

Given only the ancients' view of the universe as a large number, which suggests that the universe is a finite wheel, forever revolving about the earth or the sun (depending on which ancient one attends to), then we are chained to this "wheel of life" and doomed to repeat ourselves in proportion to the size of the wheel, how rapidly it revolves, and how long we live (or how often we are repetitively reincarnated and at what position in relation to the hub). Probability and diminishing return are the laws of this circular, finite motion, and *the absurd,* not *the surd,* becomes man's rational fate. Even the late Paul Tillich expressed something like this fate: that life cannot be reversed, but it can be repeated. The

medieval world view, that the universe is a clock made up of "wheels within wheels," still leads to the absurd for rational man. Only in modern times, with small voices here and there reporting that there are irregularities in orbits, that "heavenly bodies" do get out of step, that machines and automatons (and man) do break down unpredictably, that our solar system is traveling through other wheeling systems, is the irrational "rolling wheel" theory of creative behavior coming to the fore. Metaphors of irrational possibility, to counteract the metaphor of rational probability, are emerging: that the orbitings of the universe produce irregular and elliptical "egg-shaped" figures, that individual man is also pliable and changes shape, depending on the territory he circulates in. (This hope of a large-numbered universe of possibility has even seeped down into the academic community itself: a few years back a Stanford self-study committee proposed that perhaps the task of the university was to aid students in becoming whole, no matter how lopsided, rather than offering students the fragmented bits and pieces of the old "well-rounded education" ideal—the remains of Humpty-Dumpty after his fall from his fence-sitting position come to mind.)

But as we accumulate a history, we are still often tempted by self-effacing and humanly demeaning doubt that the energy we inheritors of history are presently investing will gain us only diminishing returns. We are often led to interpret history as a true record of some heroic "silver age" always in a past which we can only attempt to repeat, but had no hand in making, and against whose silver heroes we can only measure ourselves. We forget that history also is written by men and women whose needs for measurement and evaluation are as desperate as the nonhistorians'. We forget that they too might have experienced the terribly depersonalizing and dehumanizing fate of rational man—the absurdity of forever living in and repeating the shadow of one's forefathers. Such a fate is not a sound basis for either filial respect or self-respect, and often leads the offspring to perform the savagely grotesque, primitive burlesque of living like his father, and destroying himself in hopes of killing off his father's shadow. Among nations, we have records of this absurd phenomenon occurring on a collective scale: the Egyptian pharaohs erased the names of their antecedents, perhaps in the hope that they would be believed in as the "true god-king," which springs, full-blown, from nowhere mere man can comprehend. Or, more recently, the attempt by the Soviets to deny the name of Stalin, in hopes of creating a

reversal of the diminishing-return law (an economic theory that is anathema to devout Communists' belief in historical determinism—and their problem as well, for they also believe that Marx-written history predicts certainty).

Or, caught in this dilemma of misuse of history, we are often tempted to resort to another kind of face-saving primitivism—what Lovejoy and Boas called "cultural primitivism": the discontent of the civilized with civilization or with some conspicuous and characteristic feature of it. "It is the belief of men living in a relatively highly evolved and complex cultural condition that a life far simpler and less sophisticated in some or all respects is a more desirable life." True, to return to some classically simple way offers us a little rest, but it is a means more than an end; if it becomes an end in itself, then we have inherited the absurd fate of shadow-man that only promises "whatever has been done can be done easier the second time." That is, when we primitively accept the idea that the romantically rational view of history suggests (that history is a true record of *time* as a fixed universe of large numbers), we often stick ourselves with another master as harsh as the contemporary complexity we fear is mastering us—silver heroes never again to be; and, filled with a filial envy softened by nostalgia, we behave as if, indeed, there is nothing new under the sun; or, if something is new, it must be worthless.

But historians cannot be blamed if we behave like beggars and fools, like simpleminded and gullible investors of the capital they offer for our use as *we* see fit to use it. A more humanizing and self-supportive use of history is to use it as a part of an incomplete jigsaw-puzzle map: a map does not tell you where to go; it is not the whole of the territory it refers to; but it can help you get someplace, once you have made a destinal decision of your own—and a map often can help you determine where you are. When we think that historians slip from the Olympian fence-sitting position *we* imagine they assume, and become qualifiers more than quantifiers, it is our fault, our image of them that has fallen. When we think that they are behaving like the critics and entrepreneurs of narrow values, it is we who have misunderstood the uses of history; it is we who have accepted the romantically rational idea of history as true-record. Historians do not have quite so simple a task as do cultural dandies, and the difference between the two necessarily contrasting cultural functions is similar to the difference between the surveyor-cartographer and the tourist using his map: to the former, his work is new discovery; to the

latter, it is symbolic of a "past" territory to be repeated.

We all have a birthright of mortality and fallibility; and the historian, like the rest of us, has occupational hazards we should be able to understand because we too fall victim to them—the diminishing-return ailment, as example (which the Greek historians call the "theory of degradation").

The historian George Kubler revealed this dilemma in his book *The Shape of Time*. To paraphrase him, Kubler suggested that practicing the arts and crafts of man today might be compared to entering a worked-out mine, left over from the "gold rush" (or silver rush) days. One can poke about a petered-out mine shaft and pick up bits of leftover vein gold, or sift and wash the tailings in hopes of accumulating some "small change" the 49ers contemptuously cast aside in their compulsive rush to "strike it big." (Or, if one is simply "a little learned" about gold, one may come away with a lode of "fool's gold"—or silver—that wouldn't fool even the most illiterate, but practically educated, prospector on a dark night.)

Now, proper historians spend much time exploring the worked-out mine shafts and combing the tailings that man has left, from which the historian must create a "past" universe. Their voluntary job is to reconstruct the process of human discovery, labor, work, and play, let us say. And the more successful they are in their job, the more they learn to respect those past people who beat the law of probability, the odds against their ever discovering anything due to limitations of physical hardship and ignorance. The temptation seems to me to be obvious: such men and women past are often transformed into supermen and superwomen through the simple process of a mortal and fallible creature, the historian, doing his proper work.

Histories that are short on quantity and long on qualitative judgment (mainly through the sin of deliberate omission) are, of course, not our soundest capital. They are like worked-over mines, and are not supportive of the newcomer, who, upon reading such histories, begins to feel like a "latecomer" walking in late on the last showing of a movie, just as the hero wins the girl: either the hero is a superman the latecomer can only envy but not identify with humanly, or the hero is simply dumb-lucky, for all the human struggle is left out of the latecomer's idea of how just reward is attained.

But to put Kubler's mine analogy into a more humanly valuable and supportive perspective, let me use the idea of an archaeologist sinking a shaft into some hypothetical spot on earth, in an attempt to reconstruct an idea of time as man's "past." At a depth of seventy miles down, he would discover the first single-cell life on earth, say. At thirty-five miles down, he would discover the first plant life on land. At twenty miles down, he would discover the first animal life on earth. Dinosaurs would appear at about fourteen miles and disappear at about seven, at which point the first signs of mammals would appear. At 370 *feet*, the first "true" man would show up; and at about 26 feet, the Neolithic Age would begin (many subways run deeper). Modern man, obviously, is only a footprint deep in contemporary dust. To put it another way, man has been around only about one one-thousandth of the time that life has been developing on this planet, in linear, chronological historical terms. Viewed from this perspective, the latecomer is not so bad off, for this perspective demonstrates figuratively that there is more room for discovery at the top than at the bottom of a worked-out shaft.

"Photography" is a latecomer to man's developmental pictorial tradition. In one sense it is the most immediate, and even direct, contact we presently have with the broadening and deepening picture of the "nature of things," or the universe as large numbers. From the space-probe cameras to the electronic microscope, we are getting back photo-detailed reports on the "bigger and bigger picture" —lopsided bits and pieces of a jigsaw picture puzzle we may never see completed and can only imagine as an aesthetic whole. These bits and pieces of lopsided information refer to both the surd and absurd, the irrational and rational reality we are a part of a surprisingly random and awesomely redundant "natural picture of things." And all this information constitutes some of the referents for histories not yet written, histories of and about "photography," which must be created by man for man—at least until we find a more preferred and absolutely credible agent or agency to present and represent us with (and as) progressively revised senses of the times of space in a universe of large numbers.

As I am best able to personally understand contemporary human needs, what we densely populated, urban-educated, technologically dependent, earthbound creatures need is a sense of some of these yet-to-be-written histories—*now*. I think they are lacking, not because of superstitious fear, academic meanness, or social insecurity of historians, so much as because of a lack of proper education of history-users. My feeling is that we most lack education in the *appreciation of large numbers* in general, and in photography, where an appreciation of the

large numbers of lopsided bits of photo-derived information is becoming essential, this education is slow in coming, due, in large part, to the misuse of available histories and the abuse of the historian's role by *practitioners* of the photo arts and crafts. (I realize what I am saying might sound crazy, but I fear it won't sound crazy enough to convince.)

In the world of the art of ideas, the photographer is not very well represented or respected. The medium spawns a product so temptingly specific, so loaded with a redundancy of information that emphasizes the trivial, that we can't see the state of the forest for the specific trees we are threading our way through daily—snapshots, photo reproductions, films, TV imagery, etc. A single photograph's redundancy of detail, if we respond to it as a valued object, often seems to be saying that "the universe is in a grain of sand," yet we are faced with a desert of space in time, and hope to survive in it. It is tempting to use a single photograph as an oasis. The historian's staggering task is to sift through, even count, the grains; and the rest of us must learn ways and means to appreciate such large numbers if we wish to survive humanly, rather than primitively. If, indeed, there is much more redundancy in the photo "information explosion" than we know how to presently use, how do we store it so it does not spoil, spoil either us or our offspring? If we blindly follow inductive reasoning to the absurd, then any one photograph is worth a million—which one photograph is it, out of the billions of photo exposures that are being spawned compulsively by man, and automatically by man's machine offspring? If we follow one version of surd deductive reasoning, all we need to do is imagine the billions, and we can deduce the one "masterpiece" of greatest value—but whose imagination shall we use?

The seventeenth-century thinker Jacob Bernoulli proposed a theorem of probability in his *Ars Conjectandi* (a theorem that was later badly named "the law of large numbers" by Simeon Poisson). The theorem suggested that in a sufficiently large set of similar things or events (mainly binary decisions, such as tossing coins for a heads/tails decision, or indulging in the overt exposure/no-exposure photographic behavior pattern), it is almost certain that the frequency of likeness among the members of the set will approximate the probability of any one member of the set sharing the general characteristics that define the set. This seems to have been the basis of our modern penchant for trusting "the law of probability" in a universe of large numbers. The deductivist can thus imagine the characteristics of a set, a universe of large numbers, and will surely find a particular member that encompasses all those characteristics approximately. ("Good photography is that which approximates the most consistent characteristics of most photographs made." The question is: have you the time to look at most photographs made, much less access to them?)

The problem with such reflexive rational theorems is that they are self-fufilling prophecies of what will be. If one ignores the idea that words refer to many things other than words alone, and looks only to the dictionary for the definition of a word, one may trace it, from synonym to synonym, and back to the same word one started from. (The space-probe we just sent towards Jupiter has an Alta Mira–like pictographic display attached to it, which, in addition to showing two averaged-out male/female *homo sapiens* in outline form, etc., also proposes that "1=1," which here on earth among the pure rationalists is a profundity that may communicate their authoritarian need for central order, but that does not mean it will necessarily impress "others" with *man's* progress of thought and feeling about universal destiny.) The contemporary illustration of Bernoulli's rather innocuous theorem of probability is coin-tossing (we could use exposure/no-exposure). Under certain carefully examined conditions, no event taking place under those conditions is the simple determining event for all other events; however, the results of all the "independent" events will finally present a predictable pattern of the probable occurrence of similar events in the future-as-linear-time. That is, one toss of a coin (or one exposure of light-sensitive material) does not necessarily affect the next toss of the same coin, or the outcome of simultaneously tossed coins through the universe, yet given a large enough number of tosses (or exposures), a predictable pattern will emerge.

Or, to put the theorem in terms of speech and language: chance utterances are reduced in proportion to the growing number of utterances made, historically. (The longer our animal ancestors babbled, the more certain human "language" became, in the historical view of us who already have it and use it as a rather repeatable, redundant system of communicating. If you tell me what a "good photograph" is, and give me enough time to make seemingly random exposures, I'll slowly make more and more "good photographs.")

Or, at the time Daguerre first displayed a photography plate publicly in 1839, it was anybody's guess what the next one might look like, this theoretical idea suggests. But as the number of photo exposurers exponentially increased (like human population)

through the remainder of the nineteenth century, and into the twentieth century, and now into our last third of the century, the probability has grown that any one photograph will look more like others than not, and the latecomer is doomed, like Sisyphus, to repeat himself in the shadow of a man-made "past." (If dinosaurs had any choice in the matter, perhaps they chose to repeat themselves into extinction.)

Some neurophysiologists propose that there is a "regenerative loop" or neural orbit in the brain which will transmit continuous "feedback" impulses so long as neural energy is supplied. F. S. C. Northrop, in attempting to understand why ideologies repeat themselves as political conflicts throughout history *(The Meeting of the East and West),* used this scientific observation to define what he called "trapped universals." To boil down his erudite solution to my task, and to crudely paraphrase him, he said in effect that if you don't like the law of probability trapping you into its universe as large number (of tossed coins), then use coins with more than heads/tails choices; and, I would add, slip them into the game as randomly as you can. If you don't want to repeat yourself photographically, stop using equipment and materials designed to give predictable results.

And there is another way out of this one-sided version of appreciating large numbers. To go back to the Bernoulli family again, Daniel, the nephew of Jacob, observed that the value (quality) of a quantity (an amount of money, for example) varies according to the quantity already defined (possessed). Building from this idea, Alfred Marshall, an economist, developed the theorem called "declining marginal utility": if the odds are even, a given sum of money will not hold the same value when won as when lost.

That is, what the 49ers left will have a different value to those who later discover it than to the 49ers. The appreciation of the historians' legacy is this: you can't lose what you didn't win yourself. You *can* use it, however, as a grubstake for further prospecting. Your choice is ideological: if you are "trapped in a universe of diminishing return," and you don't like it, prospect for something else with that stake. In the universe of large numbers, 1=1 is but one choice.

"A man is a small thing, and the night is very large and full of wonders," remarks King Karnos, in Dunsany's play *The Laughter of the Gods.* There are rational numbers and irrational numbers—the absurd and the surd. History gives us choices, and assures us that we are never lost simply because we don't know where to go next. If we are standing on the shoulders of our ancestors, it is we who cast the shadow. The fact is, it is not their shoulders, but their graves we stand on; and in reading their history in their photo headstones, it should soon begin to dawn on us, as our history grows, that self-respect is not made from repetitive envy and filial contempt, but through the knowledge that it is we who are to be envied—we are alive, in a universe of such large numbers we are only beginning to appreciate.

As John Maynard Keynes noted in his *A Treatise on Probability:* "The gambler is in a worse position if his capital is smaller than his opponent's." The *past* is not an opponent; it is our capital, and thus we have more to win with than to lose from, thanks to the historian.

CUTHBERT BEDE (THE REV. EDWARD BRADLEY, 1827–1889),
ROBERT HUNT F.R.S. (1807–1887), AND THOMAS SUTTON (1819–1875)

HELMUT GERNSHEIM

CUTHBERT BEDE
(THE REV. EDWARD BRADLEY, 1827–1889),
ROBERT HUNT F.R.S. (1807–1887),
AND THOMAS SUTTON (1819–1875)

Helmut Gernsheim
*Photographic Historian and Collector
Castagnola, Switzerland*

CUTHBERT BEDE
(THE REV. EDWARD BRADLEY), 1827–1889

Cuthbert Bede takes a unique place in the history of photography. His right to fame rests solely on one book: *Photographic Pleasures, popularly portrayed with pen and pencil.* It was published in London in 1855.

Due to the fact that Bede's amusing sketches were published in book form they are hardly known, when compared with Daumier's caricatures, which appeared in the popular press and are usually given preference in illustrating the humorous aspect of early photography. The ludicrous side of the young art, or more correctly the sight of its practitioners with their cumbersome apparatus, was naturally fair game to the caricaturist, but apart from occasional cartoons in *Punch* Cuthbert Bede is the only artist in Britain who seized in word and picture the salient points of the new art. The twenty-four lithographic plates contain a threefold number of sketches "radiant with the raciness of Cruikshank, the broad and round humour of Rowlandson, the knowledge of the world of Doyle, and quick apprehension of Leech"—to quote a contemporary reviewer. Four of them had already appeared as woodcuts in *Punch*, and one in *Cruikshank's Magazine.*

Cuthbert Bede's sketches are all based on actual happenings, reported in the photographic press or related to him by amateurs—he himself did not join the ranks until 1863—and this circumstance makes *Photographic Pleasures* so valuable to the historian of photography. They depict the labours and worries of the early photographers, who were the object of curiosity, and often ridicule, wherever they set up their apparatus. The gold-embossed cover of the book, as well as the frontispiece, shows a tall gentleman bent double under the weight of his huge camera and tripod, and sweltering under the burning sun—"photographic pleasures" indeed. Under the title "The Infant Photography struggling against the Serpents" the artist gives vent to the happy outcome of the long struggle of English photographers against the daguerreotype and calotype patents, and their liberation, in December 1854, from Fox Talbot's attempts to bring the collodion process into his grasp too. Another plate depicts the fright of an elderly female who encounters a five-legged monster directing a metal tube at her, and only able to gasp "Don't fire, Sir!" before fainting. In *The History of Photography* I have reprinted Cuthbert Bede's unforgettable account of his gradual ascent to the rooftop glasshouse of a daguerreotype establishment. In the

accompanying plate, laconically entitled "To secure a pleasing portrait is everything," we see the sitter in the iron grips of the posing chair holding his breath, while the photographer, clad in tarboosh, counts the seconds of the exposure. Lastly let me pick out another poignant illustration: an amateur, half disappearing under his darkcloth, surveys the fine view he is about to secure for his portfolio, when a bull rushes at him from the rear, lifting him and his camera on his horns—and thus bringing the photographic outing to an abrupt end. Needless to say, a group of children has gathered to witness the incident with fiendish delight.

The text of *Photographic Pleasures* is the perfect example of the Victorian ideal of blending amusement with instruction. It is a punning commentary on photography from the earliest investigators up to the publication of the book in February 1855. Nowadays it can, however, be read with full enjoyment only by someone thoroughly acquainted with the various personalities of the period and their idiosyncrasies. The introductory sentence is a fair example: "In the light style in which I shall treat the subject, I do not seek to rival Mr. Lyte,[1] I cannot speak of photography with the brilliant setting (forth) of a Diamond,[2] I do not profess to hunt up the details of the subject with the ability of a Professor Hunt,[3] I cannot treat it philosophically as can Sir William Newton,[4] I cannot write of it after the manner of Bacon, as can Mr. Hogg,[5] but I will buckle to the subject, though without the aid or ability of a Buckle,[6] and I will not make the subject as long as Mr. Long[7] has done."

The slim octavo volume was a great success. It was reprinted in 1859 and appeared in 1863 in reduced size as a cheap popular edition, in which the illustrations were reproduced by means of automatic lithography, and the hard cover replaced by paper.

Edward Bradley was the son of a surgeon at Kidderminster (England), where he was born on 25 March 1827. The pseudonym Cuthbert Bede is made up of the names of the two patron saints of Durham, at which University Edward Bradley studied, and graduated with a B.A. degree in 1848. The following year he took his licentiate of theology. Not yet being of age to take orders, he stayed a year at Oxford pursuing various studies, though without becoming a member of the University. It may be safely assumed, however, that the adventures which befell young Mr. Verdant Green in Oxford are to some extent autobiographical.

The Adventures of Mr. Verdant Green, illustrated by the author with several hundred woodcuts, was Cuthbert Bede's first book and his greatest literary success.[8] It was originally issued in three parts in 1853, 1854, and 1856 as shilling "Books for the Rail." A one-volume edition was issued in 1857 with a woodcut portrait of the author as frontispiece, after a photograph by O. G. Rejlander. The popularity of the book can be gauged by the fact that one hundred thousand copies of it had been sold by 1870, and it saw many reprints after that date. In part II on page 73 there is an amusing illustration of a young lady photographing our hero. "Miss Fanny Bouncer was good-humoured and clever," wrote Cuthbert Bede, "and besides being mistress of the usual young-lady accomplishments, was a clever proficient in the fascinating art of photography, and had brought her camera and chemicals, and had not only calotyped Mr. Verdant Green, but had made no end of duplicates of him in a manner that was suggestive of the deepest admiration and affection."

Cuthbert Bede was a friend of George Cruikshank, Mark Lemon, and Albert Smith, for whose serials *The Month, The Man in the Moon,* and *The Town and Country Miscellany* he began to write about 1850. He contributed with pen or pencil to a great many papers and periodicals, including *Punch* (1847–55), *All the Year Round* (1853–55), *Notes and Queries* (1852–86), *The Field, The Gentleman's Magazine, The Graphic,* and others. In a letter he wrote to H. P. Robinson in October 1863 he mentions taking lessons in photography,[9] and his *Visitor's Handbook to Rosslyn and Hawthornden*, published in Edinburgh without date (1864 or 1865) is illustrated by sixteen excellent small photographs, presumably halves of stereo pairs taken by the author himself.[10] All the other twenty books published by Cuthbert Bede were illustrated with pen drawings. His last book, *Little Mr. Bouncer and His Friend Verdant Green* (1878), was a sequel to the earlier volume, but did not repeat its phenomenal success.

The Rev. Edward Bradley was ordained in 1850 and became curate of Glatton-with-Holme in Huntingdonshire, and successively the rector of Bobbington, Staffordshire (1857), Denton-with Caldecote, Huntingdonshire (1859), and Stratton near Oakham, Rutlandshire (1871). In 1883 he became vicar of Lenton-with-Hanby, a village near Grantham, where he died on 12 December 1889. He was married and had two sons.

NOTES

1. Maxwell F. Lyte (1828–1906), a well-known photographer.

2. Dr. Hugh W. Diamond (1809–86), a medical doctor famous for his photographs of lunatics, and a regular contributor on photography to *Notes and Queries.*

3. Professor Robert Hunt F.R.S. (1807–87), a distinguished scientist, originator of several processes on paper, and leading writer on photography in Britain.

4. Sir William Newton (1785–1869), a celebrated miniature painter and keen amateur photographer. Bede refers to Newton's paper "On Photography in an Artistic View," read to the Photographic Society of London in 1853, which caused a great stir for unorthodox views advanced.

5. Jabez Hogg (1817–99), a distinguished microscopist, contributed articles on photography to the *Illustrated London News*.

6. Samuel Buckle of Peterborough, a well-known calotypist of landscapes. He introduced a special brush for the preparation of the paper.

7. Charles A. Long published in 1854 a treatise on photography, which, though short, was rather long-winded.

8. The book was the subject of a modern radio adaptation by the British Broadcasting Corporation.

9. The letter of Cuthbert Bede to H. P. Robinson of October 1863 was published in *The Practical Photographer*, August 1895.

10. A copy of this book with photographs is in the Gernsheim Collection, University of Texas.

ROBERT HUNT F.R.S., 1807–1887

Though of humble birth and receiving but an inadequate education, Robert Hunt was gifted with an immense capacity for acquiring knowledge and a brilliant mind. He may truly be counted among the Fathers of Photography, so great is the debt which photography owes him. "I am confident," he wrote, "there is not one who has made the philosophy of photography so entirely his study as I have done," and this claim is fully borne out by the facts. Hunt was the leading authority on photography in the first twenty-five years of its existence, the principal investigator of its chemical phenomena, its principal writer, and its first historian. The *Catalogue of Scientific Papers* issued by the Royal Society, which elected him a Fellow in 1854, lists fifty papers by him, and this list does not take into consideration Hunt's numerous contributions to the British Association, the *Philosophical Magazine*, the *Art Journal*, the *Magazine of Science*, and many other journals.

Robert Hunt was born at Devenport, England, on 6 September 1807, nearly six months after his father, a naval man, had perished in a wreck. Left with a very small pension, the young widow could not afford a public-school education for the boy. After attending for a few years a primary school, he was sent at the age of nine to a secondary school at Penzance in Cornwall, where they had moved, staying with a relation. When twelve years old, the boy was apprenticed to a London surgeon with the intention of being articled at the age of sixteen, but Hunt was treated with such severity by his employer that he ran away. For the next five years his time was divided between the house of a physician who befriended him and that of a brother who was a chemist and druggist in Fleet Street, London. Finding that the cost of attending lectures and hospitals was more than his mother could afford, Hunt started a business with an uncle in Penzance, which ended in failure. During this time, however, he gave his first lectures on science at the Penzance Literary and Scientific Institution, which he helped to establish.

About 1838–39 Hunt married in Devenport, and it was here that he commenced his investigations in photography. Prior to Sir John Herschel's experiments with glass positives, Hunt and John T. Towson, another Devenport man, had succeeded, during the summer of 1839, in obtaining positive copies from glass negatives—a process to which they rightly attached greater importance than to either Talbot's or Daguerre's methods.[1] We are left in the dark as to the reasons why this glass process failed to reach the limelight of publicity and why it was abandoned in favour of paper. All we know is that Hunt in 1839 also worked with a direct positive paper process for which he offered sensitized paper for sale.[2]

The opening sentence of Hunt's first article on photography makes it quite clear that prior to 1839 he was acquainted with Wedgwood's and Davy's experiments: "Having many years since repeated, with much interest, the experiments of Wedgwood, Davy, and Wollaston on the chemical influence of light, it was with much pleasure that I read Mr. Talbot's paper on 'Photogenic Drawing,' which opened to me new views, and pointed out paths rich in the promise of important results."[3] On another occasion we learn the exact date, 28 January 1839, of commencing his photographic experiments, and from then on "the investigation of the chemical phenomena of the solar rays has been the constant employment of all the leisure which a busy life has afforded me."[4]

Hunt's official work was in geology and mineralogy. In 1839 he was appointed Secretary of the Royal Cornwall Polytechnic Society at Falmouth, a position he held until 1845, when he became Keeper of the Mining Records at the Museum of Practical Geology in London. His work there entailed obtaining correct returns of the mineral produce of the United Kingdom, and the publication of the annual *Mineral Statistics*, which was of importance to the commercial world. When in 1851 the Government School of Mines was organized Hunt was appointed Lecturer on Mechanical Science in addition to his other position, but after two years he resigned his professorship in order to do more research and writing

on photography. He remained Keeper of Mining Records almost to the end of his life (until 1882).

Hunt's manual of photography, published by Griffin of Glasgow in May 1841, among a miscellany of scientific papers bound in one volume, was the first general treatise on photography in any language. Its original title, *A Popular Treatise on the Art of Photography, including Daguerreotype and all the new methods of producing pictures by the chemical agency of light,* was modified in later editions, but it immediately established itself as a standard work. The rapidly changing new processes introduced in the 1850s led to much enlarged and constantly revised editions in 1851, 1853, 1854, and 1857, each providing the latest information about all the photographic methods then in use. It is an essential source book for the historian on early photography, as is Hunt's *Researches on Light,* which was published in 1844 and may be regarded as his magnum opus. This book was, as the subtitle explains, "an examination of all the phenomena connected with the chemical and molecular changes produced by the influence of the solar rays, embracing all the known photographic processes and new discoveries in the art." It went into three editions (1844, 1854, and 1862) and contains the first brief history of photography.

Considering familiarity with all the manipulative details of each process which he wrote about essential, Robert Hunt made in the course of his researches thousands of pictures, always of the same buildings, trees, and plaster casts, which he had taken innumerable times, "quite content to leave the production of beautiful images to other manipulators."[5]

In a communication to the *Liverpool and Manchester Photographic Journal* Hunt deplored the almost entire absence of original research into the physical and chemical phenomena which are involved in the production of photographs.[6] He pointed out that whilst photographers are content to master the difficulties of manipulation without further enquiry, investigation was vital for the furtherance of photographic science, which in turn would bring about improvements and lead to the discovery of the reasons for certain disquieting faults then occupying the attention of photographers and public alike, such as the fading of prints. He also urged the proper examination of the problems involved in the production of photographs in natural colours. "There is something delightful in producing a good photograph, but there is something far more satisfying in making a discovery which will advance the art. To make discoveries we must walk out of the beaten track, and the more divergent the roads may be along which investigators choose to tread, the greater will be the prospect of a full solution of the problems which I have ventured to indicate." However, scientific investigation and artistic execution are qualities rarely found combined in one man, and so the division of labour continued.

Hunt's discoveries provided interesting parallels to the main road rather than new avenues of approach. In 1844 he found that the photographic paper image could be developed by protosulphate of iron in less than a minute—the developer hitherto used being gallic acid. He called this process, which he communicated to the *Athenaeum*, "Energiatype,"[7] but later renamed it "Ferrotype" because of the ferrous sulphate, a developer later used in the collodion process. He introduced two other photographic processes: the "Chromatype" (1843)[8] and the "Fluorotype" (1844), in which the paper was prepared with chromium salts and sodium fluoride respectively, producing himself fine photogenic drawings of leaves in various colours. Like the "Ferrotype," these processes failed to find practical application.

Robert Hunt was a member of the Photographic Club formed in London in 1847, and played a prominent part in the formation of the Photographic Society in 1853. A member of its first council, and active on many committees, he was elected a vice-president in 1856. He was also on the jury of the Great Exhibition 1851, and the International Exhibition 1862. The multifarious duties of a government appointment connected with a science differing so widely in character from that of photography may be responsible for directing Robert Hunt's thoughts into other channels in the last twenty years of his life. Perhaps he had also become disenchanted by the mechanization and vulgarization of photography. We can only guess at the reason for his failure to take any interest in the art once so well loved by him. His last contribution was a historical article that appeared in 1882[9]—five years prior to his death at his Chelsea home on 17 October 1887.

In addition to the publications already mentioned, Hunt also wrote on nonphotographic subjects: *The Poetry of Science* (1848), *Panthea, or the Spirit of Nature* (1849), *Elementary Physics* (1851), *Synopsis and Handbook of the Great Exhibition of 1851,* and similar works on the International Exhibition of 1862; and *Popular Romances of the West of England* (1865), illustrated by George Cruikshank. He was responsible for a new edition of *Metals and Metallurgy* and several editions of Ure's *Dictionary of Arts, Manufactures and Mines,* the seventh of which (1878–81) Hunt greatly enlarged.

NOTES

1. *London & Edinburgh Philosophical Magazine*, vol. 15, 1839, p. 384. See also Robert Hunt, *A Popular Treatise on the Art of Photography*, Glasgow, 1841, p. 72, and John T. Towson in *Liverpool and Manchester Photographic Journal*, April 1858, p. 82. The date 1838 given by Towson is no doubt a slip of memory.

2. Robert Hunt, *Philosophical Transactions*, February 1840, p. 5.

3. Robert Hunt, "On the Permeability of various Bodies to the Chemical Rays," *Philosophical Magazine*, February 1840.

4. *Notes and Queries*, London, February 1854.

5. A selection of these early photographs, dating from 1844 onwards, were exhibited at a meeting of the Photographic Society of London in April 1889 by John Spiller, to whom they had been presented by Hunt's widow. They now form part of the Gernsheim Collection at Austin, Texas.

6. *Liverpool and Manchester Photographic Journal*, 1857, p. 72.

7. Robert Hunt, "Energiatype—a new Photographic Process," *Athenaeum*, London, vol. 1, June 1844.

8. The Chromatype had a brief revival at the end of the nineteenth century, when a great many "artistic" printing methods were introduced, or reintroduced.

9. *The Year Book of Photography for 1882*, London, 1881.

THOMAS SUTTON, 1819–1875

As editor of *Photographic Notes* (1856–67), compiler of the first *Dictionary of Photography* (1858), introducer of a triplet lens (1859), inventor of the first reflex camera (1861) and other apparatus, author of the best handbook on the calotype process (1855) and the first photographic novel (1865), and above all as contributor of numerous articles to the photographic press, Thomas Sutton was a prominent figure in British photography from 1855 until his death twenty years later. Said to be kind and genial in private life, he had the reputation of being opinionated and contentious in photographic matters, and prone to mix his ink with an undue amount of gall when he became involved—as frequently happened—in any controversy.

Thomas Sutton was born in the Kensington district of London on 22 September 1819, and studied at Caius College, Cambridge, where he took his B.A. degree as 27th Wrangler in 1846. His first photographic experience was being daguerreotyped in the summer of 1841 by Antoine Claudet on the roof of the Adelaide Gallery—the second photographic portrait studio in Britain, which had just been opened. That sitting, and Claudet's advice to the student intending to take up the art, evidently left a deep impression. Sutton's account of it is a historic document: Alison and I reprinted it in *The History of Photography*.

While on holiday in Jersey a few weeks later Sutton made friends with an amateur daguerreotypist, and determined to make a hobby of photography. Having little success with the daguerreotype, he changed over to the calotype, without, however, being more successful. Cambridge studies and married life compelled him to lay aside photography for several years. Pleasant memories of Jersey induced him to settle there in 1850. He bought land and built a cottage at St. Brelade's Bay. After settling in he took several lessons in the calotype from a Mr. Laverty, evidently with more accomplishment than in his previous efforts, for he bought himself a 10-by-12 inch folding camera and became a keen calotypist during a fifteen-month stay with his family in Italy from 1851 to 1853. While in Rome in 1852 Sutton made the acquaintance of two celebrated photographers, Comte Flachéron and Robert MacPherson. The former was a great champion of the calotype, employing Blanquart-Evrard's modification, in which he initiated Sutton, who also tried his luck with the albumen-on-glass process, which MacPherson had just taken up. Trials with both decided Sutton's preference for the paper process on account of its artistic qualities.

On his return to England in 1853 he submitted about a hundred of his best negatives to the print-seller Joseph Cundall in London, who ordered a dozen prints of each. Sutton intended to do the printing himself, his ambition being to make them as beautiful and permanent as those published by Blanquart-Evrard in his monthly *Album Photographique*. For months he labored in vain in his attempt to find out how these prints were produced. Assuming that the trouble lay perhaps in the quality of his Italian paper negatives, he sent Blanquart-Evrard a new batch of negatives of Jersey subjects for printing at the Imprimerie Photographique at Lille. This set of photographs was published by Sutton under the title *Souvenirs de Jersey* in 1854. As to the printing secret, the French photographer evaded Sutton's enquiries, politely declining his offer of £100 for it and pointing out that a similar offer from the Prince Consort had not induced him to reveal his method.

The fading of calotypes produced by Fox Talbot's method, and also of albumen prints, had caused serious concern to photographers, print-sellers, and the public alike, jeopardizing photographic publication and harming the profession in general. After some further experimentation Sutton at last believed he had found the secret. This was later proved to be

not so. His method of preparing the sensitive paper differed, but the essential point of developing the positives like negatives in a saturated solution of gallic acid which shortened the (daylight) exposure to a few seconds (instead of printing out in sunlight for several hours), and their subsequent toning with chloride of gold to give them greater permanence, Sutton had discovered for himself. Unfortunately, he did apparently not take the same precautions in rinsing the prints as they did at Lille, for whilst Blanquart-Evrard's prints have preserved their strength to this day, Sutton's have turned yellow. (*Vide* the frontispiece to his Calotype Manual, 1855.)

Triumphantly Sutton published, in July 1855 as a shilling pamphlet, *A new method of printing positive photographs, by which permanent and artistic results may be uniformly obtained.* Prince Albert, who had given the Fading Committee financial support, thereupon suggested to Sutton the establishment of a commercial printing firm, offering his patronage. Sensing competition, and realizing that his secret was now in the public domain, Blanquart-Evrard consented to become joint manager with Sutton of the "Establishment for Permanent Positive Printing," which started operations at St. Brelade's Bay, Jersey at the end of September 1855.[1] By December there appeared the first issue of their joint publication *The Amateur's Photographic Album*, which continued at irregular intervals for at least a year, each part containing three or four photographs. Though not permanent in the now-accepted sense of being produced without silver salts, the prints have withstood the test of time rather well.

On 1 January 1856 the partners, whose association lasted for about two years, started a new venture: *Photographic Notes,* a monthly, and from September 1856 on, a fortnightly journal, originally published in Jersey and later in London. It was edited by Thomas Sutton until its merger, in January 1868, in the short-lived *The Illustrated Photographer. Photographic Notes* has a personal and very characteristic style, and was frequently used by Sutton as a convenient platform for launching personal attacks on those who did not agree with his opinions. The volume for 1859 is particularly rewarding in that respect. In this journal Sutton also serialized the first novel inspired by photography, written by himself. It appeared in 1865 and was as unimaginative as its title: *The Photographers.* The earlier volumes of the *Notes* were decidedly biased in favour of the paper processes, free at last from Fox Talbot's patent restrictions, a freedom that gave the process a new lease on life or rather a life it had never had before.

Though Sutton's manual, which appeared in March 1855, was not the first exposé of the calotype, it was the most detailed account. Together with Le Gray's handbook of the Waxed-Paper process—which could now also be practised in England without fear of prosecution by Talbot—it brought about what I termed the "Golden years of photography on paper." Amongst amateurs the paper processes enjoyed a tremendous popularity in this short revival before paper was completely eclipsed by the much faster, but also much more complicated, collodion process of Frederick Scott Archer. Sutton at any rate was the great champion of paper, and in his zeal to uphold its virtues he became occasionally ensnared in predicting the downfall of collodion, long after professional photographers were employing nothing else. This gave rise to acrimonious controversies and led to some extraordinary acrobatics by Sutton to extricate himself from untenable positions which were damaging to his reputation. Having rather rashly predicted in 1854[2] the speedy extinction of the collodion process, adding that "positives in collodion have been entirely exploded," he praised the latter two years later as "a method so satisfactory when properly conducted."[3] By design or coincidence the same issue of his journal contains an advertisement of a new positive collodion, made and sold by the author! A month later Sutton remarked on the extraordinary popularity of ambrotypes during the past year and completely reversed his original derogative opinion by stating, "A really fine glass positive . . . may, I think, be considered a highly artistic work."

Sutton was notorious for changing his opinions and enthusiastically advocating what he had previously attacked with virulence. The tenacity with which he clung to the paper process—long after everyone else was working with collodion—led Henry Greenwood, proprietor of the *Liverpool and Manchester Photographic Journal* (later the *British Journal of Photography*) to give Pope's lines a new twist:

One process only will this genius fit
So wide is art, so narrow Sutton's wit.[4]

"The Jersey oracle," as he nicknamed Sutton for his frequent potent pronouncements, did not change over to the collodion process until late in 1859. Early that year Sutton found cause for another of his heated controversies with the Liverpool journal over its new title, which called forth a just rebuke:

The Jersey oracle has again spoken; though not with the same potency, yet with about as much

truthfulness in its utterances as there was in those of the ancient Delphic auguries. The proprietor and editor of a Jersey contemporary has bestowed, for many years, some delicate attentions on the proprietor and editors of this Journal—his remarks and allusions being as uncourteous in style as they have been incorrect and malicious in matter.[5]

Sutton's most important contribution to early photographic literature, apart from *Photographic Notes*, was undoubtedly the compilation of an excellent *Dictionary of Photography*—a small encyclopaedia —which was quite a respectable effort for one man. It was the first of its kind when it appeared in 1858; a second revised and enlarged edition was published in collaboration with George Dawson nine years later. Yet despite the fact that Sutton wrote over the years a number of practical instruction booklets on various so-called improvements of the collodion process, I believe that his interest was more and more drawn to the advancement of photography in the optical and mechanical fields.

His suggestion for a gun camera for taking instantaneous photographs,[6] made in 1859, could have been realizable even with wet collodion plates, but such a camera was not built until 1882 for Professor Marey's chronophotography, making possible the recording of the movements of flying birds. More disputable are Sutton's inventions of a panoramic camera and wide-angle water lens, which were patented by him the same year and manufactured by Ross & Co.[7] Neither of them was new. Friedrich von Martens had a panoramic daguerreotype camera constructed for his own use in 1845, with which he took excellent views of Paris on curved daguerreotype plates in semicircular holders, partly to counteract the aberration of his lens and partly on account of its extreme curvature due to a visual angle of 150°. Scott Archer, on the other hand, had in 1852 introduced a water lens, made for him by the same maker, Ross. All that was new in Sutton's lens, it could be argued, was the calculation of curves in this lens, as Archer's object had been to gain rapidity and not a wide-angle effect. Sutton's achromatic lens had an angle of 100° and consisted of two thick concave-convex glass lenses forming a spherical shell and having the spherical cavity between them filled with half a pint of water. The glass shell acted as a concave lens, the sphere of water as a convex lens, with a small stop located at the centre. The water had to be changed every day the lens was used.[8] Sutton's panoramic camera was made in several sizes, and

adapted for work with collodion plates or paper negatives. Because of the great curvature of the lens, both focussing glass and plate holders had to be curved, as were also the tanks for sensitising and developing, and of course the printing frames. The smallest plate size for collodion was 3 inches by 7 inches and for greater convenience Sutton suggested the use of dry collodion (i.e., preserved collodion) mica sheets. Both camera and lens were exhibited at the International Exhibition in London in 1862,[9] but apart from P. H. Delamotte we know of no other photographer working with it.

Similar criticism of lack of novelty was raised against Sutton's much-heralded invention of a symmetrical triplet lens for architectural photography, about which he read a paper to the British Association in September 1859. For the triplet too had a direct precursor in a similar lens designed for Archer, with the object of shortening the focus of a double combination lens to give freedom from distortion. Both Archer's and Sutton's triplets consisted of two achromatic meniscus lenses of equal foci with a small convex lens sandwiched in between. As Archer was dead and his triplet apparently forgotten, a committee appointed by the Photographic Society of Scotland awarded the palm to Sutton's lens as the only one giving freedom from distortion in architectural subjects.[10]

On the other hand, the single lens reflex camera which Sutton had constructed and patented in 1861 was an original invention—even though based on earlier camera obscura designs. Like many photographic inventions of the time, it came long before a demand for it arose, and its manufacture did probably not go beyond the prototype. The internal mirror, fixed at 45° to the lens, was manually turned up before the exposure.[11] Sutton also displayed at the Photographic Society of London the model of a three-man schooner specially built for photographic purposes.[12] Whether or not it was made for himself, forming the basis for his later novel *Romance in a Yacht* (1867), we are unable to say. He was certainly unconventional, a theme which supplied him with enough material for a three-volume novel in 1866.[13]

In 1861 Sutton was appointed lecturer on photography at King's College, London, in succession to T. F. Hardwich, but after a few months he resigned this position on account of the inconvenience of travelling frequently between Jersey and London. Apropos a communication from Hardwich on his discovery that gelatin and oxide of silver form a chemical compound insoluble in water, Sutton made this prophetic observation: "Gelatin is certainly calcu-

lated to play an important part in photography. I have sometimes thought it possible to employ sheet gelatin in the negative process. The subject is worthy the attention of experimentors." This was written in 1856,[14] fifteen years before Maddox's epoch-making experiments with gelatin. Sutton also sensed the importance, or at least the inherent qualities of speed, of silver bromide, for in giving a detailed account of Gaudin's gelatin-iodide process in his journal in 1861[15] he suggested trying silver bromide instead of iodide, but made no experiments.

While on the subject of chemicals I must briefly mention another of Sutton's inventions: a preservative collodion process employing glycerine (1873), for which advantages over all other preservative processes were claimed, but which was introduced at a time when gelatin emulsion plates were already looming large on the horizon.[16]

The decision to discontinue the publication of *Photographic Notes* in December 1867 was probably due to Sutton's move the same year to Redon in Brittany. What had induced him to leave his beloved Jersey is unknown to us. Having no journal of his own any longer he became a regular contributor to the *British Journal of Photography,* any old animosity having been buried. In this journal he published *inter alia* "Reminiscences of an old photographer," on which we have drawn to some extent for the earlier part of Sutton's life. His residence in France lasted until 1874, when Sutton came to live at Pwllheli in North Wales, where he died very suddenly of cramps in the stomach on 19 March of the following year. As an epitaph the *British Journal of Photography* published, as the sentiments of a travelling photographer but possibly their own: "He sometimes wrote harsh things, which by no twisting of the English language could be otherwise than harshly construed, when I thoroughly believe that in his heart he would utterly repudiate such sentiments and the inferences which might inevitably be drawn from his communications."

NOTES

1. The first advertisement appeared in *The Photographic Journal,* London, 21 September 1855.

2. *The Photographic Journal,* October 1854.

3. *Photographic Notes,* London, 15 December 1856.

4. *Liverpool and Manchester Photographic Journal,* 15 January 1859.

5. Ibid.

6. *Photographic Notes,* August 1859.

7. *The Photographic Journal,* 15 March 1860, and December 1861, pp. 321–24.

8. A Sutton water lens is preserved at the Science Museum, London. It has a diameter of 4 inches and a focal length of 6.5 inches.

9. Fullest description in Dr. Diamond's review in "Record of the Exhibition 1862," published by *The Practical Mechanic's Journal.*

10. *The Photographic Journal,* 15 September 1859, p. 41.

11. Described in *Photographic News,* London, 11 October 1861, p. 483.

12. *The Photographic Journal,* 9 April 1859.

13. Thomas Sutton, *Unconventional,* London, 1866.

14. *Photographic Notes,* 1856, p. 133.

15. *Photographic Notes,* 1 June 1861, p. 157.

16. *British Journal of Photography,* 1873.

MRS. JULIA MARGARET CAMERON, VICTORIAN PHOTOGRAPHER

CHARLES HARVARD GIBBS-SMITH

MRS. JULIA MARGARET CAMERON, VICTORIAN PHOTOGRAPHER

Charles Harvard Gibbs-Smith

Keeper Emeritus
Victoria and Albert Museum

On a serenely beautiful afternoon in October 1875, the routine bustle on the P. and O. dock at Southampton was in full swing. A liner was taking on board her passengers and cargo for Suez and the Indian subcontinent.

Those who were idly leaning on the rails, watching the scene, soon became aware of three passengers who had arrived on the dockside beneath them. The lady of the trio was deploying a platoon of porters to carry their luggage on board, and the attention of the spectators was soon sharply focussed on four of these men who were seen to lift up what appeared to be two brand-new coffins and stagger with them up the gangway. Each of these coffins—for coffins they now clearly were—seemed occupied by somebody, or something, exceedingly heavy. This rather gruesome exercise being completed, an even more curious spectacle was presented to the astonished onlookers, as a buxom but protesting Jersey cow was coaxed, pulled, and shoved up the gangway and aboard the ship.

At last, after a further assortment of boxes, bags, and packages had also been taken into the liner, the porters were seen to file by the lady of the party; and she—instead of giving them tips—thrust a roll of paper into the hand of each, a gift which seemed to produce resigned mutterings, and certainly no smiles. From the ship it was only possible to see that this female director of operations was a squat elderly little woman of great vitality and determination, dressed in a cheap cotton frock without any claim to shape, let alone fashion. Those below on the dock, however, saw that although endowed with neither grace nor beauty, she did possess extremely fine and lustrous eyes, and a compelling presence.

Her companions were two men; one seemed to be her son, who was discreetly, almost sombrely dressed; the other appeared to be her elderly husband, dressed in a travelling cloak, and grasping a carved ivory staff, his benign face looking serenely out from a mane of silver hair which seemed to float about his shoulders.

What their shipmates-to-be were witnessing was the home-going of a family named Cameron, bound for their estates in Ceylon, where mother and father wished to die in peace when God should ordain it. But Mrs. Cameron had no faith in the ability of the Sinhalese to construct decent coffins, which, in any case, served as perfect packing cases for the family plate and china. The cow was to provide proper nourishment for the elderly Mr. Cameron, and for any other family in need on the voyage. As to the rolls of paper, which she had so blandly handed out

to the disgruntled porters, they were no ordinary sheets, but large-sized sepia photographs, probably of scenes from Tennyson's poems, but possibly including one or two portrait-studies. One wonders how many of these momentoes found their way into their new owners' homes, and indeed how many survive unrecognised today in Southampton parlours.

This *largesse photographique* was to mark the end of an epoch; not a grand epoch of wars or revolutions, but a small quiet epoch concerned with the recording of people's faces, so that future generations might the better understand what manner of men and women their owners had been.

Julia Margaret Cameron was a great eccentric; but she was also one of the greatest photographers of all time. If we call to mind the appearance of such men as Browning, Tennyson, Darwin, Carlyle—and many other Victorian giants—it is probably through the eye of Mrs. Cameron's lens that we remember them.

Mrs. Cameron was born in Calcutta on June 11, 1815, a week before the battle of Waterloo; she was the third daughter of John Pattle, an official in the Bengal Civil Service, who was renowned, it was said, as being the "biggest liar in India." Not surprisingly, after what must have been an entertaining life, he drank himself to death. But he must have had hidden talents; he married the beautiful daughter of an aristocratic French emigré, and by her had two sons and seven daughters, one of whom was Julia. All the daughters were captivating beauties, except Julia; and all of them—including Julia—made excellent marriages, all to Englishmen. Julia and her sisters were brought up by their French grandmother, and were "finished," as we used to say, in both England and France, before returning to India.

The ugly duckling, however, possessed some formidable qualities to compensate for her physical defects. Mrs. G. F. Watts, wife of the artist, said later of Julia:

> To all who knew her she was a unique figure, baffling all description. She seemed in herself to epitomize all the qualities of a remarkable family, presenting them in a doubly distilled form. She doubled the generosity of the most generous of the sisters, and the impulsiveness of the most impulsive. If they were enthusiastic, she was so twice over; if they were persuasive, she was invincible. If she had little of the beauty of her sisters, she certainly had remarkably fine eyes that flashed like her sayings, or grew soft and tender if she was moved.

This remarkable tribute is borne out by all we know of Mrs. Cameron.

Julia returned to India from England in 1834, and, after a period of family domesticity, married Charles Hay Cameron there in 1838. She was his second wife, and twenty years younger than he. Charles Cameron was one of those distinguished—but largely unsung—Britons who devoted their lives to the betterment of conditions in the lands to which they were called to serve. He was a jurist of great attainments who, after serving in Ceylon, was largely responsible for composing those famous "Indian Codes" which history often credits to Lord Macaulay. Cameron also became president of the Council of Education for Bengal, and finally the fourth member of the Supreme Council of India. He retired in 1848.

It was during these richly productive years of her husband's work—when she was also rearing her own family—that Julia became a close friend of the governor-general of India and his wife, Lord and Lady Hardinge. When Lady Hardinge was absent, Julia became the virtual head of European society in India. As a result of this preeminence, Mrs. Cameron came to assume her rather imperious manner, a manner that was to stand her in good stead when she later had to cope with the varying social strata of Victorian England.

It is always fascinating to plot the course of events which leads one's hero or heroine from obscurity to fame. Socially speaking, the connecting links in Mrs. Cameron's life were fairly routine; but that these links were to be so quickly forged, to transform within a year an Anglo-Indian hostess—albeit at the top of the tree—into the trusted confidante of England's literary elite, was surely a rare triumph.

The Camerons arrived in England in 1848, and first settled at Tunbridge Wells, where they were neighbours of Sir Henry Taylor and his wife. Taylor—who was to become the most photographed man in English public life—was one of the half-dozen controlling officials at the Colonial Office; he was also an accomplished minor poet, and had been in the running for Poet Laureate when Tennyson won the honour. It is of great subsequent significance for us that he was one of the noblest-looking men in the land.

It was at Tunbridge Wells that Mrs. Cameron may be said to have started on her new career in the service of the great. At first it was a career of admiration, flattery, and generosity toward the objects of her devotion. Put like this, it may sound rather horrible; and, in truth, she did come near to smothering some of those whom she most loved and admired by the sheer force, intensity, and volume of her feelings. Until she found creative release in photographing her friends, she would deluge them

with adulatory letters and shower them with every kind of gift, until the Cameron family seemed in danger of losing everything valuable, or indeed movable, in their home.

Before they followed the Taylors to Sheen, near Richmond, Julia bombarded them with letters and gifts. Here is Sir Henry: "She writes us letters six sheets long all about ourselves, thinking that we can never be sufficiently sensible of the magnitude and enormity of our virtues. . . . She keeps showering upon us her barbaric pearls and gold, Indian shawls, turquoise bracelets, inlaid portfolios, ivory elephants."

With most people there comes a time when, in desperation, they react to this sort of attention by headlong flight, or by outright and often cruel rejection of their "tormentors." But Mrs. Cameron seems to have penetrated this sonic barrier, and emerged into a realm of friendship in which the enormities of her benevolence were accepted as an essential part of her deeply generous self. In fact, to advance the aeronautical simile a little further, one might say she was such an amazing and worthwhile person that her sonic boom was looked upon as a necessary condition of her existence, and therefore to be borne uncomplainingly by her friends. Here is Henry Taylor again: "Mrs. Cameron has driven herself home to us by a power of loving which I have never seen exceeded, and an equal determination to be loved."

After following the Taylors to Sheen, the Camerons set up what might be called a "salon," the better for Julia to tempt in, catch, and attach those men she most admired. Thackeray, the astronomer Sir John Herschel, and Lord Hardinge (the former governor-general) were already old friends. Tennyson, Watts, Aubrey de Vere, and Holman Hunt soon followed them into the fold.

And so this remarkable woman embarked on her passionate and eccentric pursuit of the literary and artistic lions. She did not give a damn about what she said or did, so long as word and deed achieved the desired ends, and—above all—so long as what she did was useful to her friends. So absorbed by the occasion would she become that one might see her, deep in conversation, accompanying her guests to the station, stirring her cup of tea as she went.

She also became a constant visitor to Little Holland House in Kensington, the home of her beautiful sister Sara and her husband Henry Thoby Prinsep, one of the century's outstanding Indian civil servants. The Prinsep family entertained on a lavish scale, and their friends were largely artists and writers; so Julia made

the house her London headquarters, or shall we say her London spider's web. Here the scope of her conquests widened, and she revelled in them. Looking back on this expansion of Julia's with the wisdom of hindsight, we realise that she was unconsciously amassing a formidable array of sitters, who would be immediately to hand as soon as the urge to use a camera descended upon her.

When she was not in the physical presence of her friends, she launched such a veritable torrent of letters upon them that they could only pray for the lesser ordeal of her arrival on their doorsteps. In a letter to the astonished Thackeray, she once said: "Nobody writes as well as I do. Let me come and write for you!"

There was a time when she wrote to Sir Henry Taylor every day; and he answered every day. It was this faithful friend who was once driven to confess—but with affection—that "her genius is too profuse and redundant, not distinguishing between felicitous and infelicitous. She lives upon superlatives as upon her daily bread." And the Tennysons, not yet fully under the Cameron spell—but soon to be captured—spoke through Mrs. Tennyson, when she wrote direct to Julia: "The only drawback is the old complaint that you *will* rain down precious things upon us, not drop by drop, but in whole Golconda mines at once."

The Camerons had moved again, this time to Putney Heath; and it was here that Julia made one of her most generous gestures which was later to bear some very romantic fruit. It started rather oddly, but characteristically, when she caught sight of an Irish woman, with her small daughter, begging on the Heath. Taken with the beauty of the little girl, Mrs. Cameron decided, on the spur of the moment, to look after them, and promptly installed them in her small lodge. When the Camerons finally moved to Freshwater, which we will come to in a minute, the Irish mother was found work in London, and the daughter was taken to the new home and educated with Julia's own children. The girl grew into a beautiful woman—her name was Kate Shepherd—and she later went to London for a few weeks to accompany an exhibition of Mrs. Cameron's photographs and provide any information required. When doing this job she was seen by a highly eligible young man who was training for the Indian Civil Service. He waited until eighteen months later, when he was sure of his position in India, and then called on Mrs. Cameron and asked for Kate's hand in marriage. After certain difficulties with the young man's family, and with Kate's mother—who thought

that marriage so far above her daughter's station in life would end in unhappiness—the wedding took place. All went well, for Kate fitted into her new life with effortless grace, and her husband rose high in the service. "What is more important," wrote Mrs. Cameron, "it was a marriage of bliss, with children worthy of being photographed, as their mother had been, for their beauty."

At this point it is of interest to see how Mrs. Cameron went about her voluminous writing. She is here writing to Tennyson of the young wife of the banker Everard Hambro, whom she had met at Canford Manor:

Frolicsome and graceful as a kitten, and having the form and eye of an antelope. She is tall and slender, not stately and not seventeen—but quite able to make all daisies rosy, and the ground she treads seems proud of her. Then her complexion (or rather her skin) is faultless—it is like the leaf of "that consummate flower" the Magnolia—a flower which is, I think, so mysterious in its beauty as if it were the only thing left unsoiled and unspoiled from the garden of Eden. A flower a blind man would mistake for a fruit too rich, too good for human Nature's daily food. We had a standard Magnolia tree in our garden at Sheen, and on a still summer night the moon would beam down upon those ripe rich vases, and they used to send forth a scent that made the soul faint with a sense of the luxury of the world of flowers. I always think that flowers tell as much of the bounty of God's love as the Firmament shows of His handiwork.

She finally completes the picture of Mrs. Hambro: "Very dark hair and eyes contrasting with the Magnolia skin, diamonds that dazzle and seem laughing when she laughs, and a costume that offers new varieties every third hour."

It was in 1860, when her husband was temporarily away in his beloved Ceylon, and she was very lonely during his absence, that Mrs. Cameron visited the Tennysons at their new house, Faringford, in the Isle of Wight village of Freshwater. She promptly decided to move there herself. So she bought two cottages at Freshwater, joined them together with a tower, and named the house Dimbola, after one of the Cameron estates in Ceylon.

The Freshwater period in Mrs. Cameron's life lasted a full fifteen years, some of the happiest of her life. Her friends were only too glad to visit her on the Isle of Wight. With the Tennysons' friends added for good measure, and with frequent trips up to Little

Holland House, she blossomed as never before. And never before did she so strive to serve her friends, and increase their well-being, even occasionally to their distress. Hearing, for example, that there was a smallpox scare on the island, she persuaded the local doctor to accompany her to Faringford, where she confronted Tennyson with the rumour, and demanded that he be vaccinated immediately. The unfortunate poet fled through the house, and up the spiral staircase which led to the haven of his study. But it was virtually impossible to evade the Cameron onslaught; she stationed herself at the bottom of the stairs, and started shouting up at him, "You're a coward, Alfred; you're a coward!" He soon capitulated.

But this period also saw some of Mrs. Cameron's most delightful and generously eccentric behaviour. For the great Benjamin Jowett, Master of Balliol, friend of Tennyson, and translator of Plato and Aristotle, she built a little cottage so he could work in peace when he came to stay at Freshwater. For her beloved Sir Henry Taylor, when she became worried at the thought that the room she had prepared for him was too dark, she wrecked the peace of the good people of Freshwater by suddenly demanding, and getting, a new and large window put in the wall of his bedroom just before Sir Henry arrived.

However, it was for her even more beloved husband that she worked the most charming miracle, and we are indebted to Mrs. G. F. Watts for the account of what happened:

Mr. Cameron once regretted that too much space was given up to vegetables in their garden. Her orders went forth secretly to friends and to henchmen that this must be remedied; but on no account could the work be done when Mr. Cameron wished to walk in the garden, which was every day. In cartloads, therefore, turf was brought and laid down out of view, and as soon as Mr. Cameron had gone to bed, her army was marshalled and, by lantern light, the vegetable garden was swept away; so when Mr. Cameron looked out next morning a fine grass lawn spread out before his astonished eyes.

Mr. Cameron was then obliged to travel to Ceylon again; and during this second absence, Mrs. Cameron went to visit her daughter Julia and her husband at Bromley; this was late in 1863. It was on this occasion that she was presented with a camera, and all the accompanying equipment necessary for the messy business of producing wet collodion photographs.

The motives behind this curious gift remain some-

what obscure. Perhaps Julia felt that something new and challenging would take her mother's mind off her loneliness; or possibly she remembered that her mother had at some time been heard to say she could do a much better job than the photographers who took her friends. The words which accompanied the gift are on record, however, Julia saying, with apparent casualness, "It may amuse you, Mother, to try to photograph during your solitude at Freshwater." Seldom has the start of a great career been documented with such accuracy!

Today it is very hard to appreciate what a formidable task Mrs. Cameron undertook when she decided to express herself through photography. She had nothing but textbooks and a few hints from friends to guide her. The wet-collodion process itself was a veritable nightmare to master; and in fact, she never did succeed in mastering the technique completely. She certainly could have done it if she had given her mind to the job; but she was just not the sort of person to persevere in any technique beyond the point she felt necessary for her purpose.

The wet-collodion process—the only method generally practiced from about 1851 to 1871—was strictly for the professionals. To start with, everything had to be done by the photographer. There were no commercially made films, or shops for developing or printing. You started with a piece of clear glass which had to be perfectly polished; next, the liquid collodion had to be carefully poured over it, and allowed to dry to a tacky state, before the plate was put in the sensitising bath, in the dark. It then had to be placed in the camera wet, and kept wet throughout the exposure, whilst perfect cleanliness had to be preserved at all times to avoid the smallest speck of dust, or the slightest scratch on the plate, any of which would show up on the resulting negative. The plate, after a long exposure, had to be taken out and immediately have the developing solution poured over it. Then it had to be fixed, washed, dried, and finally varnished, before any prints could be taken from it. For this last process, the plate had to be warmed in front of a fire before the varnish was poured over it and drained off. Every one of these steps was fraught with difficulty and danger, and the plate could easily be ruined at any stage of the process—even at the last, when the varnish could cause the film of collodion to crack.

Then there was the preparation of the printing paper, which Mrs. Cameron chose to do herself, rather than use the ready-made albumenised paper available at the time, as she wanted the warmer tones of the proper sepia print.

Along with the terrifying complexity of this collodion wet-plate process came the inevitable black stains on clothes and hands from the silver salts, as well as the smell of the collodion. It was not for nothing that photography at this time was often nicknamed the "black art."

Added to all this, Mrs. Cameron made things far more difficult for herself—and for her sitters—by using large plates to avoid enlargement; at first they were eleven inches by nine inches, and later fifteen by twelve. She did this to produce the effects she sought, which meant—with the two lenses she had —that the unfortunate sitters had to try to compose themselves, with eyes fixed on a point, for a period from three to seven minutes.

As I am not a photographic expert, I am not going to attempt a technical critique of Mrs. Cameron's work. My friend Helmut Gernsheim, to whom we all—and I in particular—owe a great debt of gratitude for his research into not only Mrs. Cameron's work but the whole field of early photography, took the view that Mrs. Cameron's effects were the result of her refusal to take small plates and enlarge them, of the exceedingly long exposures, and of defects in her equipment and technique, which was obviously very slovenly. I am not in a position to comment on this, except to say that as Mrs. Cameron was very well aware of the work being done by the hundreds of professional photographers around her, she would have surely *changed* her technique if it was not giving her the results she wanted, no matter how difficult she or her sitters found the work. Her technique was, if you like, a kind of self-imposed inefficiency, which seemed to fit her own individual personality.

It may amuse you to hear the experience of one of her sitters, who has not yet, to my knowledge, been identified:

The studio, I remember, was very untidy and very uncomfortable. Mrs Cameron put a crown on my head and posed me as the heroic queen. This was somewhat tedious, but not half so bad as the exposure. Mrs Cameron warned me before it commenced that it would take a long time, adding, with a sort of half groan, that it was the sole difficulty she had to contend with in working with large plates. The difficulties of development she did not seem to trouble about. The exposure began. A minute went over and I felt as if I must scream; another minute, and the sensation was as if my eyes were coming out of my head; a third, and the back of my neck appeared to be afflicted with palsy; a

fourth, and the crown, which was too large, began to slip down my forehead; a fifth—but here I utterly broke down, for *Mr* Cameron, who was very aged, and had unconquerable fits of hilarity which always came in the wrong places, began to laugh audibly, and this was too much for my self-possession, and I was obliged to join the dear old gentleman. When Mrs Cameron, with the assistance of "Mary"—the beautiful girl who figured in so many pictures, and notably in the picture called the "Madonna"—bore off the gigantic dark slide with the remark that she was afraid I had moved, I was obliged to tell I was sure I had.

This first picture was nothing but a series of "wobblings" and so was the second; the third was more successful, though the torture of standing for nearly ten minutes without a head-rest was something indescribable. I have a copy of that picture now. The face and crown have not more than six outlines, and if it was Mrs Cameron's intention to represent Zenobia in the last stage of misery and desperation, I think she succeeded.

This sort of ordeal was hard to bear at any time, and worse than ever with Mrs. Cameron, who wasted innumerable plates and thus innumerable extra minutes of her sitters' lives, before she was satisfied with the results.

Only the most intrepid and determined amateur photographers surmounted these many obstacles. But Julia Cameron possessed the necessary qualities in abundance, and she won through. We simply cannot imagine her giving up anything in the face of anything—let alone allowing a mere inanimate technical process to stand between her and her goal! It was not until the following year, after months of heartbreaking and backbreaking effort, that she could write proudly on the mount of one of her prints, "Annie, my *first* success," and add the date, "January 1864." It was the portrait of a sweet young girl—a "local"—who did not seem to mind the necessary ordeal, and welcomed the modest fee Mrs. Cameron paid.

Considering her unique circle of distinguished friends, it seems curious to us today that her first short phase of photography—from 1864 to 1866—included almost no portraits. Her output during this period was confined to posed pieces done in rivalry with the contemporary subject-painting of biblical and allegorical subjects, such as the wise and foolish virgins, romantic studies of the Madonna and Child,

and so on. This output, which is certainly of importance to those who study Mrs. Cameron's work, is not—and never has been—popular with anyone! But almost at once she had started sending her work to photographic exhibitions. Reviews were mostly unfavourable from the technical press; but high praise was given by artists. However, one photographic journal was bolder than the rest, and pronounced her work "admirable, expressive and vigorous, but dreadfully opposed to photographic conventionalities and proprieties." She was always more appreciated on the Continent than in Britain; at Berlin she first won a bronze medal, then a gold. In Paris in 1867 she was treated with great respect and her work hailed as belonging, "if not to the most beautiful, at least to the most remarkable photographs of the English section in the exhibition."

In 1866 Mrs. Cameron bought a new camera, which took giant plates of fifteen inches by twelve inches. Then, for four triumphant years, she photographed her celebrated friends, and little did they realise what they were in for. Having learned to love her, and endure her own exuberant love and generosity in return, they now discovered that even greater demonstrations of affection were involved on her side, and far greater ordeals demanded on theirs.

Already, in her first photographic phase, Mrs. Cameron had learned that few ordinary mortals could resist her invitation to come in and pose for a photograph; she had no compunction whatever in going forth into the lanes round Freshwater, and compelling complete strangers to walk over to Dimbola and spend two or three hours in the suffocating heat of their hostess's converted hen-house, posing in all sorts of draped positions. As I have said, a pose might have to be held for as much as seven minutes at a time—an ordeal which must be experienced to be appreciated, and having been appreciated, never be repeated. It was, therefore, the final test of loyalty when the procession of great men—and a few women—sat or stood in acute discomfort in front of her lens, and were often required to pose on more than one occasion before returning to their normal lives.

A few men refused to sit for her, including Garibaldi, and some had to be wooed sedulously. Here is William Allingham in his diary entry for June 10, 1867:

Down train comes in with Mrs. Cameron, queenly in carriage by herself, surrounded by photographs. We go to Lymington together, she talking all the time. "I want to do a large photograph of Tennyson and he objects! Says I

make bags under his eyes—and Carlyle refuses to give me a sitting, he says it is a kind of *inferno*. The *greatest* men of the age (with strong emphasis) Sir John Herschel, Henry Taylor, Watts, say I have immortalised them, and these other men object!! What is one to do, h'm?" (This is a kind of interrogative interjection she often uses, but seldom waits for a reply.)

But there were so many successes that it is idle to worry about the few who turned their backs on her unique form of ensuring their deeper immortality. As we watch those great men and fascinating women passing in review, looking out from Mrs. Cameron's great sepia prints, we can only feel they knew perfectly well that they were thereby attaining a second—a visual—immortality, that their faces, seen by the most sensitive and adoring of friends, would then go down to an admiring posterity as worthy accompaniment to their poems, their prose, and their paintings. It was because of her sitters' forbearance, and Mrs. Cameron's genius, that we now have an array of photographic portraits without equal before or since. There are Tennyson, Browning, Longfellow, Trollope, Carlyle, Darwin, Herschel, Watts, and many others, and—among the women—the loveliest study ever made of Ellen Terry.

When we remember that the collodion process had been so highly praised, since its invention in 1851, as the equal of the daguerreotype in meticulous detail, and when we stand before Julia Cameron's masterpieces—in which fine detail is thrown to the winds—do we fully realise her genius. She often took only the head and shoulders of her sitters, simply and directly lit to produce a dramatic chiaroscuro effect, with their faces seen against a dark background. With little or nothing in sharp focus, and the subject often incapable of remaining perfectly still for such a time as was demanded of him, the effect is of extraordinary intensity and vitality.

And yet there is another more important quality which seems to pervade Mrs. Cameron's photographs and set them apart from all others. It may perhaps be described quite simply as the quality of affection—mutual affection between the sitter and the photographer. Such a quality of vibrant rapport suffuses and radiates from Mrs. Cameron's photographs: it is an extremely rare occurrence in the history of the camera and its images.

As Mr. Cameron became ever more frail, the time of their departure could not be postponed for long; he pined after Ceylon, and so did his wife. She must have known that her mission was drawing to a close.

She had written to Mrs. Tennyson, "It is a sacred blessing which has attended my photography; it gives a pleasure to millions and a deeper happiness to very many."

So they returned at last to Ceylon. On that autumn afternoon in 1875, as the plain little woman supervised the loading of her bags and baggage, her coffins and her cow, and as she prepared to take her adored and adoring husband home to die, she was at last firmly and quietly closing the door on twenty-two years of compulsive bustle and hurly-burly, of compulsive devotion and service to the literary and artistic leaders of the nation. She must have felt a deep satisfaction in knowing that she left behind her a golden—or rather a sepia—legacy, which would gain immeasurably in richness with the years, until the end of recorded history.

Surprisingly, both she and her husband paid a brief return visit to England in 1878; then they departed for good. Despite her far stronger constitution, it was Julia who died first, just a few months after her return to Ceylon, on January 26, 1879. She was taken in a cart drawn by two white bullocks, over the mountains to a little churchyard in a valley just north of Galle. On May 4, 1880, Charles Cameron died; he too was borne across the mountains, to lie beside his wife.

Mrs. Bowden-Smith has left a description of the scene; I quote it now to end this essay on the remarkable and most admirable Julia Margaret Cameron: "I cannot describe the beauty of that valley. High mountains surround it and rolling green grasslands, and a great river runs all along it. The little church stands on a knoll not far above the river, which flows into a lower river, also a dream of beauty. They could not have found a more beautiful resting-place."

VICTOR REGNAULT, CALOTYPIST

ANDRÉ JAMMES

VICTOR REGNAULT, CALOTYPIST

André Jammes
Antiquarian Bookseller and Collector, Paris
Translated by Robert Sobieszek

Victor Regnault is quite well known. President of the Académie des Sciences, member of the Institut and director of the Manufacture de Sèvres, he has been associated with some remarkable studies of physics. To cite the *Histoire des Sciences,* published under the direction of Maurice Daumas, "his works have become classics, and it is upon them that modern physics of gases is based. It has been unnecessary to revise the theorems he formulated."

He seems to have been interested in photography from the very birth of that art, and like Arago, Fizeau, and Foucault, he kept pace with all its developments. In June 1841, he experimented with samples of Fox Talbot's paper that Biot had sent him. In 1847, with his students, he verified Blanquart-Evrard's advancements, using paper to obtain negatives. As early as 1851, he participated in founding the Société héliographique, and his name figures at the bottom of the first manifesto of this society, with the signatures of Becquerel, Delacroix, Niépce de Saint-Victor, and others. When the Société héliographique was replaced by the Société Française de Photographie, he was made president, a position he retained from 1855 to 1868.

In spite of this long and personal activity dedicated to photography, historians of photography have neglected Victor Regnault. Neither Potonniée nor Gernsheim mentions him, and Lécuyer hesitates to attribute his works. Fortunately, a number of Regnault's masterpieces are extant; they permit us to classify him among the greatest masters of primitive photography. Yet it is difficult to know precisely what portion of his work has come down to us. Some landscapes are preserved in the Paris Bibliothèque Nationale, in the Kodak Museum at Harrow, England, and in the collection of André Jammes. The Société Française de Photographie also has some landscapes, as well as an especially admirable series of original negatives, almost all portraits, many of which are still unpublished.

Regnault's work can be grouped into three series:

1. Scientific photographs. These represent measuring devices, Regnault's laboratory, and some physics experiments. Certain of these prints were destined to be used by engravers for illustrations in scientific books containing experiment reports:

Mr. Regnault has recently reported to the Société héliographique a very practical use that he has been able to make of the heliographic paper print, namely, the reproduction of very complicated scientific instruments which are consequently difficult to represent well with the

ordinary resources of drawing. Mr. Regnault begins in the normal manner by obtaining a negative print, and then, with this, a positive, representing the objects which he intends to engrave. . . . The images he obtains in this manner often leave something to be desired; they are neither clean enough nor complete enough in this state to give to the engraver. What does Mr. Regnault do then? He defines his images with drawing ink by retracing all the details with pen and drafting pen; then he washes these images in a reactant that destroys the photographic image. There then remains a pure and perfectly exact design definitely traced on the white paper. What a resource this way of proceeding would be for all great machines—locomotives, for example, whose mechanism is so complicated and whose reproduction because of this demands so much precision and clarity.[1]

2. Portraits. These are family portraits in which one can perhaps identify his wife, his children, and various portraits of scientists, notably Claude Bernard, his illustrious colleague at the Collège de France. The collection of these portrait negatives is conserved at the Société Française de Photographie.

3. Landscapes. Nine landscape "Views in France" are known to have been exhibited in London in December 1852. It is impossible to identify them with any precision, for the only additional facts known are that they were lent by J. Stewart and that the negatives were on waxed paper. Among the prints conserved at Harrow and at Paris are some landscapes made in England in collaboration with John Stewart, son-in-law of J. F. W. Herschel. Finally, the most beautiful extant series represents the Manufacture de Sèvres and its surroundings. The surroundings can be dated 1854, the year in which Regnault became director of the establishment.

Victor Regnault evidently knew the various photographic processes of his time, yet it is obvious that his artistic temperament was entirely satisfied with the caloytype. The process consisted, as is well known, in coating a very smooth sheet of paper with potassium iodide and silver nitrate, developing the image with gallic acid, and fixing it with hyposulfite of soda. Regnault's formulas are found in a letter from Stewart to J. F. W. Herschel, published at the beginning of the exhibition catalogue of the Society of Arts, London, 1852. It does not seem that Regnault applied any important innovations to his methods, but he did demonstrate a particular carefulness. It is known, for example, that he sensitized his paper in a reservoir which he placed for some time in a vacuum in order to eliminate any air bubbles and to assure the penetration of the sensitized material. He found it necessary even to have special photographic paper samples made for him. From the scientific point of view his photographs are difficult to judge, since we do not have his experiment records or his laboratory notebooks, which were destroyed in 1870. Nevertheless, his negatives and prints bear witness to the highest technical quality of the time. One can give equal thought to the fact that he was one of the first to make practical use of photography as a means to describe or record scientific experiments.

The aesthetic qualities of the calotype had seduced him. Solely because he wanted to justify the artistic value of the paper process, Paul Périer has left an interesting account of Regnault:

Large and delicate at the same time, detail without harshness, just the right amount of softness in the midgrounds and finally a hint of relationship to the best works of the great schools of painting constitute the nearly incontestable qualities [of the calotype]. . . . Such appears also to be the opinion of our excellent and illustrious president, Mr. Regnault, who, in his rare leisure moments, produces some of the highest quality prints, known only to a very few privileged individuals. But Regnault speaks to us about art as if he had had no other religion.[2]

Victor Regnault was a man who possessed a solid artistic culture, and being director of the Manufacture de Sèvres was for him a perfect means of combining art and technique, an association that he again found ideally in photography. He lived in an atmosphere that fostered vocations, and at ten years of age his son Henri was already an artist. The father encouraged this ardent vocation, so ardent that one day the neophyte had to be rescued from a cage in the Jardin des plantes where he was drawing a lion. Henri was considered one of the great masters of "historical painting," so much so that the "humble servant" was scarcely spoken of in Sèvres. After the death of his son at Buzenval in 1871, and after the pillage of his laboratory by the Prussians, Victor Regnault officially declared that only painting could hope to express artistic sentiments.

NOTES

1. *La Lumière*, 1851, p. 19.
2. *Bulletin de la Société Française de Photographie*, 1855, pp. 199–200.

40. Victor Regnault. *Ladder, Manufacture de Sèvres.* c 1851.
Print published by Blanquart-Evrard in the second series of
Études Photographiques (before 1855), plate 205.

41. Victor Regnault. *Gate of the Manufacture de Sèvres.*
c 1851. Calotype. Collection André Jammes, Paris.

42. Victor Regnault. *Old House at Sèvres.* c 1851.
Calotype. Collection André Jammes, Paris.

43. Victor Regnault. *Portrait of a Scientist?* c 1852. Calotype.
Printed from the original negative in the collection of the
Société Française de Photographie, Paris.

44. Victor Regnault. *Acoustical Experiment.* c 1852.
Calotype. Printed from the original negative in the
collection of the Société Française de Photographie, Paris.

45. Victor Regnault. *Laboratory of the Collège de France.*
c 1852. Calotype. Société Française de Photographie, Paris.

46. Victor Regnault. *Woods at Sèvres or Mendon.* c 1851.
Collection André Jammes, Paris.

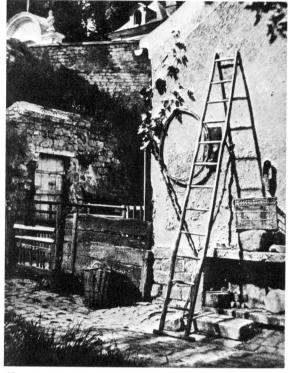

40.

41.

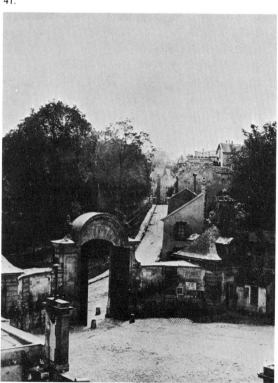

42.

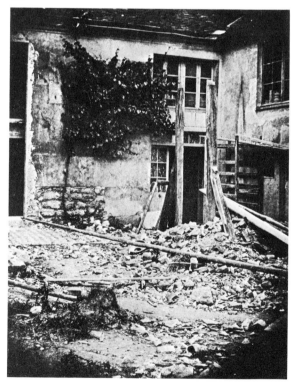

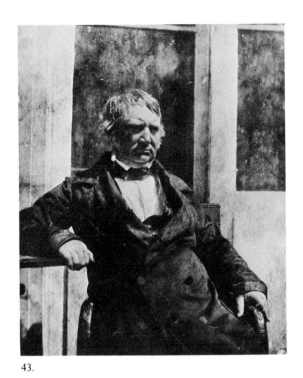

43.

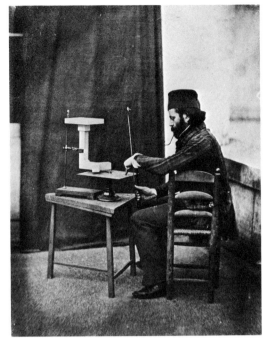

44.

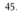
45.

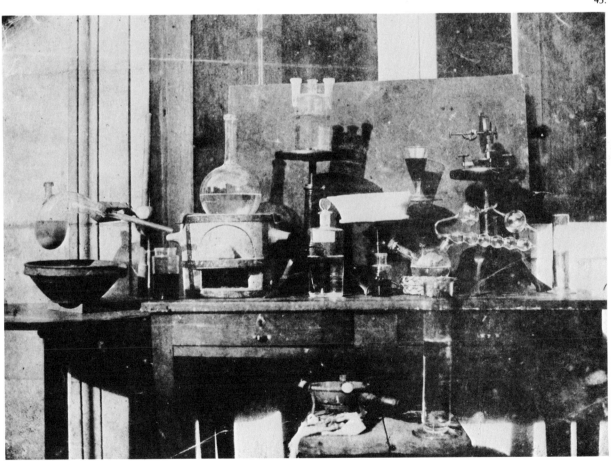

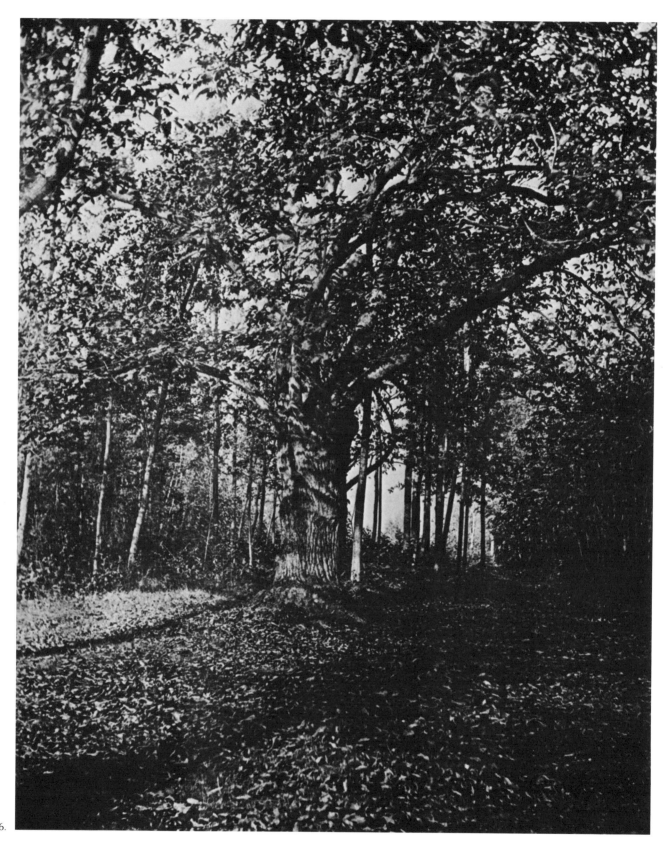

46.

PHOTOMONTAGE AFTER WORLD WAR I

JEAN A. KEIM

PHOTOMONTAGE AFTER WORLD WAR I

Jean A. Keim

Diplomat, Chinese Historian, Professor of History of Photography, University of Paris, prior to his death in 1972

The term "photomontage" designates a means of operation and the product obtained. Its definition varies with its creators. In his preface to the first photomontage exhibition, in 1931 at the Kunstgewerbe Museum of Berlin, Cesar Domela-Nieuwenhuis wrote: "Photomontage is the artistic arrangement of one or several photographs in a picture (with typography or color) in a unity of composition; a certain knowledge is necessary for this, an awareness of the structure of photography (created through tones), the division of the plane, and the construction of the composition." The author brings in an idea of value which is still open to discussion. In his introduction to the exposition *Die Fotomontage, Geschichte und Wesen einer Kunstform* [Photomontage: History and Nature of an Art Form][1] Richard Hiepe declares, "Photomontages are totally, or for the most part, composed of photographs and other reproductions of compositions of pictures." This definition has the advantage of not drawing a line between the different types of photomontage; it tends, however, not to distinguish between the elements of photomontage, photographs, prints, and drawings, such as sketches, paintings, and engravings. F. Schiff is more precise: "Photomontage is the technique which permits one to compose, from various photographs taken in different places and times, a new picture."[2] This definition seems to exclude retouchings, inscriptions, or added sketches.

To understand the subject, one might propose a definition: "Photomontage is a new image created, totally or for the most part, from pieces of photographs." This has the advantage of emphasizing photography without rejecting the insertion of another genre; it permits one not to exclude any of the different techniques used—negative montage, positive montage, collage—in considering the result: the creation of a new picture by the juxtaposition of other pictures.

Advocates of a "pure" photography, conceived solely by physical and chemical means, do not acknowledge photomontage, in which man has intervened to delimit the photograph and usually to erase all sense of continuity by means of retouching. It is a basic truth that, even if it is created with photographs, a photomontage is not a photograph and does not require the same qualities for its elaboration. Photomontage belongs, however, to the domain of photographic imagery. Too narrow a view limits photography by excluding certain kinds of works whose value, but not whose existence, can be disputed and whose forms and motivations have been modified over the years.

The first photomontages were created in an "artis-

tic" attempt to imitate the pictures in vogue at the time. The photographers, often former painters, did not resign themselves to being considered artisans of an inferior order; they wanted to rival recognized art, the kind that the salons rewarded with medals. This tendency spread in Great Britain at the end of the 1850s with the "combination printing" of Oscar G. Rejlander and Henry Peach Robinson, whose success at the time was astonishing. They no longer have any followers, although at the present time the Chinese Chin-San Long, with his "composite pictures," imitates the pictures of the old masters of his country.

A second tendency, less well known but just as important, appears in photomontages: the reconstitution of a reality that could not be obtained directly. The collodion plates, owing to their extreme sensitivity to blue, permit one to obtain only white, empty skies over landscapes; two different exposures—one short one for the sky, one longer one for the landscape—partially transferred on the positive, furnished an image more like that seen by the eye. Events where the photographer was not present are recreated. The King of Prussia's visit to the Agricultural Exposition of Berlin in 1861 is a photomontage made with separate photographs of the king, queen, bystanders, and prize sheep.[3] In the United States the process was also used; the horse race at Dexter was re-created by John L. Gihon in 1867; Gentile's picture of the staff of General Sheridan in 1877 is another well-known example.[4] In 1870, the Canadian William Notman began to make some "composite photographs"; in view of his success, the Canadian government ordered from him for the International Exposition of Paris a *Curling au Canada;* it shows the principal personalities of the country, with Montreal in the background.[5] One may cite also the proclamation, before hundreds of onlookers, of the Dogma of the Immaculate Conception at the Council of Rome in 1870, "composed with real elements."[6] Tragic scenes, such as the execution of the Emperor Maximilian of Mexico in 1867, do not escape this genre.[7] To show the horrors of the Commune, an expert reconstructed the shooting of the generals with a crowd whose heads were replaced by those of the victims. The expulsion of the Dominicans from Arcueil is another example. Photomontage becomes a false witness: the picture composed with the portraits of Senator Millard Tydings and the leader of the American Communist Party, Earl Browder, cost the senator his seat.[8]

A third tendency seeks a form of reality other than that which the human eye can perceive. Disdéri assembled on the same calling card, in mosaic,

numerous portraits of celebrities on the legs of the dancers of the Paris Opera. These pictures achieved great success and were sold in great numbers. Unscrupulous practitioners of overprinting created "spirit photographs," where, next to a living descendant, the dead person appeared in the form of a ghost; eventually they had to explain their activities in court. Amateurs at the end of the last century placed their models in new settings or unaccustomed positions. Numerous books at the time proposed many faking procedures to their readers.[9] An example is the folding screen made from 1873 to 1874 by the Danish writer Andersen, which was covered with pieces of photographs glued next to one another.[10] Another use of photomontage appeared in humorous, patriotic, and erotic postcards, which were very popular at the turn of the century. The painter Paul Citroën and the poets Paul Éluard[11] and Robert Desnos possessed splendid collections of these "popular" pictures. Finally, innovations in photomechanical processes made it possible to mix photographs and texts on publicity posters.[12]

Photomontage saw a revival after World War I. We are not attempting here to give a historical account of this new period of photomontage; rather we are trying to define its tendencies and forms.

Certain "photomonteurs" claim to have invented this "new" form of expression. Georges Grosz declares: "When, in 1916, one morning in May around five o'clock, in my Südente workshop, John Heartfield and I invented photomontage, we were both far from suspecting the immense possibilities of this invention, nor the thorny path which would lead to its success. We pasted on a piece of cardboard, pell-mell, advertisements for hernia bandages, a collection of student songs, dog food, wine and schnapps labels, and magazine photos cut up any which way and assembled in opposite directions, so that what was said by the picture would have been immediately censured if it had been put into words. It is in this way that we put together postcards which could have been sent from the front lines home, or from home to the front lines."[13] Hannah Höch tells of a time when she was at Gribow, on the Baltic Sea, with Raoul Hausmann in an old inn. They saw on the wall a photograph in which a head was glued on a background prepared in advance. Hausmann said: "One could do something like that with photos."[14] Hannah Höch specified, another time, that the picture represented "the Emperor William II, surrounded by his ancestors and his descendants, oak trees and German decorations and, a little higher, a young gunner under whose cap had been pasted the

portrait of our host. Thus the young pioneer stood proudly surrounded by his superiors in the middle of earthly glories."[15] In a letter to Van Deren Coke, Hannah Höch gave another version: "We got the idea for a trick picture from the official photographs of the regiments of the German army; they used very elaborate mounts showing men with houses or landscapes in the background. On the mount, the photographer inserted the figure of his client."[16] On the other hand, Raoul Hausmann cited as inventors Baader, Hausmann, Heartfield, Höch, and Grosz.[17]

These discussions of paternity are of little importance. Photomontage was only rediscovered and reutilized in a systematic fashion. When it was "discovered" by the members of the Berlin Dada group, it changed in form and content.

The new "photomonteurs" were not photographers, with the exception of several who also practiced photography, such as Bayer, Moholy-Nagy, and Rodchenko. The others were painters, graphic artists, like Arp, Baumeister, Berman, Citroën, Dali, Domela-Nieuwenhuis, Ernst, Grosz, Hausmann, Heartfield, Höch, Kluzis, El Lissitzky, Renau, Schuitema, Schwitters, Szczuka, and Tiege, and sometimes writers like Éluard, Hugnet, and Prévert. They created their works with photographs taken by experts, usually anonymous; they utilized pictures reproduced by photomechanical means; they expressed themselves not as photographers but as creators, using a new means of expression not yet codified, where everything is permitted. They did not seek, at the outset, to create an artistic work, to reconstruct a scene, to amuse; they were part of movements, and they militated for artistic or political philosophies.

One might wonder why they utilized photomontage. To be sure, knowledgeable explanations were given after the fact by the artists and their theoreticians. They are probably valid, and "photomonteurs" have followed the current.

It is necessary, however, to put on record two responses given to me. Paul Citroën—one of the pioneers, since he made montages as early as 1919—declared that he had created his photomontages as a joke. He wrote in a public lecture entitled "Wir Maler heute und die Kunsttradition" [We Painters of Today and the Artistic Tradition]: "The old artist willingly remembers the joke that he played in his time with his friends of the same age; but it is impossible for him to take seriously these pasted pictures, later called photomontages, and today collages, which now enjoy international renown and worldwide repercussion in the little circles of specialists who are interested in them."[18] As for Cesar Dom-

ela-Nieuwenhuis, who only began to practice this mode of expression in 1927, he recognizes simply that he made publicity photomontages to earn money.

Any work, by its very existence, poses problems, even if its creator is not conscious of them. What are the causes of its appearance? To what needs is it responding? It is not at all absurd, then, in spite of creators' declarations, to seek out deeper reasons which permit one to give a valid explanation of the phenomenon of the renaissance and expansion of photomontage.

One must first notice that the recourse to the collage by the cubist painters did not give rise to the use of photographs. In the framework of the Italian futurist movement, we may cite the little photograph of General Joffre pasted to Carlo Carra's picture *Officier français observant les manoeuvres de l'en-nemi*, but this photographic image is utilized not for what it represents but as an object existing in itself. The same can be said of the photographs used as early as 1918 by the Russian suprematist artists, Malevich and Gustav Kluzis. The new photomontage appeared with the Dadaist movement.

Traumatized by the upheavals of World War I, men began to reexamine the conditions of existence. In view of the collapse of the old society, recognized values began to be contested. The Dadaist movement, born in Zurich in 1916, is evidence of this. It would be erroneous to seek doctrine in it. As Georges Hugnet says, echoing Tzara and Breton, Dada is "a state of mind," which attempts to undermine prejudices and established situations.[19] Photomontage appeared in Berlin when the initial Zurich group emigrated. Already its German adherents had amused themselves by creating photomontages; they realized with astonishment that they possessed a new means of provocation.

Raoul Hausmann, who was an active member of the movement, agrees: "The Dadaists of Berlin were the first to use photography to create out of often totally disparate elements, spatially and materially, a new unity in which was revealed a new picture, visually and conceptually, of this chaos of an age of war and revolution."[20]

In the catalogue of the first Dada fair in 1920 in Berlin, the theoreticians explain: "Each time that infinite quantities of time, love, efforts have been spent in painting a body, a flower, a hat, a cast shadow, etc. . . . we have only to take scissors and cut out, from among the paintings and photographic representations, whatever we need."

The art of the past, according to the Dadaists, denies reality, presents itself in an arranged form; we

must come back to the reality which is hidden from us. Georges Grosz called his collages "materializations" which were "made with paintbrush and scissors." No formal search, but a need to signify in order to transmit a message.

Dada wanted to be anti-art. In the search for artistic desanctification, photomontage was a useful weapon. Hannah Höch declared: "We call this technique photomontage, because this term includes our aversion to playing artist. We looked at ourselves as engineers, we claimed to construct, to 'mount,' our work like a locksmith." Grosz's "materializations" are signed "Constructor Georges Grosz," while Heartfield writes on the photomontage of *Maréchal Grosz* "the mounter."

This profession of faith did not prevent Dada from exalting revolutionary formulas at the Dadaist fair of Berlin in 1920. A sign proclaimed, "Art is dead, long live the new art of the Tatlin machines"; Hannah Höch wanted "to integrate the objects of the world of machines and industry with the world of the arts." Everything was permitted; each photomonteur followed his own path. Some used more pieces of photography, others freely used more inscriptions. Some deformed perspective, others sought to respect it with new forms. Some tried to shock, others were already trying to please.

Raoul Hausmann was wild and violent; he set fire to any room. He was the theoretician in a movement where the rule was not to have any. His mode of creation is well explained in a letter dating from 1967—that is to say, nearly a half-century later—describing the execution, in 1920, of *Tatlin at home.*

I was always surrounded by magazines, press photos, and technical catalogues, and I looked there for what I needed, evidently. In the post-war Berlin of the twenties, when they were still shooting in the streets and the tanks were approaching heavily, one would speak with enthusiasm in the avant-garde of a mechanical technique of which one had only a vague idea. One day I was leafing through an old American magazine, thinking of nothing. Suddenly the face of an unknown man sprang to my eyes, and I don't know why I immediately made the connection with the Russian Tatlin, the inventor of the art of the machine. As for me, I wanted to represent this man with a brain full of machines, cylinders, and flywheels. I took a good sheet of cardboard and said to myself that I must show this man in perspective. I began then by painting a room seen from a little above. I cut off the man's head and glued it in the lower part of my watercolor. I began to cut out pieces from an automobile magazine and to place them under his eyes. Yes, but that was not enough. This man had to be thinking about a large piece of machinery. So I looked in my photos and found the poop of a boat with a big propeller; I pasted that vertically on the wall of the background. Didn't this man also have the desire to travel? Whence the map of Pomerania on the left wall. Tatlin was surely not rich. So I cut out from a French newspaper a man who was walking, with a worried forehead, turning out his pockets. With what was he going to pay his taxes? Fine, but it was still lacking something on the right side. So I painted a dummy in my picture. But obviously that still was not enough. I cut out from an anatomy book the internal organs of a human body and glued them onto the torso of my dummy. And at its feet: a fire extinguisher. I again contemplated my picture. No, there was no longer anything to change. It was good. It was perfect.[21]

Hannah Höch, once the companion of Raoul Hausmann, gives evidence of an unbridled and poetic fantasy; under sometimes doctrinaire appearances, her creations are often purely playful. Georges Grosz's pictures are savage social criticism against authority, against the army, against the bourgeoisie. John Heartfield, who changed his name, Helmut Herzfelde, to an English surname out of defiance of the wartime German nationalists, made the photomontage on the catalogue cover of the first international Dada fair in Berlin in 1920. John Heartfield was direct; he did not encumber himself with subtleties; in the framework of the Dadaist movement, he launched his first brutally political pictures when he began to work for the Malik publishing house. We must also mention Hans Arp and his famous, naively antibourgeois *Gant;* Johannes Baader, anarchist; Johannes Theodor Baargeld, founder of the Dada group of Cologne, where Max Ernst began his first photomontages with a poetic verve, and used old engravings, created often from photographs; and Kurt Schwitters, who expressed himself in many media.

It is permissible to discuss the value of these Dadaist works; they exist, or at least they existed; they have cracked the narrow pictorial frames that hemmed in creators. "The plastic domain does not belong to painters alone."[22] Photography shatters into pieces, just as typography did elsewhere. Dadaism, without producing remarkable pieces, had the merit of clearing the table: new constructions will never be the same again.

In 1922, a Russian art exposition put the Soviet artists in touch with Dadaist photomontages. The same year, at the Bauhaus festival at Weimar, Tristan Tzara, pope of Dadaism, hurled the word "dissolution."[23] The Dadaist photomonteurs pursued their work in diverse directions while new practitioners from other horizons developed their works.

Rapidly, the positions became clear. In 1924, László Moholy-Nagy, while teaching at the Bauhaus, made his first photomontages, while Max Burchartz used in his work the products of heavy industry. The same year, John Heartfield displayed, in the window of the Malik publishing house, his large *Pères et Enfants*, taken from three retouched negatives; the Russian El Lissitzky produced his self-portrait, *Le Constructeur*, and the Pole Mieczyslaw Szczuka published his first photomontages in the magazine *Bloku*.

In France, Surrealism, which welcomed the former Dadaists, did not disown photomontage. But its form was modified in answer to the theoreticians. The poet Pierre Reverdy, followed later by Breton's *Manifeste du surréalisme*,[24] wrote as early as 1918, "The more the connections between two compared realities are distant and slight—the more it [the picture] will have emotive power and poetic reality." This search for an "imaginary quality that tends to become real," to use Breton's terms, has given birth especially to photomontages by writers—André Breton, Paul Éluard, Georges Hugnet, Jacques Prévert. The literary point of view prevails over the classical representation. The theoreticians, like Aragon, call for works which are, according to the formula of Lautréamont, "beautiful as the happy meeting of a sewing machine and an umbrella on a dissection table." The plastic quest remained paramount in Max Ernst, who continued to work without worrying about rules; it reached its summit in the painter Karol Tiege, founder, with the poet Vitezslav Nezval, of the Czechoslovakian surrealist group. Tiege's spare photomontages, where the female nude is always present in irrational situations, possess a poetic purity and simplicity which make them some of the most perfect lyrical successes of this mode of expression.

The Bauhaus collages are more theoretical. Therefore one must not group in this category the *Villes* of Paul Citroën, even if in 1923 *Das Illustrierte Bild* reproduced one of them to illustrate the Bauhaus Exhibition. Klee, indeed, then professor at Weimar, after having asked Citroën, "What is it?" took the photomontage, placed it on the wall, and declared, "You are a refined man." Citroën was sensitive to horizontal and vertical lines and to changes in perspective. His first works date from 1919, and his

photomontages are not characteristic of the Bauhaus doctrines which extol construction.

In 1924, Moholy-Nagy, in the framework of his graphic works, used a photomontage that was more elaborate, more geometric, and at the same time graphic and intellectual. In his general system, which replaced the weakness of the hand by the objective camera, he rediscovered new possibilities with his "Photoplastiques" which are "more lifelike than life itself." He considered this means of creating a picture to be a "simultaneous representation; a visual interplay; a disquieting union growing large in the imagination by imitating basic reality."[25] The artist, in spite of his efforts, remained a cold theoretician. The same is not true of Willy Baumeister, whose pictures are skillfully composed, or of Herbert Bayer, who was professor of photography at the Bauhaus, and whose surrealistic, hallucinatory pictures are permeated with poetry.

The Bauhaus was seeking applied art. Already Moholy-Nagy had used photomontage in publicity; a whole series of works follow the same direction. In Germany Max Burchartz and Johannis Canis, and in the Netherlands Paul Schuitema, Piet Zwart, and Cesar Domela-Nieuwenhuis with his remarkable sign for the Berlin museums, mix letters with photographic images to create modern publicity.

John Heartfield, to the indignation of the former Dadaists, gave free reign to his fantasy on the covers of Malik books, giving them a new, attractive format. He attained a virtuosity served by an imagination that never slept. He added stature to photomontage by making it a powerful political instrument, anti-Nazi, in such a way that it is not indecent to compare Heartfield to Daumier, and that it seems normal for Aragon to speak of the "knife which penetrates the heart." Heartfield's images are violent, direct, summarized by a short caption that strikes the observer brutally. They are conceived for the printed page, and they sparkle in publication, as, for example, in the *Arbeiter Illustrierte Zeitung*, organ of the German Communist party. It is true that the philosopher Ernst Bloch wrote: "The satirical glued photos were so close to the people that many an intellectual did not want to hear about photomontage."[26] Aragon, however, has perfectly defined the work of Heartfield, who "has employed that very photography which was challenging painting to new poetic ends, thus diverting photography from its imitative direction toward expressive usage."[27] The power of these pictures—the pregnant woman before the dead child, the dove run through with a bayonet in front of the Palace of the Society of Nations, the death's-head of

fascism, Hitler the "vegetarian" preparing to behead the gallic cock—has not diminished with time. "People have no idea how difficult it is to be a photomonteur!" cried John Heartfield.[28]

The Russians El Lissitzky and Rodchenko, at the time of their trip to Berlin on the occasion of the Russian art exposition in 1922, discovered a photomontage different from the attempts of suprematist and constructivist painters. Rodchenko declared to Hausmann: "This is not yet known in our country."

Rodchenko had studied the cinema with Vertov and Koulichev. He illustrated the poems of Mayakovsky and created signs for the exhibits, with photos which he had taken: "The exactitude [of photography] and its documentary fidelity give the representation the power of leading to contemplation, as that was not possible with pictorial or graphic means." El Lissitzky, architect and typographer, after having traveled in western Europe, became interested in large photomontage frescoes, and created a photomontage that measures 23 meters by 4 meters, in 1928, for the pavilion of the Soviet press at the Cologne exhibit. From the *Tribune de Lenine* with its simple, airy lines, to the involved, vivid photomontages of *L'U.R.S.S. en construction*, a whole evolution unfolds toward a complete utilization of photomontage. Among the Soviet photomonteurs one must not forget Gustav Kluzis, who organized his construction "according to the principle of maximum contrast," giving a new force to propaganda.

In 1931, at the Kunstgewerbe Museum of Berlin, an exhibit of photomontages opened, with a catalogue containing a preface by Gustav Kluzis and an introduction by Cesar Domela-Nieuwenhuis. It marked the importance acquired by this means of expression which developed in all directions in a realistic, but not naturalistic, form. F. Schiff wrote: "The peculiar value of photomontage does not lie in its documentary character, but in the *dialectical rapport* between *its composition*, which is antinaturalistic or paradoxical, and its documentary content."[29] It would be possible to classify photomontages according to their plastic or graphic character, their realistic or imaginary tendency, their desire for action or their gratuity; a task of considerable importance awaits researchers, and it is not possible to predict their conclusions.

After 1931, photomontages continued in the various existing directions. This mode of expression departed from painting. It cannot be compared to the collage, even if it is sometimes confused with it, for it does not carry an element of reality, such as a piece of cloth or a piece of newspaper, but a piece of a substitute for reality. It cannot be confused with photography, which represents an existing moment. Photomontage is a creation *sui generis*.

Photomontage as it was understood after World War I is certainly no longer in favor. But it facilitated innovations in publicity and in typography to which we are so accustomed that we are no longer aware of them. Today it has taken a form that is less brutal, more subtle, demonstrating once again that the domain of a means of expression must not be limited, and that one must take care not to diminish the capital of beauty provided by its creators.

NOTES

1. Ingolstadt, 1969.

2. In *L'amour de l'art*, Paris, June 1936.

3. Wolfgang Schade, *Europaische Documente*, Stuttgart, Berlin, Leipzig, s.d.

4. Robert Taft, *Photography and the American Scene*, New York, 1964.

5. *Portrait of a Period*, Montreal, 1967.

6. Silvio Negro, *Nuevo Album Romano*, Rome, 1964.

7. Aaron Scharf, *Art and Photography*, London, 1968.

8. Arthur Rothstein, *Photojournalism*, 2d ed., New York, 1965.

9. Oganowski and Violette, *La photographie amusante*, Paris, s.d.; A. Bergeret and F. Drouin, *Les récréations photographiques*, Paris, 1891; Hermann Schnauss, *Photographic Pastimes*, London, 1891; Walter E. Woodbury, *Photographic Amusements*, 1st ed., 1896, 9th ed., New York, 1921; C. Chaplot, *La photographie récréative et fantaisiste*, Paris, 1902.

10. Herta Wescher, *Die Collage*, Koln, 1968.

11. Paul Eluard, "Les plus belles cartes postales," in *Le minotaure*, Paris, 1933.

12. The painter Clovis Trouille, famous for his painting *Oh! Calcutta! Calcutta!*, was a specialist as early as 1912 in montage for deluxe publicity catalogues: "Sometimes I would find on my drawing table the Venus de Milo appearing to be leaving a *pissotière*, sometimes I saw there the reproduction of a woman leading a cow next to the photo of a sumptuous salon." In Jean-Marc Campagne, *Clovis Trouille*, Paris, 1964.

13. Hans Richter, *Dada Art und Anti-art*, Koln, 1965.

14. Heins Ohff, *Hannah Höch*, Berlin, 1967.

15. Hans Richter, *Dada Art*.

16. Van Deren Coke, *The Painter and the Photograph*, Albuquerque, N.M., 1964.

17. Raabe, *Expressionismus*, Olten, 1965.

18. In *Eranos Jarbuch*, vol. 38, Zurich, 1968.

19. In *Cahiers d'art*, 1, 2, Paris, 1932.

20. In Kenneth Coutts-Smith, *Dada*, London, 1970.

21. *Die Fotomontage: Geschichte und Wesen einer Kunstform*, Ingolstadt, 1969.

22. Georges Hugnet, "L'esprit dada dans la peinture," *Cahiers d'art*, 6, 7, Paris, 1932.

23. Conférence sur dada, *Merz T Tapsheft*, Hannover, 1924.

24. André Breton, *Manifeste du surréalisme*, Paris, 1924.

25. *Malerei, Foto, Film,* 2d ed., 1927; Mains und Berlin, 1967.

26. *Erbschaft dieser Zeit,* 1962.

27. "John Heartfield et la beauté revolutionnaire," in *Les collages,* Paris, 1965.

28. Wieland Herzfelde, *John Heartfield,* Dresden, 1971.

29. *L'amour de l'art,* Paris, June 1936.

A HISTORICAL SKETCH OF PHOTOGRAPHY IN HAMBURG

FRITZ KEMPE

A HISTORICAL SKETCH OF PHOTOGRAPHY IN HAMBURG

Fritz Kempe

Director, Staatliche Landesbildstelle Hamburg

Translated by
Dr. Arnold Weissberger

The history of photography in Hamburg is a small but not unimportant part of the history of photography in general. In the 1840s, the daguerreotypists Carl Ferdinand Stelzner and Hermann Biow, who today are considered to be among the internationally recognized masters of early photography, worked in Hamburg. Around the turn of the century Hamburg was one of the centers of pictorialism, in German called *Kunstphotographie.*

The "Hamburg School" of the gum-bichromate process, the chief masters of which were Theodor and Oskar Hofmeister, stimulated work all over the world, and the masters of the "new style" from all over the world participated in the ten big Hamburg exhibitions of artistic pictorialism. On the suggestion of Professor Dr. Alfred Lichtwark, these exhibitions took place from 1893 to 1903, mainly in the Kunsthalle (Museum of Art). It was revolutionary for a museum of art to open its doors to photography: "It appeared to the public as if a meeting of scientists was going to use a church as an assembly hall."

These exhibitions were organized by the merchant Ernst Juhl. The society which he founded for this purpose in 1892 was later called Gesellschaft zur Förderung der Amateur-Photographie (Society for the Advancement of Amateur Photography). Above all, however, Juhl collected photographs so that material would be available for the history of photography at that time when, in the words of Lichtwark, "science longs for it which always awakens one mail delivery day too late." A large part of the "Juhl collection" became the foundation for the collection of material depicting the history of photography that I organized in 1952 at the Staatliche Landesbildstelle Hamburg. This is the only collection of pictures, apparatus, and literature on the history of photography in the possession of a state of the Federal Republic of Germany. However, it is not this collection alone which continues the photographic tradition of Hamburg to the present.

Hamburg, the largest center of commerce in the Federal Republic, is also a town of publishing and advertising. The Hamburg newspapers with a circulation of almost 6 million, the magazines and illustrated journals with a total circulation of 24.6 million, the television industry, and the more than one hundred advertising and public relations agencies have an extraordinary need for pictures. As a consequence, many renowned pictorial journalists and advertising photographers work in Hamburg. Amateur photographers likewise are active in Hamburg, and some of their societies date from the time of Lichtwark. The Freie Vereinigung von Amateur-

photographen (Free Association of Amateur Photographers), for instance, was founded in 1898. Finally, the Staatliche Landesbildstelle (Pictorial Archive of the State) has the oldest permanent photo gallery in the Federal Republic. The showing "Albert Renger-Patzsch and His Pupils" in May 1971 was its two-hundredth exhibition.

Within the frame of this essay it is impossible to deal with the whole of Hamburg photography up to the present. We must be satisfied with a sketch of the early days and the turn of the century. I used for this purpose Wilhelm Weimar's *Die Daguerreotypie in Hamburg 1839–1860* and my own fundamental works to provide for the first time a short photographic history of the Free and Hanseatic City of Hamburg.

EARLY PHOTOGRAPHY IN HAMBURG

When the system of Daguerre was published on August 19, 1839, Carl Ferdinand Stelzner, a painter of miniatures who had lived in Hamburg since 1837, rushed to Paris to learn the details. It was his third journey there. From 1831 to 1834 he had perfected his skills as a miniature-painter, studying with Jean-Baptiste Isabey, among others. Museums in Scandinavia and in Hamburg preserve precious miniatures by Stelzner. Their delicacy of line and the love of fashionable detail were carried over into his daguerreotypes.

The biography of Stelzner has only recently been clarified. He was born December 30, 1805, at Gömnitz in a part of Holstein which then still belonged to Oldenburg. The following day in Altenkrempe he was baptized under a fictitious name because he was the illegitimate son of a district official's daughter from Mecklenburg and a merchant from Nuremberg. The painter Carl Gottlob Stelzner in Flensburg took him as a foster child and gave him his name. As a miniature-painter he visited all European capitals. In London on November 3, 1834, he married the painter Caroline Stelzner, the daughter of his foster parents. Malicious tongues insisted that he had married his real sister. This childless marriage was dissolved by divorce in 1848. Caroline, however, continued to be a friend to him and to his second wife, Anna Henrietta, and her four sons.

C. F. Stelzner opened his first atelier on September 2, 1842, in Caffamacherreihe 32 with Hermann Biow, who the year before had operated a "Heliographisches Atelier" (Heliographic Atelier) in Altona, which was at that time still part of Denmark. In 1842 Biow established a business in the lookout tower of the Baumhaus (customs house) of Hamburg harbor. This was the first atelier in Hamburg. In their common announcement Stelzner and Biow advertised that they were able "to furnish portraits from the size of a ring up to the largest dimensions hitherto provided in daguerreotype."

Hermann Biow, son of the painter Raphael Biow, was born in 1810 in Breslau. He differed from Stelzner in the monumental style of his pictures and their corresponding dimensions—up to 26 centimeters by 32 centimeters, a size almost unheard of for daguerreotypes. Envisaging a national gallery, Biow took pictures of many important contemporaries. In 1849 a work was published containing 126 portrait plates of members of the Frankfurt National Assembly "drawn on stone after the photographs by Biow." In 1846 he was honored with "highly interesting commissions" by the King of Saxony in Dresden. In 1847 King Friedrich Wilhelm IV called him to Berlin, where he was permitted to establish his atelier in the Rittersaal (Hall of the Knights) of the palace. (The only known photoportrait of the unfortunate monarch was taken by Biow.) The year 1849 he spent in Dresden, where, in a riot, he lost his apparatus and many daguerreotypes. He died of a liver ailment on February 20, 1850, in Dresden, while preparing for an edition in copper engravings of his gallery of German contemporaries.

The first polemic pamphlet of photography, *Der Daguerreotypenkrieg in Hamburg oder Saphir, der Humorist und Biow, der Daguerreotypist vor dem Richterstuhl des Momus* [The War of the Daguerreotypists in Hamburg or Saphir, the Humorist, and Biow, the Daguerreotypist, before the Law Court of Momus], was published in Hamburg in 1843. In it an anonymous writer, "Cephir," called Biow's passion for collecting "a real fury for famous and infamous personalities." Moritz Gottlieb Saphir had sharpened his malicious pen on Biow (whose repartee was not bad, either). Saphir ridiculed photography as "sun theft painting" *(Sonnendiebstahlsmalerei)*.

The big fire of Hamburg, which lasted three days in May 1842, made Biow and Stelzner photoreporters, but the forty-six daguerreotypes which Biow took "of the still smoking ruins" have been lost. The Historische Verein (Historical Society), to which he had offered them, rejected the offer, guided by the opinion of a certain Professor Wiebel who for "theoretical chemical reasons" did not accord a long life to daguerreotypes. Of Stelzner's photos only the view taken from the exchange building of "the fire ruins of the Alster area" exists. It is considered the oldest news photo in the world. A few daguerreotypes of Stelzner's of the reconstruction also still exist. His home at the Jungfernstieg burned down,

but on November 15, 1844, he reopened his atelier in a new house, Jungfernstieg 11, where he lived until his death on October 23, 1894. It was the tragedy of his life that as a result of handling poisonous mercury vapors he went blind in 1854. Nevertheless, he had become a well-to-do man and moreover a great master of "Biedermeier" photography.

As it was everywhere, the daguerreotype had been rapidly accepted in Hamburg; up to the year 1860 approximately 170 daguerreotypists can be traced there. Among them was Benny Bendixsen (1810–77), who came from Copenhagen. On June 16, 1844, he made "a new daguerreotype" of Hans Christian Andersen "with excellent results," as the poet remarked in a letter. H. Oskar Fielitz (1819–59), whom Stelzner after his loss of sight had entrusted with the direction of the atelier, was a native of Brunswick. From the study of chemistry he had turned to the daguerreotype. He visited the United States in 1850 and imported from there the technique of *hohen Politur* ("high polish"), which endowed his daguerreotypes with particular beauty. The former actor and later innkeeper Wilhelm Breuning (1816–72) is also reported to have worked at Stelzner's before he established himself in the St. Georg borough. He started to talbotype in Hamburg in July 1846, one month before Biow. A beautiful ambrotype of the actress Charlotte Wolter taken by Breuning in 1861 has been preserved. The first female daguerreotypist in Hamburg was Emilie Bieber; she opened her atelier on September 16, 1852, in the Grosse Bäckerstrasse 26.

THE ATELIER E. BIEBER—A TYPICAL EXAMPLE

Emilie Bieber, born in Hamburg on October 26, 1810, did not achieve the artistic rank of Stelzner and Biow, but she became the founder of a world-renowned photo atelier. In the beginning she appears not to have succeeded with the daguerreotype, because after two years she agreed to sell the atelier. The day before the transfer, however, she went to a fortuneteller. When this lady predicted many carriages in front of her house, she canceled the agreement, paid an indemnity, and continued to take pictures. The success came, and after she had moved her atelier in 1872 to a five-story house on the Neue Jungfernstieg, she named as her successor her nephew Leonard Berlin (born November 18, 1841, in Altona). He established the fame of the house E. Bieber, to which he added his name, and became Professor and Photographer by Appointment to a half-dozen kings, princes, and dukes. Emilie Bieber died on May 5, 1884, in Hamburg at the age of seventy-four.

Emperor Wilhelm II liked to have his picture taken by Professor Berlin-Bieber. In 1892 he commanded him to come to Berlin. When Berlin-Bieber was on the train he heard that Hamburg had been put in quarantine because of a cholera epidemic. He immediately had his family come to Berlin and founded a branch of E. Bieber, whose directorship he held up to World War I, when he sold the business. Leonard Berlin-Bieber died in Hamburg on February 4, 1931. As early as 1902 he had designated his son Emil, born in Hamburg on January 8, 1878, to head the Hamburg studio. It was at that time transferred to a corner house on Jungfernstieg, soon called the "Bieber Corner," so popular had his name become.

It is difficult to decide which pictures at a big atelier have been taken by the owner himself because it was usual to engage operators who, for day-to-day production, had to adapt to the proprietor's style. The Viennese Raimund F. Schmiedt (1874–1943), who entered E. Bieber's enterprise as studio director in 1893, played an important role in the modernization of the shops in Hamburg and Berlin. Later he established himself independently as a renowned portrait and theater photographer in Hamburg.

Emil Bieber promoted his work by public exhibitions. In Hamburg in 1912 he showed color diapositives, 18 centimeters by 24 centimeters in size, of the palace and park Wilhelmshöhe. They were made by the autochrome process of the brothers Lumière and displayed next to paintings by Franz von Stuck. The same year an album was published with twenty-three portraits of the Hamburg Senate. For many years Emil Bieber created whole-figure portraits of the Knights of the Prussian order of the Black Eagle. In addition to portraits of many princes, he took a picture of the painter Adolph von Menzel. The red leather portfolio was ready, but World War I prevented the presentation of the collection to Wilhelm II. The year 1927 was the seventy-fifth anniversary of the founding of the firm, but when *Arisierung* ("Arification") threatened after 1933, the Biebers dissolved the business in Hamburg and emigrated via England to Cape Town. There Emil Bieber succeeded in reestablishing himself. He retired in 1955. Twice he returned to Hamburg, where his archive of negatives had escaped destruction. In 1958, through a Hamburg newspaper, he offered 35,000 negatives to all those who recognized themselves or relatives. On April 19, 1963, the death of Emil Bieber ended the photographer's dynasty of E. Bieber, which for more than one hundred years had made portraits of bourgeoisie and of nobility.

PHOTOGRAPHIC ART AROUND 1900—
REVOLUTION OF THE AMATEURS

Like every atelier in the last third of the nineteenth century, the house of E. Bieber mass-produced the kind of portrait photos which Alfred Lichtwark (1852–1914) denounced: "Artificial posture, illumination and retouching correct the disobedient nose, and in the very end the portrait becomes a delusion—a mere phantasy on the provided theme." Lichtwark asked the public for "respect for nature" and called on the amateur photographers to demonstrate this respect. They honored his request. The first exhibition in the Kunsthalle in 1893 showed 6,000 photos by 458 photographers from all countries. Lichtwark himself gave three lectures which were published in book form with the title *Die Bedeutung der Amateur-Photographie* [The Importance of Amateur Photography]. This was the first time that an art historian and director of a museum committed himself as progressively to photography.

About ten years later he confessed: "The taste, the purely sensuous beauty of the tone and of the attitudes of the works sent to us by the most recent generation of the American amateurs still leave us wondering." This referred to the works of Alfred Stieglitz, Edward Steichen, Clarence H. White, and Alvin Langdon Coburn. Of course, in the meantime, a programmatic style had evolved from the "back to nature" philosophy which conceived of photography as a part of the total artistic concept of art nouveau, of the *Jugendstil*. The call for a renewal of photography in line with the artistic trends of the time found its echo. The "father of artistic photography in Germany," however, was, in the opinion of his contemporaries, Ernst Wilhelm Juhl (1850–1915). Though not a photographer himself, he stimulated the amateurs in their work by essays and the publication of pictures. When, however, in 1902 he published photographs by Steichen in the *Photographische Rundschau* and enthusiastically commented on them, he was made to resign from the office as artistic director of that journal. The narrow-minded among the amateurs were not willing to go along with his well-justified enthusiasm, but the Hamburg School of artistic photography owes him a great debt. Juhl created the organizational foundations by providing atelier, workshops, library, and conference room through the Gesellschaft zur Förderung der Amateur-Photographie (Society for the Advancement of Amateur Photography). There the brothers Theodor (1868–1943) and Oskar (1871–1937) Hofmeister taught the gum-bichromate process and the taking of

the "figure picture" *(Figurenbild)*, which they had created.

The Hofmeisters were pure amateurs. Their talent was kindled by the pictures which they saw in the Hamburg exhibitions. In 1895 for the first time they took part in an exhibition. In 1896 they became prominent with pigment prints of fishermen's pictures. According to an entry in their sketchbook, they took the first picture for this purpose in October 1896 at Finkenwerder. The figure picture became their specialty, in addition to the portrait and the landscape. They devoted themselves "with great seriousness" to presenting the life of peasants and fishermen. "The small, delicate, pretty is overcome. They want to see big and they do it," Lichtwark said.

Beginning in 1897 the Hofmeisters were the head of the Hamburg School. They were obsessed with the urge to create and they rose like a comet. They took pictures in all parts of Europe; Oskar usually did the photographing alone, whereas Theodor did the gum-bichromate printing. They took the process from the "Viennese School" of Heinrich Kühn and his friends, whose contributions they gratefully acknowledged. They developed the gum-bichromate process to its fullest potential. This, together with their penchant for symbolism and their preference for a low position of the camera in order to increase the height of the subject, constituted their personal contribution to artistic photography. There are no casual snapshots because they stylized in the camera, and the gum-bichromate process enabled them to suppress and to emphasize. They saw the world through their temperament with a selectivity which can be understood only in terms of a holy artistic fervor. In 1901 at the "Third Photographic Salon" in Philadelphia the brothers showed their gum-bichromate prints, resembling paintings. An American critic wrote: "The treatment of light and shadow in the landscapes is broad and strong and all their pictures make a permanent impression on the viewer." Their pictures went from hand to hand at international exhibitions; even the Queen of Italy bought one of their prints, which as a rule existed only in the original.

They were generous in teaching amateurs. Most significant was their influence on the merchant Heinrich W. Müller (1859–1933), who began to photograph seriously in 1897. Georg Einbeck, merchant and painter born in 1871, created a series of placards for the Hamburg exhibitions on a photographic basis. His picture *The Silence*, a swan motif, has perhaps most markedly the stamp of the art-nouveau style. A great number of minor masters also originated in the Hamburg School, two of particular note being the

physician Dr. Eduard Arning (1855–1936) and the merchant Gustav Trinks (1871–1967). This era of flourishing artistic photography lasted until about 1903. Its messengers were well-to-do citizens. Its patrons were the patricians of the Hanseatic City of Hamburg. The production by the color gum-bichromate process of the large wall pictures resembling paintings was expensive; their manneristic tendencies may be symptomatic of a certain emotional poverty on the part of the photographers.

It is arrogant to characterize pictorialism and art-nouveau photography as mere deviations. This could be maintained only if at the same time one damned the other artistic tendencies of the epoch which aimed at renovating the style of life. But who today would still seriously discuss this issue?

Lichtwark's hope that the change of style initiated by the amateurs would convert the professional photographers was fulfilled. In 1883 Rudolph Dührkoop (1848–1918) had opened an atelier for artistic photography in Hamburg without ever having learned photography. Since his success was small, he attended the lectures of Lichtwark, who whenever possible avoided being photographed. Of the two known portraits of Lichtwark, one, taken in 1899, was made by Dührkoop. Around this time Dührkoop's star began to rise. His successes were based on pictures made in an amateur fashion of men in their homes or out of doors. Following the tendency of artistic photography, he strove for permanent prints of his work, for which he used photogravure. With this process he published in 1905 a portfolio, "Hamburgische Männer und Frauen am Anfang des XX. Jahrhunderts" [Men and Women of Hamburg at the Beginning of the Twentieth Century], followed in 1906 and 1907 by portfolios of the members of the Royal Academy of Science and of the Technische Hochschule (Institute of Technology) in Berlin. Dührkoop also had established a branch atelier in Berlin. The Hamburg Gewerbekammer (Chamber of Trade) enabled Dührkoop in 1904 to visit the World's Fair in St. Louis, following which he visited some of the most important towns in the United States. His pictures were shown in many exhibitions; photographic journals in the United States published portraits taken by him and devoted appreciative articles to him.

His daughter, Minya Diez-Dührkoop (1873–1929), cultivated the fashionable accent of art nouveau even more strongly and created outstanding double portraits. She was one of the first members of the Gesellschaft Deutscher Lichtbildner (Society of German Photographers), which was founded in 1919 by the Hamburg photographer Kurt Schallenberg (1883–1954). (Schallenberg later emigrated to Australia where he operated a photo studio under the name of Shalley.)

The influence of the "soft focus," as artistic photography was also called, continued for a long time. The Hamburg teacher Arnold Petersen (1876–1950) applied it to the genre of *Heimatphotographie* (home-country photography), which he propagated, and the merchant Heinrich v. Seggern (1860–1948) created pictures strong in atmosphere of the Hamburg harbor and its ships. Both presented their photographs chiefly in bromoil print, which had succeeded gum bichromate.

PHOTOGRAPHED "HAMBURGENSIES"

The concept of the "Hamburgensie" is most closely connected with the city views in lithography by Peter Suhr, which preserved the Hamburg of the "Biedermeier" time. Suhr, like many painters before him, worked with the camera obscura. Whereas after the big fire Stelzner documented the reconstruction work in daguerreotypes, Suhr still industriously copied his camera obscura pictures. One such copy which shows the newly constructed Hotel Zingg has been preserved in the State Archives of Hamburg. The views of the city by the lithographer and talbotypist Charles Fuchs (1803–77), however, helped the breakthrough of the photographic "Hamburgensie." His talbotypes, painted over in order to hide the structure of the paper, have great beauty. Around 1862 the photographer Carl Friedrich Höge (1834–1908) gained importance by his collodion-process pictures on glass plates, which are attractive because of their archaic character. The most productive photographers were G. Koppmann and Company. Georg Koppmann (1842–1909) had opened an atelier in 1865, but soon began to concentrate on topographic pictures. After 1872 the building department in Hamburg commissioned him to record the historically important houses, streets, and squares which were being sacrificed in order to enlarge the harbor and improve the sanitation of the city. It is said that Koppmann and Company took well over ten thousand topographic photographs, most of which were on glass plates 30 centimeters by 40 centimeters in size. In 1868 J. H. Strumper (1843–1913) began to take Hamburg photographs. He also created large numbers of city views, as well as photos of events important to the history of the city. Strumper as well as Koppmann reproduced his pictures for sale by photocopies. They all were troubadours of a lost city landscape, of the Gothic, and of the Baroque. These

photos are the only documents of their beauty. They have become the now highly valued "Hamburgensies."

Since the demolition of the picturesque but unhygienic dwellings of the small bourgeoisie continued after 1900, the street photographer Paul E. A. Wutcke (1872–1945) did a large business. He suspended signs over the streets stating the date of demolition and then assembled the dwellers before his camera. Thus unartistic but almost surrealistic pictures came about. Johann Hamann (1859–1935) and his son Heinrich (born 1883) presented a broad palette. Johann Hamann came to photography through an uncle, a retoucher in the Atelier E. Bieber, and opened his own atelier in Hamburg in 1889. One of his most scurrilous portrait commissions came from the HAPAG, which ordered pictures to be taken of its 150 captains, one each with and one without cap. Johann specialized in photographing Hamburg citizens in their homes with flashpowder light. Today the pictures are authentic documentations of the interior decoration of the nineties. The Hamanns also photographed events. Son Heinrich traveled for the HAPAG after 1907 taking pictures in color with autochrome plates of the destination points of the ships' voyages. When in 1911 the keel was laid for the giant steamer *Imperator*, Heinrich Hamann documented the building of the ship from the keel to the masthead. Their areas of activity, however, were unlimited. They made a series of pictures for stereoscopes, photographed animals and gymnasts, and even attempted movies. In 1971, at eighty-eight, Heinrich Hamann administered, together with his sister, the enormous archive of 18-by-24-centimeter plates which is a rich source for photos of the "world of the day before yesterday."

An appearance *sui generis* was Hans Breuer (1869–1961), who settled in Hamburg in 1897. One of the first true photoreporters in Germany, he recorded Prince Otto von Bismarck's last days in pictures. Breuer also photographed Emperor Wilhelm II in 1900 in Bremerhaven, when at the embarkation of German troops to China he spoke the notorious "Pardon will not be given." The photo went around the world. Breuer's patron, Albert Ballin, enabled him to take more than forty trips abroad with the ships of the HAPAG. He photographed the palaces of the Duke of Cumberland, many contemporaries, such as the poet Detlef von Liliencron (1906) and Wilhelm Busch (1907), and again and again the city of Hamburg. He also photographed Hamburg in its destruction during World War II. Hans Breuer worked into his ninety-first year. The smallest size which he ever used was 13 centimeters by 18 centimeters.

The work of this group of photographers in Hamburg proceeded without personal ambition, unhampered by any experiments with style. However, though primarily documentarists, they nonetheless now and then created works of art.

APPENDIX

The collection concerned with the history of photography at the Staatliche Landesbildstelle Hamburg contains daguerreotypes of Stelzner, Biow, Breuning, Fielitz, Emilie Bieber, and many other Hamburg daguerreotypists. The art-nouveau photography is richly represented by the work of the brothers Hofmeister, of H. W. Müller, Arning, and other amateurs, as well as by a collection of Dührkoop and his daughter. Equally well represented are the Atelier E. Bieber and the chief masters of Hamburgensie: Fuchs, Höge, Koppmann, Strumper, and Johann and Heinrich Hamann. The negatives left by Wutcke and Breuer were purchased by the Staatliche Landesbildstelle. The numerous other objects of the collection cannot be discussed here. Someday it will be transferred to the Museum of Arts and Crafts in Hamburg, which owns the formal framed wall pictures of the Hofmeisters and of other art photographers. Stelzner's daguerreotype of the fire ruins of the Alster area is in the Museum for the History of Hamburg, which has a large collection of photographic "Hamburgensies." The largest collection of old Hamburg photos is in the private collection of Fritz Lachmund in Hamburg. The State Archive deserves thanks for indefatigable collaboration in the research on photography in Hamburg.

47. Carl Ferdinand Stelzner. *Ruins in the Hamburg Alster Area after the Great Fire.* 1842. Daguerreotype, reversed. Museum für Hamburgische Geschichte.

48. Carl Ferdinand Stelzner. *The Dancer Maria Taglioni.* Staatliche Landesbildstelle Hamburg c 1845. Daguerreotype.

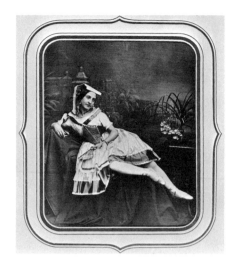

48.

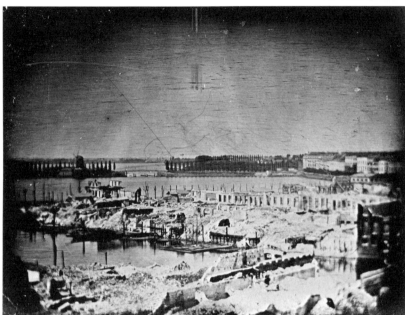

47.

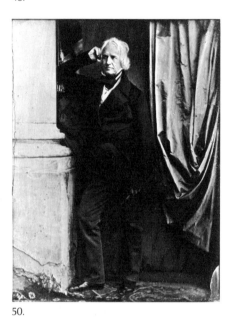

50.

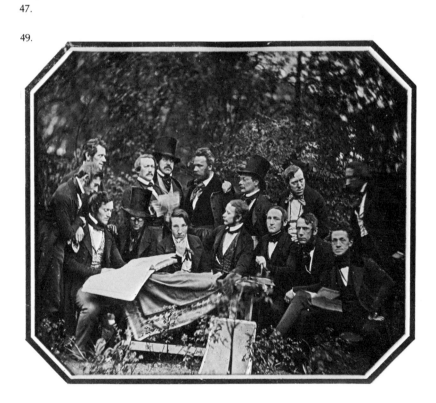

49.

51.

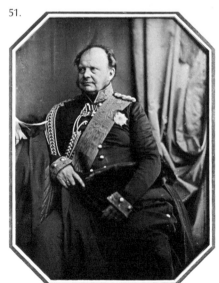

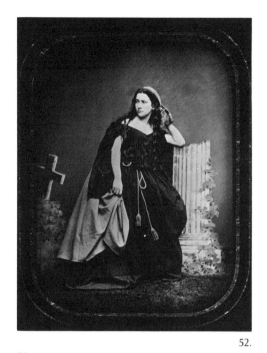

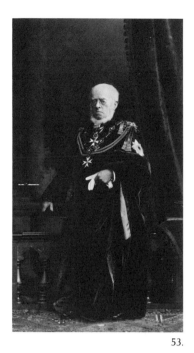

54.

52.

53.

55.

56.

49. Carl Ferdinand Stelzner. *1843 Meeting of the Hamburg Society of Artists in the Summer House on the Caffamacherreihe.* Daguerreotype. Staatliche Landesbildstelle Hamburg.

50. Hermann Biow. *Portrait of the Sculptor Christian Rauch.* Berlin 1847. Daguerreotype. Staatliche Landesbildstelle Hamburg.

51. Hermann Biow. *King Friedrich Wilhelm IV, King of Prussia.* Taken in the Berlin Castle. 1847. Daguerreotype. Staatliche Landesbildstelle Hamburg.

52. W. Breuning. *The Tragedienne Charlotte Wolter as "Deborah."* 1861. Ambrotype. Staatliche Landesbildstelle Hamburg.

53. E. Bieber. *Adolph von Menzel, Court Painter.* Staatliche Landesbildstelle Hamburg.

54. Prof. Leonard Bieber. *Last Portrait of Prince (Eduard Leopold von) Bismarck.* 1897. Taken one year before his death. Staatliche Landesbildstelle Hamburg.

55. Theodor and Oskar Hofmeister. *Sea Calm.* 1899. Heliogravure (photogravure) from a gum print. Staatliche Landesbildstelle Hamburg.

56. Theodor and Oskar Hofmeister. *The Lone Rider.* 1903. Heliogravure (photogravure) from a gum print. Staatliche Landesbildstelle Hamburg.

57.

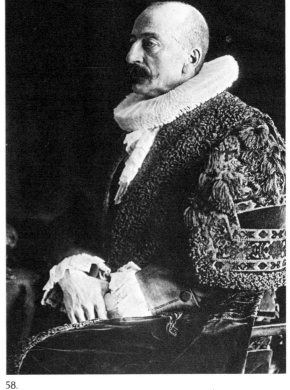

58.

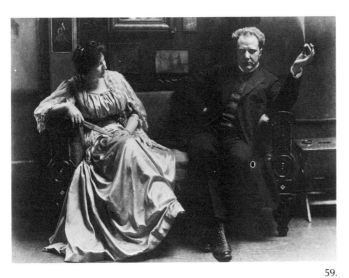

59.

57. Rudolph Dührkoop. *Interior.* 1910.
Staatliche Landesbildstelle Hamburg.

58. Rudolph Dührkoop. *Mayor J. H. Burchard.* 1905.
Staatliche Landesbildstelle Hamburg.

59. Minya Diez-Dührkoop. *Double Portrait.* 1907.
Staatliche Landesbildstelle Hamburg.

60. Charles Fuchs. *Sülze and Teerhof.* c 1850.
Talbotype, colored by Theobald Riefesell.
Staatliche Landesbildstelle Hamburg.

61. Carl Friedrich Höge. *Stubbenhuk 1, Schaarsteinweg
Bridge, Herrengraben.* c 1865.
Staatliche Landesbildstelle Hamburg.

100

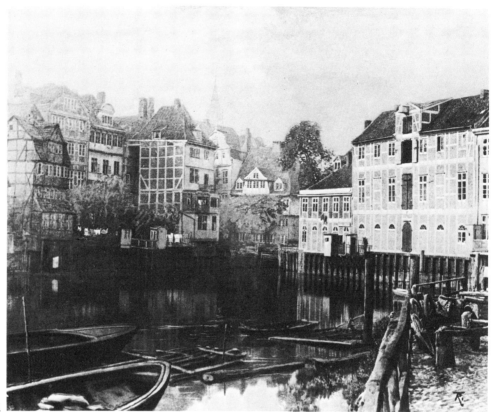

60.

61.

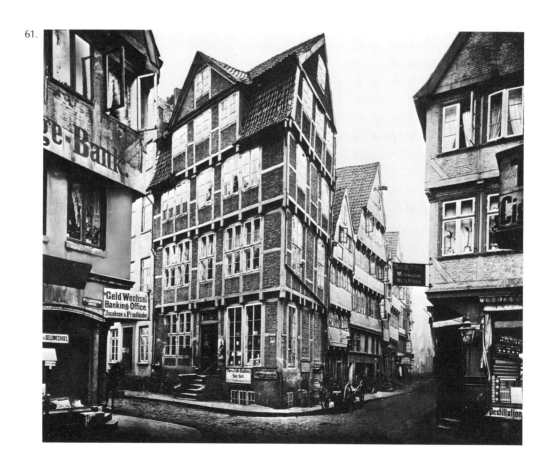

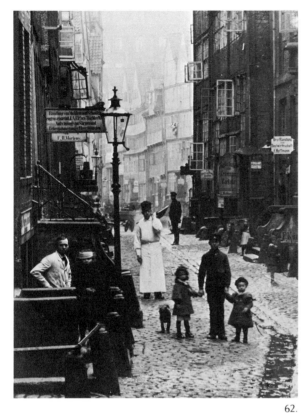

62.

63.

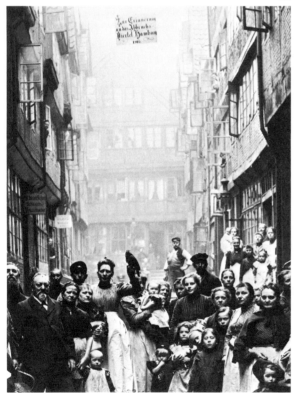

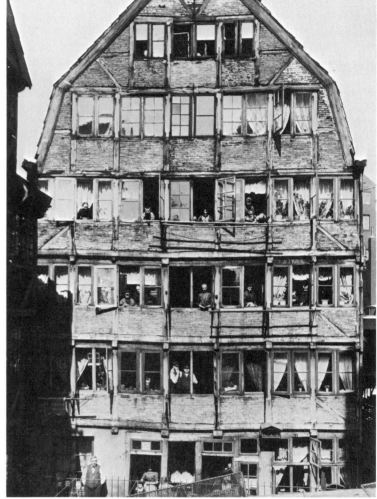

64.

62. G. Koppmann & Co. *Dovenfleeth—October 1883.*
(Detail.) Staatliche Landesbildstelle Hamburg.

63. Paul Wutcke. *Court in the Great Bäckergang.* 1905.
Staatliche Landesbildstelle Hamburg.

64. Hans Breuer. *Birthplace of the Composer Johannes
Brahms, Hamburg.* 1904.
Staatliche Landesbildstelle Hamburg.

PHOTOGRAPHY AS FOLK ART

JERALD MADDOX

PHOTOGRAPHY AS FOLK ART

Jerald Maddox

*Curator of Photography, Prints and Photographs
Division, Library of Congress*

Photography has a short history, particularly when compared with other visual media, but even so it has inspired a large amount of study and writing. Considering this material, it is interesting to note that most of it describes the history of photography as evolving around two primary approaches. The earliest, perhaps, was what one might call technical: photographers strove to acquire the utmost mechanical control of their medium. Appearing only slightly later was the primarily aesthetic approach: the photographer was mainly interested in making an artistic image. He may or may not have had technical control, but frequently when he did it was limited to the amount necessary to produce the image he had in mind and little more. In the nineteenth century these two approaches were often found in opposition, sometimes even in agitated and strong argument. The twentieth century brought modifications of both trends, some mixing of the two, and possibly a third approach in photoreportage, but even there the work, while basically subject oriented, can bend toward a technical or an aesthetic emphasis. These fundamental approaches remain valid today, and many photographers can still be defined in terms of whether their picture-making is basically shaped by a use of technical control or by aesthetic inspiration.

It would appear, however, that there is yet another direction to consider, one which has apparently been largely ignored by many photo historians through the years, but one which has a potentially great influence. It is an approach which would actually seem to go back to the beginnings, having existed along with the better-known approaches. It is not an approach easily defined, but once described seems almost obvious. This photography is not primarily concerned with either technology or aesthetics, although it will make use of both as seems necessary. Instead, the primary interest of this type of photography is simply the making of photographic images as a visual record, as a means of preserving certain events or objects without any further complications or involvements. If one tries to find an analogy for this photography in the other arts, the closest approximation would be found in folk arts. Like photography, these other folk arts are frequently aware of more developed technology and aesthetics and will sometimes make use of them, but usually only to the point necessary for the most basic purpose of making an image which carries the meaning or records the information the maker wants. It is also interesting to note that in folk art and folk photography the use of technology or aesthetics is often only incompletely understood, and this can result in a peculiarity of

appearance that many find the most attractive part of folk art. Folk art in the traditional sense is a well-established concept, and has been an area of scholarly study for some time. It has not, however, frequently been applied to photography, and yet there would appear to be a large amount of work that can be profitably considered only within this context.

Some exhibitions and writings have been concerned with aspects of this idea, most importantly John Szarkowski's exhibition and catalogue, *The Photographer's Eye*, but these seem to have been relatively isolated incidents. To my knowledge no one has attempted to bring this material together and work it into a larger study. To some extent this is so because much of the material that would be necessary to such a study is largely unknown to scholars. Much of it has undoubtedly been lost through the years, but a large amount of it would seem to be preserved in various archives and historical societies. There it exists in a kind of limbo, almost unknown except for the most general kind of catalog reference. Because this material is usually a gift, and because it generally is of lower photographic quality than work produced by photographers involved in one of the other three approaches, it is often put in storage and seldom looked at.

This situation is not entirely undeserved, because a large amount of this material contains very little worth studying and consists of the most limited type of subject matter. Many of these collections contain nothing more than hundreds of snapshots of family and friends, places visited, and other scenes almost meaningless except to those who participated in the events recorded. A few pictures might be pulled out to illustrate the charms of naive observation, but the total will not have any kind of coherent meaning to most of us. Perhaps the only positive aspect of this basic folk photography that comes to mind (other than the pleasure it gave to its makers) is that it has had a stylistic influence on the work of some creative photographers. And yet it is possibly the example that comes most easily to mind when one first applies the concept of folk art to photography.

In many of these same archives, however, one can find other collections, also filled with work lacking technical finish or artistic sophistication, yet different from the basic folk photography just described in that the photographer makes an effort to go beyond the taking of isolated family snapshots and travel pictures to produce a consistent body of work with a unifying theme. In some cases this may be done with some kind of professional aspiration, but it is just as likely done for personal reasons. This type of folk photography is sometimes characterized by its concentration on a defined and limited range of subject matter. Relatively uninfluenced by the most current styles and trends, it still shows enough awareness of them—most often in technical matters—that it might be described as advanced folk photography.

Such, perhaps, is the A. Rizzuto Collection in the Library of Congress, and a consideration of this material may help clarify the definition of advanced folk photography. The collection consists of work produced by Rizzuto in New York City during the 1950s and 1960s. It is a large collection, consisting of perhaps as many as sixty thousand individual images, mostly negatives, but also including a few hundred prints and contact sheets. Very little is known about Rizzuto beyond the most basic biographical facts. He was born in Deadwood, South Dakota, in 1906. His family moved to Omaha, Nebraska, where he went to school. He graduated from Wittenberg College in Ohio in 1931. He took up photography and spent most of his later life in New York City, where he died in 1967. He apparently had no need to work at a steady job, and was able to give a great deal of time to photography. The photographs were made with a definite end in mind and were to be used for an illustrated survey of Manhattan three hundred years after its founding. The book was never finished, but this is not important for our consideration of his work. In his attempt to make his book, Rizzuto obviously exposed a lot of film, and most of it was limited to the area to be covered in the book.

What has resulted is a rather fantastic documentary record of New York City for the years circa 1952 to 1966. The coverage is so detailed that at times it is a day-by-day record. It is interesting that Rizzuto was very careful with the organization of his work, arranging it by year and month, and then by day within the month. This, and the fact that there is much more material than ever could have been used in his book, suggest that Rizzuto had something more in mind. The care used in organizing the material may have simply been the result of a basically orderly personality, but somehow one feels something larger and more important was intended.

New York City, and then only certain aspects of it, is the dominating subject matter of Rizzuto's work. Again and again the same themes are stated and pushed upon the viewer: the physical qualities of the city, its size and bulk, the superhuman aspects of buildings and streets extending beyond the limits of ordinary vision; then, within the city, people—human beings, in almost unbelievable numbers. In many pictures one sees only the mass of anonymous

pedestrians; in others individuals emerge and, while still a part of the mass, each is unique, with his own traits and character.

Each photograph can be considered by itself, but the totality is more important. Within that totality, Rizzuto presents two or three large themes, more or less separate but still fundamentally a part of the whole.

One theme is the structure of the physical city, and many views show the familiar and unfamiliar aspects of this. The tip of Manhattan with the well-known configurations of the Empire State Building and surrounding buildings will appear in one photograph, and in another the anonymous piles of large apartment complexes from less well known parts of the island. In attempting to capture the scale of this physical vastness, Rizzuto reveals an awareness of more technology than most of his work would suggest; he uses extreme wide-angle lenses to produce an exaggerated image of space which emphasizes the sensation of great size. Other photographs approach the physical environment more closely, showing a row of storefronts or a street. On first glance these all look alike in their generality, yet each is unique within the context of the particular image and invites detailed study.

Another theme is people, more specifically people living in the city. The initial impression that comes from these images is one of a multitude of humanity, thousands and thousands of people, forming one, giant, many-legged beast. This theme of people is primarily developed, however, in terms of individual beings. Sometimes one is part of a crowd but emerges because of some peculiarity of appearance or action. In another case the image is more concentrated, and a single person is shown isolated in the physical environment of the city. It may be a shopkeeper, someone just standing on the street, a skid-row drunkard, or a traveler in a railway station. In every case we are shown an individual—caught in a particular state, at a particular time, in a particular place.

These pictures show man within an environment, and we see human beings acting within the physical confines of the city, interacting with it to make a living creature of the whole thing. With this the collection itself becomes a third theme, simple in its largeness and complex in its parts.

The value of the Rizzuto collection, advanced folk photography as it were, comes from its size and thoroughness. In terms of physical quality and finish these are not great photographs. The general choice of subject matter does not show in the photographer

a strong visual sense for the dramatic incident or subject. Nor does one find images which reveal an understanding and control of the photographic process to the point where this in itself makes the photograph a work of art. There is a fundamental knowledge of photography, and Rizzuto's occasional use of special lenses indicates a degree of technical sophistication. This seems, however, to be overwhelmed by the basic drive to make pictures, to the point where the number of images suggests the process of taking photographs was almost automatic for him. The important element here is found in repeated observations, received and taken many times over. Rizzuto's persistence and concentration were like those of a professional photographer, but with the possible exception noted previously, his technique and execution were not. Instead, there is a directness to his use of the medium that suggests an analogy with the self-taught folk painter. Like that of Le Douanier Rousseau, Rizzuto's overall vision is the most important thing. One learns just the technique required, and then one makes pictures.

It is difficult to know how many collections of advanced folk photography might exist in archives and historical societies, and this is probably unimportant, for even if only a few collections of this type exist, it is still significant for photo history. Like other folk artists, the folk photographer offers a different vision, which is in its own way as important as anything other approaches offer. It obviously is not a question of aesthetics, nor of specifically significant subject matter. It is rather the offering of a way of seeing, personal and intensely concentrated; and when one thinks upon it, this is what photography has been concerned with from the beginning. Styles and trends may move away from this point from time to time, but it seems that sooner or later everything comes back to it. In Rizzuto's so-called folk photography, basic, fundamental photography exists in its purest state, a reminder, and perhaps a guide.

65. A. Rizzuto. *July 1955.* A. Rizzuto Collection,
Library of Congress, Washington, D.C.

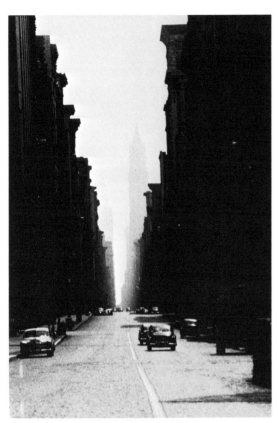

67.

66.

68.

66. A. Rizzuto. *New York Street*. A. Rizzuto Collection,
Library of Congress, Washington, D.C.

67. A. Rizzuto. *Rockefeller Center, New York*. A. Rizzuto
Collection, Library of Congress, Washington, D.C.

68. A. Rizzuto. *Woman on Street*. A. Rizzuto Collection,
Library of Congress, Washington, D.C.

THE FIRST PHOTOGRAPHIC RECORD OF A SCIENTIFIC CONFERENCE

KATHERINE MICHAELSON

THE FIRST PHOTOGRAPHIC RECORD OF A SCIENTIFIC CONFERENCE

Katherine Michaelson

Lecturer, Fine Art and Architecture
Heriot-Watt University
Edinburgh, Scotland

By September 1844 the calotype studio at Calton Stairs, Edinburgh, was in operation for portrait work of all kinds. The ministers who were being recorded for inclusion in the Disruption Picture were attending while on business in Edinburgh as well as a regular stream of other people. D. O Hill had made arrangements to send a large collection of calotypes, two hundred in all (which may have represented the total output of the studio since May 1843), to Liverpool on September 1, where they were exhibited at Mr. Grundy's Repository of Arts, 26 Church Street.[1] They received an enthusiastic but inaccurate report in the *Liverpool Standard,* which Hill had to correct later in the month. Hill was from the start advertising the process; only two months after the studio was set up, a selection of composition studies was on view in Alexander Hill's shop in Princes Street and a frame of eight studies was shown (as the work of Robert Adamson, directed by D. O. Hill, R.S.A.) in the Royal Scottish Academy exhibition in February 1844.[2] From the outset Hill exhibited and popularised the process in which he was involved in every way he could.

On September 20 or 21 it was suggested to him that the process be used to record the participants at a big scientific conference in England. As in the first place the Calton Hill studio depended on the goodwill and sanction of Henry Fox Talbot (who had patented his discovery for England, Wales, and Berwick-upon-Tweed), Hill had to write and obtain his permission for this venture. The letter (but not the envelope) survives:[3]

H. Fox Talbot Esq.
Calton Hill Stairs
Edinburgh. 21st September 1844.

Dear Sir,

It has been suggested to Mr. Adamson and myself, to attend the meeting of the British Association at York, for the purpose of making Calotype portraits of some of the eminent men who may be present. We can give no response to this suggestion until we learn whether you would feel inclined to sanction our being there for the above purpose. It is very uncertain even in the case of your being agreeable thereto that we could leave Edinburgh for this purpose, but to enable us to entertain the project at all, I will feel very much obliged if you will take the trouble to inform us at your earliest convenience whether our presence there would be sanctioned by you—whether you would permit us to dispose of Calotypes so made—or what are the terms you are inclined to dictate as the

Patentee, to enable us to use these privileges. The favour of an early reply would be very obliging to

<div style="text-align:center">

Your very obedient servant.
David Oct. Hill.

</div>

H. Fox Talbot Esq.

From this it is fair to assume several things. First, that it was Sir David Brewster who made the suggestion. Not only was he a founding member of the British Association (the first meeting taking place at York in 1829) but he had in the first place set Adamson up in business to exploit Henry Fox Talbot's process in Scotland. He would, as a member of the committee and secretary for one of the sections, have known that a fair number of photographic papers were to be read. He knew also that Henry Fox Talbot would be coming in this connection, and what more elegant than to demonstrate in an impeccable scientific setting that difficult man's great discovery?

Second, as was the rule throughout the partnership, D. O. Hill played the leading role. Adamson never emerges from the shadows; perhaps a retiring character, or possibly a very taciturn man, he allowed Hill to lead and direct throughout. The tone of the letter suggests to me that Hill was in no doubt whatever that Fox Talbot's permission would be granted for the work. Presumably this letter went to Fox Talbot at his London address or at Lacock. A reply (which no longer exists) giving permission arrived in Edinburgh on September 24 and followed Hill to York, where he and the calotype equipment were installed probably on the twenty-seventh. He (not Adamson) checked in with the conference administration on the twenty-eighth.[4]

Hill knew York well, as the main resting place on the overland journey between Edinburgh and London. He had had contacts with William Etty of York (at his London studio) since the 1830s,[5] and may have stayed in 1844 with former friends at 15 Castlegate. Some arrangement was made either by Hill or Brewster with the botanist Henry Baines,[6] the keeper of the York Museum, for the calotypists to work there.

The Yorkshire Philosophical Society had taken up residence in the grounds of the former St. Mary's Abbey and their collection, then as now very rich in Roman antiquities, also included the superb Romanesque statues and other decorative work which had been excavated by the society in 1829 (vetusta monumenta). At first sight this seems a strange place to set up the studio, but the long south wall of the abbey ruins would have been ideal for the printing frames; the darkroom (for preparing the cameras) and the "studio" where the sitters were posed are not now identifiable, as the museum has been built over and around much of the site, enclosing the diaper-work stone and the deeply molded column which appear in calotypes taken on September 28, 1844, and October 1, 1844. On the twenty-eighth Hill wrote again to Henry Fox Talbot, having received the forwarded letter of September 24 giving the calotypists his sanction.[7]

<div style="text-align:right">

15 Castle Gate,
York.
28th September, 1844.

</div>

Dear Sir,

I have just received a packet from Edinburgh which encloses your most obliging letter of the 24th. I have again to return you an expression of the sincere thanks of Mr. Adamson and myself, for your liberality to us in permitting us to Calotype in York. I trust that our efforts here will add some new interest to your beautiful art. I have written the editor of the Liverpool Standard and have put him right both as to the Discoverer and the Possessor of the discovery of the Calotype.

I have requested him to forward to you a copy of the paper in which he inserts my remarks. I have told him to address to you at the British Association, York.

I hope I may have the pleasure of seeing you again before your train for Scotland. If there are any of your scientific friends here you would wish us to Calotype we will be most happy to do it.

<div style="text-align:center">

I remain, dear sir,
Your obliged servant,
D. O. Hill.

</div>

H. Fox Talbot Esq.

One would very much like to know details of the prices at which the calotypes were sold (especially as at the end of the conference a daguerreotypist had set up a studio in York).[8] One would also like to know where and when Hill and Fox Talbot first met prior to this conference in York.

At some point before nightfall on the twenty-eighth the calotypists recorded two men of the establishment of the B.A. It seems very likely that this session was organised by Sir David Brewster, the only person capable of stage-managing the event.

The Marquis of Northampton was recorded in at least three studies, the best known of which appears in Calotypes.[9] William Willoughby, Earl of Inniskillen, was also recorded twice. These two distinguished men typify the changing character of scientific

research in the mid-nineteenth century. By class and background they were spiritually linked with the Royal Society of the seventeenth and eighteenth centuries, gentlemen amateurs in the best sense of the word, the Marquis of Northampton being also president of the Royal Society. Their fields of work were more of the present time and may be illustrated by Inniskillen, a recorder and statistical analyzer of rainfall (on his estate at Florence Court in Ireland), the paper being read by his technician, Mr. Thompson. Mr. Baines, the Yorkshire botanist, the host of the calotype studio (and also for the conference sections on geology and natural history), also sat for his portrait. These studies were probably taken in the chapter house ruins, as the Romanesque carved stones appear. The next day being Sunday, no calotypes were made. On Monday, a busy day, the printed notices of the calotype studio were made and distributed, an eloquent tribute to the pace of life in the mid-nineteenth century. Henry Fox Talbot's notice survives.[10]

Notice of Hill & Adamson re Portraits
at B.A. Meeting.

———

Calotype Portraits of
Distinguished Members of the British
Association

———

It has been considered desirable that the opportunity afforded by the present meeting should be embraced in order to secure Portraits in Calotype of the leading Members of the Association.

Mr. Fox Talbot, the discoverer and patentee of the Calotype process has liberally given his permission, and the Local Committee have kindly afforded the necessary facilities at the Museum for carrying this design into execution.

Mr. Fox Talbot is respectfully requested to further the above object by sitting for his portrait here, at any hour on Monday, Tuesday, or Wednesday between the hours of nine and four o'clock. The sitting occupies only a minute or two.

Mr. D. O. Hill R.S.A. will superintend the artistic arrangement of the sitters.

A few specimens of Messrs. Hill and Adamson's Calotype Pictures may be viewed at the Museum.

York Museum
Monday 30th September, 1844.

Henry Fox Talbot checked in to the conference on Monday, September 30,[11] though he may have arrived on the Sunday and met Hill and Adamson. Several views of St. Mary's Abbey grounds were taken, possibly with Fox Talbot's cooperation. The Earl of Inniskillen returned, with two young ladies, and posed again, by the carved stone. A curious large calotype (wrongly labeled Durham) survives, showing the south door of York Minster, with a group of men on the steps. This is an uncommonly long exposure (the hands of the clock testify that at least ten minutes have passed) and here again Fox Talbot may have assisted. *The Pencil of Nature,* 1844, discusses architectural and landscape studies in some detail, and these are of course Hill's artistic preoccupation far beyond portraiture.

On Tuesday, October 1, the studio was in full operation; at least seven identifiable sitters were recorded, and possibly several unknown sitters. Mr. J. Chanter, "A great Patentee in London," certainly represents new interests in contemporary science. He is lively and alert in the calotype study and obviously noted this photographic enterprise with some interest. Among the numerous puzzling features of the Calton Hill studio is that of the nondevelopment of the technique. Mr. Chanter seems just the sort of man to have pushed it out to wide applications. W. R. Grove, M.A., F.R.S., the Professor of Experimental Philosophy of the London Institution, joined the discussion in the opening session of Section B (which included photography) on the afternoon of September 28, and spoke again on Tuesday. He was an acquaintance of Henry Fox Talbot. His main interest was the treatment of paper to obtain a good impression. Dr. Hugh Falconer (1803–65), a charming man, sat for two studies. He was a botanist and biologist, a friend of Darwin. He may have given his calotype to Darwin.[12]

The other recorded sitters were local Yorkshiremen: Captain the Hon. J. W. Gray, later Admiral Gray; Dr. Sampson of York, who had a splendid bulldog face; Dr. Longley, the Bishop of Ripon (three poses); and Sir John Johnstone, "The son-in-law to the Archbishop," M.A., M.P., F.G.S. He may have been instrumental in getting the calotypists out to Bishopsthorpe to record the archepiscopal household. At the meeting of Section B (Chemical Science) on Saturday, September 28, Mr. Hunt had read a paper on the energiatype and had exhibited photographic impressions on paper. Professor Grove spoke about photographic paper. Henry Fox Talbot did not join the conference for these sessions, but on Tuesday, October 1, he attended the session when Mr.

Robert Hunt spoke on the amphytype, a new photographic process by Sir J. Herschel, which he had discussed with Mr. Fox Talbot. Here the latter contributed at length, describing his own methods in detail and objecting to all the new names for the process now being put forward. Some fairly heated discussion seems to have taken place. Fox Talbot referred to work by M. Lassaigne and Dr. Fife of Edinburgh on the chemistry involved in the process, and Mr. Hunt asserted that he had been using the same process at the time when the two latter gentlemen had stated that they had discovered it. Hunt, who had published his *Treatise on the Art of Photography including Daguerreotype* at Glasgow in 1841, had sought permission from Henry Fox Talbot to include some of his work in the third edition of his *Manual of Photography* in 1844, and had been refused. In the Scottish National Portrait Gallery (SNPG) a calotype survives, labeled "Mr. Hunt of Glasgow," but in the absence of a definite background it is hard to assign this calotype to the York meeting or the Calton Hill studio. As in any case this could be a quite different Mr. Hunt, associated with the Free Church and recorded in autumn 1843 in Glasgow, it cannot now be proved definitely that Adamson and Hill and Hunt came into contact.[13]

The next day Mr. Chanter returned to York Museum to sit for a further two studies, a not unusual proceeding which happened frequently in Edinburgh. A Dr. Inglis of Halifax also sat for his portrait. This was James Inglis (1813–51), who seems to have been one of the few men present to take further advantage of the new process.[14] Following recent research, it is now possible to link this study with a curious calotype now in the SNPG of an old woman with a large goitre. This was very probably taken by the Calton Hill calotypists at Dr. Inglis's request; he returned to the studio on "March 2" (dated neg. SNPG), which may or may not be the date when the patient sat. Dr. Inglis's main work was on the treatment of goitres; after graduating at Edinburgh in 1829 he wrote an essay on iodine and chromine in 1835, when in general practice in Castle Douglas. In 1838 he moved to Halifax, where he was still resident in 1844, and in 1851 he died from a heart condition. One of the stars of the British Association also sat to the calotypists, Professor Edward Forbes of Kings College, London, who though a botanist by training was working on glacier ice. This study is an involved half-turned pose with dramatic contrast lighting, unlike the work of the day before, where the sitters, seated on a chair with a striped cover, were either in profile (Inglis) or three-quarter turned. On October 3 the whole Baines family posed, Mr. Baines's four daughters dressed in identical striped dresses.

Mr. Staveley, the M.P. for Ripon, sat for one study, and a Dr. W. or N. Cooke Taylor, who may have already been known to Hill, as he was occasionally a contributor to the *Art Union Journal*.

On October 4 the apparatus was transported to Bishopsthorpe, where the aged Archbishop of York posed in his wig as a visible link with the older Church of England, and his beautiful wife, Mrs. Harcourt, posed no fewer than seven times in a variety of toilettes. One study so exactly illustrates Trollope's Mrs. Proudie that it is a clear case of art imitating nature.

Two unidentified men were also recorded. In one study a headrest can be seen on the negative, penciled out. The other man holds a daguerreotype.

Several more calotypes, not specifically identified as being at York Museum, can be traced to this occasion because the sitters have small connections with Scotland and are listed in the published accounts of the meeting.[15] The sitters include Sir Henry de la Beche (1798–1855), the geologist, who wears a superb striped waistcoat; Sir J. Bethune, a Yorkshireman; Mr. Young; Sir John Boilleau, who lived at Kettering Hall, near Peterborough, a friend of Dr. Waagen and the chevalier Bunsen[16] (Boilleau was an art collector with a wide range of interests); Charles Peach, the coastguard geologist; Archdeacon Wilberforce (1805–73), then Archdeacon of the E. Riding, possibly taken at Bishopsthorpe on the Friday; Dr. Scoresby, D.D., F.R.S., an intrepid and widely travelled scientist who like Sir David Brewster was in Holy Orders, and who sat for three separate studies; Dr. Edwin Lankester, M.D., F.L.S.; and Dr. P. G. Latham, M.D., F.R.S. (1812–88). Possibly Dr. Charles Lyall, the geologist, also sat for a portrait. He was certainly included in a very well known group taken at Bonaly in the Pentland Hills with members of Lord Cockburn's household. In all, some fifty calotypes were taken, and one has to assess what effect the Scots portraitists can have had. The atmosphere at this conference was rarefied in the extreme, and with so much going on it is noteworthy that a good number of people were attracted by the process. Certain snags were beginning to develop by the end of the year, not the least being the shadow of Henry Fox Talbot, which in England could be repressive.

The saddest feature, to the outlook of a century later, is the number of opportunities missed. Why did not M. Arago, Professor Wheatstone, Mr. Babbage attend? Why did not Henry Fox Talbot sit to the

calotypists? The answers may lie in the files of unidentified calotypes, or may in fact be that the accidents of time allow much to slip out of the sieve and only in a country of compulsive hoarding like Scotland can detail of the order of the calotype archives in major collections survive.

NOTES

1. *Liverpool Standard,* 10 September 1844. The editorial speaks of "admirable unerring likenesses, full of life, character and vraisemblance." The reply, 28 September 1844: "You have made the mistake of attributing the *discovery* of the art to Mr. Adamson of St. Andrews by whose chemical manipulations, under my artistic superintendance these sketches have been produced. The *discovery* of this very beautiful and most valuable art the world owes to an English gentleman—the eminent and well-known prosecutor of science, namely Henry Fox Talbot Esq. of Lacock Abbey." Information supplied by Mr. Gill, R.P.S., and Mr. Harold White.

2. *The Witness,* 12 July 1843.

3. Letter in a private collection.

4. *Yorkshire Gazette,* 5 October 1844.

5. Etty Correspondence, York Central Public Library.

6. Henry Baines, who joined the museum in 1829, in 1844 had been on the staff of the museum for fifteen years. In 1857 he published the *Complete Flora of Yorkshire.* His wife was named Rebecca and the children in the group are probably Ellen, Mary, Ann, and Maria. York Central Public Library.

7. Letter in a private collection.

8. *Yorkshire Gazette,* 5 October 1844, p. 1.

9. Andrew Elliott and J. G. Gray, *Calotypes,* 1924, no. IX.

10. Science Museum, South Kensington, London.

11. *Yorkshire Gazette,* 5 October 1844, p. 2.

12. *History Today,* 1968.

13. Letter, Goldschmidt Catalogue No. 58; Geo. Eastman House Catalogue 52, 1939.

14. Research currently undertaken by Professor G. M. Wilson, University of Glasgow.

15. *The Times,* September/October 1844; *Yorkshire Gazette,* 14 September and 16 October 1844; *Transactions of the British Association,* York, 1844.

16. Sir John Boilleau: see Waagen, *Treasures of Art in Great Britain,* vol. 3, 1854. See also Owen Chadwick, *Victorian Miniatures.*

For generous help in producing this essay, I must warmly thank Professor Geoffrey Best, University of Edinburgh; Mr. A. T. Gill FRPS Royal Photographic Society, London; Mr. Harold White FIIP, FRPS; Professor Wilson, University of Glasgow; The Hunterian Museum, University of Glasgow; The Science Museum, South Kensington, London; York Public Library; Mrs. D. Provest, Special Office Services. Thanks are due to the Scottish National Portrait Gallery and the University of Glasgow for permission to reproduce the calotypes in their collections. This article could not have appeared without their cooperation.

69.

70.

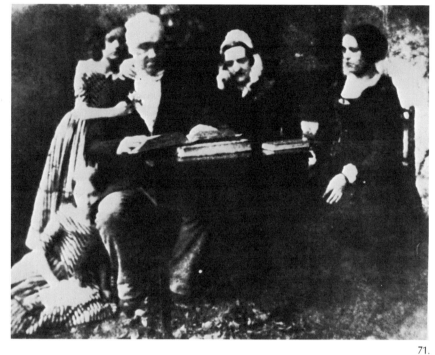

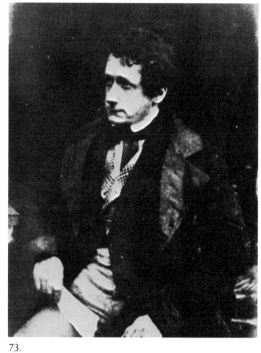

71. 73.

72.

69. D. O. Hill and Robert Adamson.
Sir David Brewster. Calotype.

70. D. O. Hill and Robert Adamson.
The Marquis of Northampton.
Reproduced from Heinrich Schwarz,
*David Octavius Hill, Master of
Photography,* London & New York,
1932.

71. D. O. Hill and Robert Adamson.
Dr. Baines and Family.
Negative inscribed "York Museum."

72. D. O. Hill and Robert Adamson.
York Minster, South Door.
Glasgow University, Glasgow
Hunterian Museum. Modern print
by F. C. Inglis, c 1905.

73. D. O. Hill and Robert Adamson.
Dr. Hugh Falconer. Calotype.

115

74. D. O. Hill and Robert Adamson. *Dr. Sampson of York.*
Calotype.

75. D. O. Hill and Robert Adamson. *Mr. Peach, the*
Coastguard. International Museum of Photography at
George Eastman House, Rochester, N.Y.

MAX ERNST, ÉTIENNE-JULES MAREY, AND THE POETRY OF SCIENTIFIC ILLUSTRATION

AARON SCHARF

MAX ERNST, ÉTIENNE-JULES MAREY, AND THE POETRY OF SCIENTIFIC ILLUSTRATION

Aaron Scharf

Professor of Fine Arts
The Open University, Bletchley
Buckinghamshire, England

In 1963, Max Ernst was thanked, along with Gino Severini and Marcel Duchamp, for his share in paying homage to the incomparable French physiologist, medical engineer, and inventor of chronophotography, Étienne-Jules Marey (1830–1904), in a comprehensive exhibition of the scientist's work organized by the Cinémathèque française in Paris. Ernst's painting *The Birds,* 1925, shown there at the Palais de Chaillot, commemorated his debt to Marey as did Severini's *Pan Pan at the Monico,* 1911–12, and *Self-Portrait,* 1912, and Duchamp's *Chess Players,* 1911–12. Duchamp's famous *Nude Descending a Staircase,* 1912, was represented by a large reproduction. All these paintings partake of some special kinship with Marey. The last four mentioned relate for the most part visually to Marey's chronophotography, to the peculiarities of its imagery. But Ernst's *Birds* seem to me to go beyond the purely visual and embody also a sensitive spiritual rapport with Marey's persistent investigations into the flight of birds.

Ernst shares with Marey a great preoccupation, not to say obsession, with birds. Birds form a constantly recurring iconographical element in Ernst's work, no doubt given impetus by the psychic demands of childhood reminiscences. The symbolism (such of it as one can fathom) is contrived and personal. Often, it is associated with love or with death.

Ernst's painting, *Gulf Stream and Bird,* 1926–27 (Fig. 76), seems to be derived visually from diagrams of insect and bird flight reproduced in Marey's book, *The Graphic Method in the Experimental Sciences* (first published in 1878 and reissued with a section on chronophotography in 1885—Fig. 77). Many early investigations into the phenomena of insect flight were based, oddly enough, on acoustics, the particular frequency of the wing strokes determined purely by the sound pitch. Marey questioned the efficacy of this approach and set about devising methods whereby the subject, its wing tip placed in close proximity to the recording apparatus, traced its own movements directly onto a smoked sheet of paper attached to a revolving cylinder. His later myographic technique for recording the flight of birds incorporated a rubber membrane in conjunction with a corset fixed to the bird which sent the muscular impulses through flexible tubes to a recording stylus (Fig. 78). The resulting graphs were rendered in fine white lines, forming slightly convoluted parallel striations on a black ground.

But it is the incarcerated or the threatened bird, Ernst's symbol, most likely, for unrequited love, rather than the liberated one, which forms a dominant theme in his paintings between 1924 and 1926.

Here, the bars imprisoning the birds, sometimes rendered wtih subtle curvilinear undulations, are reminiscent of the myograph's combed linear effects. Such was Ernst's power to metamorphose visual form, that a scientifically mundane motif appears also to represent, in works of the same period, an oceanic view of Nature, expressed in its immense topographical rhythms, its vast seas and skies, and the elemental force of its earthquakes. This linear implement in Ernst's work reappeared subsequently in a number of other guises. Never quite abandoned, it recurs with great force a decade later, as we shall see, once again motivated by an exotic scientific imagery in the form of Marey's chronophotographs.

Among the beautifully haunting images of Ernst's *La femme 100 têtes*, 1929, a book of montages made from late-nineteenth-century engravings, is one which shows the circular track and mobile camera housed in a railway car first used by Marey in 1882, a year after he became established at the College de France's physiological station at the Parc des Princes in Paris (Fig. 79). Dominating the sparse collage elements added by Ernst to the original engraving is a curious vessel containing a fish and two birds. To know its source and meaning may help to shed some light on the artist's intentions and on the more subtle meanings Marey held for him. The engraving appears as one of those fascinating illustrations of scientific pastimes available to Ernst in old copies of *La Nature* which we know he employed in a considerable degree, and most imaginatively, in creating *La femme 100 têtes*. He might also have found the image in a source no doubt utilized by André Breton: one of the several editions published in the 1890s of Gaston Tissandier's *Popular Scientific Recreations*.[1] The strange contraption added by Ernst to the Marey engraving represents what was called an "Aviary Aquarium." By introducing a balloon-glass into the bottom of an ordinary aquarium vase, the source of air through the neck concealed, the effect was achieved of birds living imprisoned in the water of an aquarium. It helps us to know that most of Marey's early recording devices such as the myograph, and later the chronophotograph, necessarily involved rather cumbersome means for holding the bird captive, even during flight (Fig. 78). Could Ernst in this montage have been playing again on a private obsession, referring to Marey's regrettable practice in his use of a *doubly* imprisoned bird?

Considering the larger context of Ernst's work and his self, not to say social, awareness, despite the smoke screen of an esoteric art, it is hard to believe that his motivation here could have been merely whimsical. The title of the plate in the German edition of *La femme 100 têtes* [*The Hundred Headless Woman*], appropriately surrealistic in its play on words *(cent, sans)*, is sufficiently ambiguous for us to impart to it a tangential meaning related to the captivity of birds: "die landschaft wird in höchsten grade umbewusst" ("the landscape would be questionable in the highest degree"). But Ernst's titles are by themselves unreliable as evidence of his intentions, for not only do they participate in the deliberate dislocation of realities in a garbled syntax, that route to the psyche beloved of Surrealists, but he often altered them on later occasions to correspond with new responses to the work.

The power of Marey's chronophotographs, or those of his followers, to promote hallucinatory responses gave to them a special niche in the Surrealist Pantheon. But, strictly speaking, Ernst's oblique references to Marey are only intimations of his (and the Surrealists') larger concern with science and scientific illustration: not science per se, but with the art in science; with, we might say, the ineffable poetry of its images. His statements on the importance of science to artists, particularly such theories as Heisenberg's "Uncertainty Principle," formulated in 1927, are sufficiently known not to be repeated here. In the use of scientific imagery, his works support the Surrealist desire to make mystery operate "outside the realm of shadows," an obvious reaction against the neo-Romanticism and waning influence of *fin-de-siècle* Symbolism. Unlike other artists enamoured of science, Ernst's is not a search for equivalents, nor is it his desire, as in the case of Kandinsky and others, to create a science or theory of his own. He has found in the incredible advances of science not the antithesis of imagination or the stifling of instinct, but a magical source no less awesome than that, centuries old, evoked by alchemy.

Many of the compelling hieroglyphic by-products of experimental scientific research, not to mention the evocative engravings to be discovered in books popularizing science such as Amédée Guillemin's *The Forces of Nature* and Figuier's *Marvels of Science* and in illustrated popular-science journals, served this twentieth-century necromancer well. Neither the graceful arabesques of acoustical wave motion, nor the shape of sound made visible long ago by the ingenious M. Lissajous, nor some of the enchantingly illustrated "Récréations Scientifiques" which were featured regularly in the French *La Nature* and which reappeared in the pictorial press of other countries escaped Ernst. Always with an eye for the bizarre, for the surreal image ready-made, Ernst quite deliber-

ately brought scientific illustration within his creative purview.

Fascinated by illustrations of that enchanting and somewhat forgotten world of scientific parlour games, of cut paper tricks, experiments with specific gravity, with inertia, fulcrums, and air-flow, experiments with light and magnetic fields, Ernst metamorphosed such images in the plates of *La femme 100 têtes* and elsewhere. The enigmatic appearance of his well-known painting *Oedipus Rex,* 1922, with its giant hand clasping a walnut, the fingers run through by some strange metallic instrument, has its more mundane (though no less significant) origin in one of those "scientific" amusements: "How to make a nail appear to pierce the finger," a nicely oblique reference to the pin with which it is said Oedipus, in remorse, put out both his eyes.

Ernst's passion for Lewis Carroll, for the man who "made poetry out of mathematics," follows quite consistently. Carroll's works on logical paradoxes ("The Game of Logic," "What the Tortoise Said to Achilles") appealed to Ernst immensely. He produced eight plates for a French edition of *The Hunting of the Snark* in 1950. His illustrations in 1966 for a new edition of Carroll's *Symbolic Logic* (originally published in 1896) are a fascinating combination of unadulterated scientific illustrations and expressive, cipher-like brush drawings. John Russell puts it sensitively in his excellent monograph on Ernst when he says that his was a passion for those things "halfway between mathematics and poetry."

Illustrations made by Ernst especially for Russell's book originate in early diagrammatic engravings of optical curves, nebulae, and the polarisation of light. Ernst uses them as straight *images trouvés,* his raw material disinterred from the pictorial ephemera buried in the archives of nineteenth-century science. In the spirit of Klee, Corbusier, and Ozenfant, Ernst called attention to the evocative importance of microscopic images. He used his own cardiogram in a later painting called *Laity,* though it would be stretching credulity to suggest that it may have been subconscious recall since Marey was the inventor, in 1863, of the cardiograph. Ernst's superb series of "shell flowers," 1926–29, appears to be imaginative mutations originating in botanical illustrations of fungus forms. Could it be that his knowledge of scientific experiment was so up-to-date that certain of his paintings in 1942, such as *Young Man Intrigued by the Flight of a Non-Euclidian Fly* and *The Bewildered Planet* actually illustrate little-known cloud-chamber photographs taken of wildly orbiting particles during atomic disintegration?

Ernst's stimuli came from visual sources in technology too. A remarkable example of his genius for transformation can be seen in *La Belle Jardinière,* 1923 (Fig. 80). Here, the source of inspiration is a photograph of a swing-winged aircraft taken about 1910 (Fig. 81), resembling rather a giant moth than an aeroplane. How appealing this photograph must have been for Ernst, the metamorphosis of the craft into an insect already begun.

Ernst's creative process, it seems to me, is in the nature of William Blake's response, in 1820, when he saw in Robert Hooke's compelling engravings of a flea (*Micrographia* 1664) what might be called reality's confirmation of visionary experience. This fascination for the unknown, perhaps reflecting some essential survival, or even self-destructive, instinct of the human species (*vide* Edgar Allan Poe, Charles Baudelaire, William James, et al.) is the more powerful *not* because the imagery of the unfamiliar is totally alien—for if it were its consequences would surely be less—but because it partakes of the discomforting stimulus of *déjà vu.*

With the range of scientific illustration augmented by the photographic camera, and its distribution subsequently increased by photomechanical reproduction processes, the hidden universe, the extramundane appearance of reality, was invested with a degree of authenticity never previously attributed to drawing and engraving. Furthermore the pictorial sense of actuality inevitably ascribed to photography of this kind could only increase the conviction that Nature herself was capable of harbouring a mysterious and provocative imagery: Nature herself was capable of producing art.

Now this idea that art is always around us or in us, either external and hidden and waiting to be revealed, or lurking in the subconscious and in dreams and waiting to be liberated, is at the centre of Surrealist concepts. Hence the importance given to the *objet trouvé,* the "found object" or, in a less sculptural and more sophisticated sense, the "found image." Hence also the near-mystical dedication to chance, to the fortuitous event, and to the impersonal characteristics of mechanistic pictorial techniques: the "mechanism of inspiration" as Surrealists so efficaciously describe them. That is why the photographic camera and the idea of the "decisive moment," that magnificently perceptive phrase coined by Cartier-Bresson, with all its implications of poetic therapy and liberating force, might well be considered the supreme surrealistic implement. Thus, the prolonged elaboration of a spontaneously discovered or conceived image, as is common in

Surrealist painting (though less so in its sculpture), poses a contradiction. The more calculated paintings of Surrealists are, from that *ideological* point of view, inferior to the immediacy of their graphic techniques, though *pictorially* the success of such paintings, I believe, may be measured largely in terms of their approximation to a photographic kind of imagery. Max Ernst was most certainly aware of this factor.

How much of Marey's photographic methods Ernst knew is hard to say. Marey performed some remarkable experiments about 1900 to determine the airflow around objects of different shape. These were made at a time when a number of vintage aerostatic theories were about to be superseded. Marey's empirical methods depended heavily on the chronophotographic camera as his recording instrument. Though referred to as the first "wind-tunnel" experiments, they were, strictly speaking, carried out in a sealed, glass-fronted chamber with a black velvet backdrop before which fillets of smoke were introduced. To facilitate the photographing of the trajectories of smoke, oblique lighting by magnesium was employed. Placed in the path of these jets of smoke were obstacles of different shape and set at different planes, all producing fascinating images of aerodynamic turbulence (Fig. 82). The techniques were based on Marey's earlier photographic procedures in 1893, when investigating the alternations in speed and direction of liquid waves encountering objects which inhibited the flow.

Apparently unknown to Marey at the time, an English scientist, Henry Selby Hele-Shaw,[2] then Professor of Civil, Mechanical and Electrical Engineering at the University of Liverpool, was conducting similar experiments and recording them by photography. Marey, it seems, first became aware of Hele-Shaw's investigations in 1899, and in September 1901 *La Nature* published, a week apart, illustrated reports of both Marey's current activities in aerodynamics and Hele-Shaw's earlier work.

Ernst must most certainly have discovered both these articles in back numbers of the magazine, the illustrations used there touching off a strong and sustained creative response. For over ten years he produced a number of strange and rather evocative paintings, the curious formal themes of which were unmistakably inspired by the Marey and Hele-Shaw photographs (Figs. 83 and 84). These paintings were a revivification of Ernst's earlier preoccupation with the linear grids of 1926 and 1927, though they had about them now a new and decidedly Freudian aspect.

Visually, these photographs have all the attractiveness of acoustical or magnetic field patterns made by subjecting iron filings to either sound or electrical waves. Hele-Shaw's experiments were, in fact, an attempt to confirm, by empirical means, theoretical solutions made by mathematical calculations and by their resulting diagrams in the investigation of electromagnetic flow characteristics. Hele-Shaw was among the first to propose a hydraulic theory of electricity. By his analogous methods, invisible electrical phenomena were brought into view by shooting, under pressure, thin streams of coloured glycerine into a transparent glycerine matrix. The phalanx of liquid trajectories thus rendered visible form a diversity of patterns when encountering obstacles placed in the path of the current, or "lines-of-force." The current moves into areas of least resistance, just as in magnetic field experiments, thus producing seriatim the characteristic and very attractive rhythmical delineations. These things are worth describing, as they throw light on Ernst's transformations of this rather esoteric imagery into mystifying excursions into landscape and seascape.

Ernst's *Blind Swimmer: Effect of Touching,* 1934 (Fig. 85), in the Julien Levy collection is a kind of artistic obeisance to both Marey and Hele-Shaw, combining, as it does, elements from the photographs of both scientists. His *Blind Swimmer* of the same date, in the collection of Mrs. Pierre Matisse, is a near-literal transcription of another Hele-Shaw photograph. Hele-Shaw's illustrations in the *La nature* article include both photographs and linear diagrams made from them. But it is tonal and not linear veracity Ernst seems to want here; not only because that may have seemed more properly in the province of painting, but to elicit, one presumes, a stronger sense of dimension and thus to affirm in pictorial authenticity the reality of such abstract images. If we look closely at these paintings we will see with what scrupulous care Ernst rendered the subtle tonal nuances of each linear component. I doubt that his *Blind Swimmer* could thus have been blindly executed.

From 1934 and 1935 until as late even as 1949, the same notation of parallel and undulating lines of force, executed with the same subtlety of tonal modulation, consistently recurs. The titles of the paintings based on this matrix are quite significant. For whatever sense of fantasy or of sexual germination they suggest, they spring from the precise content of the scientific experiments, e.g., *Blind Swimmer: Effect of Touching* is, literally, moving liquid encountering physical obstructions. "Blind" possibly refers to the title of the article on Hele-Shaw: "La photographie des mouvements invisibles."[3]

In *Landscape: Effect of Touching,* in which a bird is introduced, Ernst turns the lines of force into terrestrial laminations and stratified ocean waves. Another title for the same painting, indicated in Russell's book, is *Landscape with Germ of Wheat,* 1934–35 (Fig. 86). This is not surprising, as the more meaning one could extract from those pictures the better, Ernst believed. The titles of his works were seldom thought of as immutable. The *Blind Swimmer* undergoes a number of transformations, from the prototype copy to a variety of fanciful representations of earth and sea with birds. Later, in paintings such as *Bird and Sea,* 1947, *A Beautiful Day,* 1948, and *Blind Swimmer,* 1948, the lines of force have become attenuated, rectilinear, and intersecting. Embedded somewhere in these forms is the familiar instrument thrusting its way to the hidden egg. Here, the symbolism becomes quite obvious. The theme reappears in *Birds and Oceans,* 1949, where within the striated bands of the composition the familiar forms begin, one might say, to beget.

What manner of obsession could have commanded so many variations on this single, apparently innocuous, theme? Was Ernst merely yielding to whimsey in his protracted metamorphoses of the *Blind Swimmer* or was his preoccupation with the theme a response to some deeper mood? *Blind Swimmer,* we should note, first appeared at a most disconsolate time for Ernst, then living in France, after his homeland had acquiesced to the Nazi tyranny. To what else could he have been referring when he wrote, "I see barbarians looking to the west, barbarians emerging from the forest, barbarians walking to the west"? Ernst's revulsion for that modern barbarism can perhaps be measured by the fact that, in 1937, he volunteered (though unsuccessfully) to help the Republican cause in Spain. Was there some futile meaning implicit in the *Blind Swimmer,* Ernst's *cri de coeur?* A further clue to his motivations will be found in his ironically third-person autobiographical notes, also written in retrospect. He wonders which road to take in life (which way to swim?):

> What to do about consequent confusion? Struggle like a blind swimmer? Appeal to reason? Submit to discipline? Or, accentuate contradictions to the point of paroxysm? Should he abandon himself in his night, indulge in the luxury of losing reason? The young man's temperament predisposed him to accept the last solution.[4]

Yet however much Ernst's determination to indulge in the luxury of a pretended madness, his

works of the period, far from being mad, are powerful premonitions of things to come. He depicts invasions of monstrous beings and the silence and desolation of ruined cities at night. More symbolically remote, though no less meaningful, is his series of gardens in which creep noxious plants, trapping and devouring aeroplanes and birds alike. Mocking and pessimistic, Ernst's titles, deceptively idyllic, belie the visual content of the works. His *Triumph of Love* or his *Angel of Hearth and Home,* his montages collected under the title *Une semaine de bonté* (1933, published in 1934), are dark, frightening chimeras spawned of a cruel, despotic world. It is that context in which we must view the *Blind Swimmer,* its secret rapport with science and its ironical references. Yet it is not perhaps without a germ of hope for regeneration.

NOTES

1. Tissandier was for many years editor of *La Nature.*
2. My thanks are due to Dr. Colin Russell, Reader in the History of Science and Technology at the Open University for supplying me with biographical material on Hele-Shaw.
3. The article was written by Lucien Bull, Marey's assistant and later successor at the Physiological Station in Paris.
4. Quoted in the Arts Council of Great Britain Catalogue of the Max Ernst exhibition, 1961.

76.

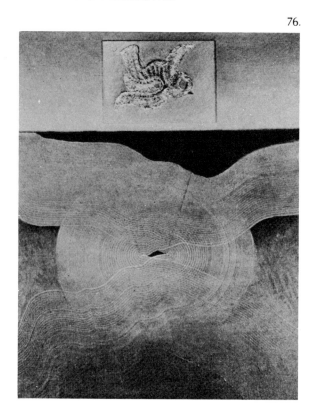

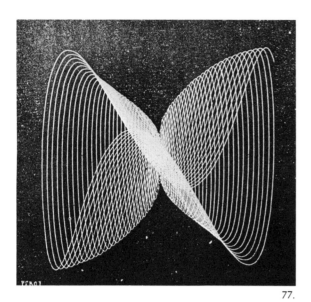

77.

79.

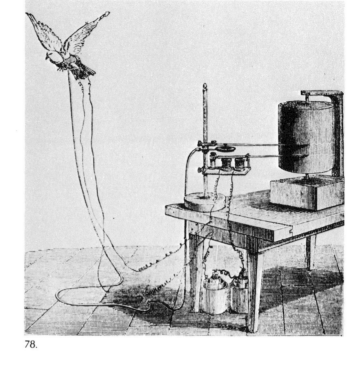

78.

80.

76. Max Ernst. *Gulf Stream and Bird*. 1926–27.
Private collection, Belgium.

77. E. J. Marey. Harmonigraph recording of insect flight.
Reproduced from E. J. Marey, *The Graphic Method in the
Experimental Sciences*, 1885.

78. E. J. Marey. Myographic device for recording bird flight.
Reproduced from E. J. Marey, *The Graphic Method in the
Experimental Sciences*, 1885.

79. Max Ernst. Reproduced from Max Ernst, *La femme 100
têtes*, 1929.

80. Max Ernst. *La Belle Jardinière*. 1923.
Present whereabouts unknown.

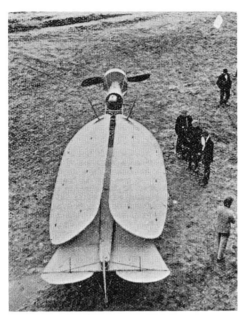

81. Photographer unknown. Photograph of
early swing-winged aeroplane. 1910.
Courtesy Aaron Scharf.

82. E. J. Marey. Chronophotographs demonstrating
aerodynamic turbulence. 1900.
Courtesy Marey Museum, Beaune.

83. E. J. Marey. Reproduced from E. J. Marey,
"Les mouvements de l'air étudiés par la
chronophotographie," *La Nature,* 7 September 1901.

84. H. S. Hele-Shaw. Reproduced from
"La photographie des mouvements invisibles,"
La Nature, 14 September 1901.

85. Max Ernst. *Blind Swimmer: Effect of Touching.* 1934.
Collection Julien Levy, Bridgewater, Conn.

86. Max Ernst. *Landscape with Germ of Wheat* (or *Effect of Touching*). 1934–35. Present whereabouts unknown:

AN EIGHTEENTH-CENTURY ENGLISH POEM
ON THE CAMERA OBSCURA

HEINRICH SCHWARZ

AN EIGHTEENTH-CENTURY
ENGLISH POEM
ON THE CAMERA OBSCURA

Heinrich Schwarz

*Professor, History of Art, and Curator of
the Davison Art Center, Emeritus
Wesleyan University*
prior to his death in 1974

Ever since the appearance of my book on D. O. Hill, which may be considered the first scholarly monograph on an individual photographer, I have been assembling a rather substantial amount of material dealing with the history and prehistory of photography. Working first in Europe, later in this country, it was possible to establish an archive on these and related subjects. By using collections and libraries specializing in photography, which until recently had seldom been used by art historians, and by extending the photo-historical research into the fields of art and literature—which needless to say are loaded with important information on photography and photographers—new sources and vistas could be opened which have hardly been tapped by earlier photohistorians.

Part of this research and work consisted in collecting material for a biographical dictionary of photographers visualized as a supplementary volume to Thieme-Becker's *Künstler Lexikon,* a project which only a few years ago may have seemed rather awkward and preposterous, but which is viewed in a very different way since photography is gradually being considered a legitimate branch of the graphic arts. Only a short time ago the Louvre and the National Gallery in Washington opened their premises for the first time to one-man shows of photographers: Henri Cartier-Bresson and Alfred Stieglitz, respectively. At exactly the same time, 1959, a new edition of Helen Gardner's popular one-volume history of art was augmented by a chapter on photography. At a recent annual meeting of the Print Council of America, photography was introduced for the first time in a small group of lectures on the graphic arts. Besides material for the biographical dictionary of photographers, a good many more fields and aspects are included in this "archive," which goes beyond the problems of art and photography and may be characterized as a contribution to the studies of problems of art and science, of the interrelationships between science and art, in particular, of the use of mechanical devices by artists and the consequent impact on their work.

Thus this research is by no means limited to the period after 1839, the year when the image produced in the camera obscura could be made permanent, but includes numerous other aspects of the history of optics: the mirror, the black mirror, the microscope, the telescope, the magic lantern, the pantograph, the camera lucida, and a good many others.

One of the most comprehensive sections is devoted to the prehistory of photography which includes the *machine à dessiner,* as devices first

designed by Leone Battista Alberti, Leonardo, and Dürer were called in France in the eighteenth century, and above all, the camera obscura, the immediate precursor of the photographic camera. Until now comparatively little of this material has been published, though some of it has been covered in frequent lectures. Among the published papers on the camera obscura, the first one deserves mention, "Giambattista Marinoni's Camera Obscura,"[1] and the last one, "Vermeer and the Camera Obscura."[2]

The file on the camera obscura, going back to antiquity and covering the centuries up to the end of the nineteenth century, may be the most extensive collection of material on this device ever assembled. In the meantime, some of this material has become common knowledge and a number of these contrivances can be found illustrated and discussed today in popular histories of photography. The documentation, however, and above all the study of the relationship of the camera obscura to the history of art, which inspired this research, has yielded and will yield further important insights.

Out of this material a small item, which to my knowledge has not been published and is probably unknown even to connoisseurs and specialists of the history of photography, may seem an appropriate contribution to this collection of essays which honor the most meritorious and distinguished photo historian in this country. I am well aware that I am guilty of an exaggeration by entitling this paper, "An Eighteenth-Century English Poem on the Camera Obscura," since the anonymous poem, describing the miraculous working of the camera obscura, is the rather poor fabrication of an amateur. It may well be, however, the literary product of a distinguished and accomplished, indeed famous, London optician, John Cuff, for whom the sixteen-page pamphlet was printed in 1747. The last page of the pamphlet contains an advertisement listing the instruments manufactured by John Cuff and available at his store "at the sign of the Reflecting-Microscope and Spectacles . . . in Fleet Street." John Cuff attained a significant reputation through his microscopes. By adding a heliostatic mirror, Cuff improved upon Dr. Johann Nathaneal Lieberkühn's (1711–1756) solar microscope and described his instrument in a twelve-page brochure, dated 1744, which also appeared in a French edition the same year. One year earlier John Cuff had published another pamphlet called: *The Description of a Pocket Microscope, with the apparatus thereunto belonging*, etc.

From the advertisement on page 16 (the last page) of the *VERSES, Occasion'd by the Sight of a CHAMERA OBSCURA*,[3] we can see that John Cuff[4] was particularly preoccupied with the manufacture of microscopes, besides constructing refracting and reflecting telescopes and "all Sorts of the most curious Optical Instruments." To these "curious optical instruments" belongs the "Chamera Obscura, for exhibiting Prospects in their natural Proportions and Colours, together with the Motions of living Objects." It has not been possible yet to find a camera obscura made by or attributable to John Cuff. However, knowing how popular portable cameras were in the eighteenth and early nineteenth centuries with artists and amateurs or simply with people who enjoyed the view produced in the camera obscura—Horace Walpole, Goethe, and many others availed themselves of or described this instrument or used it simply for pleasure—we may assume that Cuff produced and sold a good many of his cameras to artists, scientists, and amateurs. He was, of course, not the only English optician active in this field, and we have lists of numerous other eighteenth-century optical instrument makers who manufactured and sold cameras and black mirrors, another device which had been used by artists and amateurs since the seventeenth century.

Even though we cannot identify any of them with John Cuff, it may be interesting to look at some of the eighteenth and early nineteenth century contrivances. The variety of their forms and shapes is considerable. Some of the French and German models are by now quite well known. Yet, a few years ago, when they were first used in illustrating art-historical lectures and papers, they were hardly known and rather startling.

The camera constructed by Johannes Zahn and described and illustrated in 1685 in his *Oculus Artificialis* is strongly reminiscent of an early photographic camera.

Another German device, Georg Friedrich Brander's camera, is described and illustrated in his book *Beschreibung dreyer Camerae Obscurae*, published in Augsburg in 1769 and followed by two more editions in 1775 and 1792. Of a somewhat earlier date are the cameras which may be found in *Diderot's Encyclopedia Methodique* (1762–1765), where they are discussed in the section: "Beaux Arts," a fact which is quite significant and revealing. The engraving shows in the lower part a *Porte Chaise* camera obscura, which, of course, was movable and could easily be adjusted to any desired position. In the upper part of the engraving on the right-hand side a tent camera is pictured, installed on a table, a system which survived deep into the nineteenth century, as

a wood engraving illustration in Atkinson's *Elementary Treatise on Physics,* published as late as 1870, proves.

The Italian "Vedutisti," Canaletto, his nephew Bernard Belotto, Francesco Guardi, Gianfrancesco Costa, and Michele Marieschi, to mention but the most famous names, were among the most avid users of the camera obscura, for which we have a variety of documentary, pictorial, and above all, scientific proofs. How the tent camera was used in the field may be seen in an etching by Gianfrancesco Costa in his *Delicie del Fiume Brenta,* 1750, while another kind of portable camera can be exemplified by the camera used by Canaletto (c.1760), a product of the workshop of the Venetian optical instrument maker, Domenico Selva. A German model appears in a mid-eighteenth century portrait mezzotint of the court painter Joachim Franz Beich, while a drawing of about 1810 by the Dutch painter Jurrian Andriessen (1742–1819) shows the camera in use by an artist or draughtsman standing in the dark doorway and directing his camera into the street which appears in full daylight.

An eighteenth-century camera obscura installed in a coach, and to be used not so much as a drawing aid as a device to view and enjoy the passing landscape from the darkened coach interior, is described and illustrated in a German eighteenth-century magazine.

Among the English eighteenth-century devices a kind of camera obscura may be found which seems not to have been manufactured or used in any other country: the book camera, which when closed and not in use could be kept inconspicuously among the folio volumes of a library and which could be easily put to use when opened. There is one specimen measuring 24½ inches by 18 inches in the Harvard University collection of scientific instruments,[5] and another one, said to have been owned and used by Sir Joshua Reynolds, in London's Science Museum.

John Cuff's cameras were certainly made of more solid material than the book cameras which were of cardboard, wood, and leather. It is rather likely that the boxes for Cuff's cameras were manufactured by other craftsmen, probably carpenters as we can assume from specimens which are still preserved, while he was responsible only for the lenses and their grinding, the mirrors, and possibly for the brass stands.

A painting (35½ inches by 27¼ inches) done in 1772 and now in the collection of Queen Elizabeth II at Windsor Castle shows John Cuff as a fairly old man with his assistant in his workshop, probably in Fleet Street.[6] Over the years the names of the two men had fallen into oblivion since the painting, presumably purchased by or painted for King George III or his Queen Charlotte, was entitled *The Lapidaries* in Redgrave's inventory of Queen Victoria's paintings in 1859; it had been correctly named when it was exhibited in the British Institution in 1814, the catalog entry reading: *Mr. Cuff—Optician—Zoffany.*

Johann or John Zoffany—his real name was Zauffely—was born in 1733 in Frankfurt am Main. His parents came from Bohemia and his father worked as an architect in the service of the Prince Thurn and Taxis family. After having studied with Martin Speer, a German disciple of Francesco Solimena, and after a short stay in Rome, Zoffany, accompanied by his wife, left Germany in 1763 and went to England, which was to become his second homeland, so that he may be found more often listed as an English than as a German artist. After rather difficult years during his early English career—his wife left him and returned to Germany—he became one of the most renowned and successful English portrait painters, particularly well known for his theatrical scenes—several with the famous Shakespearean actor David Garrick—and for his "conversation pieces." This happened at a time when the great English portrait painters of the eighteenth century, Thomas Gainsborough and Sir Joshua Reynolds, were at the peak of their fame. Zoffany's style and genre, which clearly show the impact of Hogarth's paintings, differed, however, from that of the English portraitists, who had borne Van Dyck's representative and monumental portrait tradition into the eighteenth century. John Cuff's workshop may be considered a characteristic example of Zoffany's style—showing clarity, verisimilitude, and exactitude of some of the seventeenth-century Dutch genre painters and painters of cityscapes, some of whom, like Vermeer van Delft or his contemporary, Pieter de Hooch, may have availed themselves of optical devices, such as the camera obscura.

Toward the end of the 1760s, Zoffany was receiving high prices for his painting. In 1769, Zoffany was among the founding members of the Royal Academy. After 1771 at about the time of the painting of Cuff's workshop, Zoffany painted the portrait of King George III and other members of the Royal family (who, incidentally, were also clients of John Cuff). After another stay in Italy where he painted for Queen Charlotte the *Tribuna* of the Uffizi, with its art treasures (now in the Royal Collection), and after a stay in Vienna where he was knighted by Empress Maria Theresia he settled in Rome for several years. In 1779 he returned to England. By then the demand for

his conversation pieces and portraits had declined. In 1783 Zoffany left England for East India, where he remained much in demand among the Indian princes and the English civil servants for his portraits and conversation pieces. He returned to England in 1789 or 1790 and died there in 1810.

Reynolds', and for that matter Gainsborough's, style could not be more different from Zoffany's. Yet, we do know that Reynolds made use, at least at certain times, of the camera obscura, just as many famous and less famous painters of the nineteenth and early twentieth centuries made ample use of photography. Increasingly, such evidence is being revealed. Today, this evidence, leading even to the discovery that certain nineteenth- and twentieth-century paintings were completely based upon or derived from photographs, is not too surprising or sensational.[7]

What Reynolds had expected from the camera must have been the chiaroscuro effects yielded by the camera. If Zoffany availed himself of the camera, which is by no means unlikely and for which his acquaintance with John Cuff and his instruments may offer another clue, he may have done it to increase the verisimilitude of his paintings and the clarity of his renditions, which a few years later photography was to achieve with the camera.

It may not be accidental that Horace Walpole criticized Zoffany's painting of John Cuff's workshop for being too "natural,"[8] just as he had labeled Jean-Etienne Liotard's portraits as "too like to please" —judgments which may bring to mind Pope Innocent X's words in front of his portrait by Velazquez, "e troppo vero" (1650), words which, however, were more directed to the psychological veracity of the likeness than to the exactness of the outward appearance and resemblance. It was this for which Zoffany and his Dutch predecessors were striving and which in the nineteenth century was to find its fulfillment through the invention of photography.

NOTES

1. Heinrich Schwarz, "Zur Geschichte der Camera Obscura," *Die Galerie*, Vienna, Heft 11, January 1934, pp. 79–84.

2. Heinrich Schwarz, "Vermeer and the Camera Obscura," *Pantheon*, Munich, vol. 24, no. 3, May–June 1966, pp. 170–82.

3. The only two copies of the pamphlet known to me so far are in the British Museum Library (Cat., vol. 248, col. 60) and in the New York Public Library.

4. John Cuff, who in 1748 became Master of London's Spectacle Makers Company, was particularly well known through his microscopes. A compound microscope made by John Cuff in 1744 and an aquatic microscope (c.1745), formerly in the collection of Kew Observatory, founded by King George III, are in the Science Museum, South Kensington, London. His own writings, listed in the B. M. Cat., vol. 46, col. 872, are devoted to various kinds of microscopes which he devised and constructed. Cuff's microscopes and some of his other optical instruments are described and illustrated in numerous eighteenth-century standard works on microscopes, such as Henry Baker, *The Microscope Made Easy*, London, 1742; Henry Baker, *Employment for the Microscopes*, 2d ed., London, 1747; George Adams, Jr., *Essays on the Microscopes*, 2d ed., London, 1798; John Mayall, Jr., *Cantor Lectures on the Microscope*, delivered November-December 1885, London, 1886, p. 49.

5. The Harvard book camera is described in an invoice of August 17, 1765 as "a large book Camera Obscura, obtained from B. Martin at a cost of 3/13/6." I. Bernard Cohen, *Some Early Tools of American Science*, Harvard University Press, 1960, p. 159, where also the book camera used by Sir Joshua Reynolds is mentioned.

6. Lady Victoria Manners and G. C. Williamson, *John Zoffany, R. A. His Life and Works*, London, 1920, pl. p. 34-35, where the painting is erroneously entitled, "Portrait of Peter Dollond, the Optician with his Assistant, known as 'The Lapidaries.'" Oliver Millar, *Zoffany and his Tribuna*, Studies in British Art. The Paul Mellon Foundation for British Art, London, 1966, pl. 5 confirmed the correct name of the sitter, pointing out that in 1772 Peter Dollond was only forty-two years old. A complete documentation of the portrait of the John Cuff painting may be found in the catalogue of the exhibition, *Romantic Art in Britain: Paintings and Drawings, 1760–1860*, The Detroit Institute of Arts, January–February 1968; Philadelphia Museum of Art, March–April 1968, No. 39.

7. Aaron Scharf, *Art and Photography*, London 1968; Cat. *Malerei nach Fotografie: Von der Camera Obscura zur Pop Art*, München, Stadtmuseum, September–November 1970; Heinrich Schwarz, "Art and Photography: Forerunners and Influences," *Magazine of Art*, November 1949, pp. 252–57 may be considered the first paper devoted to this topic.

8. Horace Walpole wrote beside the catalog entry of the 1772 exhibition where the Cuff painting was exhibited under No. 291: "Extremely natural, but the character too common nature and the chiaroscuro destroyed by his servility in imitating the reflexions of the glasses." Manners and Williamson, *John Zoffany*, p. 35.

87. *VERSES, Occasion'd by the Sight of a CHAMERA OBSCURA*, London, John Cuff, 1747. Overleaf.

VERSES,

Occasion'd by the Sight of a

CHAMERA OBSCURA.

In nova fert Animus mutatas dicere formas Corpora. ——

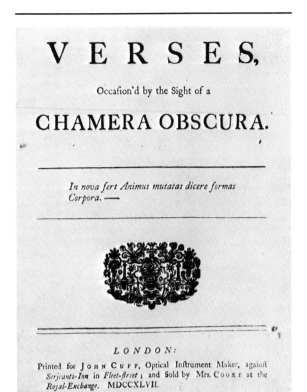

LONDON:

Printed for JOHN CUFF, Optical Instrument Maker, againſt *Serjeants-Inn* in *Fleet-ſtreet*; and Sold by Mrs. COOKE at the *Royal-Exchange.* MDCCXLVII.

[3]

ON THE

CHAMERA OBSCURA.

SAY, rare Machine, who taught thee to deſign?
And mimick Nature with ſuch Skill divine?
The Miracles of whoſe creative Glaſs,
Struck with Amaze, the ſuperſtitious Claſs,
Of Fools, in * BACON's Days, and did for Witchcraft paſs;
Productions ſtrange! weak Reaſon did tranſcend;
And all admir'd, but few could comprehend;
The Cauſe conceal'd; th' Effect Men plain perceive;
Compell'd by Sight thy Myſt'ries to believe.

Come; lead us to thy Chamber; there unfold
Thy ſecret Charms, delightful to behold;
 How

A 2

* Friar *Bacon*, who for his Skill in Optics, and other Arts, was tried for a Conjurer.

[4]

How little is thy Cell? How dark the Room?
Diſcloſe thine Eye-lid, and diſpel this Gloom!
That radiant Orb reveal'd, ſmooth, pure, polite;
In darts a ſudden Blaze of beaming Light,
And ſtains the clear white Sheet, with Colours ſtrong and
 bright;

Exterior Objects painting on the Scroll,
True as the Eye preſents 'em to the Soul;
A new Creation! deckt with ev'ry Grace!
Form'd by thy Pencil, in a Moment's Space!
As in a Nutſhell, curious to behold;
Great HOMER's ILIAD was inſcrib'd of old;
So the wide World's vaſt Volume, here, we ſee
To Miniature reduc'd, and juſt Epitome:

Each wondrous Work of thine excites Surprize;
And, as at Court ſome fall, when others riſe;

 So,

[5]

So, if thy magick Pow'r thou deign to ſhew;
The High are humbled, and advanc'd the Low;
Thoſe, who to *Rank* of worthieſt Place aſpire,
And Right-hand Honours as their Due require;
Thou to the Left conſigns; — (foretold their Doom,
In ſacred Writ;) — and others take their Room.
Inſtructive Glaſs! here human Pride may trace,
Diminiſh'd Grandeur, and inverted Place:
How like to Thine, are fickle Fortune's Ways?
Delighting to tranſpoſe, depreſs, and raiſe;
O! couldſt thou ſhew ſuch Influence on my Lay!
Whilſt I thy various Properties diſplay;
And lift to loftier Heights my Genius low;
That equal to my Theme my Verſe might flow;
Then, wou'd I paint great Nature's Works and Thine,
In laſting Characters, and each ſtrong Line,
Shou'd juſtly repreſent the Archetype divine.

 Now

[6]

Now tow'rds that Garden spread the Paper Screen;
What instantaneous Beauties gild the Scene?
The Chrystal Fountains, and the fine Caskade;
The living Statues, and green Arbour's Shade;
The painted Hollies, and the smooth-shorn Yew;
The Lillies lovely white, and Iris blue!
The gaudy Tulips; and the blushing Rose,
With each gay Flow'r that on the Margin glows;
Array'd in all their native glorious Dyes;
Waving their Tops, as the soft Zephyrs rise:

Or, shou'd the rich Autumnal Season suit;
The Print presents us with all kinds of Fruit;
The red-ripe Cherry, and the Sun-burnt Peach;
And purple Grape, hang here within our Reach;
Of Mulb'ries plenteous store on those fair Trees,
In Clusters, court the Hand their Load to ease;

That

[7]

That loose Branch shakes, by Winds rent from the Wall,
Down drop the Plumbs; see! catch 'em in their Fall.

How wou'd that Painter boast his Pencil's Art?
Who cou'd such Motions to his Piece impart?
But, here, thou hast no Rival in thy Fame;
'Tis thine alone to copy Nature's Frame,
So strictly true, she seems the very same;
In just Proportions; Colours strong or faint;
By Light and Shade; without the Daub of Paint:
To animate the Picture, and inspire,
Such Motions, as the Figures may require,
From Heav'n, Prometheus like, thou steal'st the sacred Fire.

Again, the blank unsullied Scheme display;
Earth, Ocean, Air and Sky, thy Call obey.
Their num'rous Charms the various Beings blend;
As far and wide the Landskip does extend;

5

Fresh

[8]

Fresh Wonders entertain our ravish'd Sight;
The Change of Scene affords us new Delight:
See! distant Hills advance above the Sky,
Whose Tops below the lifted Vallies lie;
There lowing Herds in the rich Pastures graze;
The fleecy Flock, here, from the Shepherd strays.

Poor tim'rous Hare! how swift along the Plain
Thou darts thy Flight; thy Flight, alas! is vain;
Inspir'd by sound of Horn, and Cries of Hounds,
O'er the high Fence the gen'rous Courser bounds;
The Huntsman, Horses, Dogs, pursue the Chase,
With eager Speed and fierce tumultuous Race;
Decreed thy Death, nor can thy Doublings save;
They seize their Prey, and drag thee to thy Grave.

See yonder Cottage its new Height admire,
Uprais'd above the Steeple's lofty Spire;

Now

[9]

Now smile the fruitful Fields of ripen'd Corn,
Whose golden Plenty does the Print adorn;
How the Clown stares! smit with Surprize and Love,
To see th' inverted pretty Milk-Maid move,
With Pail beneath her Head, and Feet above;
While swift his Windmill whirls its giddy Sail,
This Way and that, obedient to the Gale:

Near the thick Copse, the dazling Meteor's Blaze
Dances the swampy Green, in giddy Maze;
Avoid the Path, ye simple Hines, nor tread
The dang'rous Track: bewilder'd and misled,
The lonesome Trav'ler, oft, at dark Midnight
Pursues, with pleasing Hopes, the wandring Light;
Too late repents; misguided by the Flame,
Thro' miry Bogs, wet Marsh, and muddy Stream;

B

O'er

[10]

O'er Hedge and Bush; 'midft Briars, Thorns and Brakes,
Such dreary Ways the Jack-o-Lanthorn takes,
Then plung'd in Pond, or Ditch, the drowning Wretch
 forfakes.

So warn'd; beware falfe Lights, that lead aftray,
And tempt your Feet to quit the good old Way;
By fafer Courfe to guide you they pretend
To Heav'n, while headlong down to Hell they tend.

 The Kyte and Lanthorn mounting from that Plain
Aloft in Air, difpread a fhining Train;
Which like a falling Star, in dead of Night,
With long continued Trail of ftreaming Light,
Defcends a-down the Chart;—fome Truant Boy's Delight.

 Conceal'd by yon' tall topfey-turvey Trees,
Whofe bending Branches anfwer to the Breeze;

We

[11]

We juft difcern fome Nobleman's fair Seat;
How happy to enjoy fuch bleft Retreat,
If Happinefs wou'd deign to dwell among the Great!
Here crofs the Landfkip Ravens wing their Flight;
There fkulks the Screech Owl, hideous Bird of Night;
Thefe pretty Songfters hop from Spray to Spray,
And with fweet Notes falute the dawning Day;
While tow'ring Larks, attempting high to foar,
With downward Pinions nether Skies explore;
Birds in full Flocks forfake our Hemifphere,
Purfue their deftin'd Voy'ge in the Mid Air;
And, quite beyond our Ken, to diftant Climes repair.

 What Firmament? which we from far defcry,
Whofe azure Surface elevated high,
And wide extended, feems another Sky;
The vaft unbounded Ocean's level Green!
Now, undifturb'd by Winds, calm, fmooth, ferene.

B 2

[12]

O Sight magnificent! O beauteous Train!
A moving Grove floats on the wat'ry Plain,
And with approaching Glories decks the fhining Main.
A gallant Fleet! Great BRITAIN's boafted Pride,
And fureft Safeguard! with what State they ride,
And prefs the Bofom of the fwelling Tide;
The painted Streamers dancing to and fro,
Set ev'ry Sail to court all Winds that blow;
The Sun Beams with reflected Luftre play
On the bright Surface of the glaffy Way,
So ftill the peaceful Deep! So foft the Gale!
Who in thofe Gallies wou'd not wifh to fail?

 Ah! truft no Summer's Sea, nor Harlot's Smile,
With fweet Deceit, and flatt'ring Joys, a while
They 'lure; then, faithlefs, ruin thofe they once beguile:

Witnefs

[13]

Witnefs the Warning-piece before our Eyes!
Lo'e there! th' Horizon low'rs; black Clouds arife,
With Darknefs, thick as Night, inveloping the Skies.
Blefs us! what quick, fierce Fires the Lightnings
 dart?
The livid Blaze illumes the gleaming Chart;
Hark! the loud Tempeft roars, the Thunders roll,
And rat'ling Vollies rend the tott'ring Pole,
Yet cannot fhake the tranquil Mind and ftedfaft Soul:
Againft the Rocks thofe raging Billows dafh;
That flying Foam feems fome bright Lightning's
 Flafh;

 How are the Glories of our Glafs defac'd!
The Room obfcur'd; the Picture quite eras'd;
Obliterated All!

O

Now mourn the fhatter'd Fleet, to Pieces torn ;
The wretched Seamen on the Surges born,
Become the Mock of Winds, and cruel Tempeft's
 Scorn :
What Heart obdurate the fad Shock can bear
Without a folemn Sigh, and plenteous Tear ?
When will this dreadful Hurricane have End ?
Kind Heav'n fome Friendly Ray of Comfort fend ;
Thy heavy Judgments do not always laft,
Pity fucceeds when Punifhment is paft :

 See ! while I fpeak, a glimn'ring Light arife,
And the gay Bow bedeck the milder Skies ;
Its Arch contracted, and revers'd its Horns,
Like the fair Moon, when new, the Chart adorns ;
The Waves fubfide, the boift'rous Winds decreafe,
The troubled Motions of the Waters ceafe,
A fettled Calm enfues, and all is Peace :
 Enough !

Enough ! now ope' the Door ! See Sol's bright Ray
Breaks in, the fickning Figures faint away,
And all their Beauties fade, funk in the Flood of Day ;
So fhine the Starry Train, and Planets bright,
With peerlefs Luftre, all the darkfome Night,
But vanifh at the fplendent Sun's approaching Light.

F I N I S.

JOHN CUFF,

OPTICAL-INSTRUMENT-MAKER,

At the Sign of the Reflecting-Microfcope *and* Spectacles, *againft* Serjeant's-Inn *Gate, in* Fleet-Street ;

MAKES and Sells all Sorts of the moft curious Optical In-ftruments, *viz.* REFRACTING TELESCOPES, proper for Celeftial and Terreftial Obfervations, either by Land or Sea : And REFLECTING TELESCOPES, as invented by Sir ISAAC NEWTON, and Mr. GREGORY.

MICROSCOPES of feveral Kinds, both fingle and double, (either for the Study or the Pocket) particularly a DOUBLE MICROSCOPE, of a New Conftruction, invented by the faid *J. CUFF,* to remedy the Inconveniencies complain'd of in all the former Sorts : The SOLAR MICROSCOPE as improv'd by him, with a moft convenient and manage-able Apparatus for viewing Objects, and drawing their Pictures with Eafe and Exactnefs. The AQUATIC MICROSCOPE, invented by him for the Examination of Water Animals. The OPAKE MICROSCOPE, which by reflecting Light upon Objects that have no Tranfparency, renders them diftinctly vifible : Alfo *Wilfon's Pocket Microfcope, Culpep-per's Microfcopes,* &c.

A NEW MICROMETER, contrived to meafure the real Size of Mi-crofcopical Objects, in Compound, Single, and Solar Microfcopes, by a Method entirely New.

The CHAMERA OBSCURA, for exhibiting Profpects in their natural Proportions and Colours, together with the Motions of living Objects : MAGIC LANTHORNS ; Convex and Concave SPECULUMS ; MULTIPLY-ING-GLASSES ; Barometers ; Thermometers ; Speaking-Trumpets, and various Sorts of Mathematical Inftruments.

Likewife, OPERA-GLASSES ; READING-GLASSES ; and SPECTACLES, of true Venetian Green-Glafs, Brazil Pebble, and the fineft Flint-Glafs, ground on Brafs Tools, in the Method approved by the Royal Society. All at Reafonable PRICES, either WHOLESALE or RETALE.

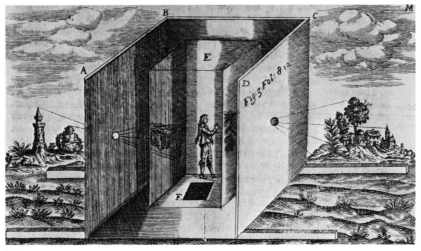

88.

90.

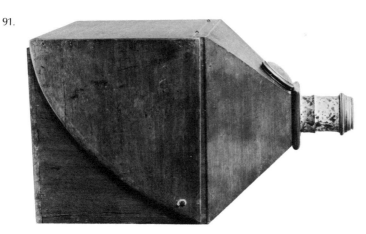

89.

91.

88. Camera obscura. Engraving from
Athanasius Kircher, *Ars Magna Lucis et
Umbrae*, Amsterdam, 1761, pl. p. 709.

89. Gianfrancesco Costa. *Veduta del
Canale verso la Chiesa della Mira.*
Reproduced from *Delicie del Fiume
Brenta*, vol. 1, 1750.

90. Georges Desmarées. *Portrait of the
Painter Joachim Franz Beich.* Drawing by
J. G. Bergmüller. Mezzotint by Johann
Gottfried Haid. International Museum of
Photography at George Eastman House,
Rochester, N.Y.

91. Venetian camera obscura,
built by Domenico Selva, c 1760.

92–93. English book camera obscura, 1765.
92, closed; 93, open. Courtesy Collection of
Historical Scientific Instruments, Harvard
University, Cambridge, Mass.

94. English camera obscura, formerly
owned by Sir Joshua Reynolds. British
Crown Copyright. Science Museum, London.

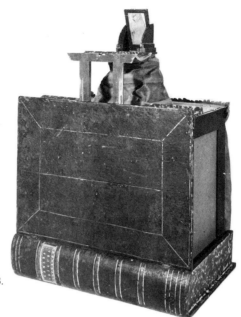

92.

93.

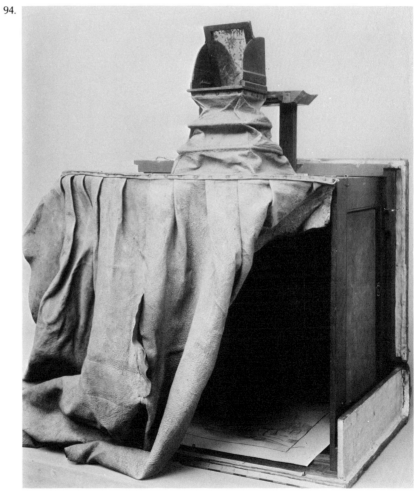

94.

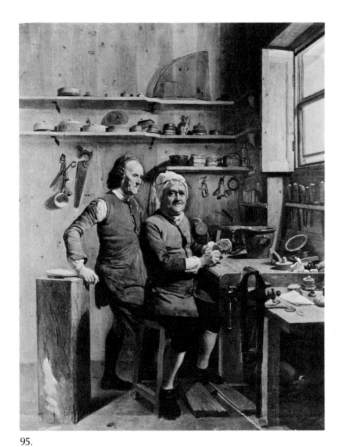

95.

96.

95. John Zoffany. *John Cuff and his Assistant*. 1772.
Windsor Castle, Her Majesty Queen Elizabeth II.
Copyright reserved.

96. Jurrian Andriessen. *Artist with Camera Obscura*.
Pen and wash drawing. c 1810.
Koninklijk Oudheidkundig Genootschap, Amsterdam.

138

MODELS FOR CRITICS

HENRY HOLMES SMITH

MODELS FOR CRITICS

Henry Holmes Smith
Professor of Art, Indiana University

To an outsider, the miniature feuds and furies of photography may appear to be totally inconsequential. Yet I must take seriously the squabbles among photographers over photographs they make or prefer (as in, say, *Camera Work* where Stieglitz tangled with Fraprie, or in *Camera Craft* of the mid 1930s, where pictorialists and Group F/64 scored off one another, or still more recently in *Infinity* and other contemporary periodicals, where journalists and advertising illustrators have claimed total victory).

Something important for all photographers seems to lie just beneath the surface of such discourse. More often than not, I sensed the attempt to differentiate among ways of viewing life and aspects of human experience. Historians and critics are required to establish these differences clearly and test all grounds for argument. Without such efforts to distinguish one viewpoint from another, criticism may remain merely impressionistic and appreciation become merely personal.

As I considered the problem further, a single conclusion seemed inescapable: we all may be the victims of some major defects in our way of thinking about photography. How else are we able to account for the lack of workable terms with which to describe real differences among types of photographs—lensless pictures, x-rays, electron micrographs, for example, as opposed to conventional camera work. Some of them are so unlike others that at first glance they seem to be products of different media. Yet I find many of these pictures engage my enthusiasm, and most of the different kinds, on closer study, appear to be made by reasonable men and to deserve serious consideration. I have also wondered why it is so difficult to weigh rationally the arguments supporting strongly held positions.

Perhaps a book by Thomas S. Kuhn offers some answers to our predicament. *The Structure of Scientific Revolution* deals with differences of opinions among scientists. It offers some hints as to how these viewpoints gain currency and what tends to stabilize some of them. These suggestions in turn are the basis for the thoughts that follow.

In the preface to his remarkable book, Kuhn writes:

> I was struck by the number and extent of the overt disagreements between social scientists about the nature of legitimate scientific problems and methods. Both history and acquaintance made me doubt that practitioners of the natural sciences possess firmer or more permanent answers to such questions than their colleagues in social sciences. Yet somehow the

practice of astronomy, physics, chemistry, or biology normally fails to evoke the controversies over fundamentals that today often seem endemic among, say, psychologists or sociologists. Attempting to discover the source of that difference led me to recognize the role in scientific research of what I have since called paradigms. These I take to be universally recognized scientific achievements that for a time provide model problems and model solutions to a community of practitioners.[1]

When I read these sentences, it struck me at once that photographers might justifiably adopt a similar phrase. For us it would read: "a recognized, *if not universally recognized,* photographic achievement that for a time provided model problems and model solutions for a body of practicing photographers."

The paraphrase cannot be precise because, while technical achievements in photography almost always are universally accepted, artistic achievements of model quality may be and often are open to question. Work important enough to invite our attention should either have originated with a major photographer or have served as a model for a group of photographers. Eventually, such work may achieve almost universal recognition, as has photojournalism, advertising illustration, and the pictorialism of sixty-five years ago. That such prototypes of models are familiar is more a tribute to the wealth of their sponsors than to the challenge of problems posed or the inventiveness of solutions provided. They do, however, set minimal standards of universality against which models of individual photographers of more enduring worth may be tested.

MODELS IN PHOTOGRAPHY

Without question, the body of work in which we will seek models originates only with photographers and their photographs. And the best men are seldom likely to be instructed in their task by a critic. In fact, it should be said flatly that the critic, by definition, must come *after* the work, not before it, and, when the work is really new, the critic is seldom familiar with it. This is a critic's limitation, and should be accepted more willingly than it is.

If, then, the critic must look to photographers and their photographs for the models which are to instruct him, how is he to know which models to consult? In the absence of universally recognized achievements, what substitutes may be sought?

I turn again to Kuhn's book and adapt his words to my needs.[2] A major photographic achievement will possess these two characteristics:

1. It is sufficiently unprecedented to attract an enduring group of adherents away from competing modes of photography.
2. It is sufficiently open-ended to leave all sorts of problems for the redefined group of photographers to solve.

With these definitions to guide us, what large classifications of model problems and solutions might we consider?

First, we have those based on technological considerations. Some of these are too new to rate; others are almost entirely lost in history. An example of the latter is the mirror-like reflecting surface of the daguerreotype shadows. I believe this is one of the most psychologically relevant and unexplored possibilities for twentieth-century photography that one could work with. The effect is to interlock the viewer and the pictured subject. To escape this, he must twist and turn either the picture or his viewpoint.

There must be a hundred or more examples from the history of photographic technology almost equally relevant, almost totally neglected. The ambrotype with its thin negative image on transparent glass also comes to mind. But others, far less exotic, may be just as useful. No more need be said of possible technical models, lest others be neglected.

Second, we have models of creative energy, evidenced by huge quantities of work, often embracing lifetimes. Sometimes these will be the product of an individual (Atget, Stieglitz, Strand, and the elder Weston, for example). On other occasions (as with the Brady photographers or the expedition photographers of the nineteenth century in the far western United States), technical resources and subject matter conspire to give a strong impression of unity.

Other models simply betray unabashed subservience to arbitrary preferences. They provide things to do for their own sake—efficient if casual, even thoughtless shortcuts to picture-making—and may be praised for efficiency without saying anything for their originality or intensity of feeling. In any case, work in this third class must be distinguished from that in the second. And if we feel a need to praise the third kind of work, it will probably be for reasons almost totally different from those given for praising the second.

But this cannot be and is not intended to be a comprehensive list of possible models. That would really get us no further.

HOW MODELS FUNCTION

A model will be appropriate for photographers only during that time when it provides them with

genuine problems and an inviting variety of possible solutions. This is not to say that opportunities inviting to a later generation will not be overlooked today if problems and solutions are ahead of their time. Even after it has lost vitality for photographers, a model will be useful to critics whenever they are considering photographs made from that model.

Models that appear meaningless or lifeless to the practicing photographer may still hold abiding interest for the critic. They may even cease to occupy the attention of some important photographers who used them before critics became aware of either the photographers or their work. This may conspire to make some critics appear old-fashioned. Yet, better late than never.

It is essential for the critic to understand the model that is relevant to the work he is considering, realize that it is different, note the differences, and be able to discern applicable special problems and unique solutions. Models make it possible to study bodies of work of photograpers, as a group. Critics use such references, either explicitly or implicitly, when preparing their essays of praise or disapproval. Yet such reference material will also be of interest to the nonphotographer who would develop a sense of appreciation for a particular kind of photography. It has the added value of aiding an interested observer in keeping kinds of photographs separate, in helping discover what a particular kind of photograph should "look like."

Sometimes the collected body of work, assembled from photographs by a number of individuals concerned with similar problems and closely related solutions, may even clarify a frustrated attempt at appreciation. It is not improbable that a model solution may be misunderstood because the problem to which the photographer addresses himself is only dimly sensed by the critic who studies the work in the light of an imperfect or inapplicable photographic solution he already knows. When this happens, perception or understanding is blocked. This must not be taken as a plea for charity for the misunderstood. That is probably the fate of many an artist. It is merely cautionary, an attempt to account for some of yesterday's mistakes. To warn against tomorrow's errors would be presumptuous.

On the other hand, there may be fortunate occasions when model problem and solution coincide, and we come to immediate appreciation of the work. Then we may too eagerly congratulate ourselves for what, in effect, is a concealed or masked tautology. What we take credit for is largely the result of a happy accident. In any case, we need to recognize

more quickly that there are different problems with different solutions; sufficiently different solutions will produce photographs that fail to resemble one another.

All of this may appear to support the contention of those who have said that I have a talent for plainly stating the obvious. I would be more willing to agree with them if their more subtle utterances had met some of our main problems head-on. This may sound harsh on critics, but I do not intend to be. All of us who try to practice criticism or attempt essays of appreciation need to realize that we must keep our model problems and solutions firmly and clearly in mind before proceeding to our main task. I confess with chagrin that I have seldom been able to do this, and I sometimes wonder if many critics realize that they are supposed to know their models. Some of their remarks do not reveal such a realization.

Fortunately for photography, two eminent exceptions have been Beaumont and Nancy Newhall. One always knows who made their models and where the Newhalls stand. Beaumont Newhall, in 1937, sketched characteristics of two models; he contrasted the detail of the daguerreotype with the mass of the calotype, the delicacy of the former with the relative coarseness of the latter.[3] If the daguerreotype's characteristics are taken as one model, we can follow through directly to the twentieth century and the work of Atget, Stieglitz, Strand, and Weston.

This model, eroded substantially by the popular adoption of the miniature camera and its pretense to precision and detail, remains with us and perhaps will gain strength. A critically important offshoot of the model is found in the work of Callahan, Siskind, and, most notably, Sommer. In all three cases, the manner of making the picture remains constant, but the substance of the image moves in three directions. In Callahan's work, the rigor of single-scene, single-event photography is disrupted sometimes by additional exposures, sometimes by dismissal of importance of specific place, and sometimes by other compositional devices. In Siskind's work, the role of scene is substantially reduced and image reality depends only slightly on identification of objects.

In Sommer's work, particularly his classic work of the 1950s, objects are removed from nature's jurisdiction and preempted by the artist. Although he demonstrates virtuosity with the traditional untouched picture of objects, he gains unique force and strength when his picture is based on almost total interference with objects he has collected, as he selects, assembles, and composes them with complete disregard for the natural, the expected, and the

ordinary. Such encounters are in everyone's life, but are barely countenanced outside our dreams. The difficulties his work presents to an observer who seeks to confirm the importance of everyday experience are evidence that here is the beginning of a new model. Even though it has lain fallow for two or more decades, it still holds substantial promise.

One may compare the popular work of Jerry Uelsmann with the less familiar work of Frederick Sommer. Much of Sommer's difficulty for many viewers rests in the clarity with which he forces his vision on us. One may feel a similar uneasiness when observing Uelsmann's pictures without realizing that his use of darks is comforting, like a half-heard ambiguous comment that could be either compliment or criticism. Sommer demands more complete attention and makes us realize we cannot yet take up the entire content of his image.

PRAISING OUR FAVORITES

Generally, in the absence of strong evidence that photographers are paying any attention, the critic had best address his remarks to the general public, which needs all the accurate information that anyone can provide about what photographers are really up to. In this circumstance, he might even deal with work that he feels he can honestly praise. (But, of course, no critic could be persuaded to follow that course—or could he?)

Suppose, however, that a critic should look for something to praise, what might he expect to find? Among the great and respected models generally recognized might he not find some work that performed one or more of the following functions? Photographs of the kind to which I have been referring are able to:

1. Challenge our complacency
2. Activate and exercise our imagination
3. Mold and direct our vision (or sense of sight)
4. Guide and release our emotions (and how this makes us look sometimes!)
5. Release our inhibitions
6. Direct us to our essential set of signs and symbols
7. Chasten our sentimentalities
8. Provide us with some of our life force
9. Restore our spirit

Are not these worth praising? What critic dare assert that the object of his best attention never does one or more of these things to him? Why does he admit it so seldom?

Yet when a great achievement reaches its maturity,

if we allow it to, it may present a serious problem for the younger photographers. It may take attention and support from newer, less orthodox models, it may suffocate its neighbors with the weight of its tradition. Then dare an honest critic continue to bestow unqualified praise?

Photographers and critics, we who love photography, are bound to distribute praise and disapproval as we feel we must. Yet as we do this, we ought to contemplate our betters, the few master photographers from the past and in our midst.

For in the ungainly adolescence of our art, dare we deny these magic men and women, our nearest most treasured heroes and heroines, all the honor, all the praise at our command? Would that really be too much?

NOTES

1. Thomas S. Kuhn, *The Structure of Scientific Revolutions*, Chicago, University of Chicago Press, 1962, pp. *x–xi*.
2. Ibid., pp. 18–19.
3. Beaumont Newhall, *Photography 1839–1937*, New York, Museum of Modern Art, 1937, pp. 40–45.

PHOTOGRAPHY AND THE THEORY OF REALISM IN THE SECOND EMPIRE:
A REEXAMINATION OF A RELATIONSHIP

ROBERT A. SOBIESZEK

PHOTOGRAPHY AND THE THEORY OF REALISM IN THE SECOND EMPIRE: A REEXAMINATION OF A RELATIONSHIP

Robert A. Sobieszek

Associate Curator, International Museum of Photography at George Eastman House

We have sufficient authority in the Dutch school of art, for taking as subjects of representation scenes of daily and familiar occurrence. A painter's eye will often be arrested where ordinary people see nothing remarkable.

—William Henry Fox Talbot
(1844)

During the initial decade of the Second Empire, the pictorial arts in France were witness to two relatively novel phenomena. First, Realism was gaining the center stage of the art world. Between 1849, when Courbet had exhibited his *Après dîner à Ornans,* and the mid fifties, the Realist sensibility dominated most critical thinking and writing. Secondly, after the death of Daguerre in 1851, paper photography suddenly began to supplant the daguerreotype in importance. As opposed to the fascination with reprographic experimentation of the daguerreotype era, photography suddenly experienced, during the 1850s, its first quasi-golden period of artistic activity. Both Realism and photography were heatedly debated at the time, yet no attempt has been made until now to discuss how, if at all, they may have been related.[1] The present essay is an attempt to describe some of the connectives that seem to have been operative between these two art forms.

Subsequent historical research has brought to light an imposing array of both incidental and important facts concerning relationships between painters and photography during the nineteenth century. Some painters—usually the more conservative ones—were dramatically opposed to the new invention. Ingres, along with other official painters, had signed a public statement to the effect that photography could not "in any circumstance" be considered a work of the "intelligence and study of art."[2] We know, on the other hand, that Delacroix, Manet, and Courbet all used at one time or another some photographs as sources for their paintings.[3] Degas[4] and Corot[5] were likewise influenced by the photographic image, as were certain academic and official painters.[6] Yet in all of this literature, little has been proposed that would indicate that photography was any more than a short-cut to personal observation, a substitute sketch of sorts. And because of the artistic stigma attached to the new art, the painters themselves are found to be rather reticent in discussing the use of photography in painting.

The connectives between the two pictorial arts are to be found, instead, in the criticism and art theory of the time. Within the period under consideration (c. 1850–65) pro-Realist criticism as well as some

influential ideas of Positivism exhibit certain marked affinities to contemporary photographic aesthetics. Some paradoxes are also quite obvious in the same collective body of writing. An analysis of these affinities will then lead to a second point of coincidence between the two arts that is perhaps even more important than the aspect of verisimilitude or photographic objectivity. It appears that both photography and Realism placed a large amount of emphasis upon everyday phenomena for their subject matter, and the genre subject was the principal pictorial concern that was common to both of these arts.

The materialistically based social philosophy of Positivism had a strong impact upon French thought of the mid-nineteenth century. By establishing the laws of phenomenal relatedness and continually emphasizing the study of nature and social objects, not according to their origins but after their present behavior, Positivism was able to cause a return to an Aristotelian approach to nature. Weakening—at least in the popular mind—the absolutism of the Platonic, and therefore more romantic, science which had existed in force since the seventeenth century, this philosophy could substitute a belief in the supremacy of scientific particularism.[7] For the Positivists, such as Auguste Comte and Ernest Renan, science and scientific exactitude were the hope for the future.[8] But while the scientistic attitude gained in popularity, the promised moral consequences of the philosophy lagged, leaving the more modern amorality of scientific objectivity. Because of its materialism, Positivism was morally incapable of dictating what was objectively better or worse. The resulting objectivity was important for the art of the period. The artist's approach to nature was no longer bound necessarily to the Classical tradition, nor did the intense introspection of Romanticism retain its previous currency.

The artist was expected by the Positivists to see nature much as the scientist did: with total disinterest and objectivity. Whether or not this was possible—and there is reason to suppose it was not—is less important than the fact that it was postulated. There is a distinct similarity between the popular positivist ideation and the nature of the highly materialistic style of art which has come to be called Realism.[9] From Positivism came a new conscience of reality and a new appreciation of the values of nature, which resulted in an apparent drive towards objectivity. Scientific exactitude and the faithful reproduction of reality are, for Realism, necessary for the work of art.[10] Positivist materialism and scientism require that art be limited to the objectively established

phenomena of nature and to the relationships that have the character of laws resulting from direct observation. The principal Realist critics took hold of this concept and made it the basis of their attitude towards painting. On the other hand, it was photography's seeming dependence on the phenomena of nature that troubled most observers.

After the social revolutions of 1848 and after the popularization of Positivism became established in French thought, a socially objective approach to the world was demanded. Essentially, a new style or a new form of art was likewise necessary—a much more naturalistically based one. Whether the style is currently called realism, naturalism, or objective naturalism is of little concern. Such labels only lead to a furtherance of the confusion that already exists when discussing the degree of imitation in the styles of Courbet, Millet, Méryon, and some of the more official painters such as Gérôme and Meissonnier. "Photographic realism" in the objective rendering of visual phenomena was a major factor in the seventeenth-century Netherlandish painting to a degree which was hardly found in nineteenth-century French art. One could even postulate that any verism in mid-nineteenth-century French painting came directly from the concurrent renewal of interest in the Dutch genre and still-life painters,[11] and that even if photography had not been invented the same fascination with material appearances would have come from this much earlier source. Besides, during the decade immediately preceding the publication of Daguerre's process, for instance, the painter Paul Delaroche had shown that he was completely versed in the techniques of minute rendering with such successful pictures as his *Mort du Duc de Guise*, 1835.

The art of Courbet and the other Realists was realistic in a way differing from its photographic verism—in its approach to the external world, Realism made the everyday subject matter of prime importance. It is on this basis that the paintings and drawings called Realistic are most similar to photography. In addition, by examining the problem of photography's influence on painting, and vice versa, within this framework, the completely fallacious notion that Realism originated as an imitation of the verisimilitude of the photograph can be dismissed.[12]

The traditional hierarchy of suitable subject matter for painting, established in France by Félibien in the preface to his *Conférences* of 1667, began to seriously diminish in importance after the reign of Napoleon. By mid-century a greater emphasis was placed on the far lesser themes in which nature and

natural phenomena began to equal man and the gods in importance. This occurrence was noted by the critic Castagnary when he reviewed the Salon of 1857:

> Religious painting and historical or heroic painting have become gradually enfeebled to the same extent that theocracy and monarchy, to which they refer, have become weakened; their elimination, almost complete today, leads to the absolute domination of genre, landscape, and portraiture which exalt individualism: in art, as in society, man is becoming more and more man. . . .
>
> Nature and man, landscape, portraiture, genre—there is the whole future of art. Is there not more than enough there to surpass and conquer the ancients? . . . The theory which I have just put forward tends to establish the fact that art, by a motion proper to it, is modifying itself at the same moment in its subject and in its object; in its subject in that the traditional spirit is being little by little blotted out before the free inspiration of the individual; in its object by the fact that the interpretation of man and nature are being slowly substituted for divine myths and historical epics.[13]

The more progressive critics held that traditional subject matter was no longer applicable to modern life; the language of Classical antiquity and of the Christian renaissance could no longer be understood by the spectators of the Second Empire. Théophile Thoré called for a new language of art that could be readable by these spectators, and that would take the appreciation of art away from the grasp of an elite few.[14] The subject which could now be understood by the modern public was modern man and his social landscape.

The paintings of the Realist school, and especially the works of Gustave Courbet between 1849 and about 1860, visually exhibited the new subject matter, whose principal characteristic was its worldly materiality.[15] In a manuscript only recently published, Castagnary described Courbet's role in the establishment of a new pictorial subject matter. It deserves to be cited in full:

> Certainly, in 1848, precisely when Pierre Dupont put to verse the miseries of the workers and when George Sand wrote Mare au Diable, there was nothing surprising in a painter, of common birth, republican in attitude and education, taking for the subject of his art the peasants and

the bourgeois amongst whom he had spent his childhood. The humility of the subjects gives nothing to their aesthetic value; the important thing is to treat them with force and gravity. By painting them in an attitude of natural grandeur, by giving them the strength and the character that was reserved until then for gods and heroes, Courbet accomplished an artistic revolution.[16]

However, Courbet was not the first painter to elevate the commonplace to the nobility of the greatest and most profound subjects of traditional art.

There was, in addition, also a widespread distribution of bourgeois and peasant imagery in popular woodcuts and engravings.[17] But Courbet was the first to bring its use to such public notoriety and to create a following of admirers and critics who saw in him the fulfillment of Positivist aesthetics. To some critics like Proudhon it did not really matter if the painter did or did not paint his pictures with the intent of using them as propaganda for a social revolution.[18] They found their own social and political notions contained within the pictures nonetheless.

The aesthetics of Realism and Positivism were directly linked. The central feature of positivistic scientism was the objective and exacting observation of nature in all its particular manifestations. According to the first editorial of the review *Réalisme,* "Art . . . is a real thing, existing, visible and palpable: the scrupulous imitation of nature."[19] Realism claimed as subject matter for the artist anything and everything that belonged to nature, but with the implicit emphasis on material nature. The nonmaterial subject matter of thoughts and fantasies was not considered legitimate for the artist. In a letter printed in *L'Artiste* of 1855–56, Courbet's apologist cited a statement by Proudhon concerning *Les Baigneuses:* "Any figure, ugly or beautiful, can fulfill the aim of art."[20]

There is some similarity between this comment and Victor Hugo's defense of ugliness in art, which appeared in his *Préface de Cromwell* in 1827. But Champfleury and Proudhon are allowing the ugly to be the entire subject matter, whereas the romantic poet includes it in the work of art for the sake of contrasting the beautiful or the sublime.[21] Furthermore, Realism was not apologetic for the ugly; it simply rendered it because it was there. According to Fernand Desnoyers in 1855:

> Realism is the true depiction of objects. . . . The word *realist* has been used only to distinguish the artist who is sincere and clear-sighted from the one who obstinately, in good or bad

faith, looks at things through colored glasses. . . . Ugliness or beauty is a matter for the painter or poet; it is for him to decide and choose; but one thing is sure, poetry, like Realism, can be found only in what exists, in what is to be seen, smelled, heard, and dreamed, provided you don't dream deliberately.[22]

Desnoyers continues by allocating to the artist—either the painter or the writer—the identical right "which mirrors have." This metaphor is important for its implication that he accepted any subject as readily as any other.

The logical extrapolation of this argument is two-fold. First, the artist becomes nothing more than a complicated piece of unthinking machinery, an automaton rendering what lies before him on a one-to-one basis. The parallel here to the mechanistic nature of photography is more than apparent. Secondly, since any subject is as good as any other, what results is a complete neutrality of subject matter, with the traditional hierarchy totally inactive. This may not be as bleak as it sounds. Even Desnoyers would probably not have agreed with this extension in logics; on the other hand, no artist would have been able to affect such a situation. However, an actual result of this tendency towards a greater objectivity was an increased interest by the artists in their natural and social landscapes, and a "certain feeling of delight in natural things . . . which is reminiscent of the fresh pleasure in the world of the early Renaissance."[23]

The Realists, for all their praise of complete objectivity and neutrality before their subjects, did not consider photography a legitimate art. Champfleury wrote in 1857 that "it is necessary to paint real sentiments, the attitudes that each one observes himself; the author is led to attentively study the unrolling of facts, to paint the real objects; this then is the difficulty of modern art."[24] Desnoyers and Champfleury, at this point, are in apparent agreement: the artist is to deal with the measurable and objectified world. The subjects of fantasy are denied validity by both critics. Courbet's defender, however, could not extend his theory to picture-making by photography. He is quite vehement and intractable when he states that "the reproduction of nature by man will never be a *reproduction* nor an *imitation*, it will always be an *interpretation*." Furthermore, "man, not being a machine, can not mechanically render objects."[25] Herein is the greatest contradiction within Champfleury's aesthetic, for even though his ideas may agree more with the actual nature of artistic

vision, they are not in accord with the objective purism of the strict Realists. According to the editors of *Réalisme,* imagination was condemned as being nonobjective. Therefore the position of the artist confronting nature was to be completely impersonal to the point of painting the same picture ten times without faltering and without the later copies differing essentially from the preceding ones.[26]

What is important is the failure of Champfleury and others to realize that because photography depends on the existence of a material reality, it was in no way true that the photographer did not have an equivalent faculty for interpretation as did the painter or author. This failure, however, was characteristic of a whole body of antiphotographic art criticism.

The arguments between the advocates of photography as an art and those who considered it to be an unthinking, mechanical process were second only to the arguments between the ancients and the moderns.[27] Adverse criticism of photography was not the property of the Second Empire. Immediately after the public announcement of the invention of photography in 1839, the German newspaper *Leipziger Anzeiger* reacted with the comment:

To want to fix fugitive reflections is not only an impossibility, as very serious experiments have shown here in Germany, but the desire borders upon sacrilege. God created man in His image and no human machine is able to fix the image of God; it would be necessary for Him to suddenly betray His own eternal principles in order to permit a Frenchman, in Paris, to launch into the world an invention so diabolical.[28]

Not all of the adverse criticism was as spurious as this. And the issues at stake were of more serious aesthetic import for the whole field of art and photography, the resolution of which has yet to be achieved.

In his *Dissertations historiques, artistiques et scientifiques sur la photographie,* published in 1864, Alexandre Ken offers a capsule version of the main argument against photography as a fine art, a view which Ken personally does not agree with:

The artist imagines, conceives and creates, he has for himself the domain of the ideal, as well as that of reality. The photographer has before him only reality. The domain of the ideal is closed to him, the instinct, sentiment, taste, the heart, and the soul of the artist are for nothing in those marvels which he places for sale before us, and which excite the admiration of the

public, in them there is only a mechanical process that gives the produced effects. It is the instrument rendering the model, such as it is; it does not create, compose, nor combine, nor can it ever see beyond reality.[29]

Such then was the general attitude towards this new technique for making pictures. In many respects it is little different from the attitudes of the current artistic community concerning the same question.[30] And just as there now exists a body of apologists or defenders of photography as art, so did there occur a similar defence during photography's early decades. Ken continues his chapter by claiming that nothing can ever pose limits on where art is possible and where it ceases. Art is as varied in its forms and styles as the range of human imagination. All that is necessary, says Ken, is that the work excite our hearts and minds to an admiration which is then able to transcend the material and bring us to an ideal. "Whether that sentiment is born of the beautiful that is created by the imagination of the artist, or whether the beautiful and the true in their material reality awaken it in our souls, does not concern us."[31]

Another critic who defended photography's status as an art form, Louis Figuier, refused to accept the challenge that the camera was the only effective agent in making the picture while the photographer stood by completely helpless. He countered this thesis in 1860 by stating that the camera's lens, like all technical means, was equivalent in importance to the artist's crayon or brush. Photography for him was only a process like drawing or engraving: "what makes the artist is sentiment and not the process."[32] Most likely Figuier's argument was a valid extension from an important earlier article. In 1851, Francis Wey replied to a charge by David's pupil Delécluze that photography was fatally acting upon imitation in the arts. The article, "Du Naturalisme dans l'art; de son principe et de ses consequences . . . ," which appeared in the foremost photographic review of the period, was the first to have presented a neoplatonic theory of art to the photographic public. According to Wey, neither drawing, nor color, nor verisimilitude was considered to be the essential factor in art; "it is the *mens divina*, it is the divine inspiration whose origin is immaterial."[33] Where photography was important was in its potential to free the artists from an enslavement to reproduction.[34] It is actually only a minor addition to have the photographer affected by the same sort of inspiration or sentiment as other artists; this is precisely what Figuier did.

All of the early attempts to ward off the hostility of the critics and to justify photography's place among the other picture-making arts were sincere and some were even inspired. An interesting observation is that when these attempts are fully elaborated, they seem to come much closer to the later Realism of Zola, where art is said to be nature "as seen through the temperament of the artist," than to the strict Realism of Desnoyers and the editors of *Réalisme*. The situation was, briefly, that the hard-core Realists who advocated that art be nothing but a mechanistic rendering of whatever nature presented to the artist refused to allow the most perfect epitome of this method, the photograph, to be considered as an art. Conversely, the photographic critics, bound to a defensive position by the art community, took pains to extend current and quasi-classical art theory to include the art of photography. In this way, some photographic ideas of this period became more liberal and modernistic than the strict Realist theories of the time. There was, however, until 1862, no fully worked out aesthetic of photography.

Such an attempt was made by André Adolphe-Eugène Disdéri when he published his treatise on the techniques and the aesthetics of photography, *L'Art de la photographie*.[35] Disdéri is perhaps best noted for his "invention" of the carte-de-visite, which he patented in 1854.[36] He is almost never mentioned today for his work on aesthetics, yet in it there is not only a fairly complete system for understanding the beauty of the photographic image, but also some rather distinct connectives to the theories and practices of the Realists.

For Disdéri, the aim of photography is not the faithful rendering of nature in a disinterested manner. It does not suffice that the photographer simply know how to use the instrumentation, but that if he is to make a good picture, he must know as much about pictorial qualities as does the painter.[37] Champfleury, in his *Le Réalisme*, had postulated a figurative battle between ten daguerreotypists and ten draftsmen.[38] Each of them set their cameras and their sketch pads before an identical scene in nature. The comparison of the final results proved for Champfleury that photography was not art: all ten of the daguerreotypes were exactly identical while the ten drawings showed the distinctive traits of the personalities behind the pens. The draftsmen apparently had unconsciously changed, or even had seen in different ways, what was before them. The cameras could view nature only in a single fashion. Disdéri, on the other hand, sees no great distinction between painting and photography when it comes to representing nature.

From the point of view of the exact imitation of nature, the two arts present at first the greatest similarity. The photographer is able to express, in effect, like the painter, the natural spectacle with its forms, its accidents of perspective, of lights, and of shadows.[39]

Where the two arts differ is when it comes to color. Unable to render color as the painter does, the photographer is closer to the draftsman. But even here color plays a part, for some colors appear darker than they should on the sensitized plate, and others lighter. Therefore, not only does the photographer have to abstract all colors from the scene in front of him, but unlike the draftsman, he must at the same time take account of them in order to know just how the scene will appear in photographic black and white.[40]

The painter and the photographer are alike for Disdéri in that they both are guided by the same laws of beauty and unity and by the same rules which govern all works of art. But painting and photography differ greatly in their manner of composition, and it is this difference that is the most important factor distinguishing them. The painter, Disdéri says, is not limited in his choice of objects which he wishes to portray or represent. On the contrary, he takes individual items from wherever he finds them, makes notes about them, and sketches the best examples of each. He then recombines them into a finished arrangement, almost like organizing particular harmonies into a complete concert. Having no real need for precomposed reality, the painter expresses his ideas by the "creation of possible and likely scenes." Since exact imitation is actually beyond him, he has to be content with indicating the idea of the object by rather imperfect copies. The objects in a painting are "signs which recall the complete representations that they represent."[41]

The photographer, continues Disdéri, is placed in a much more rigorous and a much different circumstance. He is bound directly to reality, he cannot escape from it. Photographic pictorialization is "condemned to exact imitation" by the implacable and rigid faithfulness of the instrumentation. But there is an art to photography, a purely personal and nontechnical art which is the domain of the photographer:

> . . . all of his art consists in choosing the scenes which reality offers him, to be able to bring to these spectacles the modifications which his craft allows him and which the sovereign laws of beauty dictate.[42]

Like Figuier two years previous, Disdéri is actively dissociating the so-called art of photography from the mechanistic process and placing the art within the human artist, the photographer.

If the photographer can only choose what nature gives him to choose from, then the real art of photography is in the choice. This choice is not simple nor is it innate in man. Only by the careful and patient study of nature, of all its manifestations, its forms, its lights and darks, its seasonal changes, can the painter or the photographer achieve a point at which the one can arrange and the other choose. The photographer with such a background will choose the most suitable vantage point with regard to perspective and the two-dimensional composition of elements. He will choose the proper lighting of the scene and, if he desires, the figures he wants in the scene. "It is here especially that choice constitutes a true creation, if it is made directly and immediately when nature has attained the maximum of the expression for which the photographer has searched."[43] Even the extremely conservative art critic, Philippe Burty, reporting on the Exposition de la Société Française de Photographie in 1859, had to admit that some photographers were distinctly recognizable by the degree of intelligence exhibited in their prints. He concluded by saying that "if photography is not a complete art, the photographer has always the right to be an artist."[44]

Champfleury had stated that "the most advanced partisans of Reality in art have always maintained that there was a choice to be made in nature."[45] He had also asked if the daguerreotype machine takes the pains that the novelist takes when he "chooses a certain number of thrilling facts, groups them, distributes them and enframes them." His answer was implicitly negative. Disdéri's answer to a similar question would have been an emphatic affirmative. Disdéri had made a system aesthetic from essentially Clement de Ris' dictum of 1853: "Whoever says art, says choice; whoever says choice says comparison, and supposes the idea of taste."[46]

If the photographer is bound to reality, he can nevertheless arrange the elements of the scene which he is going to represent within certain limits. Disdéri's description of the ideal photographic studio and what can be effected within it is indicative of the limits he saw photography potentially capable of:

> In an immense studio perfectly arranged, the photographer, master of all the effects of light by the blinds and the reflectors, furnished with backgrounds of all sorts, of decors, accessories,

of costumes, could he not, with intelligent and well trained models, compose tableaux of genre or of historical scenes? . . . Could he not represent interiors like those of Van Ostade, Pietre de Hoogh, Chardin, or Granet; to attempt all genre compositions in the dimensions and in the taste of Terborch or Teniers, or fantasy like Watteau and Diaz? Could he not attempt the sentimental like Scheffer, style like Mr. Ingres? Could he not treat history like Paul Delaroche in his painting of the *Mort de Duc de Guise?* What stops him from undertaking vast compositions like Veronese?[47]

By the examples he uses as well as by his general attitude towards the portrait, Disdéri shows that his taste in art closely parallels the official tastes of Louis Phillipe.[48] More interesting yet, his choice of examples directly follows the probable sources, mentioned previously, for the Second Empire's taste for highly veristic imagery in painting: seventeenth-century Dutch genre and such *juste milieu* painters as Delaroche and Scheffer.

When Disdéri abstractly discusses the question of the photographer's choice in nature, he upholds an implicit and rigorous naturalism. All nature is before the photographer, and there are no restrictions on what he should choose except what the dictates of unity and beauty set up. In qualifying the objectivity of the photographer in this fashion, he is, obviously, not as strict a Realist as was Desnoyers or Proudhon. And except for the principal emphasis he places on the portrait, which he undoubtedly considered as the highest form of the photographic art and from which he made his incredible fortune, his aesthetics are almost purely naturalistic. The photographer, according to Disdéri, is to go directly to nature as it is and accept what is there. He must then take hold of what is presented and photograph it before the initial emotion and feeling dissipate. By following this directive, the photographer would have been approvingly regarded by those Positivists who called for a study of nature in its present behavior. Disdéri is hardly a complete scientist; he recognizes the personal aspect of photography and allows the picture maker his choice. "To choose nature in its most favorable moments, by augmenting its beauty by more or less profound modifications, to seize it, to fix it, there is the entire art of the photographer."[49]

In his attitude towards genre scenes, Disdéri exhibits what is perhaps the closest concrete parallel to the paintings of the Realists. The simplest and the most photographically suitable scenes are best for the photographer to choose; those which can be easily studied and reproduced in their best aspect are highly recommended. There are four such subjects which are especially suitable for genre photography: peasant culture, various métiers or occupations, military life, and intimate home scenes.[50] The photographer must recognize and be able to portray the true signification and character of each scene. He has to attempt all proper combinations in order to embellish and augment this character. The countless possible variations will force the photographer to determine the fundamental aspect of the scene as well as the accidental effects. He must then be able to keep what is most important and diminish what is merely accessory. This preliminary procedure accomplished, the scene can be portrayed in its most characteristic and beautiful presentation. In turn, the natural truth and the expression of life within the scene will be least deranged.[51]

The photographic portrayal of such genre subjects had been a recurring predilection for French photographers since the beginnings of the medium. Even the lengthy exposure times necessitated by the daguerreotype process did not dissuade picture makers from informally occasioned scenes of city life (Fig. 97). And Hippolyte Bayard's calotype work is principally a collection of intimate, domestic situations. It was during the 1850s, however, that genre photography attained anything close to respectable popularity. Photographers such as Louis-Désiré Blanquart-Evrard (Fig. 98), Victor Regnault, Gustave Le Gray, Moulin, Charles Nègre, and Humbert de Molard each fashioned exquisite genre pictures as sensitive in their story-telling capacities as any painting by Deschamps or Millet. Casual and usually posed *in situ*, the best of these photographs reflect an aesthetic prosaicness that best defines naturalism in pictorial art. Later, during the 1860s, a greater amount of dependence upon studio setups and artificialized situations takes place, examples of which, while just as potentially charming, are entirely different in feeling. Some of the most flagrant instances of studio genre are the sets of stereographs narrating a serialized, often humorous, story. More prestigious and larger scale works were likewise common; the album *Pérégrinations d'un objectif* of 1862 by M de C. is a notable example (Figs. 99 and 100).[52] Highly literary and particularly droll at times, the pictures range in subject to cover all of Disdéri's recommendations except military life.

Disdéri's list of the four most suitable scenes for genre photography is an almost complete breakdown of the important subject matter chosen by the

Realists. The list might even be paralleled with the names of painters who were prone to one or two of these subjects. Millet and Courbet were chiefly interested in peasant culture, Daumier and Méryon with métiers and city scenes. Meissonnier and Detaille specialized almost solely in military genre, while Courbet again would be involved with home scenes. None of these subjects are found in earlier Romantic paintings with anything near the same degree as they were after 1848;[53] when they are portrayed by the Romantics, these subjects seldom exhibit the straightforward and almost prosaic qualities which they do with the Realists. And with the very important exception of the landscape, they were the principal subjects in French Realist painting until the end of the century, most notably in the works of Manet and Degas.

It may not be too inappropriate to cite at this point some contemporary critical acclaims of certain genre photographers by way of example. Almost directly concurrent with the revolutionary Realism of Courbet, the photographer-painter Charles Nègre was occupied with the very subjects that Disdéri suggested were the best for photography. After being trained in the studio of Paul Delaroche, Nègre learned the calotype process from Gustave Le Gray, also an academically trained painter who will be remembered more for his photographs than for his paintings. As André Jammes points out in his monograph on Nègre, the calotype was as important a revolution as was the daguerreotype process. While it lost the aspect of the miraculous object and the smallest detailings that were characteristic of the daguerreotype, it gained in its luminosity and in its greater reproducibility.[54] The prints by these early calotypists, especially those which have not faded, are still surprising in the degree of soft and atmospheric light which has been captured in them.

Nègre always considered himself primarily a painter, and took photographs only as sketches for his paintings. But there is a life, a human warmth, and a sensitivity in his photographs which is missing in his paintings. And the critics at the time were not blind to the qualities of his photographs. Writing in *La Lumière* in 1851 about Nègre's *Petit Chiffonnier*, (Fig. 101), Francis Wey says:

Mr. Charles Nègre has proposed to render a subject without being preoccupied with line, and by the sole effect of planes, slightly alike to the procedure of the colorists, Mr. Nègre has given a remarkable proof of the suppleness, of the diversity of the resources of photography.

His *Petit Chiffonnier* is at once solid and vaporous like a drawing by Mr. Bonvin; it is the most skilled and the most fugitive rough sketch. . . . A portion of a wall, a disappearing distance, two blocks of stone, on one of which the hero of the subject is sitting next to his basket; there is the entire staging; it is not in the least complicated. The head, topped by a sorry cap, is careless, disdainful and mocking; the shirt of this Diogenian urchin is mellowly padded with a ray of sunlight; the generously indicated pants are mottled, torn, slashed, patched-up, in a way that would make Murillo and the author of the *Casseurs de pierres* jealous. The *Chiffonnier* of Mr. Nègre is no longer a photograph; it is a thoughtful and willful composition, executed with all the qualities foreign to the daguerreotype and claiming only these. Nothing more unforeseen, nothing more interesting than these prints where the heliographic mechanism has disappeared, where nature, not content by being painted in its material reality, seems to interpret itself, to have recourse to the coquetteries of art and to choose the beautiful sides that it is suitable for it to show.[55]

The similarity to Courbet and to Realist subject matter was not particular to this picture. Throughout his work as a photographer, Nègre chose those subjects which, while being slightly romanticized, were almost exactly synonymous with the subjects of Daumier and Courbet. And those critics who were disappointed in the apparent failure of Realism to depict the humanity and the social phenomena of the city could have looked to the pictures of everyday life in Paris by Nègre and seen that this lacuna was being filled.

One could even find, like Proudhon, implicit social commentary in Nègre's work. Ernest Lacan, in 1853, found in the photographer's *Joueur d'Orgue* (Fig. 102) a visual statement about modern civilization's abandonment of the aged:

The part played by the lights and the shadows on the wall against which the bonhomme leans, and the somber vault which sinks behind him, recall the most vigorous drawings by Decamps; whereas the finely reproduced traits of the intelligent, pensive and sad face of the old man, and the minute details of his clothing of yellowed, worn and sordid corduroy, refer to the most carefully studied subjects of Meissonnier. Two children, a little girl and a little boy are listening, mouths gaping, arms hanging, to the

sounds, unexplainable to them, of the popular instrument. There is a strange contrast between the attentive pose, the amazed expression of these children who have seen little and to whom everything is astonishing, and the expression of lassitude and discouragement of the old travelling musician who has seen so many things, he for whom all science has been able only to reduce to begging. It is not us who say all that, it is Mr. Nègre's print. It is not only a cold reproduction of three figures posed by chance: it is a reasoned picture, with its intentions and its teachings.[56]

The approach to pictorial criticism and the language used in describing the picture are incredibly alike to the typical painting criticism of the period.

According to Lacan, Nègre "had invented the photography of genre,"[57] especially with such pictures as his *Chiffonnier* and *Ramoneurs* (Fig. 103), but it was Moulin, in the same critic's opinion, who was "the photographer of genre." This photographer, Lacan writes, was not content with making portraits, views, or even academies which could have been sold to painters as sketches. Instead, he followed the example of Nègre and composed "subjects . . . uniting interest with a beauty of execution."[58]

The flavor of the critical language which Lacan uses when describing some of Moulin's pictures is again exemplary of photographic criticism of the period. Concerning Moulin's *Fileuse,* Lacan writes:

This scene is not only a delicious composition, it is also an admirably well executed print. The group is very skillfully posed in its simplicity. The two heads have a touching and truthful expression; the mother's is totally in the sentiment of Gerard Dou. The features of the child, which have a rare beauty, have been rendered also with an unbelievable felicity.[59]

Lacan ends his column by expressing an assurance that if Moulin continued making such genre pictures, he would become a decided name among artists. More importantly, he would be able to "powerfully compete in disproving the still held opposition to photography, which maintained that it was only a mechanical operation and that its results had nothing to do with imagination and artistic sentiment."

In conclusion, we have seen that there were, during the 1850s and early 1860s, certain parallels between the aesthetic theories of Realism, which in turn were based in part on Positivism, and some critical positions dealing with the nature of photogra-

phy. The paradox evolved that Realists were incapable of taking their stand of complete and utter neutrality before nature as far as accepting photography as a fine art. The photographic critics were unwilling to have the new art relegated to a subordinate role as a purely mechanistic technique. Both were sure that the human mind and feelings were distinctly necessary for any art; even the strict Realist Fernand Desnoyers had bowed slightly to this position. The only exception has been found in the first editorial of *Réalisme,* where the stubborn assertion of Realism's pure objectivity was expressed, but where no mention of photography is made. The result of each viewpoint, however, was similar at least in one respect: nature was to be the only real *primum mobile* for both the painter and the photographer.

Secondly, it was not necessarily photography's ability to portray material reality with ultimate exactitude which affected the art of the period. Rather, its necessary dependence on the subject matter of material reality brought it closest to the major tendency in French painting of the time: Realism. Both of these pictorial arts made pictures out of the everyday, the mundane, the ignoble, and the unheroic; one by a willful but necessary choice, the other by a choice within a definite necessity. Courbet said that a painter "should paint only what his eyes could see."[60] By this he meant that painting is not to be concerned with the entire realm of ideas, fantasy, and imagination; there was beauty enough in nature as it presented itself to the artist.[61] Castagnary made this very point when he stated:

. . . the beautiful is in nature and is found in the most diverse forms in reality. As soon as it is discovered there, it belongs to art, or rather to the artist who knows how to see it. As soon as the beautiful is made real and visible, it has its artistic expression in itself. But the artist has no right to amplify this expression. He can touch it only at the risk of changing its nature and consequently of weakening it. The beautiful given by nature is superior to all the conventions of the artist.[62]

It was this same nature to which Disdéri advised the photographer to go for his subject matter. And it was the same nature, the nature of France in the middle of the nineteenth century, its landscapes, its towns, and its peoples to which Thomas Couture, the teacher of Puvis de Chavannes and Manet, told his students to go in 1867:

I know why you paint Turks, tigers, serpents, all that we are not familiar with; it is because you

154

fear comparison with the original. Give to the public what it knows and loves, and . . . let the Turks alone. . . . Believe me, the locomotive has not yet been painted. . . . Our workmen have not yet been represented; they remain yet to be put on canvas.[63]

In short, it was the unmitigated acceptance of natural and social phenomena which is found in both the theories and practice of the Realists as well as in the aesthetics and the pictures of photography. Both Realism and photography jointly contributed to a corpus of visual material with the same or similar subject matter, an almost identical fascination in the material appearance of reality, and a distinct contemporaneity of the pictorial image. It was this corpus of material which became part of the tradition out of which the more dramatic tendencies of modern art were to grow.

NOTES

This paper originated in a seminar with Gerald Ackerman at Stanford University in 1968. It became one of the two short essays submitted in partial fulfillment of the degree of Master of Arts at that University. The present version has been greatly aided by the generous suggestions of Beaumont Newhall and André Jammes.

1. Exception has to be made of Gisèle Freund's *La photographie en France au dix-neuvième siècle*, Paris, 1936. But probably, since it was a pioneering work, much of the material had been treated somewhat summarily. The author's approach, in addition, is much too simplistic in its Marxist orientation. Cf. also Aaron Scharf's *Art and Photography*, London, 1968, pp. 95–107, and passim; and Robert A. Sobieszek, "Historical Commentary," *French Primitive Photography*, Philadelphia, 1969, unp.

2. Some of the other signers of this protestation were Hippolyte Flandrin, Robert Fleury, Troyon, Puvis de Chavannes, among others. The protestation is cited at length in Freund, *La photographie en France*, p. 130.

3. On Delacroix and photography, cf. F. A. Trapp, "The Art of Delacroix and the Camera's Eye," *Apollo*, vol. 83, no. 50, 1966, pp. 278–88. Also cf. Aaron Scharf and André Jammes, "Le Réalisme de la photographie et la réaction des peintres," *L'Art de France*, vol. 4, 1964, pp. 181 ff.; and Beaumont Newhall, "Delacroix and Photography," *Magazine of Art*, vol. 45, November 1952, pp. 300–303. Scharf's *Art and Photography*, pp. 89–94, has one of the best chapters on this relationship yet. For Manet and Courbet and their use of photography, see Scharf and Jammes, "Réalisme de la photographie," p. 181 and passim.

4. On Degas, see Scharf and Jammes, "Réalisme de la photographie," p. 187 and passim. A more detailed discussion of Degas' interest in photography and its kinetic characteristics can be found in Aaron Scharf, "Painting, Photography, and the Image of Movement," *Burlington Magazine*, vol. 104, no. 710, May 1962, pp. 190–92.

5. Corot's debt to photography is discussed in Aaron Scharf, "Camille Corot and Landscape Photography," *Gazette des Beaux-Arts*, vol. 59, 1962, pp. 99–102.

6. Paired photographs and paintings by both Victor Hugo and Charles Nègre are illustrated in Scharf and Jammes, "Réalisme de la photographie," passim. Important monographs on both of these artists are: Paul Gruyer, *Victor Hugo photographe*, Paris, 1905; and André Jammes, *Charles Nègre photographe*, Paris, 1963. For a discussion of the interest taken in photography by Meissonnier, Gérôme, and Detaille, see Scharf, "Painting, Photography, and the Image of Movement," pp. 186–89.

7. Cf. John Tull Baker, "The Precursors of Naturalism," *Courbet and the Naturalist Movement*, ed. George Boas (Baltimore, 1938), New York, 1967, pp. 37ff. Also cf. Joseph C. Sloane, *French Painting Between the Past and the Present: Artists, Critics, and Traditions from 1848–1870*, Princeton, 1951, p. 56.

8. Auguste Comte, *Cours de la Philosophie positive*, Paris, 1830, p. 62. Comte wrote regarding the necessity of scientism: "One must conceive the study of nature as destined to furnish the veritable, rational base for man's action on nature, since the knowledge of the laws of phenomena, of which the constant resultant is to enable us to predict, can alone conduct us in the active life." Ernest Renan, in hia *L'Avenir de la science, pensée de 1848*, Paris, 1890, p. 37, was far more extreme than Comte when he wrote that the goal of science was man's progress towards a modern utopia: "To scientifically organize Humanity, such is therefore the final word of modern science, such is its audacious, but legitimate pretention." Cf. also Freund, *La photographie en France*, p. 102.

9. Cf. Sloane, *French Painting Between the Past and the Present*, p. 57.

10. In a letter to Mlle Leroyer de Chantepie dated March 18, 1857, Gustave Flaubert wrote that "the artist ought to be in his work like God in creation, invisible and omnipotent. He should be felt everywhere but not seen. Art ought, moreover, to rise above personal feelings and nervous susceptibilities! It is time to give it the precision of the physical sciences, by means of a pitiless method!" Gustave Flaubert, *Extraits de la Correspondance ou Préface à la Vie d'Écrivain*, ed. G. Bollème, Paris, 1963, no. 524, p. 188. Translated in George J. Becker, *Documents of Modern Literary Realism*, Princeton, 1963, pp. 94–95. Four years prior to this letter, Flaubert had written to Louise Colet (14 August 1853): "I detest photographs. . . . I will never find them true." Cited in Madeleine Cottin, "Une image méconnue: la Photographie de Flaubert prise en 1850 au Caire par son ami Maxime du Camp," *Gazette des Beaux-Arts*, vol. 66, 1965, p. 236.

11. We might cite in this respect the pioneering work of Théophile Thoré (William Bürger). This critic-turned-art-historian, besides compiling a two-volume study of Dutch paintings in the museums of Holland (*Les Musées de Hollande*, Paris, 1858), is significant in bringing about a renewed interest in both Frans Hals and Vermeer.

12. One of the earliest claims to photography's blame in forcing painting to be more objectively veristic is found described in an article by Francis Wey, "Du Naturalisme dans l'art; de son principe, et de ses consequences; à propos d'un article de M. Delecluze," *La Lumière*, no. 8, 30 March

1851, p. 31; no. 9, 6 April 1851, p. 34. According to Wey, there is a decided "violent return to nature" in painting. "What is, in the eyes of the Academy's painters and critics, the most important, the true and the greatest culprit? what is this revolutionary, this unrelenting leveler of modern art? IT IS HELIOGRAPHY." Wey is here paraphrasing such critics as Delécluze whose letter he is answering. Wey himself felt that photography was a gift to painting; by accomplishing its natural ability to veristically record reality, the camera art would show up the mediocre and hack painters for what they were. Painting could then concern itself with its more important task: "Photography will constrain the artist to rise above the mechanical copying of objects, it will leave behind that which goes no higher, it will annihilate what has only a semblance of the ideal or what is limited to the narrow limits of geometry, perspective and mathematical clarity. . . . and it will furnish [artists] with arguments without end to justify the boldest fantasies of the imagination."

13. Jules Antoine Castagnary, "Le Salon de 1857," *Salons 1857–1870*, Paris, 1892, vol. 1, pp. 7–11. Cited and translated in Sloane, *French Painting Between the Past and the Present*, pp. 63–64.

14. In the preface to his *Salons de T. Thoré, 1844, 1845, 1846, 1847, 1848*, Paris, 1868, p. xxxix, Thoré points out the inadequacy of classic and Christian iconographies, calling them a "double symbol." He held that it was necessary to "break the old prison of the double symbol, to emerge from the Babel of confused tongues, and create, by virtue of common thought, a common language as well." Cf. Sloane, *French Painting Between the Past and the Present*, pp. 64ff.

15. Edmond About writes in his *Nos artistes au Salon de 1857*, Paris, 1858, p. 25, that Courbet seems to be continually shouting from the rooftops: "There is nothing down here but matter, and matter has only one property, that of being hard enough to break a hammer. Everything that ripples, everything that shimmers, everything that shines through elegance, grace and suppleness belongs to the land of dreams. When you want to know whether an object is real, take a flint and strike it!" Cited and translated by Ruth Cherniss, "The Anti-Naturalists," *Courbet and the Naturalist Movement*, p. 79.

16. Gustave Courbet, *Courbet, raconté par lui-même et par ses amis; sa vie et ses oeuvres*, ed. Pierre Courthion, Geneva, 1948, vol. 1, p. 101.

17. See the discussion of these popular prints with emphasis on Courbet's reaction to them: Meyer Schapiro, "Courbet and Popular Imagery: an Essay on Realism and Naïveté," *Journal of the Warburg and Courtauld Institutes*, vol. 4, 1941, pp. 164–91. The prodigious amount of popular, everyday subject matter found in the illustrations and caricatures of the daily press must also be kept in mind. The relationships between the works by Guys, Garvani, Daumier, Devéria, etc., and those by the Realists are often remarkably direct. An entirely unknown aspect is, however, the influence that these illustrations had on the photography of the time, and vice versa. One essay has been attempted so far, although very specific in its intent: Anne d'Eugny and René Coursaget, *Au temps de Baudelaire, Guys et Nadar*, Paris, 1945.

18. Cf. Pierre-Joseph Proudhon's discussion of Courbet's *Les Casseurs de pierre*, for example: *Du principe de l'art et de sa destination sociale, Oeuvres complète de P.-J. Proudhon*, ed. Bougle et Moysset, Paris, 1939, pp. 194ff.

19. The review *Réalisme* was established in July of 1856 and was edited by Jules Assezat, Edmond Duranty, and R. Thulié. The statement is cited by Freund, *La photographie en France*, pp. 105–6, and n. 3.

20. Champfleury (Jules Husson), *Le Réalisme*, Paris, 1857, p. 278. Originally it appeared in 1855 as "Du Réalisme; Lettre à Madame Sand," *L'Artiste*, vol. 16, 1855–56, pp. 1ff.

21. Cf. Cherniss, "The Anti-Naturalists," p. 89.

22. Fernand Desnoyers, "On Realism," *Documents of Modern Literary Realism*, pp. 80–82. The article appeared originally as "Du Réalisme," *L'Artiste*, vol. 16, 1855, pp. 197–200. That Desnoyers would not have agreed with my extrapolation below is signaled by his inclusion of dreamed subject matter in a list of what the artist might legitimately portray. But, remembering his strict Realist stand, he adds: "provided you don't dream deliberately."

23. Sloane, *French Painting Between the Past and the Present*, p. 64, n. 46.

24. Champfleury, *Le Réalisme*, p. 86.

25. Ibid., pp. 92–93. Desnoyers, in his "On Realism," p. 81, is less extreme than Champfleury and perhaps closer to the truth when he states that photography is not true simply because it is colorless.

26. Cf. Freund, *La photographie en France*, p. 106, where she describes the editors of the review *Réalisme* as maintaining that the artist should be "impersonal to the point of being capable of painting the same picture ten times in a row without hesitating and without the later copies differing essentially from the preceding ones." Cf. p. 150 for a description of Champfleury's allegorical contest between the daguerreotypists and draftsmen where this perfect replication of the pictures by the daguerreotypists is seen to be the proof that photography is not art.

27. Writing about the photographic section in the Salon of 1859, Louis Figuier claimed that, "if we had not had in our century the quarrel between the ancients and the moderns, we would have had the quarrel between the engravers and the photographists [sic]." *La Photographie au Salon de 1859*, Paris, 1860, p. 1. The general popularity of the term "the quarrel of the Ancients and the Moderns" during the Second Empire can be traced to the publication of Hippolyte Rigault's *Histoire de la querelle des ancients et des modernes*, Paris, 1856.

28. Cited in Freund, *La photographie en France*, pp. 101ff. Parallel cases of pointing out the moral dangers concerned with an extended and unmitigated natural scientism are to be found in Goethe's *Faust* and his *Wilhelm Meister*.

29. Alexandre Ken, *Dissertations historiques, artistiques et scientifiques sur la photographie*, Paris, 1864, p. 233.

30. Cf. Libor-Sir, "Une Photographie artistique, est-elle une oeuvre d'art?" *Terre d'Images*, no. 25, May 1966, p. 10, and the reactions in nos. 31, 32, and 33 of the same year.

31. Ken, *Dissertations historiques*, pp. 233–34. That the French Academy refused at first to even consider photography as an art to be exhibited at the Salon along with painting should not be viewed as a specific attack on the new medium. Rather rigid, but unspoken, boundaries were upheld between the various art *forms*, in addition to the demarcations imposed upon the different subject matters.

The so-called "minor arts" were not thought of as art at all, with the result that pictures by the political and social caricaturists, and graphic illustrations in general, were officially beyond the responsibility of the Academy, and therefore not included in the annual exhibition. It is somewhat astonishing in this light that photography was presented at the Salon, albeit physically separated from the paintings, as early as 1859.

32. Figuier, *La Photographie au Salon de 1859*, p. 4.

33. Wey, "Du Naturalisme dans l'art," p. 35.

34. See above, n. 12.

35. Disdéri, *L'Art de la photographie*, Paris, 1862.

36. The technique for producing cartes-de-visite was a process by which up to eight or ten individual pictures could be taken by a single, or at the most two, exposures. The economic benefits accrued by the portrait industry of the time were phenomenal, and it is a matter of record that Disdéri made a very large fortune from this technique. Less known is that he also patented in April of 1863 the type of picture which he called a "mosaique"; this was one of the first photomontages ever made that did not attempt to replicate a naturalistic scene. The claim of actual priority for this sort of photographic montage must go to the Scotsman G. W. Wilson for his *Aberdeen Portrait No. 1* of 1857, a copy of which is in the George Eastman House collection. For further information on the economic and social consequences of the carte-de-visite, as well as a brief summary of Disdéri's life, see Freund, *La photographie en France*, pp. 77–83. More topical comments are in Nadar's *Quand j'étais photographe*, Paris, n.d. [1900], pp. 208–13.

37. Disdéri, *L'Art de la photographie*, p. 247.

38. Champfleury, *Le Réalisme*, pp. 92–93. Note that Champfleury still uses the by-then-displaced process of the daguerreotype as his example. There was a marked difference between the daguerreotype and photography (heliography), which was repeatedly noted at the time. Cf., for example, Francis Wey, "De l'influence de l'héliographie sur les beaux-arts," *La Lumière*, no. 1, 9 February 1851, pp. 2–3: "Photography is, in whatever form, a coalition between the process of the daguerreotype and art proper. . . . it proceeds by masses, scorning detail like a skilled master, justifying the theory of sacrifices, and sometimes giving the advantage to form, and at other times to contrasts of tones. This intelligent fantasy is a lot less free in the daguerreotypes on plates of metal."

39. Disdéri, *L'Art de la photographie*, p. 254.

40. Ibid.

41. Ibid., pp. 259–60.

42. Ibid., pp. 260–61.

43. Ibid., p. 258. Cf. also H. de la Blanchère, *L'Art de la photographie*, 2d ed., Paris, 1860, p. 71: "To imitate is not all, to copy is nothing, I repeat that the essential is to choose and to choose well."

44. Philippe Burty, "Exposition de la Société Française de Photographie," *Gazette des Beaux-Arts*, vol. 2, 1859, p. 216.

45. Champfleury, *Le Réalisme*, pp. 96–97.

46. Cited with no further reference in Cherniss, "The Anti-Naturalists," p. 87.

47. Disdéri, *L'Art de la photographie*, pp. 297–98.

48. For a discussion of what these tastes constituted, see Léon Rosenthal, *Du Romantisme au Réalisme*, Paris, 1914, pp. 203–31.

49. Disdéri, *L'Art de la photographie*, p. 305.

50. Ibid., pp. 305ff.

51. Ibid. We should mention that although primarily a portraitist, Disdéri did make some genre photographs which were favorably received at the time. See, for example, Ernest Lacan, "Revue photographique," *La Lumière*, no. 24, 17 June 1854, p. 95, where the critic states: "Mr. Disdéri knows perfectly how to group his models, and to give them *truthful* attitudes; his figures are always in their role, his *action* is never incomplete." Lacan continues by describing an instantaneous city scene: "We have before us . . . two views . . . which prove with what rapidity [Disdéri] can operate. They represent the blvd. Montmartre, near No. 8, blvd. des Italiens. The view extends as far as the eye can see. The carriages which make up the crowd on the sidewalks, everything has been reproduced in the space of a fraction of a second. It is a surprising effect eliciting vertigo." A print of one of these scenes was formerly in the collection of V. Barthélemy, and was exhibited in *Photography 1839–1937*, New York, Museum of Modern Art, 1937, no. 183. Present location unknown (Fig. 104). What appears to have been yet another genre scene by Disdéri, belonging to the Cabinet des Estampes, Bibliothèque Nationale, was shown under the title *Groupe marchant* in *Un siècle de vision nouvelle*, Paris, Bibliothèque Nationale, 1955, no. 144.

52. A copy of this album is in the collections of the George Eastman House. In a letter to the author, André Jammes informs us that the photographer's initials might stand for a M. de Charly from Renaison (Loire), correspondence, 18 May 1969.

53. When genre subjects were painted prior to the Realists, they were usually met with rather cool if not hostile criticism even though the subjects were popular. In D. Nissard's "Salon de 1833," *Le National*, 25 April 1833, we read the phrase "genre, which is the popular painting of our time that everybody talks about, and that everybody goes to see." Ch. Woinez, in his *Promenades au Musée, revue critique du Salon de 1841*, Paris, 1841, p. 24, is much more hostile: "As soon as an art student or any one knows how to grind some colors, watch out, brush and palette in hand, daguerreotyping [*sic*] in whatever way, all the vulgar accidents of life." Both of these statements are cited in Pontus Grate, *Deux critiques d'art de l'époque Romantique: Gustave Planche et Théophile Thoré*, Stockholm (*Figura*), 1959, p. 167.

54. Jammes, *Charles Nègre photographe*, p. 11.

55. Francis Wey, "Album de la Société Héliographique, Première article," *La Lumière*, no. 15, 18 May 1851, p. 58.

56. Ernest Lacan, "Revue photographique," *La Lumière*, no. 37, 10 September 1853, p. 147.

57. Ibid.

58. Ernest Lacan, "La photographie de genre: Épreuves de M. Moulin," *La Lumière*, no. 34, 20 August 1853, p. 135.

59. Ibid. A superb example of Moulin's genre photography is illustrated in the Arts Council of Great Britain's catalogue to the exhibition *"From today painting is dead": The Beginnings of Photography* (Victoria & Albert Museum), London, 1972, plate 18. In this publication the photographer's name is spelled Moulins; nowhere in the French literature of the period does there occur a final *s* in the name.

60. Cited by Théodore Duret, *Courbet*, Paris, 1918, p. 126.

61. Cf. George Boas, "Courbet and his Critics," *Courbet and the Naturalist Movement,* p. 50.

62. Cited ibid., pp. 50–51.

63. Cited and translated by Eleanor Patterson, "The Academic Point of View in the Second Empire," *Courbet and the Naturalist Movement,* p. 70.

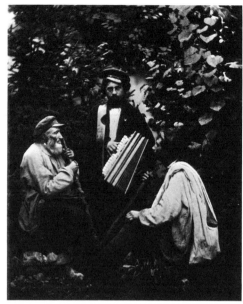

99.

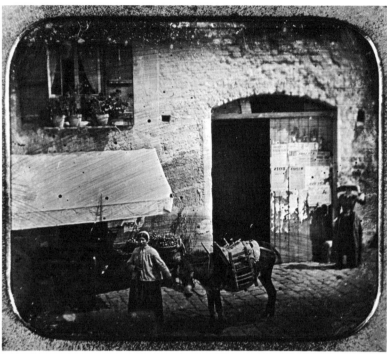

97.

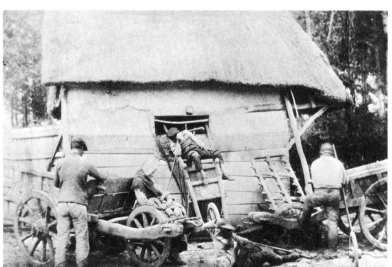

98.

97. Photographer unknown. French. Daguerreotype. n.d. International Museum of Photography at George Eastman House, Rochester, N.Y.

98. Louis Désiré Blanquart-Evrard. Untitled. Reproduced from *Études photographiques.* Plate 204. n.d. (c 1852). International Museum of Photography at George Eastman House, Rochester, N.Y.

99. M de C. *Au coin du Bois . . . ils sublient la faim.* 1862. International Museum of Photography at George Eastman House, Rochester, N.Y.

100. M de C. *En Nivernais . . . échantillons de commères.* 1862. International Museum of Photography at George Eastman House, Rochester, N.Y.

101. Charles Nègre. *Petit Chiffonnier.* n.d. (1851). Calotype positive. Collection André Jammes, Paris.

102. Charles Nègre. *Joueur d'Orgue.* n.d. (1852). Calotype positive. Collection André Jammes, Paris.

103. Charles Nègre. *Ramoneurs.* n.d. (1852). Calotype positive. Collection André Jammes, Paris.

104. Adolphe-Eugène Disdéri. *Boulevard Montmartre.* n.d. (1854). Photograph Beaumont Newhall and the Museum of Modern Art, New York. Present whereabouts of the original unknown.

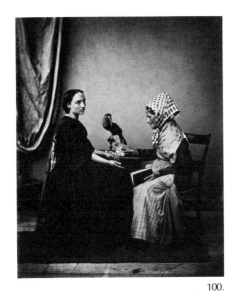

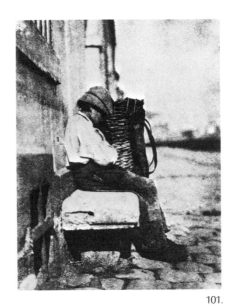

100.

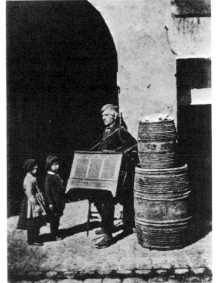

101.

102.

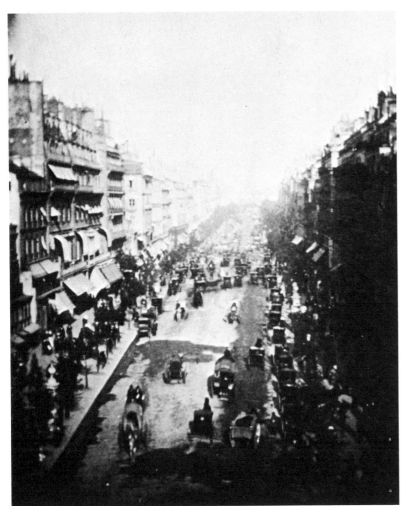

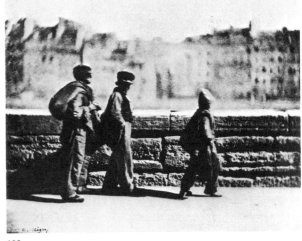

103.

104.

ATGET'S TREES

JOHN SZARKOWSKI

ATGET'S TREES

John Szarkowski
Director, Department of Photography
Museum of Modern Art

We know very little of the life of Eugène Atget, and even less of his intentions. The supportive documentary evidence that has come to light is slight and scant, and the eyewitness accounts of those who actually touched the man perhaps reveal the witnesses more clearly than the subject. (The testimony of Man Ray, Berenice Abbott, and Calmette might be considered roughly analogous to that of Matthew, Mark, and Luke, and the more ambitious reading of Pierre MacOrlan might suggest the role of John, an accredited intellectual.)

Without doubt, important new hard facts will result from a close study of known supportive materials, as well as from documents that surely still lie undiscovered in the files of some of Atget's customers. The most potentially revealing nonvisual sources in the archives of the Museum of Modern Art[1] are the following three documents:

1. A handsomely bound book (or maquette?), 13¼ inches by 10⅜ inches, consisting of sixty mounted original prints on the subject of the architecture of old Paris, with short critical captions set in letterpress, and a title page, also in letterpress, identifying Atget as *Auteur-Éditeur* of the work. The content of the captions makes it clear that Atget willingly accepted the obligations of a historian and interpreter.[2]

2. A small octavo notebook of ninety-two (originally one hundred) pages which apparently served as a combination address book and *aide-mémoire* concerning both specific commissions and general business potentials. Superficial perusal of the notebook makes it clear that Atget's business contacts were more numerous and varied than the traditional image of Atget as a naive street photographer would suggest.

3. Several score of homemade scrapbooks, in which Atget's prints were originally stored. The pages of these notebooks include, in Atget's hand, titles, negative numbers, and occasionally dates, and the covers bear titles describing the category of pictures included, and often a reference to the span of negative numbers covered. On at least one occasion, and probably more, the cover page title is written on the back of a dated invoice from Atget's photographic supplier.

Systematic and thorough study of the materials described above should provide valuable evidence concerning Atget's concept of his role, the nature

and extent of his professional practice, details of his technique, and the intellectual structure which supported his work. The scrapbooks, in particular, should provide clues that will help solve Atget's mystifying numbering system[3] and thus allow accurate dating and a chronology for his work.

Among the curatorial obligations of a museum of art, the collection and analysis of such research materials is of an order of importance second only to the preservation, cataloging, study, and exposition of the art works themselves. As the responsibility for proper housing and ordering of the original works approaches satisfaction, the museum will be able to pay increasing attention to the matter of supporting archives. The study of these documents will in turn identify other possible sources of new evidence in various private and public archives.[4]

Nevertheless, it is not likely that new supportive sources, or the close study of those already known, will substantially satisfy our curiosity about Atget's personal artistic values and intentions. It seems clear that the most important questions must be asked not of the supporting documents, but of the works themselves.

To interpret an artist's intentions on the basis of his work is admittedly a risky procedure—though perhaps not so dangerous as the prevalent assumption that the work is equatable with the artist's stated intentions. With artists, as with politicians, we should give our closest attention to what they do, rather than what they say.

The collection of the Museum of Modern Art includes in excess of three thousand different photographs by Atget. Until a satisfactory catalog and retrieval system are achieved, it is extremely difficult to see a body of work of this magnitude as a coherent whole. The reappearance of common motifs and ideas and the growth of a single idea in time can be effectively hidden by the sheer mass of material. In certain areas, however, a degree of clarity has begun to emerge concerning the relationship of pictures in the collection.

One such area is the subject of trees, which Atget photographed often and with obvious pleasure over many years. The small exhibition "Atget's Trees," held at the museum during the summer of 1972, provided the occasion for a closer consideration of this aspect of Atget's work than had been afforded previously. This consideration resulted in discoveries and speculations that interested this student and that may interest others. Several of these lines of thought can be illustrated by the six pictures reproduced here.

Close study of the six pictures establishes that they are all of the same beech tree. So far as has been determined, they are the only pictures of this tree in the museum collection. After discovering that the pictures were of the same subject, it seemed reasonable to assume that the pictures reproduced in plates 2 through 6 were made on the same day, and indeed within the same hour. The fact that some two hundred negative numbers separate plate 3 from plate 4 does not make this assumption untenable; the key to Atget's numbering system has not yet been discovered, but it is clear that there is no simple relationship between negative number and relative position in the chronology.[5] The most compelling reason for assuming that the pictures were made on the same day is the consistency of season, weather, and hour that they describe. The position of the sun is especially persuasive. I would estimate that the difference in sun time between 1011 or 1012 and 1226 would not exceed a quarter-hour. Numbers 1224 and 1225, made from the opposite side of the tree, also describe basically the same sun position.

The most interesting direct comparison offered by this group is perhaps that between 1012 and 1226. In the absence of persuasive evidence to the contrary, it would be difficult to avoid the conclusion that the two pictures were made within a few minutes of each other—1226 a little later, the sun having advanced a bit in its clockwise path around the photographer. The progression from one picture to the next would have been a natural one: the photographer has moved forward a yard or so, and very slightly to his left. The tree's trunk now intercepts a larger segment of the camera's cone of vision (incidentally hiding the distant woodpile); the new position emphasizes the massiveness of the trunk, clarifies the background, and provides a simpler and cleaner terminus for the picture's top edge. The closer vantage point simplifies pattern, and increases the importance of the sculptural undulation of the trunk. In response to this shift in the nature of the subject, the exposure is increased by a factor of four, and development is decreased accordingly. The new technical procedure reduces contrast and increases the effects of atmospheric perspective.

The reader may or may not agree that this is plausible; in any case further study of the photographs proved it to be false. If 1012 is carefully compared with 1226, it is evident that the same smaller tree is shown near the extreme right edge of both pictures. In 1226, however, the tree's lowest lateral branch has been pruned away, and the small and unkempt trees around its base have been removed.

It is thus clear that the pictures reproduced here were in fact made on at least three different occasions. It seems probable that 964 was made first, 1011 and 1012 on a later occasion, and the 1200 series at a still later date—perhaps a *much* later date.

In considering the six pictures as a group, several general observations can be made. First, none of the pictures shows the "whole" tree; thus none shows the distinctive silhouette that would seem the most obvious requirement of a conventional record photograph. Second, the five pictures of the leafless tree seem variant studies bearing on a single issue, which concerns the visual (virtual)—not the botanical, or real—structure of the tree. Third, the insistent and repeated investigation of the same subject suggests that Atget's working philosophy was not merely intuitive and impulsive, but deliberate and disciplined. This impression is reinforced by the fact that he returned after a considerable passage of time to remake and refine essentially the same picture that he had made earlier.

Perhaps a dozen cases have been noted in the museum's collection where Atget has returned to a specific motif after a substantial passage of time, and additional cases will surely be discovered as adequate cataloging is achieved. Among the fifty prints selected for the exhibition "Atget's Trees," at least seven subjects had been photographed more than once. In the case of at least four of these subjects, a substantial period of time had elapsed between the first and last photographs, as evidenced by old scars where branches had been removed after the first photograph had been made, or similarly objective changes.

Such a pattern of work is highly uncharacteristic of work done for commercial purposes. It seems likely that the trees represent one of the areas of Atget's work that had minimal commercial potential. There are, nevertheless, several hundred such pictures in the museum's collection, indicating that the subject was of central and lasting importance to Atget. The octavo notebook mentioned previously has so far yielded no suggestion that he had customers for this work. To a limited degree, painters and illustrators may have used photographs of trees as studies, but one can only sympathize with the difficulty of incorporating Atget's radically seen, closely cropped tree details into larger compositions. To this viewer, the variety, intensity, and dense complexity of Atget's tree photographs suggest that it was his intention to make pictures that were complete and self-sufficient, in the service of no exterior cause.

In the absence of adequately complete written sources, it is tempting to make much of such small crumbs of literary evidence as may exist. In Atget's case, many pages of interpretation and speculation have followed from the fact that he had hung in his doorway a sign bearing the words *Documents for Artists*. It would seem unnecessary to point out that the sign was an advertisement, not an autobiography, and that its purpose was to call attention to work that seemed potentially salable, rather than define the photographer's purpose in life.

"Atget was a great documentary photographer but is misclassed as anything else. The emotion derived from his work is largely that of connotations from subject matter," wrote Edward Weston.[6] Since any photograph (or indeed, any work of art) is among other things a document, a precise definition of the term "documentary photograph" has remained elusive. Nevertheless, the basic thrust of Weston's comment on Atget seems reasonably clear: it suggests that the content of Atget's pictures would be equally accessible to us if we could see the "subject" itself—that his photographs do no more than transmit an aspect of subject matter that is somehow intrinsic, inevitable, and "objective."

Considering the vitality of Weston's own photographic imagination, his inability to accept Atget's work without reservation is particularly interesting. By attempting to understand the nature of these reservations we may come to a fuller understanding of both men's work.

Part of Weston's disappointment on first seeing Atget's work was based on what seemed to him a certain casualness in technique.[7] Negative numbers that appeared on the face of the print, frequent vignetting of the upper corners of the picture (because of Atget's short focal length lens), halation caused by his massive exposures and heavy development—flaws such as these surely violated Weston's aesthetic sense of proper photographic *finish*. However, the center of Weston's reservations went to more basic matters, and related, I believe, to profound differences between the sense of form of the two men.

Weston was part modernist and part Platonist. His attitude toward abstraction was ambivalent and contradictory; in the sense that the word stood in opposition to precisely realistic indication, he rejected it, but in the sense that it implied distillation, concentration, and intensity of conception, it defines the very essence of his photographic quest. His writings often suggest that he believed in the existence of ideal and absolute forms, the approximate shape of which might be discovered within the

specific data of real shells, rocks, vegetables, and human bodies. He said, "All basic forms are so closely related as to be visually equivalent,"[8] and "How little subject matter counts in the ultimate reaction!,"[9] and "Peppers are reproduced in seed catalogues, but they have no relation to my peppers."[10]

If Weston's work pointed toward simplification and the independence of form, Atget was concerned with complexity and the relativity of form. Atget returned again and again to the trees of St. Cloud and Versailles because he knew that an infinite number of images were potential in them, and he knew also that none of these images was true, in the sense that it shared a privileged identity with the object photographed. He did not confuse the subject with the object. He understood that the true subject is defined by (and is identical with) the picture.

Although the breadth of Atget's interests reminds us of the Encyclopedists of the Enlightenment, the quality of his sensibility seems prophetically modern. His remarkably complex mind was non-Platonic in its perspectives: he worked not from but toward a formal ideal (idea). His conception of form was not nuclear but galactic: relative, plural, dynamic, provisional, and potential.

NOTES

1. The museum's Atget holdings consist primarily of the very large collection purchased from Berenice Abbott and Julian Levy in 1967, with the aid of a gift from Shirley C. Burden. The collection was originally acquired by Miss Abbott shortly after Atget's death in 1927, and consisted of the contents of his studio at the time of his death.

2. The caption for plate 9 of the album is typical: "Impasse de la Poissonnerie. Rue de Jarente. (4e Arrt) au bas de la Rue de Turenne—Très jolie fontaine construite en 1700. Réédifiée en 1783, sur les dessins de Caron. C'est un joli petit édicule trop ignoré."

3. At this point it can be said only that the negative numbers do not follow a simple serial system. Some late pictures have low numbers, and some early pictures have relatively high numbers; in perhaps fifty cases the same number is used twice, for unrelated pictures. It is possible that two or more broad subject areas were numbered in parallel, and/or that Atget reused certain blocks of numbers after selling the negatives to which they had originally been assigned.

4. Such evidence almost surely exists. In 1969 Yolanda (Hershey) Terbell, then of the Museum staff, received from Mlle Vinceau of the Archives Historique de la Ville de Paris copies of three letters of 1920, concerning the sale of 2,621 negatives to the Archives. These letters provide valuable suggestions, in Atget's own words, concerning his own

understanding of the function of an important segment of his work.

5. One plausible explanation for the gap in numbering might be that Atget sometimes numbered his negatives not when they were developed, but when they were first printed. Thus negatives that remained uncataloged on the darkroom shelf for an extended period of time might eventually receive numbers far out of normal sequence. The author, when a working photographer, was frequently guilty of this unsystematic procedure.

6. Edward Weston, unidentified letter of April 18, 1938, in ed. Nancy Newhall, *Edward Weston: Photographer.* Rochester, N.Y., Aperture, 1965, p. 58.

7. Edward Weston, "Daybooks, Dec. 27, 1930," in ed. Nancy Newhall, *The Daybooks of Edward Weston: Volume II, California,* New York and Rochester, Horizon Press, in collaboration with The George Eastman House, 1966, p. 201.

8. Edward Weston, "Daybooks, Oct. 1, 1931," in Edward Weston, *My Camera on Point Lobo,* Yosemite National Park, Virginia Adams; Boston, Houghton Mifflin Co., 1950, p. 78.

9. Edward Weston, "Daybooks, March 8, 1930," in N. Newhall, *The Daybooks II,* p. 146.

10. Ibid., "July 16, 1931," p. 219.

105. Eugène Atget. *Park St. Cloud.* (#964.) The Museum of Modern Art, New York.

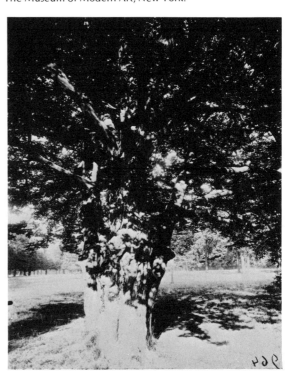

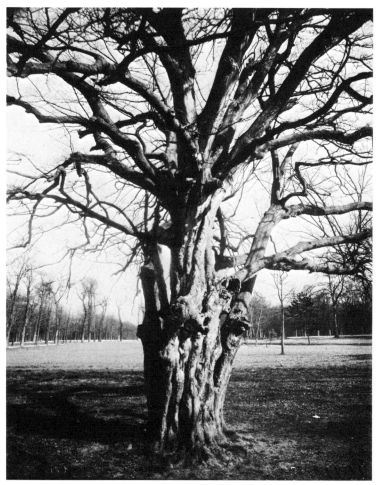

106.

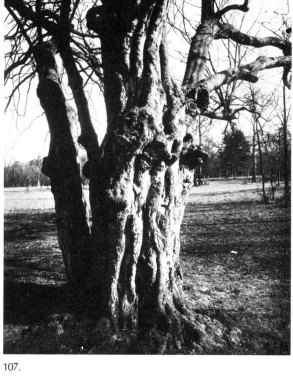

107.

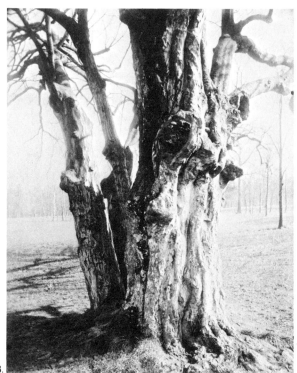

108.

106. Eugène Atget. *St. Cloud.* (#1011.)
The Museum of Modern Art, New York.

107. Eugène Atget. *St. Cloud.* (#1012.)
The Museum of Modern Art, New York.

108. Eugène Atget. *St. Cloud.* (#1226.)
The Museum of Modern Art, New York.

109. Eugène Atget. *St. Cloud.* (#1225.)
The Museum of Modern Art, New York.

110. Eugène Atget. *St. Cloud.* (#1224.)
The Museum of Modern Art, New York.

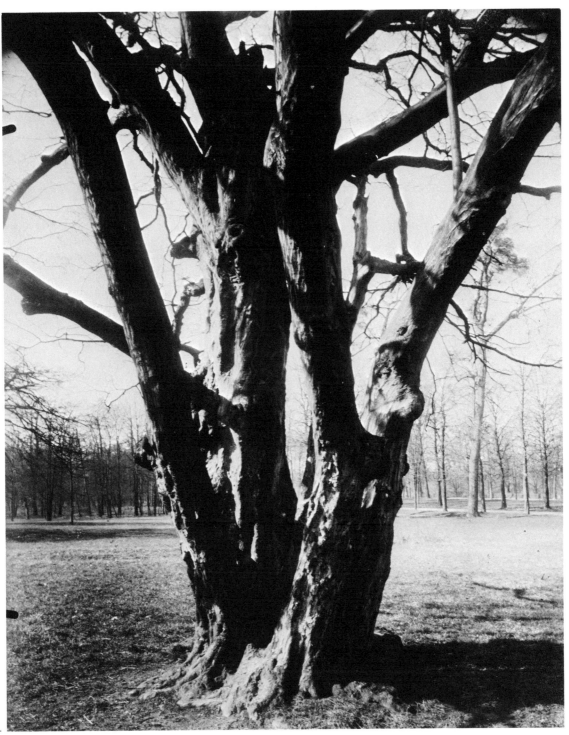

109.

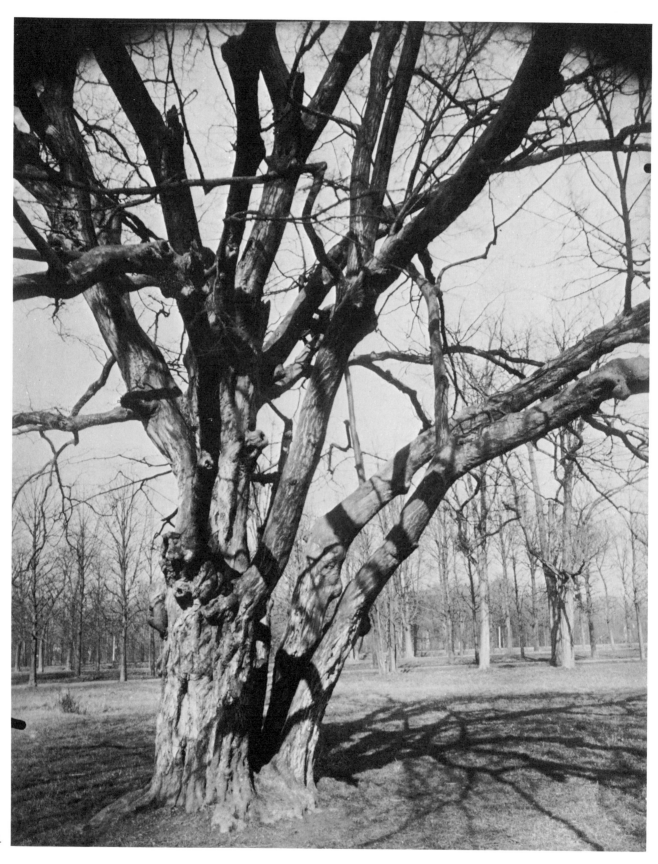

110.

SILENCE OF SEEING

MINOR WHITE

SILENCE OF SEEING

Minor White
Professor of Photography
Massachusetts Institute of Technology

The silence of seeing formulated in these pages has a contemplative-experimental basis. So with a pun in mind, if *still* photography represents a silence of seeing then it could be practiced in cinema, television, still photography, or any other form of optically originated images. Silence of seeing may be applied to the totality of photography: its photographers, its camera work, its audiences, its critics.

Here the formulation and application of silence is restricted to camera work because that small segment of photography centers around creativity. The present formulation differs from that given and encouraged by Alfred Stieglitz. Stieglitz thought of camera work as the "art of" because it aspired higher. Compared with a church spire in a village, it stands higher than necessary. He favored art and "I" consciousness. I prefer this formulation: a camera is employed and work necessary to use photography for intensified consciousness. Possibly we each mean something beyond either art or consciousness.

The present writing was also done in a state of heightened silence. Hence writing in the first person seems the more appropriate. The word "I" will be used as a child says it unaware of self; also as an old man says "I" who constantly remembers how young he is compared with the universe. Speaking thus my experiences may be generalized in relation to myself without implying universality. I write for the pleasure of those who will recognize the experiences in themselves. For such people "I" will mean collectivity instead of a uniqueness or aloneness.

To experience anything in the here-and-now I usually have to shut out multimedia dreams and thoughts twittering like cuckoos at dawn. Such a noise! So it seems logical to locate a way of silence before attempting to experience a photograph, or the subject of one I am about to photograph. In the search for a way of quieting the twittering machine, meditation was encountered; so was the Zen way of just sitting. Ultimately I found that a self-induced quietness was best for me. That way allows all my scattered parts to reassemble. I become present. Sometimes I think I center in the Solar Plexus, at other times I cannot locate any special area. Wherever located, once felt I can give all my attention to the photograph at hand, or to the subject I am about to take a silver tracing of.

I feel doubtful of my attempts to describe the induction of stillness for the purposes of camera work. There is an object, for example an ice crystal, or its silver image on the other side of my stillness. That condition satisfies part of the definition of the word "contemplation"—the object part. But few of the

objects of my attention are sacred, as the full formulation requires. Christ and Buddha figures are scarce, handwriting on the wall is a little more plentiful (graffiti). Unless, of course, I make subjects sacred by the quality of my concentration.

In various experiments with stillness I went so far as to play that I was a member of photographer Anyone's audience of viewers. I looked at his pictures in my silence and my stillness. I saw more—deeply and sooner. My experience of his image was intensified, became a journey. It did not become a psychedelic trip because of the nature of his image. That was enacted on a stage of war. The inner journey through an emotional ambience led to a sense of injustice. That journey over, I spent some enjoyment analyzing the photodynamics; you know, how this line meets that one in a smash, how this form constricts the space behind it. In this photo all of the subtle and obvious pleasures of visual tactility and structure led to a powerful sense of the inevitability of war. By way of association the main thesis of the Bhagavad Gita entered: inevitability without injustice. That was my final understanding of Anyone's image.

Seeing in silence ordinarily leads to an understanding, which in turn closes the event of seeing in a satisfying way. The journey through Anyone's picture was neither comfortable nor pleasant—nor the understanding cause a welcome relief—nor the closure in any way aesthetic. The satisfaction was one of revelation surfacing in consciousness.

At another time a different relation may dominate between Anyone, his image, and me. If my understanding of his image is not the same as Anyone's, I do not protest to him or contradict because his experience is different from mine. On the contrary I cherish his experience because it may give me a glimpse of an unfamiliar Anyone. I may like that part of him. Whenever I hear a man object to another man's response to the same photograph I get the shudders. They are both right and, when honest, beautiful. Whenever they treat honest experiences as contradictions the barriers rise higher than ever between them. And blindness is heard as the sound of seeing.

By means of people's responses and reactions to photographs, I have met many strange and wonderful, peculiar and haunting, angels and demons in my friends and my strangers. Sometimes in the process of cherishing responses I find that strangers are friends—and friends enemies in disguise. Seeing in silence leans me over a high cliff onto a different view of the commonplace. Through the Looking Glass, through the camera, through perception, through vision to what's behind! I only wish I could make such vision occur more often and last longer. So I induce this kind of silence in myself frequently. I also take those moments when it happens spontaneously as evidence of grace.

Along about the middle of my life I came upon quiet and stillness as a preparation for seeing. Before that I went at seeing negatively, that is criticizing before I even had a chance to know the photograph. In that turbulent way I acquired a certain taste by which to measure excellence. That measure was a blend of many sides—book devouring, gallery hopping, personal biases, prejudice, lying to myself, and imposing a grid of assumptions instead of waiting until a photograph, or subject about to be photographed, spoke to me. Half of all this raucous activity was useful; to this day I am not sure which half. Since I assumed that a measurement for excellence was required I had to go through all the uproar to devise a yardstick. The building part of it was useful. The error was in unconsciously coming to believe the measurement, which I accidentally called "Spirit," was an absolute, or close to that. At the same time something like *seeing* was deflating my confidence, and making me think that I did not know one iota of what Spirit meant.

Then I discovered how to be quiet with myself before photographing anything. Seeing in stillness stripped of all baggage, I began to find such deeper experiencing as left no need to criticize. My experiences were more rewarding when I did not apply any standard of quality. When I neglected to judge, vision was richer. Thus, for several years I sought experiences at the expense of criticism.

During these joyful years of growth as a beholder, I became convinced that it really does cost creative effort to give words to journeys through photographs. If I described the experience, the recital would be a minus-feeling travelogue. It was not criticism that was missing but something real out of my deeper self. So I sought to give more of myself. Had I been a painter I would probably have invented drawings or sketches of the essence feeling of my journey. Or if a dancer, I would have improvised choreography. Being wordy I tried to create a written poetic equivalent of the essence of my experience. I hoped to create something that would be a special kind of mirror, so if the photographer looked into it, he would see a hank of myself and a bone of himself in mutual understanding. I wanted to give back some of the energy that his image stirred in me.

Poems do not always come out to order, or on

time. Speechless, I would resort to expressive silence, eye contact, a handshake, or an embrace. Imagine my delight when a friend, somewhat self-consciously, communicated his response to my photograph by describing his experience with his hands on my bare back. I was surprised at the forcefulness of the communication. And grateful, very grateful to learn how far an image out of my camera had moved him.

I had felt all along that the simultaneous meeting of picture, photographer, and beholder was and is a rare opportunity. But all previous encounters had been fearful. And strangely enough fearful of love surfacing in an embarrassing way. With his hands on my back, our private, psychological hours synchronized, a moment of recognition flared. We recognized the energy of the genitals and watched it take the direction of respect and wonder. We stood in awe at the radiance encountered. Of evaluation there was none, unless a moment of being together exceeds all judgments of unions. An experience as full and open as the flight of swallows in the circle encompassing friend, photograph, and maker urge me to wish the same for all people.

Such encounters multiplied. Along the way I observed that if I make but one step toward evaluation I become the critic. At once I am whirled outside the circle of friend, photograph, and maker. Two steps and outside of the circle of three I remain.

Evaluation, or criticism at its most positive, however, cannot be postponed forever. I questioned *how to·evaluate from within* the circle of friend, image, and photographer. I would try, I thought, to evaluate during the silence of seeing an image that had been experienced in contemplation. Slowly, a few years in fact passed. Now I can say that when I go with myself together in silence before an image, I go as if before an altar. Just as I listen for the photograph to speak, I look to the altar for judgment. From many such experiences I have come to believe that, though we generally think of camera work as images and photographs, camera work includes the office of the critic. The temptation arises to qualify with such words as "positive" and "enlightened," but a capital C is as far as I want to go.

Photographers these days shun the critic, want no part of him, indeed they would exclude his office if they could find a way. But they cannot because the critic is a part of the photographer, part of every member of his audience, part of humankind. The critic is ourselves in the role of a stranger—outside, hence an enemy.

The flesh-and-blood stranger-critic has an advantage that the photographer cannot possibly have. He is not burdened with the disadvantage of having been present when the exposure was made. *This puts him on the side of the beholders.* He could be the one member of our viewing audience with both a professional knowledge of the mechanics and familiarity with the store of camera work images in the world. This puts him on the side of the photographers. On my side he can give me, in my role of photographer, a consciously expressed, perceptive experience-response to my image—something my lay audiences can never do consistently, some days on, most days off.

We could further elaborate on the qualities of the Critic. He would be familiar with his personal foibles. He would be able to discriminate his opinions from his knowledge, and prefer "considered judgments" to ego trips. He would have a breadth of knowledge of camera work to compare my photographs with others like it. If I could become so aware of myself, my hangups, and impartialities that I could commit myself objectively to isolate nourishing photographic contributions to potential viewers, or to the totality of camera work, I might try to perform the critic's task. I, however, do not hanker to recognize my deficiencies. I want to remain a subjective photographer. To do that I feel that I must defend and cultivate my personal idiosyncracies, enlarge my ego to the size of a colossal olive. I would rather leave objectivity to the critic and damn him for misunderstanding my images and me whenever I feel like blowing off steam.

Continuing on my ego trip in the role of cameraman, I would expect, if not demand, that the Critic would turn his poetic force in my direction now and then to sustain my energy and at times renew it. A rebuff often has more energy packed in it than an affirmation. Simple affirmation is needed only when needed, not every minute. Occasionally I hunger only for that *bit of the man himself,* in response to my image. That packs the kind of energy that regenerates. I take from him *energy only,* not directions or orders. The energy from an enlightened Critic would have consistently a higher energy charge than that from anyone else—except that from the passing remark of a child.

The Critic's moment of understanding of my image, when communicated to me, has the power to release me from the long commitment to a photographic image—if I am ready to let go. By the action in me of his objective response I can let go and start the search for the next photograph with seed-hunting force. The seed is in me already—the germinating sun comes from the outside—the heat of the

sun comes from the *honest* responses of my friends and the still more objective responses of the stranger-critic. The heat of the sun is as essential to the turning of the creative cycle as it is to the growth cycle of plants. Without the critic, or his function activated somehow, the creative cycle of camera work slows down and comes to a halt.

I don't know any critics in photography who work like this. I do know that they have never been encouraged in photography to take the time to become fully qualified. We have critics who seem never to have heard of a silence of seeing or George Eastman House. Yet contemplation in preparation for seeing and evaluating images might lead them to enlightenment. Anything less than understanding weakens me, dries me up. Enlightenment awakens me. Less than fully qualified critics notwithstanding, I have only rarely lacked rain. Something in me forces me to seek rain by letting my images out among strangers until one of them, a child sometimes, a passing remark, releases me from my photography. At times I have waited years before something out of the passing scene or parade of students responding to my images pierces my blindness with understanding.

Outwardly, photographic images made while in contemplation rarely look much different from those made in a bustle of activity and noise. This is true until the images are looked at in stillness, in a state of intensified perception. *Then the difference shows.*

All the above must seem simple and quite ordinary. To make sure that the reader is left with a conviction, if not an experience, that rather extraordinary states of consciousness are being pointed at, I will further say that when I look at something in contemplation, that something changes—or I change—or we both see differently. It is as if one eye sees outwardly, the other inwardly, through my heart and out to the potential viewer. Energy enters and when I have given that energy a shape, it moves out to others.

I am viewer, photographer, critic, and image at various times and in random sequence. Nevertheless the larger creative cycle turns within relentlessly, though not evenly: inception, the waxing upturn, the full flowering of the idea-feeling force in the image, the waning downturn showing images to friends and benefiting by their responses until the seed-energy brings the wheel full circle and the upturn begins again. All the phases have characteristic and emotional rises and falls. Still for me that most magic moment of all is that blank period when one image is over and the next is about to start. There is an anguish of waiting—will it ever really start again? The

tension of that moment can never be released until a bit of energy from an *honest response* pierces—like rain, like sun, like love.

In the role of the photographer I rarely can observe in myself the currents and cycles of all these forces working, beyond an intuitive recognition of rapport with livingness. In a state of heightened awareness an intuitive recognition of living energy accelerates work on an image. My energy is expended in the rite of exposure. But things go differently when I am in the role of the viewer. I can see the whole inner-outer action that results in response. At this stage I can become aware of what was going on during the exposure ritual. Long years have given me faith that the photograph made in a peculiar kind of half-seeing and half-sensing its importance will reveal to me later the whole of the experience. I can make the journey in leisure. To be sure sometimes I am surprised at what the journey reveals that I had no inkling of during exposure.

In the role of the critic (the enlightened and knowledgeable viewer) I am saddened when I feel obliged to pass judgment. Hence I feel that I dare not make evaluations from anything less than the total experience of the image in a state of concentration and contemplation. I feel compelled to give out of my deepest self, response, and out of God knows where, judgment.

No matter what role we are in—photographer, beholder, critic—inducing silence for seeing in ourselves, we are given to see from a sacred place. From that place the sacredness of everything may be seen.

INDEX

INDEX

Page numbers in italics refer to illustrations.